Institutions and Gender Empowerment
in the Global Economy

World Scientific Studies in International Economics
(ISSN: 1793-3641)

5 World Scientific
Studies in
International
Economics

Institutions and Gender Empowerment in the Global Economy

Editors

Kartik Roy
University of Queensland, Australia

Hans Blomqvist
Swedish School of Economics & Business Adminstration, Finland

Cal Clark
Auburn University, USA

 World Scientific

NEW JERSEY · LONDON · SINGAPORE · BEIJING · SHANGHAI · HONG KONG · TAIPEI · CHENNAI

Published by

World Scientific Publishing Co. Pte. Ltd.

5 Toh Tuck Link, Singapore 596224

USA office: 27 Warren Street, Suite 401-402, Hackensack, NJ 07601

UK office: 57 Shelton Street, Covent Garden, London WC2H 9HE

Library of Congress Cataloging-in-Publication Data
Institutions and gender empowerment in the global economy / editors, Kartik Roy,
Hans Blomqvist, Cal Clark.
p. cm.
ISBN-13: 978-981-270-996-7
ISBN-10: 981-270-996-7
1. Women--Economic conditions. 2. Women--Social conditions. 3. Women--Employment.
4. Women--Government policy. 5. Social institutions. I. Roy, K. C. (Kartik Chandra), 1941-
II. Blomqvist, H. C. (Hans-Christer) III. Clark, Cal, 1945-

HQ1381.I44 2008
305.4209'0511--dc22

2007048501

British Library Cataloguing-in-Publication Data
A catalogue record for this book is available from the British Library.

Typeset by Stallion Press
Email: enquiries@stallionpress.com

Printed in Singapore.

Preface

At the World Economic Forum in the Middle East held in May 2006, participants from member countries discussed some of the major institutional hindrances to women's empowerment and what needs to be done to facilitate women's empowerment. They agreed that for women attempting to empower themselves, overcoming powerful social and cultural norms is the only way forward. For example, a woman may have the legal right to work but in some countries, she must have her husband's permission to work in any organization. This is a customary or informal law. Similarly, while under Islamic law, a husband's property must be divided equally between surviving spouses and children, in practice, this does not always happen. Hence, significant gender gaps exist between men and women in areas of economic participation, economic opportunity, political empowerment, educational attainment, and health and well-being in most countries in the Islamic world.

In the edited book *Institutions and Gender Empowerment in the Global Economy*, these issues affecting women's empowerment in developing and developed countries have been raised and critically analyzed.

The first draft of the proposal for this book was prepared by K.C. Roy at the Centre for Gender Relations and Women's Studies at the University of British Columbia, Vancouver, Canada where the author spent 3 weeks as a visiting fellow in October 2004 under a special studies program leave approved by The University of Queensland where he is currently employed.

The editors wish to thank Professor Sneja Gunew, former Director of the UBC Centre for Gender Relations and Women's Studies, for providing K.C. Roy with facilities to work at the centre to prepare the first draft of the proposal for the book.

The Editors also wish to thank the World Scientific Publishing Company for agreeing to publish this edited book, and to all others who have been involved in the publication of *Institutions and Gender Empowerment in the Global Economy.*

Kartik C. Roy
School of Economics
University of Queensland
Brisbane, Queensland, Australia

Hans C. Blomqvist
Swedish School of Economics and Business Administration
Helsinki, Finland

Cal Clark
Department of Political Science,
Auburn University, Auburn
Alabama, USA

Contents

Foreword

by the late Sir Hans Singer

The following study on the impact of institutions on the empowerment of women brings together two factors increasingly emphasized in developmental studies. The first is the crucial role of good governance based on strong and properly enforced legal, political, social as well as economic institutions providing the "freedom" of the pioneering work of Amartya Sen. The second factor is the emphasis on human resources, the "human face" of the UN Millennium Development Goals and the UNDP's Human Development Reports.

With women representing half of the world's human resources plus a deep influence on the development of the other half, the reference of the empowerment of women is obvious.

As many studies have shown, in the absence of these two factors our other development tools — aid, trade, debt relief — are unlikely to achieve the desired goal of development in freedom and relief from poverty. The educational empowerment of girls has rightly been made a specific item in the Millennium Development Goals. It is hoped that the following study will bring out the present situation and point the way to improvements, wherever needed.

Institutional Affiliations of Contributors

1. Kartik C. Roy, Associate Professor, School of Economics, The University of Queensland, Brisbane, 4072, Australia. Email: k.roy@economics.uq.edu.au

2. Hans C. Blomqvist, Professor and Vice-Rector, Swedish School of Economics and Business Administration, POB 287, FIN-65101 Vasa, Finland. Email: hblomqvi@wasa.shh.fi

3. Cal Clark, Professor and MPA Director, Department of Political Science, 7030 Haley Centre, Auburn University, Auburn, Alabama 39849-5209, USA. Email: clarkcm@auburn.edu

4. Janet Clark, Professor and Chair, Department of Political Science, University of West Georgia, Carrollton, Georgia, USA. Email: jclark@westga.edu

5. Jude Howell, Professor, Centre for Civil Society, London School of Economics, LSE, Houghton Street, London WC2A 2AE, United Kingdom. Email: J.A.Howell@lse.ac.uk

6. Biman Prasad, Professor and Head of Department, Department of Economics, The University of the South Pacific, Suva, Fiji Islands. Email: chand_b@usp.ac.fj

7. Patricia Fuertes Medina, Lecturer at the Postgraduate Programme, Faculty of Social Sciences, Universidad Nacional Mayor de San Marco, Lima, Peru. Email: patifume@yahoo.com

8. Rene P. McEldowney, Department of Political Science, Auburn University, Auburn, Alabama 36849, USA. Email: mceldrp@auburn.edu

9. Rosita Dellios, Faculty of Humanities and Social Sciences, Bond University, Gold Coast, Queensland, 4229, Australia. Email: Rosita_Dellios@bond.edu.au

10. Tabitha Kiriti-Nganga, Senior Lecturer, School of Economics, University of Nairobi, Nairobi, Kenya, Africa. Email: tkiriti@yahoo.co.uk; tkiriti@mail.uonbi.ac.ke

11. Nalini Lata, Tutor in Economics, School of Economics, The University of the South Pacific, Suva, Fiji Islands. Email: lata_n@usp.ac.fj

List of Tables

List of Figures

Chapter 1

Development and Gender Empowerment: Conceptual and Theoretical Issues

Kartik C. Roy,* Hans C. Blomqvist and Cal Clark

1. Introduction

Institutions — the set of formal and informal rules that affect human behavior — play the most crucial role in the process of the empowerment of people and in the economic and social development of a country. When people are empowered, they can make use of their qualities to improve their economic and social conditions, thereby enhancing the level of economic and social development of the country.

This book focuses on the role of institutions in the context of gender-related empowerment, with special emphasis on women. However, before we examine how institutions affect the empowerment process of women, we first will make comments on the meaning and objectives of development.

2. Development

The term "development" literally means the state of being developed or a new stage in a changing situation. By "development" economists generally refer to economic development which, in turn, is often interpreted as a process generating and sustaining an annual increase in gross national income, increase in the rate of growth of real income per capita, and increase in the ability of a country to expand its output at a rate faster than the growth rate of its population.

However, economic development also requires growth to be accompanied by changes in economic structure such that the share of agriculture

* Corresponding author.

in total national output and employment continues to decline and that of the manufacturing and service sectors continues to increase. It also became increasingly clear in the late 1900s that economic development is not only about economic growth but also about dealing with problems of poverty, malnutrition, unemployment, and the overall material well-being of the poorer part of the population of a country.

The persistence of pervasive economic poverty in, for example, India even after the completion of the first three comprehensive Five Year Plans (1951 to 1966) dealt a death blow to the belief of World Bank economists and of renowned economists such as Lewis (1955) that it is only growth and not distribution that matters. This belief was based on the implicit assumption that growth would trickle down to the poor masses by creating jobs, by producing enough surplus for the state to provide subsidised food to the poor, and by altering the distribution of income in favor of the poor. The shift in the early 1970s in the views of development economists and World Bank on the connotation of the word "development" can be ascertained from the following comments of Seers (1969).

> What has been happening to poverty? What has been happening to unemployment? What has been happening to inequality? If all these three have become less severe, then beyond doubt, this has been a period of development for the country concerned. If one or two of these problems have been growing worse, especially if all three have, it would be strange to call the result 'development' even if per capita income has soared.

Nevertheless, throughout the 1970s and 1980s, the World Bank economists, by and large, continued to treat economic growth as the goal of development. In contrast, other economists, while treating "economic development" as being synonymous with "development", continued to concern themselves primarily with examining the poverty and material well-being of the population of a country. The term "development" connotes more than economic development and alleviation of material poverty. The perceptible change in the World Bank's (1990) view on development from it referring only to growth to including other aspects such as the reduction in poverty and the improvement in the quality of life (e.g., in education, health care, and the environment) as well as to greater individual freedom and a richer cultural life, began to be noticed in about 1990.

Since the early 1980s, Amartya Sen, the 1998 Nobel Prize-winning development economist and philosopher, has been promoting such a

broad connotation of development. However, since Gandhi long before Sen expressed similar ideas on development, we will comment on the Gandhian concept of development. In turn, Gandhi's thoughts and ideas were, to some extent, influenced by the writings of the young Marx. Thus, we will commence with a brief discussion of the thoughts of young Marx.

3. The Views of Young Marx on Development

The young Marx felt that attention to all economic and social activities should be the thoughts, activities, and aspirations of "social man" (Kamenka, 1973; Sen, 1999). Due to the exclusive attention to the production of goods for satisfying material wants, man's cultural and human needs may be neglected. But since man is an ensemble of social relations, economic and social policies should be directed toward fostering those relations. The young Marx wanted production to be carried on in harmony with nature. Under the capitalist production system, machines dominate human lives. This leads to what the young Marx called "human alienation" which represents an important link between young Marx and Gandhi. To young Marx, the good that a worker produces is the objective representation of his (or her) own labor, but under the conditions of capitalism he (or she) has no right to enjoy his or her own product, and therefore, he (or she) feels alienated from it (Kamenka, 1972).

Because of this alienation, the more the workers produce, the less they have to consume; the more value they create, the less value they have. Hence, the workers are alienated from their products because this alienation is emphasised in every activity of production and is reflected in every movement of their lives.

Consequently, young Marx's "human alienation" expresses itself in the following two forms:

(i) In being alienated from the products of their works, the workers are also alienated from nature and;
(ii) Since life means nothing but activity, workers alienated from their work are also alienated from their personal lives (from other members of their families). These two forms of alienation lead to two other forms:

(iii) Man's (human being's) alienation from his own universal being and;

(iv) Man's (human being's) alienation from other men (human beings).

Both refer to human beings' alienation from their genus or species. This total alienation of workers from nature, from other members of their families, and also from other human beings occurs only when the domination of the machine over human lives becomes complete. Having failed to identify themselves with the products of their own labor, the workers themselves become like machines.[1]

To young Marx, since the alienation of a worker from the product of his or her own labor originates in the recognition of private property, the end to this alienation can come after the universalization of private property, i.e., after the state takes over the ownership of private property (Kamenka, 1973; Roy, 1986). As a result, the conflict between man and nature is resolved, and once again man becomes a social being.

This Marxian "human alienation" can also be described as the outward manifestation of human poverty. The alienation resulting from the failure of a worker to enjoy the product of his or her own labor is a manifestation of economic property; and the consequent alienation of the same worker from other human beings, from nature, and from family members is a manifestation of one's cultural poverty.

4. Gandhi's Ideas on Development

The spirit of Young Marx was carried forward by Gandhi who also wanted production to be carried out in cooperation with nature by using renewable resources and who talked of the need for autonomy (independence) and self-reliance of people (Roy, 1979). According to Gandhi, the objective of development is to facilitate the unfolding of human personality. The objective of a fully developed human life, therefore, is happy living.

But, the goal cannot be realized if efforts of human beings are directed toward satisfying limitless material wants to the exclusion of the pursuit of spiritual and cultural values. The production of consumer goods to satisfy material wants can only be possible by using violent means to obtain non-renewable resources and materials from the nature, i.e., by

[1] If one visits one of the large factories manufacturing consumer goods in China and looks at the face of a worker on the factory floor one can visualize the alienation of that factory worker from his or her product and from nature.

destroying nature. This oppression of nature and violence against it are a manifestation of the poverty of nature. As the violence against nature continues to rise, nature's capacity to satisfy the ever-increasing demand for raw materials continues to weaken. Moreover, as nature loses its freedom, suffers from violence, and continues to become poorer, mankind cannot become richer, happier, and free.

The human mind, according to Gandhi, is a restless bird; the more it gets, the more it wants and still remains unsatisfied. The production of consumer goods on a large scale in giant factories makes people lose freedom and become more dependent. Gandhi accepted the essence of young Marx's ideas that man should be the center of attention in all economic and social activities. Thus, the poverty of a worker manifested in his or her alienation from the product, nature, and from all other human beings ought to be alleviated for the worker to enjoy the freedom to which he or she is entitled to pursue his or her self-determination activity. We can, therefore, also say that in young Marx's theory, poverty alleviation by bringing an end to the four forms of human alienation, empowers people to be free and to be able to pursue their self-determination activities.

Gandhi, however, rejected outright the state control of private property, the communist party dictatorship, the continuation of production in giant factories, and the ruthless suppression of individual freedom as the means to realize the goal of bringing about an end to human alienation.

The objective of happy living for everyone in a country can only be realized by fulfilling basic needs, such as simple food, simple clothes, houses, health care, and education under a system of nonviolent production in cooperation with nature. Such a system entails production of basic necessities in innumerable small-scale factory units by workers who consume the products they produce. Gandhi, however, did not strongly oppose the production of more sophisticated consumer goods for distant (international or export) markets in large factories on a large scale.

Gandhi's concept of basic needs, however, has a broader connotation which includes economic, social, and cultural needs. Hence, individuals with different kinds of capabilities will be engaged in different activities to satisfy different kinds of needs. For the proper development and unfolding of human personality, Gandhi wanted every individual to perform the following tasks during a 24-hour day:

(i) For the first 8 hours, physical labor to produce material goods to alleviate economic poverty;

(ii) For the next 8 hours, mental labor devoted to reading, writing, and learning different skills which are essential for the development of the mind. To learn anything properly, it is necessary to practice what a person learns. Hence, Gandhi regarded hand culture as essential to mind culture and placed physical labor at the root of the development of men as a human being;

(iii) For the last 8 hours, complete rest for the human body and mind, i.e., 8 hours of uninterrupted sleep.

Gandhi's development plan was targeted at the self-sufficient village republics of ancient India. Gandhi wanted to revive these republics because in the early 1900, when Gandhi was conceptualizing his thoughts on development, about 90 percent of India's population lived in villages, so the employment opportunities for these people for full utilization of their abilities had to be found in village industries and agriculture. His idea was that in such republics, while virtually no one would have enormous wealth, each would have enough to lead a happy and contented life (Gandhi, 1946).

However, under the British rule, imports of Lancashire mill-made clothes and other consumer goods from Britain virtually destroyed India's small-scale and village industries. For the revival of village republics, therefore, Gandhi called for *Swaraja* (meaning freedom and referring to the independence of India from the British rule) and "truth".

However, Gandhi's *Swaraja* also means freedom of individuals' minds, bodies, and spirits, freedom from all kinds of violence against them, and freedom from domination over them by their own government. This freedom can only be obtained by following truth; and truth can be followed in a nonviolent way.

Thus, (i) simplicity, referring to simple living and simple production by manual labor, (ii) nonviolence, (iii) *Swaraja*, and (iv) truth are the four fundamental ingredients in Gandhi's concept of development under which the aim of human life is happy living and to be free. While Gandhi wrote primarily from the point of view of India, his writings also have implications for other developing countries with large populations and pervasive poverty. Schumacher (1962) further elaborated the Gandhian concept of nonviolent development and discussed the ways in which Gandhi's ideas could be implemented.

While critics may legitimately argue that in this age of globalization, Gandhi's village-oriented, manual-labor driven development programs cannot be implemented in today's India with more than a billion people, the essence of Gandhi's concept of development still remains valid for India as well as for other countries. His "charkha" (spinning machine) and hand culture symbolize small-scale labor intensive industries. Gandhi wanted thousands of small-scale village industries to be re-established in the vast rural hinterlands of India alongside agricultural lands so that rural people, after working in agriculture for 6 months, could work in those small manufacturing units for the rest of the year. It would thereby solve Gandhi's problem of how to utilize their idle hours which are equal to the working days of 6 months in a year (Gandhi, 1934).

5. Background to Understanding Sen's Development Philosophy

First, we provide readers with a brief insight of Amartya Sen's childhood environment which left an indelible mark on his mental make-up and thought process. Sen's philosophic upbringing in his childhood took place in *Shanti Niketan* (meaning the "Abode of Peace") — an *Ashram* (meaning Hermitage), at a distance of about 160 miles north of Kolkata, built by the great Bengali and Indian poet and philosopher, Rabindra Nath Tagore, who received a Nobel Prize for Literature in 1913. Tagore established an international university called Visva Bharati in *Shanti Niketan* where teaching, learning, and other educational and cultural activities were carried out in harmony with nature, under the trees. Sen's mother, the late Amita Sen lived in *Shanti Niketan* as the most senior *Ashram Kanya* (meaning Daughter of the Hermitage). Sen's grandfather K. M. Sen was an ardent and devout follower of Tagore. Thus, three generations of Sens lived in Tagore's *Ashram*. Hence, Tagore's philosophy would certainly have produced a profound impact on Sen's life in later years. Tagore was international in outlook and culture, as his writings produced a strong influence on the West; and he himself was also influenced by Western models. His deep love for nature led him to see in all aspects of "nature" the presence of god. He regarded "individual freedom" as the quintessence of all prerequisites to enriching human lives. In his writings, he expressed his strong disapproval of all acts of suppression of individual freedom and inspired women to rise up against all acts of violence against

them. Here, one can see the similarity between the ideas of Gandhi and Tagore who had great admiration for each other. Having been brought up in his childhood in such a cultural environment, Sen could not have been anything different from what he is today.

6. Sen's Concept of Development

Sen's ideas about "development" are based on the relationship between freedom, poverty, and empowerment. Sen considers "development" to mean a great deal more than just economic growth or increases in some components of national income. It must contribute to the expansion of substantive human freedoms, as it is the effect of increases in physical output on the expansion of actual opportunities and freedom of people that measures the success or otherwise of development. But realization of this goal of attainment of substantive freedom also requires freedom of individuals to develop their capabilities and to utilize those capabilities.

Thus, in Sen's theory, "freedom" is at once the means and the goal of development (Sen, 1999). Thus, if a person after obtaining education is not able to utilize his or her capabilities to obtain employment, then that person suffers from economic "unfreedom". This can result from four situations:

(i) Availability of new jobs appropriate to a person's qualification may be very limited due to lack of freedom of business enterprises to pursue their wealth-generating activities;

(ii) Although jobs may be available, the person may not be able to obtain employment due to adverse cultural and political institutions;

(iii) Although the person may have a job, the income may have been squandered away on frivolous consumption activities, and;

(iv) Although the person may have acquired the capability to work in a particular area of employment, no attempt may have been made by that person to secure employment to make effective use of his or her capability.

According to Sen (1992), persons under the last two situations cannot be considered as poor. Poverty, therefore, according to Sen, is not low

well-being but the inability to pursue well-being because of a lack of economic means. Poverty cannot be properly measured by income (GNP per capita). Instead, it must include measures of capabilities in a number of basic functionings central to well-being (such as being adequately fed and sheltered and being in good health) which indicate attainments that do not correlate closely with these functionings. These functionings can vary from those stated above to very complex activities such as being able to take part in the life of the community and having self-respect (Sen, 1999).

To clarify this point further, Sen uses the example of men in the Harlem district of New York with capability sets and choices available to the US society having less chance of living to 40 years than men in Bangladesh due to the high urban crime rate, inadequate medical attention, racism, and other factors reducing Harlem's basic attainments and not because Harlem's per capita GNP is less than that of Bangladesh. The reason for this situation is that although people in Harlem have greater command over resources than those in Bangladesh, the cost of obtaining various social goods is higher in Harlem than in Bangladesh. In other words, the cost of social functioning for Harlem men is higher than their command over resources (Sugden, 1993). Hence, although people in Harlem have higher incomes than those in Bangladesh, their capabilities to enhance their well-being and the lives they lead and to enhance the freedom they enjoy are less than those of Bangladeshis. In elaborating the concept of development further, Drèze and Sen (2002) argue that the attainment of freedom by an individual in one area leads to the attainment of freedom in other areas.

Thus, if a person has acquired certain education and skills and has been able to secure employment, then that person has the ability to pursue his or her well-being in terms of eating adequate food, taking good care of his or her health, and wearing reasonable clothes. Freedom in all these areas strengthens the capacity of that individual to seek freedom in the social area by challenging old social customs and prejudices which suppress the individual's freedom to pursue happiness and to seek freedom in the political arena (Drèze and Sen, 2002). Total freedom then can be said to constitute the quintessence of development and happiness in life. But to reach that stage, a person's first requirements are education and skills which will ensure that person's capability to seek freedom in all other areas. This has to be provided to the citizens by the state or other organizations.

However, here differences seem to emerge between the views of Gandhi and Sen. To Gandhi, happiness is a feeling in a person's mind. To increase the level of happiness, one has to eliminate the causes of unhappiness by making available to the people only simple consumer goods for satisfying basic needs, as the supply of goods of conspicuous consumption will continue to increase the unhappiness of those who do not have the economic means to buy them. But others who will buy these goods will not be happy and contented either as the demonstration effect of a new line of more sophisticated products on their mind will keep them in a perpetual state of unhappiness.

But following Sen's argument, it can be said that a poor person's happiness, say, by just being able to eat one meal a day may not be real happiness; it may, in fact, be the result of perpetual deprivation of enjoyment of a better quality of life. Such people either have a disposition that keeps them very happy and satisfied or have learned to appreciate greatly any small comforts they can find in life and to avoid disappointment by striving only for what seems attainable (Sen, 1985). After suffering from perpetual deprivation, people tend to become fatalistic and accept the current situation as pre-ordained. This kind of fatalism has been recognized as a cause of limited wants in Boeke's (1953) theory of Eastern limited wants. Although a somewhat successful attempt was made by Higgins (1968) to undermine Boeke's theory, it still has validity in the vast hinterland of rural Asia and Africa. Poor people's fatalism still enables them to accept fully their miserable economic and social condition. Gandhi used this concept of "limited wants" as a centerpiece in his theory of "nonviolent development" for a number of reasons:

(i) During Gandhi's time, close to 90 percent of India's population lived in villages and rural towns where the cultivation of land by primitive tools and some rudimentary manufacturing activities in cottage industries were the only occupations of rural people who suffered from pervasive economic poverty. Hence, his most urgent task was to make arrangement for satisfying the basic needs of people. If resources were diverted toward the production of non-essential consumer goods, the production and supply of most essential necessities would suffer.

(ii) Also, the duty-free importation of Lancashire mill clothes and other consumer goods into India was contributing to the alarming demise

of India's small village industries. Hence to stop the total annihilation of India's village industry sector, Gandhi used his concept of "limited wants" to also convince the non-poor to keep their wants limited, thereby indirectly telling them to boycott British-made products.

(iii) Gandhi's non-violent political movement against the British rule code named "quit India movement" had to be tied with his non-violent economic development plan — because political freedom could only be enjoyed if people had freedom in economic matters.

7. The Link Between Young Marx, Gandhi, and Sen

We are now in a position to establish the link between young Marx, Gandhi, and Sen. All of them accepted that development does not simply refer to increases in national income: It connotes more than that. The deep undercurrent running through the writings of the three of them is that the ultimate goal of development is to enable young Marx's "social man" to be free and happy in life. As already noted, to young Marx the center of all activities had to be the "social man" and his aspirations and happiness. But since under the current production system a man is alienated from nature and from other human beings and receives less than his contribution to the output, his happiness can only be ensured by preventing alienation from nature and society by universalizing private property.

To Gandhi, to be happy is the ultimate goal of living. Development connotes the complete unfoldment of human personality which can occur when all kinds of human poverty have been alleviated. This requires political, economic, and social freedom of the people. Hence, achieving happiness requires freedom from all kinds of suffering and bondage. Gandhi placed limits on individual's freedom for consumption of material goods, as true happiness requires a person to be spiritually happy and contented.

To Sen, development is a lot more than the rise in national income and per capita income. The ultimate objective of development is freedom for a person to be what he or she wants to be and is to be happy which can only be derived when the individual has been able to develop all his or her capabilities to engage in economic, social, and political functionings. Lack of capabilities is "unfreedom" which results from poverty of all kinds. But unlike Gandhi, Sen places no limit on the kinds of freedom or capabilities that a person can have in terms of the choice of functionality

based on that person's personal features (which are reflected in his or her preferences) and command over commodities dependent on income.

8. Institutional Implications of Sen's Theory of Development

Implementation of Sen's ideas in any developing country is not likely to be as easy as it may seem. As we have already noted, the capability or freedom of a person to be functioning in different areas depends on that person's choice of functionings and on his/her command over commodities, i.e., income level. Hence, the first prerequisite here is for a person to have an appropriate level of income. A person with an income level too low to acquire the required capabilities cannot exercise his or her freedom of choice with regard to the functionings.

Moreover, the second prerequisite is that the state, therefore, has to help individuals build up their capabilities in their early life by providing them with basic education and health care free of cost. But even after acquiring basic skills, a person may still not be able to be functioning in an area of his or her choice say, as a doctor, unless the person has enough command over financial resources to pay for the expenses for building his or her capabilities as a doctor. Hence, the capabilities and income are interdependent.

Alleviation of poverty or "unfreedom" provides a person with resources to choose the type of commodities (or functionings) to be involved in, but for a person to have the command over money and other resources, one needs to acquire adequate capabilities which again requires sufficient financial and other resources. Take the example of a boy who comes from an extremely poor family in India but dreams of alleviating his family's economic poverty and of enjoying all good things in life by becoming an engineer, obtaining an engineering job, and earning money. But that person needs money first to pay for his engineering education before he can earn money by exchanging his skill. Thus, to alleviate "unfreedom" and gain freedom one needs freedom first.

Taking this example a bit further, one can see the other difficulties that this person may also experience in securing an appropriate employment after obtaining his engineering degree; hence, he may not be able to enjoy the freedom to do what he wants to do. "Capabilities", therefore, do not automatically translate themselves into "freedom" as some economists may think, first, because capabilities to engage in various functions will have to be acquired initially by improving one's skill and knowledge and,

second, because opportunities will have to be created for utilizing those skills, all of which signify the importance of institutions.

In microeconomic theory, using the Edgeworth box diagram (Mansfield and Yohe, 2004), one can see the need for institutions to ensure that the alteration of the existing allocation of resources between two producers does not take place in such a way that the output of one producer increases above the previous level while the output of the other producer declines below the previous level. In the same way, the box diagram also raises the possibility that the distribution of the same output between two consumers may not be efficient in the absence of some institutions.

9. Sen's Theory of Exchange Entitlement, Endowment, and Poverty

Sen's (1981) theory of exchange entitlement was developed to explain the real reasons behind the occurrence of famine. This theory seeks to explain that it is caused by the absence of the financial capacity of individuals to obtain food, and thereby, the theory seeks to destroy the historically accepted myth that famine is caused by lack of food. More broadly, our decomposition of Sen's theory of exchange entitlement shows that this theory can be very effectively used to explain the process of alleviation of poverty (unfreedom) and empowerment of people and the institutional requirements for this process to work.

10. The Essence of the Theory

The entitlement relationship as proposed by Sen is one kind of ownership relationship which could be obtained by the following four methods: trade-based entitlement, production-based entitlement, own-labor entitlement, and inheritance or transfer entitlement. One person can exchange any of these four entitlements for a bundle of commodities which can be one among the entitlements of that person's endowment. The exchange entitlement mapping or E-Mapping as set out by Sen can help determine whether the exchange entitlement for a person's ownership of certain endowments can provide that person with enough food to enable him or her to prevent starvation. Thus, the key determinants of a person's welfare which, in this theory, connotes alleviation of basic economic poverty, such

as hunger and starvation, are (i) ownership of a natural endowment and (ii) exchange entitlement which can be trade-based, production-based, and inheritance or transfer-based.

So the welfare of a laborer whose natural endowment is only physical strength would depend on whether the person can exchange his or her physical labor, i.e., can obtain employment, and whether the wage that a laborer will earn by exchanging his or her entitlement will be enough to purchase enough food to alleviate hunger and starvation. Therefore, Sen used this theory to explain that the failure of the people to exchange their endowment for food, and not the lack of supply of food, contributed to the starvation and death of more than a million people during the 1942 Famine in Bengal in British India.

Now we can easily use this pioneering theory to highlight the importance of institutions in poverty alleviation and gender empowerment.

11. Decomposition of the Theory of Exchange Entitlement

Let us first assume that there are two men:

Person A.
Person B.

Both had similar natural endowments at birth — a certain level of physical strength and intelligence. But Person A was born in a financially poor family in a village. Person B was born in a financially well-off family in a town in India.

As we can see from Fig. 1.1, two persons with similar natural endowments born in two different family environments in two different places (or even in the same village or town) may acquire different endowment sets and end up with different levels of economic well-being and empowerment. But the validity of this theory seems to be based on the following two implicit assumptions:

(i) The transition of a person from Stage 1 to Stage 5 (Fig. 1.1) is smooth so that Person A even with physical labor as his or her endowment will be able to exchange it for income to obtain the basic food, clothing, and housing for poverty alleviation and survival.

(ii) The transition is smooth for everybody — men and women.

For A	For B
Stage 1 Born with natural endowment, physical labor and some intelligence ↓	Stage 1 Born with natural endowment and some intelligence ↓
Stage 2 Natural endowment retained ↓	Stage 2 Natural endowment transformed into skill-based endowment ↓
Stage 3 Physical labor becomes exchange entitlement ↓	Stage 3 Skill-based endowment becomes exchange entitlement ↓
Stage 4 Endowment exchanged and income or bundle of goods obtained ↓	Stage 4 Endowment exchanged and income or bundle of goods obtained ↓
Stage 5 Poverty alleviated and empowerment facilitated	Stage 5 Poverty alleviated and empowerment facilitated

Figure 1.1: Decomposition of Exchange Entitlement Theory.
Stage 1: Person A and B born with natural endowments.

But in reality, institutional hindrances may prevent the smooth transition of both men and women. For women, the institutional barriers to alleviating poverty and promoting empowerment are far greater than those for men. For Man A, with physical labor as the only endowment, the transition from Stage 3 to 4 may not be automatic due to non-conducive institutions. For example, in the rural sector in India and in other developing countries, in the absence of diversification of agricultural activities and of small-scale labor-intensive manufacturing activities, the scope for employment of manual labor is limited. This scope for employment further diminishes for two reasons. First, due to the rise in wage rate, landholder families increasingly make use of family farm labor in lieu of wage labor. Second, due to the lack of effective implementation of population control measures, the supply of wage labor rises. The lack of diversification of agricultural activities and the absence of small-scale labor-intensive manufacturing activities in villages can be attributed to the failure of economic and political institutions.

Even if it is assumed that jobs are available in agriculture in Man A's village, he may still not be employed by landholder families, if he is born in a *Harijan* (untouchable) or *Chamar* (shoemaker) family because of the social stigma attached to his caste. This kind of social boycott of *harijans* is still prevalent in the southern part of India. Although the Indian Constitution prevents discrimination against any person on the basis of his or her caste, religion, sex, and color, in rural India the customary law (informal institution) supersedes formal law (formal institution).

Furthermore, in India's federal democratic state and under a multi-party system of government, the village-level formal and informal agents of the political party in power at the provincial government may prevent landholder families, by using threats, from employing Man A, if he refuses to pay monthly rent to the political party agents and obey their command. Again, here customary law supersedes the formal law.

In the Bengal Famine of 1942, the overwhelming majority of those who died had the same endowment set as that of Man A in Fig. 1.1 They could not make the transition from Stage 3 to Stage 4 (Fig. 1.1) due to the failure of the political institution (the British Raj) to create adequate jobs by improving economic institutions and political governance. Hence, they died because of the lack of economic means to purchase food.

For man B, transition from Stage 1 to 2 and from Stage 3 to 4 (Fig, 1.1) may also be adversely affected by institutional hindrances. For example, Man B's family may not have enough financial capacity and political connections to get him a place in the skill formation institution of his choice. Alternatively, because of the interference by political leaders, the impartiality of the admission process may be compromised. The transition from Stage 3 to 4 may also be beset with institutional hindrances. For example, Man A may not get the appropriate job in line with his skill and consequently the appropriate income or bundle of goods in commensurate with his qualifications. Therefore, for both Man A and Man B, the extent of their poverty would be lower without institutional hindrances.

We now assume that in Fig. 1.1, both Person A and Person B are women. Institutional barriers to the transition of poor rural women from one stage to another are far greater than those faced by men. For Woman A, the transition from Stage 3 to 4 is more difficult than for men because of gender-based discrimination practised by the society against women although formal laws prohibit such discrimination. For Woman B, the transition from Stage 1 to 2 may not be too difficult, but the young woman even from a financially well-off family may not get the opportunity to

acquire the skill that she wants because her parents may not be willing to undertake adequate investment in her education since the return from such investment will accrue to her future husband and marital home, not to her parents in their old age. Furthermore, the enforcement of the "ideology of seclusion" on Woman B by the society and by her husband (if married) or her parents (if single) may prevent her from leaving her home alone for a distant place to pursue her educational goals. Hence, the education and skills obtained are not the ones that she wanted. As a result, since the value of her acquired endowment set is lowered, her transition process from Stage 3 to 4 becomes more difficult for her. Lower value of endowment fetches for her lower income (an inferior bundle of goods). Therefore, she suffers from deprivation. Also due to gender-based discrimination against women, Woman B's chances of even exchanging her endowment set (or entitlement set) for income are less than for Man B, assuming that both have the same endowment set.

Now with lower than expected income, Woman B's capacity to alleviate her own, or to contribute greatly to the alleviation of her parents' or her marital family's poverty is reduced and thereby her chances of gaining control over her own life (i.e., the attaining of empowerment) are reduced. It is also likely that even after contributing to her family's income, Woman B may not attain empowerment due to the rule of "classic patriarchy". What this means is that the alleviation of economic poverty does not necessarily lead to economic empowerment.

As already stated, Sen's theory of exchange entitlement, endowment, and poverty was developed to explain the causes of poverty and famine. Hence the term "poverty alleviation" in Stage 5 in Fig. 1.1 refers to the alleviation of economic poverty. But in his later works such as *Commodities and Capabilities* (Sen, 1985) and *Inequality Re-examined* (Sen, 1992), he used the term "capabilities" to include economic and other aspects of poverty. In *Development as Freedom* (Sen, 1999) and in *Indian Development and Participation* (with Drèze, 2002) he used the term "freedom" to connote substantive (effective) economic, social, and political freedom of men and women. In India, to help boys and girls to acquire some basic education and skills to improve their endowment set, he has consistently been advocating the need for the state to provide universal primary education to children at the state's expense. While he supports India's democracy, he argues that China's success in achieving high growth rate for more than 2 decades is due to its success in providing basic education, skill, and health care to each child. However, this success

was achieved by a communist state. Also, communes of the communist state were able to weaken the forces of gender-based discrimination on women. Gender-based discrimination is a social informal institution, but in China, the political institution was able to curb the power of this informal institution.

12. Poverty and Gender Empowerment

As already mentioned, according to Sen (1992), poverty is not low well-being, but the inability to pursue well-being because of a lack of economic means. Here, the emphasis is on economic means, which refers to income or assets. But poverty may not always result from a deficiency of economic capabilities such as lack of income or assets. Poverty for a person may also result from the failure of basic capabilities to reach minimally acceptable levels (Sen, 1992), although the person may be financially well-off.

While the emphasis here is on the economic dimension of poverty, there are non-economic dimensions of poverty which include cultural (social) poverty embodied in gender-based discrimination against women, and all other kinds of deprivation of men and women and political poverty. All these types of poverty have been grouped together under the term "unfreedom" by Sen (1992, 2002) implying the lack of freedom of choice or control of one's own life (Todero and Smith, 2006).

The inability of people to freely voice their grievances against their state and their political leaders and to freely express their opinion against any issue for fear of severe punishment is also an important type of deprivation that people in several communist and non-communist autocratic countries suffer from. But people usually do not suffer from such deprivation in a democratic country.

Hence, what is poverty in one situation may not be so in another situation (Sen, 1999). We should note the following important points in connection with the arguments presented above:

(i) The alleviation of economic poverty does not automatically lead to the alleviation of cultural poverty of people, particularly of women.
(ii) Cultural poverty is created by social institutions such as social customs, taboos, rules of "patriarchy" and political poverty by political institutions such as the state and its governance structure.

(iii) To women in many developing countries, the alleviation of cultural poverty may appear more important than the alleviation of economic poverty for attaining substantive freedom.

(iv) But the alleviation of economic poverty provides women with some economic independence which is crucial for their fight against cultural unfreedom, including deprivation, voicelessness and helplessness. What is needed first is making women economically independent.

With this discussion of the conceptual and theoretical issues relating to development and gender empowerment, in Chapter 2 we turn to the discussion of dimensions of poverty and factors hampering women's empowerment.

References

Boeke, JH (1953). *Economics and Economic Policy of Dual Societies*. New York: Harper and Row.

Drèze, J and Sen, AK (2002). *India-Development and Participation*. New Delhi: Oxford University Press.

Gandhi, MK (16 November 1934). *Harijan*, Ahmedabad, India.

Gandhi, MK (November 10, 1946). *Harijan*, Ahmedabad, India.

Higgins, B (1968). *Economic Development: Problems, Principles and Policies*. New York: Norton.

Kamenka, E (1972). *The Ethical Foundation of Marxism*. London and Boston: Routledge and Keegan Paul.

Lewis, WA (1955). *The Theory of Economic Growth*. Homewood Ill: Irwin, p. 9.

Mansfield, E and Yohe, G (2004). *Microeconomics*. New York: Norton.

Roy, KC (1979). The Fundamental Aim of Economic Policy: A Choice Between Alternatives. In *Proceedings of the First International Symposium on Asian Studies*. Hongkong: Asian Research Service.

Roy, KC (1986). *Foreign Aid and Indian Development — A Study from the View Point of Peace and Development*. Ahmedabad: Gujarat Vidyapith.

Schumacher, EF (1962). *Roots of Economic Growth*. Benanas: Gandhian Institution of Studies.

Seers, D (1969). The Meaning of Development. *International Development Review*, 11 (December), 3–4.

Sen, AK (1981). *Poverty and Famines: An Essay on Entitlement and Deprivation*. Oxford: Clarendon Press.

Sen, AK (1985). *Commodities and Capabilities*. Amsterdam: Elsevier.

Sen, AK (1992). *Inequality Re-examined*. Cambridge, MA: Harvard University Press.

Sen, AK (1999). *Development as Freedom.* New York: Knof.

Sen, AK (1999). *Development as Freedom.* Oxford: Oxford University Press.

Sugden, R (1993). Welfare, Resources and Capabilities: A Review of Inequality Re-examined by Amartya Sen. *Journal of Economic Literature,* 31, 1947–1962.

Todaro, MP and Smith, SC (2006). *Economic Development.* Essex, UK: Pearson Education.

World Bank (1990). *World Development Report.* New York: Oxford University Press.

World Bank (1991). *World Development Report.* New York: Oxford University Press.

Chapter 2

Dimensions of Poverty and Discrimination Against Women

Kartik C. Roy,* Hans C. Blomqvist and Cal Clark

1. Introduction

Economic poverty results from the lack of income and assets to attain basic necessities such as food, shelter, clothing, and acceptable levels of health and education. These assets include (i) human assets such as the capacity of a person for basic labor skill and good health, (ii) physical assets and access to infrastructure, (iii) natural assets such as land, environment, and ecology, (iv) social assets such as a network of contracts and reciprocal obligations that can be called on in time of need, and (v) political assets which can be used to exercise influence over resources.

2. Access and Returns to Markets

To utilize one's assets to earn income, one needs to access markets. But access to markets does not automatically ensure returns to the use of assets. Returns to assets depend on access to markets as well as on all the global, national, and local influences on returns in these markets.

However, apart from the behavior of markets, the returns also depend more importantly on the performance of the institutions of state and society (World Bank, 2001) i.e., on formal and informal institutions as we have already illustrated in Fig. 1.1 in Chapter 1.

The ownership of and returns to assets are determined by not only economic forces but also by political, social, and legal institutions. The access

* Corresponding author.

of people to economic assets such as land or houses through inheritance or purchase depends on the legal structure that defines and enforces private property rights or in the case of tribal people, on customary norms that define common property resources. But compared with men, the access of women to all assets is likely to be made more difficult because of the implicit or explicit discrimination against them by the society and the state on the basis of their gender, ethnicity, or of caste and social status. The discrimination against women on such grounds takes place because of non-conducive social or cultural institutions. Hence, investigating formal institutions may not result in the whole truth about the situation of women.

3. To Cope with Vulnerability

To help poor people cope with vulnerability to economic and social risks, it is necessary to reduce the magnitude of vulnerability to such risks. The failure of monsoon or a large-scale pest attack or low farm gate prices may ruin the lives of poor landholder families as well as landless laborers whose survival depends on employment in farms. Many poor landholder family members in the south-eastern part of India committed suicide during 2004 due to rising cost of agricultural inputs which could not be met by poor returns. While the men committed suicide, the women members of affected families faced a very uncertain future.

In such cases, if a temporary rescue package in both cash and kind was made available to farmers by the State through its institutions (banks) and implemented effectively and honestly by the State's administrative apparatus, these deaths would have been avoided and the magnitude of vulnerability to risk of female members of the affected families in southeast India would have been reduced.

Apart from (i) the sudden death of the male earning member in a family, where due to the ideology of seclusion, women remain within the confines of their homes and therefore cannot utilize their capabilities, other cause of vulnerability to risk may include (ii) sudden sickness of the main earning member of a poor family which causes abrupt interruption to the flow of income to the family which also has to incur, for the treatment of the sick member, substantial expenses which the family can ill afford, as it has very little savings; (iii) wedding of a female member of a family such as daughter, sister, or granddaughter which requires a large sum

of money to pay for dowry, a lavish feast, and for other entertainments;[1] (iv) widowhood which may prevent even a young woman from utilizing her capabilities to achieve some happiness in life because of the social taboos attached with her social status as a widow; (v) risk of systematic oppression of a woman within and outside her family; and (vi) routine oppression of members of a family who in exercising their freedom of opinion openly defy the dictates of the informal agents (mafias) of the political party in power in both democratic and autocratic states.

The vulnerability to risks in all the situations described above is far greater for women than for men. When the risk of repeated occurrence of an adverse economic or social condition is minimal such as a cyclone, then poor men or women can try to cope with it, but when the risk of being confronted with repeated occurrences of an adverse situation is quite high then the vulnerability of a woman to such a risk may rise to the point where she becomes powerless, helpless, and voiceless.[2]

Such situations as we have described above occur because of the absence of Nee's (1998) close coupling of state (formal) institutions and social (informal) institutions.

In the first two situations, there were no adequate state institutions to deal with the problems that the families were confronted with. Also, there were no social (informal) institutions such as networks and community support for these affected families.

But in the other four situations, while the state law disallows many of the practices, the social customs support such practices. Hence, here the customary law supersedes the formal state laws — a clear case of Nee's non-congruence of formal and informal institutions.

The situations that we have analyzed above represent cases of economic, social (cultural), and political poverty which Sen calls "unfreedom".

[1] In many cases, the bride's parents are forced to sell their only block of agricultural land to pay for wedding expenses knowing full well that after the wedding they will face an extremely uncertain future. The marriage ceremony and dowry are social customs; hence, social institutions are widely practised throughout the Indian sub-continent right across all religions and in South East Asian countries such as Indonesia.

[2] For example, in a poor family, a woman who is tortured by her in-laws and/or by her husband routinely every night may begin to accept that such a torture and her loss of dignity have been pre-ordained for her; and consequently she becomes powerless, helpless, and voiceless. The alternative to the acceptance of such torture is committing suicide. In fact, many women do accept the alternative of committing suicide in South Asia.

In fact, public institutions can reduce the level of risk and vulnerability of the "poor" in general and of women in particular. For that to happen, it is necessary for public institutions to work well in the interests of women and the poor. Therefore, the state action which expands opportunities for women to fully utilize their capabilities is a very important source of empowerment in a deep and intrinsic sense (World Bank, 2001).

The "capabilities" mentioned above become "substantive freedom" in the works of Sen (1985, 1992, 1999). Drèze and Sen (2002), and Rodrik (2003). The elimination of "unfreedom" becomes therefore, the most fundamental precondition for gender empowerment.

4. Gender Empowerment: Discrimination Against Women

The term "gender" refers to a class usually masculine, feminine, common or neutral into which nouns and pronouns are placed. It represents the state of being male or female with references to social or cultural differences. In biological sense, it owes its origin to a sequence of DNA forming part of a chromosome, by which offsprings inherit characteristics from a parent. Women have been identified with "nature and environment" which provide the resources for the continuity of life whereas men throughout the history of civilization, have fought against nature (Roy *et al.*, 1996; Siva, 1992). By "gender" we specifically refer to women in this book. The term gender empowerment therefore, in the current context refers to arming or endowing a woman with instruments (power and authority) to take control of her own life.

Discrimination against women by the society outside their homes is also combined with intra-family discrimination against woman and girls in the allocation of food, provision for education, health, and so on. Dasgupta (1993) argues that government policies directed to address the problem of resource allocation among households or families fail to address the problem of intra-family allocation of resources which is the major source of intra-personal inequality. Accordingly, the higher infant mortality rates and other age-specific death rates for females — relative to males in India, China and the Middle East indicate a substantive anti-female bias in nutrition and health care. Consequently, the lower survival rates of girls than those of boys contributes to lower rates of return to females relative to male labor (Rosenzweiq and Schultz, 1982).

The force of patriarchal authority which severely curtailed women's freedom within and outside their homes in the pre-colonial period in Asia and Africa may have lessened somewhat in the last 2 decades of the 20th century, but has not completely died down. In tribal societies where matriarch's rule prevails, women can play some defined economic roles and are endowed with limited authority.[3] However, the total number of such women is small.

In less developed countries, the average wage received by a female laborer is generally considerably less than that received by a male laborer. Although women play the pivotal role in keeping the rural sector alive, they obtain little benefit from the modern sector of the economy. Lack of opportunities to earn a reasonable income forces men from villages to move to the urban center to secure employment with better wages, leaving behind their women in their village home to take care of all responsibilities for providing sustenance to other members of the family. They work at small farms at very low wages and also perform all household chores. This custom is widely prevalent in the rural sector in Africa, Latin America, and in some scheduled caste and tribal communities in rural South Asia.

Women's workloads are heavy as a result of child-bearing, carrying water, collecting wood, increased weeding from new crop varieties, and other farm tasks due to growing population pressures (Nafziger, 1997; Agarwal, 1989, 1994; Chen, 1989; Roy and Tisdell, 1992, 1993, 1996; Roy, 2001). Moreover, in Africa, when technological innovations increase the productivity in cash crops, men frequently divert hectarage to cash crops from women's food crops (Nafziger, 1997). In South Asia, a different picture emerges. The partial mechanization of India's agricultural production process under technological change helped male laborers because the machines that were developed were not simple handheld and light weight which would have been appropriate for women. Hence, a vast number of women were thrown out of their traditional domain of work in agriculture (Roy, 1994). In Africa, women as a rule receive lower returns

[3] Women in northeast Indian tribal societies enjoy considerable freedom in their interaction with other members of the society outside their homes and also hold some power within the family. Interestingly, among Khasia tribes the youngest daughter of parents becomes the rightful owner of the family's entire wealth and assumes the role of the matriarch.

to training and education because of discrimination, withdrawal from labor force, and having to live in the same place as their husbands. In South Asia the situation is slightly different. Women who work in the public sector receive the same wage as men. But those women who are working in private manufacturing and service industries in the informal sector tend to receive lower wages than men. Also in both Africa and South Asia women tend to shoulder most of the responsibility for cooking, cleaning, laundry, and other housework while male workers usually do not tend to perform any household task (Parpart, 1986).

However, in rural and urban South Asia, millions of women belonging to upper caste families do not work in the agricultural field or in other areas for wages but continue to perform all household duties for which they receive no monetary reward. For the value of women's work to be recognized and appreciated by their families, such work must be socially visible and consequently socially recognized (Agarwal, 1989; Roy and Tisdell, 1996). However, since household duties are not socially visible, they are therefore not socially recognized and accordingly not recognized and not duly appreciated by their husbands and other members of their families. While these women in upper caste families, which have income well above the poverty line income level, usually tend to have some education and may not be subjected to the same degree of intra-family discrimination in the allocation of foods and other necessities vis-a-vis men in urban India as those in rural India, there also seems to be a passive acceptance by all of them of their inferior status as pre-ordained and accordingly their lack of freedom under the "ideology of seclusion" as quite justified.[4]

If these women are happy with their current social and economic status under the rules of patriarchy, within and outside the confines of their homes, and since the objective of life is happy living, then one may argue that there is no need for any action to change their current socio-economic status. Being happy, they are also free because happiness is equated with freedom (Sen, 1999; Narayan, 1962; Roy, 1986). However, we fail to accept this argument for the following reasons:

Sometimes extremely poor people can have the disposition that make them feel happy and contented mainly because they are unaware of any other social and economic condition better than they currently are in. This

[4] Such an opinion was expressed by many women of relatively well-off families to K.C. Roy during his fieldwork in Midnapore town in rural West Bengal, India in 1992.

state of mental condition can be termed poverty absorption capacity or PAC. In economic terms, the larger the gap between the national poverty line income and a person's own below poverty line income, the higher the PAC.

Following this argument we can say that the PAC of these women in the socio-cultural sphere is very high. The empowerment of these women who are not suffering from hunger and starvation can be facilitated by reducing the level of their cultural PAC.

5. Dowry and Women's Bargaining Power

One of the most important reasons for passive acceptance by these upper caste women of their inferior status within their families is their lack of wage income which significantly weakens their bargaining power. But the overwhelming majority of these married women come to their marital homes with dowry — which is a kind of non-labor income. Therefore, does dowry have any effect on women's bargaining power in household decisions?

6. Theories of Household Economy

The traditional view of the household is that it is an optimizing agent. But economists are increasingly questioning the way in which the decisions are carried out within the household. While most agree that the decision is made by one individual who represents the claims of all members of the household, the consensus theory or unitary model promoted by Becker (1973, 1974, 1991) is based on the notion of an altruistic dictator who is acknowledged as the decision maker. On the other hand, the other model is the collective or Nash-bargaining models of McElroy and Horney (1981). Manser and Brown (1980), and Chiappori (1988, 1992) recognize the possibility of the existence of conflicting individual preferences among family members, and of each member trying to bargain more family resources for his or her own utility maximization using some threats. In the Nash-bargaining model, the strength of the threat or bargain increases with the availability of some fall-back or threat point utility coming from the ownership of individual-specific resources. The common resource which women can use is the divorce threat.

Bargaining models often define individuals' threat point in terms of their market earnings or individual assets. But a person's bargaining power is greatly affected by political, social, and legal institutional parameters that determine how household recourses are allocated and that define enforceable claims such as child support in individual income flows. The adverse impact of institutions on bargaining capacity can be more severe on women than on men. The implicit recognition of these institutional hindrances can be found in Sen's (1981) exchange entitlement theory which we have decomposed and presented in Fig. 1.1 in Chapter 1. Sen (1990). in his later work, however, has illustrated how social structures can affect an individual's bargaining position. McElroy and Horney (1981) argued that extra environmental parameters such as property rights in land would produce a far greater impact than the wage and non-market goods on the bargaining power of a person.

This view has been reinforced by Agarwal (1994) who made "land rights" the centerpiece of her analysis of inheritance patterns in determining bargaining positions. However, in the case of a woman, property rights do not *ipso facto* ensure her access to the properties to which she has legal rights because she needs the support of political institutions, customary rights (informal institutions), and legal institutions to effectively use her land right as the threat point in her bargaining power in the household decisions whether she lives in her natal or marital home. Recent literature on this issue of household bargaining power stresses the need for conducive institutions or extra-household environmental parameters to enable specific individuals to earn reasonable income to support himself or herself in the event of household dissolution. When women control more non-earned income, indicators of child development improve by a greater amount then when men control these resources, holding constant the total consumption expenditure within the family budget.

The empirical regularity of this phenomenon therefore strongly suggests that the pooling of family resources brings out less than perfect outcomes for female workers (Fortin and Lacroix, 1997). Recent studies (Blundell *et al.*, 1785) have rejected the implications of Becker's unitary model and found evidence to support the collective model. While wages seem to have a strong influence on the bargaining power among the couple, there is considerable evidence to support the view that the distribution of resources is unequal within the household in many developing countries (Schultz, 1995, 2002). The existence of laws banning discrimination against women in the matter of employment (e.g., in selection process,

wages, and working hours) and upholding women's right to exercise their inheritance right to parents' land and so on increases women's utility outside their homes and, hence, increases their bargaining strengths and threat point utility and thereby, their share in the resource allocation.

While a woman's bargaining power within the household resource allocation mechanism is a crucial element in that women's pursuit of empowerment, the literature recognises that without conducive extra-household environmental parameters, it would be difficult for her to use her bargaining power effectively although she may be bringing in wage income to the family.

What effect then would a woman's non-wage income have on her bargaining power in a collective household setting? To answer this question we now turn to the discussion of pre-marital investment on women and dowry within the general setting of the institution of marriage.

7. The Institution of Marriage

Economic literature suggests that marriage occurs if the perceived value of marriage exceeds that of the alternative. Under Becker's (1973) model, a woman's gain is subserved in and increases the next family's income. But after that how much the wife gains depends on how much her family's altruist cares for her. Becker (1973, 1974) was the first to apply rational choice and market models to the analysis of marriage. Becker pointed out that marriage market conditions influence the well-being of each spouse, with possible implications for consumption patterns. Since then many studies have found that marriage positively influences various measures of well-being, market labor supply, and earnings of both women and men. Becker (1991) mentioned the possibility of productivity gains resulting from marriage through a household division of labor and specialization. Thus, a wife, who comes from a poor family and consequently without any pre-marital investment in her education, can in her marital home specialize in home capital (i.e., concentrate on household chores); and the husband with premarital investment in education specialize in market capital (i.e., concentrate on market-determined work). Thereby, both increase their productivity in their specialized areas, and the entire family gains from marriage. Thus, it can be argued that the bargaining power which is endogenously determined is influenced by exogenous pre-marital investments.

But as we have already commented, in millions of poor households in the developing world, pre-marital investment in education is negligible, especially for women. Hence, in the absence of education, other independent sources of income, adequate legislation or community support, and with the lack of knowledge of avenues for strengthening their bargaining instruments, women in millions of households in the developing world have no control over their bargaining power and do not indicate any preference in the matter of intra-household resource allocation. Their voicelessness can be due to their total submission to the rule of classic patriarchy under which the dominant males would have the right to exercise threat power.

In absence of or along with the pre-marital education, the other non-labor wealth that a women can bring to her marital home is dowry.

8. The Institution of Dowry

The "dowry" is one of the most pernicious institutionalized forms of discrimination against women. It represents a composite wealth in both cash and kind with pure gold (22 carat) jewellery occupying the pride of place among all items. It travels from a bride's natal home to her marital home after her marriage. The practice of dowry is widely prevalent mainly in all South Asian countries, as well as for example, in Indonesia, in the Indian community in South Africa, Mauritius, Malaysia, Singapore, and Fiji. Because the total number of women affected by dowry runs into hundreds of millions, paying for the cost of dowry and the wedding ceremony forces millions of parents and brothers of brides to incur heavy debts and often to sell their only assets, including land. Moreover, because, instead of facilitating women's empowerment, it may disempower women, the dowry assumes crucial importance in an analysis of women's empowerment.

9. Reasons for Dowry-Giving

The origin of dowry in India goes back to a period between the 3rd and 2nd millennium BC during the Aryan rule. Although the reasons were not known, both marriage for love and for money were in vogue and women under the law had to live under the control of men (Majumdar *et al.*, 1991).

In the later Vedic period (from 1500 to 1000 BC approximately) women's status in the family and society deteriorated. Daughters were regarded as a source of misery. Married women of upper class had to suffer the presence of rival wives. Women could not attend any tribal council nor could they take an inheritance. Toward the end of this Vedic period, rules of marriage became more rigid and child marriage was allowed.

In India, since the pre-colonial days, dowry-giving had been identified with the existence of "hypergamy" under which dowry was a form of a "travel pass" for a bride from a lower caste family to an upper caste groom family (Roy and Tisdell, 1996; Fennell, 1999). It is argued that both dowry and hypergamy which reflect status asymmetry between husband and wife are tied to an upper caste ideology which entailed the seclusion of women, their exclusion from productive work, and their categorization as an economic burden (Parlwala, 1989). However, dowry is now the most vital part of all marriages, including those between the same castes, even those between a man and women of different religions and those between a man and woman of asset-less parents. However, for some asset-holder parents, dowry can be seen as a payment to the daughter as she leaves her natal home of an amount equivalent to the value of the son's inheritance.

Fennell (1999) rightly argues that such a seemingly odd behavior of assetless households is seen as a consequent to religions and other social and cultural reasons which are specifically reflected as emulation of customs of the upper class asset-holding echelons of the society and of the presence in these asset-less households of male preference. The existence of male preference is a social representation of greater value derived from men being inheritors of property. Hence, lesser value is attached to women partly because of their lower bargaining position. Hence, asset-less parents also offer a dowry to their daughter to compensate her for her lack of access to her parent's property.

Although we accept this argument of Fennell, it is a fact that all parents genuinely feel very unhappy when their daughter leaves her natal home after her wedding. Hence, dowry payment is a way of trying to make their daughter leave her natal home happily.

If it is accepted that male preference operates in the society and that in asset-holding households, there is an added dimension of inequality rising from the differential access to inheritance. One can reason, therefore, that the bargaining strength of individual members stems

not from the economic but from the social position of these members (Fennell, 1999).

It therefore follows that women with socially perceived inferior status vis-à-vis men have extremely weak bargaining strength vis-à-vis men in the household decision-making process. Hence, it is of considerable doubt that dowry can enhance the bride's bargaining power. In fact, the dowry has a total utility function which satisfies the consumption needs of the groom's family members. The bride's control over the dowry, in a large number of cases, is negligible because the dowry dehumanises her and transforms her into a "commodity". The bride becomes her own dowry (Roy and Tisdell, 1996). Following from the above discussion, one can regard the dowry payment as a fee paid to the groom's family by the bride's parents for the safe-keeping of their daughter. This is like a fee paid to one's bank for the safe-keeping of one's jewellery. Under the extended dowry system (Kishwar, 1987). the bride's parents are forced to comply with the ever-increasing demands of the groom's family members, through the life of their daughter's marriage.

In many cases, the bride commits suicide and in many other cases the bride is murdered by her in-laws and sometimes by in-laws in connivance with her husband. Hence, dowry greatly increases the bride's economic and cultural poverty or unfreedom and, accordingly, acts as one of the most powerful impediment to women's empowerment. We will discuss in more detail, the case of dowry in Chapter 3.

10. Women's Reproductive Decision

In most households, income levels determine the nature of trade-off between production and reproduction decisions. When the household needs to alter the pre-existing allocation of work among members or method of production, the decision depends on how the new allocation will affect the productive and reproduction outcomes of the household. In the short run, if the household needs greater production for meeting the household's economic survival needs, then the reproductive option will have to be placed on the back burner. In the long run, however, as the household's income and asset level rise through production and potential for inheritance also rises, the household reviews the reproductive decisions. If the need for a male child to carry forward the family name

becomes more important than keeping a female member engaged in production area, then the household agent will reduce that woman's workload in the production so that she can devote more time in the reproduction area. While the reproductive decisions are taken in this way in rich families in which the need for a woman's engagement in production area is marginal (Kabeer and Subramanian, 1996), it is important to note here that in Kabeer, Subramanian, and Fennell's analysis of the process of reproductive decision-making of the household, the household agent plays the key role. This household agent is obviously a man and not the woman who as the would-be conceiver of a child should be the main player in the decision-making process. Although among young and educated couples, the reproductive decision is usually taken jointly by both husband and wife, in the overwhelming majority of cases, where the rules of patriarchy prevail, the male member plays the key role in the reproduction decision.

This male dominance, for example, is one of the most important reasons for millions of missing women and female children in India. Drèze and Sen (1989) placed the number of missing women and girls in India in 1986 at almost 40 million. Our own estimate points to a figure of 35.5 million missing women and girls in India in 2003. If women in the household had the ultimate power in the reproductive decision-making, women would not have liked to see their children suffer from lack of food and from malnutrition and would not have aborted a female foetus.

Leibenstein's (1974) model of the marginal child, explains the process of arriving at a decision regarding reproduction. It explains why the marginal cost or disutility of an extra child increases and why the utility or marginal return from that extra child diminishes. Parents compare the marginal cost with the marginal utility of an extra child to make a decision about an extra child. While Leibenstein did not make any distinction between the marginal cost of a marginal female child and a marginal male child, in India and other countries in South Asia under patriarchy, the strong preference for a male child combined with the social perception of a girl child being a burden on the parents constitute the two additional factors which help explain the reasons for the missing women and children.

In China, the reproduction decision was taken away from the parent and placed in the hands of local officials. Thus, in India and other developing countries, women lack freedom in reproductive decisions. This is an extreme form of cultural unfreedom that millions of women suffer from.

11. Education, Health, and Employment

11.1. *Education*

Women's engagement in socially visible and socially recognized income-earning employment is crucial to alleviate their economic poverty and to gain economic and social (cultural) freedom to take control of their own lives both within and outside their homes. While there is no guarantee that women's income from employment will give them the economic and cultural freedom they deserve, without income women's chances of gaining empowerment will be greatly minimized in both the urban and rural sectors in most developing countries. Interestingly, even in societies where rules of the matriarchy prevail, the female member of families generally enjoy the freedom to go out of their home to earn cash income or collect non-market goods (indirect income) but after completing their work, once they enter the household domain, their lives come under the control of the matriarch or patriarch whoever heads the household; and they lose their control over their own income.[5]

But women require education and good health to have the capability to find and engage in paid employment. In our decomposition of Sen's exchange entitlement theory in Fig. 1.1 in Chapter 1, we have shown that the improvement in a person's natural endowment at birth would require basic education and skill-based education. But this basic education and basic health care right will have to be provided by the state to every child in the country without any discrimination against girls. Women's education is a matter in its own right, but it is also closely associated with child mortality. The under-5 mortality rate is significantly higher for children of illiterate mothers than for children whose mothers have completed middle school in many developing countries.

Apart from being less prone to malnutrition, better educated mothers are more likely to use basic health services, marry late, have fewer children at an older age and more likely to space their births, all of which are positively associated with child survival (UNDP, 2005). Throughout the developing world, the gender gap in primary and secondary schooling is closing but women still lag behind men in many countries in Africa and South Asia. While women have made significant gains in higher education enrollment in most regions of the world, two-thirds of the

[5] This was revealed to K.C. Roy by female respondents during his extensive field work in Santal Villages in one tribal belt in rural Bengal in India in January 2001.

world's 876 million illiterates are women (UN, 2000). Almost a third of the world's women live in Southern Asia and sub-Saharan Africa, where the gender gap in enrollment continues to remain wide.

Girls are more likely than boys to suffer from limited access to education in rural areas. School attendance in poorer countries is considerably lower in rural areas than in urban areas due among other things to (i) unequal allocation of services, personnel, and funds between urban and rural areas by the state; (ii) higher demands on girls' time by the household for working in the family farm or performing household duties; (iii) the poor quality of school facilities; and (iv) the widespread enforcement on adolescent and mature age girls of the "ideology of seclusion" which prevents girls from traveling to schools located at some distance from their homes. This last factor also prevents mature girls, who have completed their secondary education at schools located nearby their homes, from obtaining higher education in their chosen field at institutions located at a considerable distance from their homes. Hence, the education these girls obtain is one that their patriarchs or matriarchs impose on them and not the education in their chosen fields (Roy *et al.*, 2001). As a result, they continue to suffer from "unfreedom" in education.

Although access to higher education in most parts of the world has improved, women still cannot access the fields of study traditionally dominated by men because of gender-based stereotypes — a reflection of patriarchic culture. Consequently, role models that could lead young women to challenging and better paid careers are scarce. Derived from the same culture, the traditional view that women should engage in activities that are suitable to their roles as mothers and caregivers discourages women from enrolling in fields traditionally occupied by men.

The number of women teachers in primary and secondary education level is rising in developing countries. But women account for a lower percentage of teachers at the higher education level than at the lower education level (primary and secondary).

11.2. *Health*

Although due to innate genetic and biological differences between the sexes, women are expected to live longer than men, the longevity of each woman is related to the socio-economic and cultural factors that affect nutrition, lifestyle, access to health services, and overall health risks that she faces throughout her life.

While infant mortality is expected to be lower for girls than for boys between ages 1 and 5, discriminatory nutritional and health care practices against the girl child after the age of 5 due to cultural and behavioral factors (which are institutional) offset the biological advantage, resulting in excess mortality among girls. Such discriminatory practices have been widely prevalent in North Africa, West, Central, and East Asia, including China and Korea (UN, 2000).

Women's access to health care during pregnancy is almost universal in developed regions, but in developing countries 35 percent of all pregnant women (more than 45 million) receive no care at all. In South Asia no more than 50 percent of all pregnant women receive pre-natal care; this figure is especially low in Afghanistan and Nepal at 8 and 15 percent respectively.

A woman may receive pre-natal care but may not have a trained health attendant during the delivery process. Since a woman's risk of dying from causes related to pregnancy is determined by the number of pregnancies that a woman has, her freedom in determining the number and spacing of her children and the services needed to pass safely through pregnancy and childhood (UN, 1994) are very important.

Gender roles and relations tend to affect women's more than men's exposure to tropical diseases and infections and accordingly tend to influence access to health care and prevention programs.

Women's limited access to health services has been associated with their restricted mobility, lower level of education, lack of financial independence, and limited access to information and transportation. Also due to the enforcement of the "ideology of seclusion", women have to seek permission from their husbands and/or family heads to travel to a health care center, but this permission is mostly refused in rural families in developing countries. Women affected by leprosy and filariasis may not seek any medical attention for fear of the condition being leaked to the community which would make them social outcasts. Hence, a significant proportion of women's suffering is due to non-conducive social institutions.

11.3. *Employment*

Without paid employment of some kind, women cannot earn income; and without income, it is difficult for women to gain economic independence. But poor women in developing counties usually lack human capital such as education, training, or skill formation. These women also have a very

low stock of physical capital, such as ownership of land and machines, and concomitantly very low access to other inputs. Even if some of them have small plots of land and a little physical capital, they cannot improve their economic condition because transfer of technology to those who are illiterate or have very little education is difficult. Furthermore, even if we assume that poor women have some education, they are not able to utilize their human and physical qualities properly, because of gender-based discrimination against them. In Fig. 2.1 we have listed the domain of women's work in both rural and urban sectors in developing countries.

In developing countries in Asia and Africa, since the vast majority of the population live in rural areas, millions of women in poor landless families work as laborers in farms of landholder families. But these women also face competition from landless male labor and farming family labor. Furthermore, the demand for labor in agriculture still remains quite seasonal in South Asia and in parts of Southeast Asia. Hence, while the chances of poor landless women earning income from employment in agriculture have diminished in the rural sector work in family farms while their husbands migrate to towns to work and to earn income. Even though these women work in family farms and take care of all family responsibility, they usually have no control over the income of their husbands. In certain tribal areas in South Asia, the income that women earn is in many cases spent on alcohol by their men, but the women are also beaten up by their men. Millions of women in poor families who fail to obtain paid employment in agricultural farms spend a considerable amount of time collecting non-market goods such as fuel, food, fodder, thatching materials, and fish from the fast disappearing common property resources (CPR); and many others work as servants and maids for well-off families.

As illustrated in Fig. 2.1 women are employed in services in both rural and urban areas. In almost all developing countries, educated as well as illiterate women by and large accept employment in services sector jobs which are associated with stereotypes about women. In South Asia, however, millions of women do not engage themselves in socially visible employment outside the confines of their homes due to the enforcement of the rules of patriarchy; and many who previously were employed withdraw from market-recognized employment as their families' economic condition improves.

Discrimination against women in employment on the basis of their gender is still present in many countries. Gender-based horizontal and

A. Unorganized and Informal Sector of which:

(i) Rural
 Agriculture: Working as landless laborer; Collecting non-market goods; Working on family farm.
 Industry: Simple manufacturing by simple tools.
 Services: Working as housemaids and in other activities, including self-employment.

(ii) Urban
 Industry: All small-scale manufacturing and maintenance works.
 Services: Teaching; Nursing and working in postal services; banks, government offices, etc.

B. Organised and Formal Sector of which:

(iii) Rural Private
 Agriculture: Plantation.
 Industry: Small-scale industries.
 Services: All kinds, including jobs in schools, petty trading, and working as housemaids, etc.

(iv) Rural Public
 Agriculture: Plantation.
 Industry: Small-scale industry.
 Services: Schools; all trading activities; banks; health centers, etc.

(v) Urban Private
 Industry: Private companies and enterprises; small-scale manufacturing, etc.
 Services: All kinds, including those in government offices.

(vi) Urban Public
 Services: All government offices, schools, colleges, universities, banks, hospitals, etc.
 Industry: Public enterprises.

Figure 2.1: Women's employment in developing countries by sector and type.

vertical segregation of occupations adversely affect women more than men because typically female occupations are relatively lowly paid, have little occupational security and have little authority or career opportunities. Women account for less than 30 percent of the administrative and managerial force in all regions of the world. Despite the acceptance of the principle of equal pay for work of equal value by all countries, in most countries women earn considerably less than men (UN, 2000). Also the vast number of employed women, who are in casual jobs to effectively manage their household chores, receive wages or salaries that are not always adequate to provide them enough economic power to facilitate their empowerment.

Furthermore, one has to note that while it is most essential for a woman to have some kind of employment to acquire a bundle of goods (Sen, 1981) to alleviate economic poverty, this kind of employment and bundle of goods may not facilitate her empowerment if the status of her current employment (quality of work and pay) is inferior to the one which her endowment set could command. In such a situation, the woman receives lower pay than she deserves and remains unhappy. Also, lower pay weakens her economic power in her dealings with the other members of her family.

In another case, a woman whose current employment is commensurate with her endowment set may still remain unhappy if she wanted to acquire an endowment set superior to the one she currently possesses but is prevented from doing so by the lack of her family's investment in her education and skill formation. Here, the women has exchanged her entitlement and obtained a bundle of goods but still remains under cultural unfreedom. A case in point is the relative shares of women and men in primary teachers' jobs in various regions of the world. The share of women varied from an average of 87 percent in Eastern Europe to 47 percent in South Asia between 1994 and 1996 (UN, 2000).

11.4. *Vulnerability of female labor*

The overwhelming majority of female workers in developing countries are in the low-skilled services sector and agriculture which are low paid. In the industrializing Asian countries, young women in assembling and production line work have been socially and economically oppressed

for so long that they have low "aspiration wages" and low "efficiency wages".[6] They are willing to work for low wages for long work weeks, do not make any agitation about their low wages and do not usually join unions. But after their productivity declines, they are replaced by new cohorts (Standing, 1989). In these export-orientated countries, the female share of non-agricultural production has grown.

Women comprising a disproportionately large number of employees of small-scale enterprises in the unregulated informal sector in developing countries are unpaid or considerably underpaid. Furthermore, since the risk of bankruptcy of these small units is quite high, these female employees' vulnerability to bankruptcy and impoverishment are quite high as well.

Much of these production activities are carried out in the informal economy which lies outside the scope of state regulation and hence does not operate according to the rules and regulations officially prescribed. In the mid-1990s in India, the unregistered workers in manufacturing and service activities in the informal sector accounted for 96 percent of the total labor force in the country comprising of 390 million people (Harris-White, 2004).

Most of the Indian workforce has no formal written contracts with their employees. Their livelihood comes from casual or wage labor (30 percent) and from self-employment and trade (56 percent). Here, the vulnerability of workers who work in these areas to the risk of losing their livelihood is very high. Women are also vulnerable to sexual exploitation in service-orientated work such as housemaids and cooks in middle-class and other well-off families. Apart from the work in domestic sphere, women's work is heavily concentrated in rural sites and in agricultural work, on casual contracts, and at wages bordering on starvation — on average only 70 percent of the wages paid to men (Ghose, 1994).

Apart from their systematic oppression in most cultures, women are also vulnerable to physical injuries and assault by virtue of their social status[7]

[6] The aspiration wage is the base minimum wage without which a person would not accept employment; and the efficiency wage is the wage at which the worker would work at his or her most efficient level. Hence, this wage includes the minimum supply cost of labor and the supplier's surplus.

[7] In villages in Bihar, which is India's most backward province and where caste determines family's social status, social relations, and political and economic powers, women of *Chamar* (Gandhi's *Harijan*) families are systematically raped, and after that publicly humiliated by men of upper caste families as a punishment for a crime which these men manufacture to socially justify the course of action that they have taken.

and the nature of the job. In Thailand, for example, thousands of young village girls who flock to Bangkok to work as prostitutes often in nefarious conditions (Phongpaichit, 1982) also tend to suffer from physical assault.

Thus, the vulnerability of women to various shocks can arise from the type of employment they are engaged in as well as from their social status.

When women become highly vulnerable to various risks such as losing employment, sexual exploitation in the workplace, violence at home or outside the home, they tend to become voiceless and helpless. Therefore, for women, employment conditions, vulnerability to risk and voicelessness are interlinked. Women, can never be empowered unless these issues are adequately addressed by the state and the society.

12. Ownership of Property

Ownership right to land through inheritance from father or husband enables a woman to work the property to earn income to try to alleviate economic and social poverty (Agarwal, 1994). In many developing countries, women's inheritance rights are not recognized by law, but in many others, they are recognized. Although women's inheritance rights to land is accepted by law, in most countries that right also has to be certified by the customary law, i.e., a woman also has to establish the customary right or user right to the land (Agarwal, 1989; Roy, 1994; Roy and Tisdell, 1993, 1996). In societies where the rules of patriarchy govern the lives of women, the customary right may supersede the legal right; and the woman may fail to make use of the land. Here, the legal right (formal institution) and the customary right (informal institution) are not congruent. In South Asia, any person who has legally acquired a property from another person by paying money or by inheritance has to establish his or her customary right at least in a symbolic way even by digging a hole on the property in a socially visible and socially recognized way. In East Asia, Africa, and Latin America, the practice of establishing legal right is not as rigid as in South Asia.

However, a poor woman without any capital and food but with effective property rights still cannot alleviate her poverty and take control of her own life. Hence, state action for provision of inputs and wage goods is necessary to enable the poor woman to use her property.

13. Technological Development, Transfer, and Adoption

Use of technology can help a woman enhance the quality of her acquired endowment set and consequently the quality of her empowerment. But even in this age of communication through the Internet, women are more likely than men to lack basic literacy which would enable them to take advantage of the new global communication technology. Women comprise 64 percent of illiterate adults globally; and girls comprise two-thirds of school-age children in the developing world without access to basic education. In addition, girls are much less likely than boys to enroll in mathematics and computer science courses.

The use of technology involves a three-stage process: (i) technology development, (ii) technology transfer, and (iii) technology adoption. Those who develop technology for its use in the agricultural, industrial, and services sector, will have to be aware of the technology absorptive capacity of women employees in those sectors. The objective of technology innovation is to improve the productivity and lighten the workload in the agricultural and services sectors where women account for a substantial proportion of the total workforce. For example, the increased mechanization of agricultural production during the second phase of India's "green revolution" period (1977 to 1987) led to the displacement of female labor by male labor and machines from several of their traditional agricultural works such as (i) protection of plants from pests, (ii) planting of crops, (iii) harvesting of crops, and (iv) processing and storing of output and other post-harvesting works (Chen, 1989; Roy and Clark, 1994). The task of irrigating the crop by pumping water from deep table wells is entirely done by male labor. This is due to the fact that the machines because of their operational complexity and heavier weight were not user-friendly to women. In the same way, in the services sector in which women account for a substantial proportion of total workforce, the technology will have to be user-friendly to these women with limited literacy.

Technology transfer processes have two important aspects. First, those who want to adopt the technology ought to have easy access to it. This "easy access" in turn necessitates easy access to finance and to the supply of technology. In developing countries, access to finance for millions of women is not easy; and the supply of technology may involve a complex process of complying with many state-sponsored regulations. Furthermore, social restrictions on the freedom of movement of women outside the confines of their home prevent women from trying to acquire the means

to access the technology. Second, those who have acquired technology should be able to adopt it easily.

The transfer and adoption of technology therefore, are interconnected and form a composite process, as adoption also requires access to finance and transfer of knowledge via training for the technology adapters (Roy, 1994). In the case of women, the institutional requirement is the society's support to widespread adoption of technology by women. For example, a girl or a woman in a village in Pakistan should be able to talk to an acquaintance by a mobile phone openly on the street without being teased and harassed by male onlookers.

The process of adoption of technology in different countries follows the pattern of the international product cycle under which a new product embodying a new technology is adopted first in countries which have a high level of technology-adopting infrastructure and is transferred last to countries which have a very low level of technology adoption infrastructure. In Nigeria, for example, most rural women's access to "new" technologies does not even include audio and video cassettes. Major impediments to the adoption of new technology appear to be following:

(i) Lack of finance and/or high cost of equipment;
(ii) Lack of training;
(iii) High cost of connectivity and repair of equipment; and
(iv) Lack of adequate infrastructure (UN, 2000).

All these impediments relate to institutional failures in the developing countries.

14. Violence Against Women

14.1. *Powerlessness, voicelessness, helplessness, and peacelessness*

These problems relate to a particular state of mind of men and women who suffer from extreme poverty in the socio-cultural and economic spheres. An example would be the mental state of refugee women with children who have no food, no clothing, no minimum health care, no shelter, no security of life, and who do not know whether they will remain alive during the course of the day or night.

In other cases, women when not deprived of minimum food, clothing, health care, and shelter can also become powerless, voiceless, helpless, and peaceless due to the deprivation of their freedom and dignity resulting from physical violence committed against them regularly or from expectation of a threat of violence against their lives.

14.2. *Physical violence against women*

In a statement to the Fourth World Conference on Women in Beijing in September 1995, the UN Secretary General, Boutros Boutros Gali, said that violence against women (2006) is a universal problem that must be universally condemned. Studies in 10 countries found that in the mid-1990s, between 17 and 38 percent of women have suffered physical assaults by a partner. In the United States, a woman is beaten every 18 minutes. Domestic violence is the leading cause of injury among women of reproductive age in the United States. Between 22 and 35 per cent of women who visit emergency rooms are there for that reason. The UN special Rapporteur's report in 1994 (Saravanan, 2000) mentioned three following areas where women are particularly vulnerable:

(i) In the family where they are subjected to domestic violence, traditional practices, and infanticide;

(ii) In the community where they are subjected to rape, face sexual assault, become a commodity in sex trade, and become victims of labor exploitation in the workplace (migrant workers are examples); and

(iii) By state action, which includes physical violence against women in detention, in situations of armed conflict in refugee camps and sexual and psychological violence which are perpetrated and condoned by the state — wherever it occurs.

For example, psychological violence against women committed by the ruling political party's agents does occur in several provinces in democratic India.

The major forms of violence women are subjected to in developing countries are domestic violence, female genital mutation, termination of a female foetus due to son preference in the family, dowry-related violence, violence in the community, sexual harassment in the workplace, prostitution and trafficking, violence against female migrant workers,

state-sponsored and state-condoned violence against women which includes violence in custody, in arms conflict, and in refugee camps, and finally, traditional practices imposed on women due to their particular social status and marital status such as widows in Hindu culture.

Some forms of violence against women are practised in every country, although domestic violence appears to be the most widely practised form of violence. Violence in any form against women, takes away their human rights, dignity, freedom and in many cases permanently destroys their capacity to empower themselves. Consequently their powerlessness makes them voiceless, helpless, and hopeless.

Combating violence against women requires challenging the way that gender roles and power relations are articulated in society. In many societies women have low status relative to men and are considered as property owned by men. Changing social perceptions about women would require collaborative action between the government, private sector organizations, including teachers, legislators, mass media, and an independent, honest, and powerful judiciary capable of inflicting punishment on those committing violence against women.

15. Women's Participation in Political Governance

Women's participation in political decision-making from the local government to the national government level can weaken male bias in the formulation and implementation of state policies for the alleviation of women's economic and socio-cultural poverty and at the same time, can also weaken the oppressive power of patriarchy over women's lives.

But formal limitations to women's access to adult suffrage and election still exist in several countries in the world. In 1996, among 871 political parties in 80 countries in the world, in 67 percent of these parties there were no women in their governing bodies (UN, 2000).

Globally, women's representation in the lower house of legislatures has, as a rule, remained low except in the Nordic countries. In 2005 in several Middle Eastern countries (Saudi Arabia, Kuwait, and the United Arab Emirates) there were no women members in the lower house of their parliaments (UNDP, 2005). The countries with 33 percent and/or above representation by women in the lower house of parliament are Norway (38 percent), Sweden (45 percent), Netherlands (37 percent), Finland (38 percent), Denmark (37 percent), Austria (34 percent), Spain (36 percent),

and Argentina (34 percent) (UNDP, 2005). Also, very few women in the world hold the top executive positions in governments except those in Sweden (52 percent), Spain (50 percent), Finland (47 percent), Netherlands (36 percent), and in few Latin American countries (UNDP, 2005) where women hold more than one-third of the total positions.

Lack of finance to mount an election campaign and lack of institutional support within and outside her home to pursue a career in politics prevent a woman from making efforts to campaign for office in a democratic states. In autocratic states, the policy-making process is centralized and controlled by the leaders' immediate subordinates. Thus, changes in state policy to make economic and social institutions work in favor of women are likely to take place only if such changes are desired by the ruler and his subordinates.

Therefore, from the discussion above, it is clear that empowerment is about changing institutional relationships (World Bank, 2002). Since the state is the most formidable of all institutions, state policies and the culture of state institutions shape the actions of all other actors.

References

Agarwal, B (1989). Rural Women, Poverty and Natural Resources. *Economic and Political Weekly*, 24(43), 46–65.

Agarwal, B (1994). *A Field of One's Own: Gender and Land Rights in South Asia*. Cambridge: Cambridge University Press.

Becker, GS (1973). A Theory of Marriage: Part I. *Journal of Political Economy*, 81(4), 813–846.

Becker, GS (1974). A Theory of Marriage: Part II. *Journal of Political Economy*, 82(2), S11–S26.

Becker, GS (1991). *A Treatise on the Family*. New York: Harvard University Press.

Blundell, R, Chiappori, PA, Magnae, T and Meghir, C (2005). Collective Labor Supply: Heterogeneity and non-participation. *IZA Discussion Paper*, Bonn, Germany.

Chen, M (1989). Women Work in Indian Agriculture by Agro-Ecologic Zones: Meeting Needs for Landless and Land Poor Women. *Economic and Political Weekly*, 24(43), 79–89.

Chiappori, PA (1988). Rational Household Labor Supply. *Econometrica*, 56(1), 63–89.

Chiappori, PA (1992). Collective Labor Supply and Welfare. *Journal of Political Economy*, 100(2), 437–467.

Dasgupta, P (1993). *An Inquiry into Well-being and Destitution*. Oxford: Clarendon Press.

Drèze J and Sen, AK (2002). *India: Development and Participation*. New Delhi: Oxford University Press.

Drèze, J and Sen, AK (1989). *Hunger and Public Action*. Oxford: Clarendon Press.

Duvvury, N (1989). Women in Agriculture: A Review of the Indian Literature. *Economic and Political Weekly*, 24(43), 96–112.

Fennell, S (1999). The Consequences of Gender Relations on Economic Performance in Asia. In *Human Resources, Gender and Environment in Development*, RN Ghosh, R Gabby and KC Roy (eds.), pp. 51–60. New Delhi: Atlantic Publishers.

Fortin, B and Lacroix, G (1997). A Test of the Unitary and Collective Models of Household Labor Supply. *Economic Journal*, 107(443), 933–955.

Ghose, A (1999). Current Issues of Employment Policy in India. *Economic and Political Weekly*. 34(36), 2592–2608.

Government of India (2005). *India 2005*. New Delhi: Government of India.

Harris-White, B (2004). India's Informal Economy: Facing the Twenty-First Century. In *India's Emerging Economy: Performance and Prospects in the 1990s and Beyond*, Basu, K (ed.), pp. 266–291. New Delhi: Oxford University Press.

Kabeer, N and Subramanian, R (1996). *Institutions, Relations and Outcomes: Frameworks and Tools for Gender — aware Planning*, (Mimeographed). Brighton: IDS, University of Sussex.

Kishwar, M (1987). Toiling Without Rights: Ho Women of Singhbhum. *Economic and Political Weekly*, Vol 22, 95–101.

Leibenstein, H (1974). An Interpretation of the Economic Theory of Fertility: Promising Path or Blind Alley. *Journal of Economic Literature*, 12, 457–479.

Majumdar, RC, Raychaudhury, HC and Datta, K (1991). *An Advanced History of India*. Madras: MacMillan India Ltd.

Manser, M and Brown, M (1980). Marriage and Household Decision Making: A Bargaining Analysis. *International Economic Review*, 21(1), 31–44.

McElroy, MB and Horney, MJ (1981). Nash Bargained Decisions: Towards a Generalisation of the Theory of Demand. *International Economic Review*, 22, 333–349.

Nafziger, EW (1997). *The Economics of Developing Countries*. Upper Saddle River: Prentice Hall.

Narayan, S. (1962). *The Principles of Gandhian Planning*. Allahabad: Kitab Mahal.

Nee, V (1998). Norms and Networks in Economic and Organisational Performance. *American Economic Review*, 88(May), 85–89.

Pariwala, R (1989). Re-affirming the Anti-Dowry Struggle. *Economic and Political Weekly*, 24(17), 942–944.

Parpart, JL (1986). Women and the State in Africa. In D Rothchild and N Chazan (eds), *The Precarious Balance*, pp. 278–292.Westview: Boulder Co.

Phongpaichit, P. (1982) *From Peasant Girls to Bangkok Masseuse*, Geneva, ILO.

Rodrik, D (ed.) (2003). *In Search of Prosperity: Analytic Narratives on Economic Growth*. Princeton, NJ: Princeton University Press.

Rosenzweig, MR and Schultz, TP (1982). Market Opportunities, Genetic Endowments and the Intrafamily Allocation of Resources: Child Survival in Rural India. *American Economic Review*, 72 (September), 803–815.

Roy, KC (1986). *Foreign Aid and Indian Development — A Study from the Viewpoint of Peace and Development*. Ahmedabad: Gujarat Vidyapith.

Roy, KC (1994). Neglected Issues in Technological Change and Rural Development: An Overview. In *Technological Change and Rural Development in Poor Countries: Neglected Issues*, KC Roy and C Clark (eds.), pp. 16–47. Calcutta: Oxford University Press.

Roy, KC (2001). Impediments to Women's Empowerment in Rural India: Access to Employment, Land and Other Resources. In Ghosh, R, Gabby, R and Siddique, A (eds), *Human Resources and Gender Issues in Poverty Eradication*, pp. 188–205. New Delhi: Atlantic Publishers.

Roy, KC and Tisdell, CA (1992). Technological Change, Environment and Sustainability of Rural Communities. In *Economic Development and Environment — A Case Study of India*, Roy, KC, Tisdell, CA and Sen, RK (eds.), pp. 43–71. Calcutta: Oxford University Press.

Roy, KC and Tisdell, CA (1993). Poverty Amongst Females in Rural India: Gender-Based Deprivation and Technological Change. *Economic Studies*, 31(4), 257–279.

Roy, KC and Tisdell, CA (1996). Women in South Asia with Particular Reference to India. In *Economic Development and Women in the World Community*, Roy, KC, Tisdell, CA and Blomqvist, HC (eds.), pp. 97–124. Westport CT and London: Praeger.

Roy, KC, Tisdell, CA and Ghose, A (2001). Women's Empowerment, Sen's Entitlement Theory and Institutional Impediments in Rural India. In *Human Resources and Gender Issues in Poverty Alleviation*, R. Ghosh, R Gabby and A Siddique (eds.). New Delhi: Atlantic Publishers.

Roy, KC, Tisdell, CA and Blomqvist, HC (eds.) (1996). *Economic Development and Women in the World Community*. Westport, CT and London: Praeger (Paperback edition in 1999).

Roy, KC and Clark, C (eds.) (1994). *Technological Change and Rural Development in Poor Countries: Neglected Issues*. Calcutta: Oxford University Press.

Saravanan, S (2000). *Violence Against Women in India*. A Literature Review, New Delhi: Institute of Social Studies Trust (Mimeopgraphed).

Schultz, TP (2002). Why Government Should Invest More to Educate Girls. *World Development*, 30(2), 207–225.

Schultz, TP (ed.) (1995). *Investment in Women's Human Capital*. Chicago: Chicago University Press.

Sen, AK (1981). *Poverty and Famines: An Essay on Entitlement and Deprivation*. Oxford: Clarendon Press.

Sen, AK (1985). *Commodities and Capabilities*. North Holland, Amsterdam.

Sen, AK (1990). Gender and Co-operative Conflicts. In *Persistent Inequalities*, I. Tinker (ed.), pp. 123–149. London: Oxford University Press.

Sen, AK (1992). *Inequality Reexamined*. Cambridge, MA: Harvard University Press.

Sen, AK (1999). *Development as Freedom*. New York: Alfred Knopf.

Siva, V (1992). *Staying Alive, Women, Ecology and Development*. London: Zed Books.

Standing, G (1989). Global Feminization though Flexible Labor. *World Development*, 17(7), 1079–1098.

UN (1994). *Report of the International Conference in Population and Development*. Cairo, New York: UN.

UN (2000). *The World's Women 2000; Trends and Statistics*, p. 85. New York: United Nations.

UNDP (2005). *Human Development Report 2005*, p. 31. New Delhi: Oxford University Press.

Violence Against Women. http://www.un.org/rightsdpi1772e.htm 28 March 2006.

World Bank (2001). *World Development Report 2000-2001*. New York: Oxford University Press.

World Bank (2002). *Empowerment and Poverty Reduction: A Source Book*. Washington DC: World Bank.

World Bank (2004). *World Development Report 2005*. New York: Oxford University Press.

Chapter 3

Can the State and its Institutions Facilitate Gender Empowerment?

Kartik C. Roy,* Hans C. Blomqvist and Cal Clark

1. Introduction

In all civilizations, the informal rules and regulations of a society governed the social behavior as well as the economic behavior of individual members of the society for many centuries where the ownership of land and other resources was vested in the society. The society used to determine how in the collective interest of all community members, the production, storage, consumption, and sale of output of the commons were to take place (Roy, 1997). However, as the size of population continued to grow and the management of economic activity became more complex, there arose the need for the society to create the institution of the state to supervise, e.g., the economic behavior of members of the society (North, 1987), although their social conduct continued to be governed by customs and traditions.

2. The State and its Institutions

The State, then, created formal rules and regulations of governance for the economic, social, and political affairs of the society and also created institutions subordinate to it for implementing and overseeing the implementation of the formal rules.

Therefore, although in theory the term "institutions" refers to formal rules created by the state and informal rules created by the society, in

* Corresponding author.

practice, the connotation of the term "institutions" has widened to include also the creator of formal institutions as well as its subsidiaries which apply the formal rules. In Fig. 3.1, we illustrate the broad categories of institutions that exist in each country.

As can be seen from Fig. 3.1, a society creates its own informal institutions; and it also creates the state which becomes its formal institution. In a democracy the state creates its agent, the government, to act on behalf of the state. The government functions through the legislature, executive, and judiciary. The executive prepares formal laws and gets them approved by the legislature before they are implemented by the government's own subsidiary institutions created by the executive. The judiciary and policy forces uphold the rule of law. But apart from the rules and regulations, the bodies that create and implement those rules and bodies that oversee the implementation of those rules are all formal institutions. In this respect, the legislature, executive, judiciary, police force, banking system, trade unions, political parties, are all formal institutions. Similarly, private companies, NGOs, schools, colleges, universities, hospitals, also form part of formal institutions.

However, even in democracies, the state through its agent, the government, can also exercise powerful influence on the functions of all

Society				
Creates	Creates	Creates State/Government		
Its informal institutions viz customs, traditions, taboos, for governing social activities such as rituals, marriage, dowry, and others. Marriage and dowry are themselves institutions.	Its private formal institutions viz private companies for conducting business activities and NGOs for social sector activities.	Legislature: It passes or creates formal laws relating to the conduct of social, economic, political and other activities within the country.	Executive: It implements those formal laws (institutions) by creating its subsidiary institutions such as the government bureaucracy; financial institutions (e.g., banks); social institutions (e.g., schools, colleges, hospitals); it makes and implements rules for the production, consumption and distribution of goods, and for exporting and importing goods; creates trade unions and employment rules and also makes rules for informal institutions. It creates and controls the police force.	Judiciary: It upholds the rule of law; and police enforces the verdict of judiciary.

Figure 3.1: Broad categories of institutions.

informal social institutions and can modify important age old customary practices so that these institutions can better satisfy the current needs of the country and of the globalized world economy. If the state can do that, then this change in important social institutions will greatly facilitate women's empowerment. But the extent that the state will be able to make those changes will depend greatly on the efficiency and honesty of state institutions. In totalitarian states, the autocrat wields enormous power and, hence, can modify informal rules more quickly and effectively than the executive in a democratic state.

3. The Role of The State as the Formidable Institution

Although Smith (1776/1976), wrote about the need for establishing institutions to enable the market system to work properly to maximize the welfare of individuals and thereby of the country (community), the term "welfare" connotes both economic and social welfare. The implicit assumption here is that the maximization of economic welfare leads to the maximization of social welfare. The natural corollary of this progression is that economic empowerment leads to social empowerment. Smith's concern that formal rules, regulations, and the justice system as well as informal customs, religious, and social pressures can constrain people (both men and women) in their quest to maximize their welfare led him to advocate the need for placing limitations on government's power to interfere in people's activities by curtailing their freedom of choice of occupation and by placing restrictions on the exchange of land, on who is permitted to engage in certain economic activities and transactions, and on foreign trade.

At the same time, Smith also expressed the need for robust state institutions to protect property rights, to protect copyright and patent, and to regulate coin and currency. All these tasks can be performed by a fair and transparent legal system. Overall, Smith recommended three functions that the government as the agent of the state ought to perform:

(i) It is the duty of the government to protect the society from foreign aggression;
(ii) It is the duty of the government to protect, to the best of its capability, every member of the society from injustice and oppression; and
(iii) It is the duty of the government to produce and supply to the community, the goods of collective consumption which are non-exclusive and

non-rival in consumption and consequently, which are not likely to be produced and supplied by private sector companies or individuals.

All kinds of infrastructure which enable individuals to pursue whatever economic and social activities they choose are examples of a public good. But in modern economies, the government's institutions are not likely to be able to discharge even those functions without adversely affecting some section of the community on the basis of gender, race etc., due to institutional failures. Moreover, the state may not even be benevolent in the first place.

Consequently, the likelihood of the state maintaining the structure of its formal institutions but sponsoring and using its informal institutions to further the rent-seeking behavior of its vested interest groups at the expense of the interest of the whole community became a matter of serious concern for North (1981, 1987), Olson (1982, 1996) and Buchanan (1980, 1993).

North argues that where communities are small, each member of a community personally knows all others in the community. Hence the need for the state to act as the third party to facilitate transactions between two parties does not arise. However, as the population continues to grow and the economic growth continues in both developing and developed countries, economic transactions are likely to take place within a country between two individuals who do not know each other or between individuals from two countries. Thus, exchanges between two parties may become impersonal and inter-temporal, thereby necessitating the intermediary role of the government. But the rise of impersonal rules and contracts means the rise of the state and with it an unequal distribution of coercive powers. As a result, individuals (the state's agents) with superior coercive power enforce the rules to their advantage regardless of their effect on efficiency. North felt that rules will be devised and enforced on behalf of the interests of politically advantaged but the total transaction cost in the country will not necessarily fall (North, 1987). The implications of North's argument for women's empowerment are that since women historically have been a politically disadvantaged group in every country, the capture of state power by vested interest groups is not likely to lower the social and economic transaction costs of women, and consequently not likely to make it easier for women to alleviate poverty and thereby take control of their own lives.

There are several reasons why a government may not be interested in promoting efficient institutions. First, the government and the privileged groups which include the dominant political party, its workers, and other supporters who rely on government to fill up their pockets may be able to

increase revenue and income by restricting transactions, undermining property rights or focusing income on certain people or activities that are easy to exploit. Second, institutions that minimize transaction costs and increase the well-being of the entire population of the country are not likely to be of benefit to the vested interest groups which keep the government in power (North, 1987). The relationship between the government and the vested interest groups is based on the dictum: you scratch my back and I scratch yours. This situation prevails, for example, in all communist states and also in other states where communists run some governments at the provincial level (Roy and Sildenko, 2007).

Vested interest groups which enjoy political and economic power also include some women, but generally women's representation within such groups is marginal. Hence, their capacity to change state policy in favor of women is extremely weak. Also, these women may try to further their self-interest by following the path taken by majority members of the group. In rural areas in a developing country, more people are likely to be in a politically disadvantaged group than the people in the urban and industrial areas. Also in a federal democratic state, the members and informal agents of the party in power control the political and economic power in both urban and rural areas. Amongst these groups, the number of women is small.

However, even when the state for North (1981) becomes its own "vested interest group" creating a trade-off between economic efficiency and state power, the state can still facilitate some efficient transactions and, hence can promote economic and social well-being for the entire population, if the people transacting share some conviction about the justice and appropriateness of the society and economic system within which they are acting. This is where the major difference lies between the autocratic regimes in Confucian East Asia and democratic or autocratic regimes in non-Confucian South Asia and in other regions of the world. Confucianism implanted in minds of the leaders as well as in minds of the population at large, a strong ethical value, a sense of right and wrong which drove the vested interest groups to pursue economic social well-being of the masses despite pursuing their rent-seeking activities. As a result, women's empowerment was also facilitated to a greater extend in countries of East Asia than in countries elsewhere.

Echoing North's views, Olson (1982), argues that due to bargaining costs and the problem of free riders, individuals are unlikely to organize in their collective interest unless they are in small groups and/or

can impose selective incentives on group members. Such a coalition of self-interested persons (i.e., the politically advantageous groups or a Northian state's vested interest groups) are likely to try to redistribute income toward themselves instead of working to raise efficiency and national income, the full benefit of which they will not receive. In other words, the implication is that politically powerful groups are likely to capture state power to formulate and implement state policies to further their self-interest to the exclusion of the interests of the majority of the population which includes women. Therefore, in stable societies, politics will be increasingly organized to cater to these interests. However, in unstable societies in Africa too, a similar situation prevails. Examples are Rwanda, Sierra Leone, and Zimbabwe. In all these countries, women appear to have suffered considerably more than men.

Olson's concern with the adverse impact of the policies of such coalitions in economic growth and social change found expression earlier in Buchanan's (1980) argument that the profit-seeking activities of such coalitions of vested interest groups will undermine competition and efficiency and promote monopoly power and deadweight loss in the production and consumption in the society. The economic loss that results from the rise in monopoly power and rent-seeking activities hampers economic growth and social change which, in turn undermine women's chances of attaining empowerment. However, the losses resulting from the distortion of public policies are greater than that captured by the famous "twin triangles" of comparative statics.

Bhagwati's (1982) DUP (Directly Unproductive Profit-seeking) activities refer to the competition for rents which accrue to the winners of government largesse. The argument here is that when the state creates its own vested interest groups, state interventions which open space for rents will rise to such an extent that seeking government favors will override normal market activities.

As we have already noted from the arguments presented above, the neo-classical political economy of the 1980s and 1990s mounts a direct attack against the development economists of the 1960s and 1970s who maintained their faith in the capacity of the state's political institutions to fulfill the state's prescribed role and, hence, in the efficacy of the government intervention.

North, Olson, and Buchanan, therefore attempt to explain the state's rent-seeking behavior through the creation of the state's "vested interest

groups" (North, 1981), the "collective action" by these groups (Olsen, 1982) and the emergence of monopoly from distorted public policy (Buchanan, 1980). Lal (1983) goes even further by suggesting that since this bureaucratic failure may be worse than market failure in democratic states, a courageous, ruthless, and perhaps undemocratic government is required to ride roughshod over these newly-created special interest groups. Lal, however, did not mention the reasons for democratic failure. In reality, the bureaucracy which (as illustrated in Fig. 3.1) is the most important institution of the state is forced by the state's vested interest groups (ministers, political party leaders, party cadres, and other informal agents) in a democracy to help them engage in rent-seeking activities.

4. The Demise of the Neo-Classical State

The reasons as to why the pre-1980s neo-classical economists maintained their faith in the capacity of the state to promote the economic and social well-being of the population (and, hence, of women also) was that they accepted the effective presence of the traditional neo-classical separation of powers among the three branches of a democratic government — legislature, executive, and judiciary. Under the assumption that this is maintained, the famous Coase Theorem (Coase, 1937), shows that if property rights are well-specified and transaction costs are zero, individuals will face correct incentives and free trade, which also refers to all their restriction-free trans-actions, that will lead to efficient resource allocation among them.

Following Coase, North makes the specification and enforcement of property rights the fundamental prerequisite for the economic and social empowerment of people. The writings of both Coase and North have par-ticular significance for women's empowerment as the lack of property rights (particularly land rights) has often been cited (Kandiyoti, 1990; Agarwal, 1994; Roy and Tisdell, 1992, 1993, 2002; Roy, 1994) as one of the prime causes of the persistence of Sen's "unfreedom" and, hence, of women's lack of control over their own lives.

The traditional separation of powers in a neo-classical state implies that the executive will implement the laws passed by the legislature and that the judiciary will uphold those laws with the help of the police force. But in the developing as well as in several parts of the developed world, the rise in executive dominance over the judiciary and the police force has

signaled the demise of the neo-classical state. Even if the judges try to protect their independence from executive dominance through recourse to judicial activism, they cannot protect the sanctity of laws by preventing their capture by the executive and its agents if the independence of this police force is undermined by the executive. In such a situation a woman whose legal right to a property has been upheld by the court of law cannot make use of her property, if the corrupt police force does not enforce the decision of the law court. The demise of the neo-classical state over the last 2 decades has, therefore, witnessed two parallel trends in institutional development — a decline in the sanctity of formal institutions and an alarming rise in informal institutions, i.e., customary laws. The implications for these are that those individuals, women in particular, who do not belong to the politically elite groups, may not be able to make use of their legal ownership right to land unless their legal right (formal institution) is also supported by their customary right (informal institution) to the land. In other words, they also have to purchase their customary rights from the society. This situation prevails in both urban and rural areas in South Asia and in many countries in South America.

The enormous rise in the power of informal institutions is directly linked to the capture of state power by the executive and its vested interest groups. For most transactions to be successful, for example, in India and other South Asian countries, the congruence of formal and customary laws is necessary.

In response to North's (1981) argument that the state which represents a political elite possessing a monopoly power over violence, can use violence or the threat of violence to enforce rules protecting economic activities, Weingast (1995) (also cited in Grabowski (2005)) remarks that a government strong enough to protect property rights and enforce contracts is also strong enough to extract the wealth of its citizens. Thus, Grabowski (2005) contends that institutions constraining the behavior of the ruling elite are the necessary prerequisite for economic growth. These constraining rules generally involve an effective judiciary, an operating legislature, limits to corruption, transparency in the state's dealing, etc. But he admits that constructing effective institutions is a difficult task about which there is little wisdom or knowledge. These comments primarily refer to formal institutions, but we have already noted that the effectiveness of existing formal institutions can be deliberately weakened by the state's executive and its agents.

Hence, in the 21st century real world, state promotion of economic and social well-being of the population and empowerment of women in a country depends greatly on the extent to which formal and informal rules are congruent. These informal rules (i.e., customs, taboos, traditions) can be modified and improved by the state and the society. We are now entering the realm of new institutional economics.

5. The New Institutional Economics and Gender Empowerment

The new institutional economists (Coase, 1998; Nee, 1998) examine the relationship and interaction between formal regulations and incentives and informal incentives or constraints. For example, high government regulation and high tax rates discourage individuals and private enterprises from engaging in economic activities involving a high level of investment and considerable risk-taking. At the same time, if the informal incentives are low but constraints are high, the combined disincentives of formal and informal regulations will produce a considerable adverse impact on economic and social transactions in the country.

Victor Nee (1998) contends that while formal rules are created and enforced by state and private firms to solve problems of collective action through third-party sanctions, the informal rules (viz customs and traditional practices) which arise out of networks are enforced by ongoing social relationships. To the extent that members of networks have interests and preferences independent of what rulers and entrepreneurs want, the respective contents of informal rules and formal organizational rules are likely to reflect opposing aims and values. As a result, the transaction costs will rise. But when the formal rules of an organization are perceived to be congruent with the preferences and interests of actors in subgroups, the relationship between formal and informal norms will be closely coupled. The close coupling of informal norms and formal rules promotes high performance in organizations by lowering transaction costs.

We now revisit North's comments on the relevance of his fourth variable: ideology and conviction for minimizing transaction costs. The Northian[2] view is that despite the presence of some conviction about the justice and appropriateness of the society and economic system among people, the specialization and division of labor can produce

divergent perceptions of reality, creating contrasting and conflicting views of fairness and justice of institutional arrangements. This implies that in a country, if the state's institutional arrangements for carrying out a particular economic or social transactions by an individual, say a woman, are not perceived to be congruent with the interest and norms of the society to which that woman belongs, then the cost of completing that particular transaction rises. This view is also strongly held by Victor Nee.

The demise of the neo-classical state has given rise to a conflict between the need for a "third-party" state to facilitate the complex transactions that must be carried out if a society is to attain higher levels of well-being for its individual members and the danger that the concentration of power in the hands of such a third-party state will lead to the perversion of that power to benefit some people at the expense of others (Van den berg, 2001).

But this in turn has placed the women of developing countries in the following triple jeopardy in pursuit of their empowerment:

(i) In many developing countries, for the same kind of economic or social transaction, women are treated less fairly than men under the formal laws. An example is the payment of lower wage to women relative to men for the same kind of job in an urban office or in rural agriculture. As a result, women have far greater difficulty than men in alleviating their poverty and to attain empowerment.

(ii) The perversion of state power to benefit the politically powerful groups at the expense of others increases the economic and social well-being of group members most of whom are men. Hence, women's empowerment is hampered.

(iii) The capture of state powers by the politically powerful groups increases the flow of government largesse to these group members, prevents efficient allocation of resources and increases the monopoly power of state-sponsored enterprises. The result is that the actual rate of economic growth continues to fall below the potential rate. Consequently, the trickle down effect of this growth rate on women's empowerment continues to weaken.

In addition to these disadvantages, women's freedom to engage in any transaction is severely circumscribed by the requirement to comply with the gender-based customary norms and practices.

6. Corruption Perception Index (CPI) and Institutional Non-Compliance Score (INCS)

Transparency International defines corruption as the abuse of public office for private gain and measures the degree to which corruption is perceived to exist among a country's public officials and politicians. A higher corruption level also implies a higher level of institutional non-compliance which in turn implies a lower level of gender empowerment. In its 2005 Corruption Perception Index (CPI), Transparency International has assigned a maximum score of 10 for a country which is perceived to have no corruption and 0 for a country which is perceived to have total corruption. From this we have derived the Institutional Non-Compliance Scores (INCS) of all 13 developing countries included in our study which are reported in Table 3.1. The INCS are derived in the following ways for a country: INCS = (10 − CPI).

It can be seen from the table that among the 13 countries included in this table, Chile is perceived to be the least corrupt county with the lowest level of institutional non-compliance scoring 7.3 out of 10 for CPI and 2.7 out of 10 for INC. Bangladesh, on the other hand is perceived to be the most corrupt country with a CPI score of 1.7. Its institutional non-

Table 3.1: Corruption Perception Index and Institutional Non-Compliance Scores for selected developing countries, 2005.

Country	2005 CPI Score	2005 INC score (10-CPI)
Chile	7.3	2.7
Taiwan	5.9	4.1
Fiji	4.0	6.0
Thailand	3.8	6.2
Peru	3.5	6.5
Turkey	3.5	6.5
Burkina Faso	3.4	6.6
China	3.2	6.8
India	2.9	7.1
Philippines	2.5	7.5
Indonesia	2.2	7.8
Kenya	2.1	7.9
Bangladesh	1.7	8.3

Source: For CPI Score: Transparency International (2005), Web: www.transparency.org.

compliance score is 8.3 which is the highest among the 13 countries included in the table. From this table, therefore, we can infer that in Chile, a country with the lowest level of corruption and highest level of institutional compliance, the institutional hindrances to women's empowerment will be the lowest and in Bangladesh, the reverse would be the case.

7. Deprivation Scores

Gender Deprivation Scores provide the best picture of the relative status of women in a given society. In essence, these scores rate women on a score of 0 to 100 on a specific quantitative indicator, such as average years of schooling or maternal mortality rate. The country with the highest value is given an index score of 100, while those with lower values are given proportionate index scores according to the following formula:

$$\text{Gender Deprivation Index (GenDep)} = 100 \times (\text{Maximum Value} - \text{Country's Value}) / (\text{Maximum Value} - \text{Minimum Value})$$

For example, women in Canada have the highest level of schooling with an average of 14.2 years, while those in Chad have the lowest at 0.5 years. To calculate the Gender Deprivation Ratio for women's average number of years in school for Indonesia, therefore, that country's value of 6.8 years is substituted into the preceding equation:

$$\text{GenDep} = 100 \times (14.2 - 6.8)/(14.2 - 0.5) = 54.0$$

The calculation for fertility rate is only slightly more complex. Here, Niger has the highest rate at 8.0 and Hong Kong the lowest at 1.0. Since lower fertility rates are associated with women's empowerment, though, we need to invert the scale by, for example, subtracting a nation's fertility rate from 9 to get the "country score". For India with a fertility rate of 3.0, this produces:

$$\text{GenDep} = 100 \times (7.9 - 3.1)/(7.9 - 0.9) = 68.6$$

Table 3.2. presents the actual values for women's average years of schooling and the fertility rates for 13 developing countries. Based on these two indicators at least, women's relative status seems to be the best in Chile and Taiwan and, to a lesser extent, in Thailand and the Philippines.

Table 3.2: Actual values and deprivation indices for average years of female schooling and fertility rates for selected developing countries, early 2000s.

Nation	FemScl	DepFemScl	Fert	DepFert
Bangladesh	2.9	82.5	3.5	35.7
Burkina Faso	.6	99.3	6.7	81.4
Chile	10.1	29.9	2.4	20.0
China	5.8	61.3	1.8	11.4
Fiji			2.9	27.1
India	3.6	77.4	3.6	68.6
Indonesia	6.8	54.0	2.4	20.0
Kenya	5.6	62.8	4.0	42.9
Peru	8.0	45.3	2.9	27.1
Philippines	8.8	39.4	3.2	31.4
Taiwan	8.8	39.4	1.7	10.0
Thailand	6.6	55.5	1.9	12.9
Turkey	5.1	66.4	2.4	20.0

Source: UNDP (2005), *Human Development Report 2005*, New Delhi: Oxford University Press.

Conversely, women's position is comparatively the worst in Burkina Faso and Bangladesh and, to a lesser extent, in India and Kenya. Moreover, there does appear to be some relationship between gender deprivation and political corruption or "institutional non-compliance." Table 3.1. above, for example, showed Chile, Taiwan, and Thailand to rank fairly low on the Institutional Non-Compliance Index, while Bangladesh, Kenya, India, and Burkina Faso had much poorer records in this area.

8. Enforcer of Gender Discrimination: Patriarch or Matriarch

8.1. *Within the household*

After discussing all relevant aspects of gender empowerment, we now make some passing comments on the issue of the enforcer of gender discrimination. The literature on gender discrimination against women portrays men as being enforcer of the rules of patriarchy on women within the confines of their homes. The "altruistic dictator" approach is based on

the notion that the decision-making member within the household is able to make the best choice for all members of the household, given that he is able to reflect their interests better than they are on an individual basis. This dictator is perceived to be a man, not a woman.

8.2. *Outside the Household*

But the maintenance of production and exchange relations within the household poses a persistent obstacle to increasing women's right of appropriation over the resources they generate. Hence, there arises the need for extra-familial institutions such as women-only co-operatives to organize rural women's productive activities. Such women-only organizations can strengthen women's existing networks and do not contravene the customary law preventing the direct extra-household interaction between men and women. Also such a strategy by bringing women together in collective work groups can also be seen as a means of circumventing men's control over resources by making it possible for women to sell goods and services directly (Dixon, 1981). Also women's involvement in extra-household organizations can enhance women's bargaining power within the household (Kandiyoti, 1990). But for rural women to be able to be involved even in women-only organizations to enhance their empowerment prospects depends on whether they have the freedom to engage in such interactions.

Rural women whose extra-household income is vital for the survival of their families do not experience so much restriction on their freedom of movement outside their homes as do urban girls, urban single and married women on whom the matriarch seems to impose the rules of patriarchy more severely than the patriarch. Roy's (1996) exclusive field work in urban area of Bengal brought out this message quite clearly.

Hence, it is a misnomer that the rules of patriarchy are necessarily enforced by men. Women want to be empowered to enjoy substantive freedom, but to enjoy the substantive freedom they also need the substantive freedom of which they are deprived.[1]

[1]Present author's (Roy) through his acquaintances and conversations with many female members of middle-class families in Calcutta found that many of these families discriminate against their daughters in terms of household allocation of privileges and endowments such as swimming lessons, private tuition, and extra-household freedom for any economic and social pursuit for sons, but not for daughters, simply because they are daughters and, hence, cannot be provided with the same privileges as sons.

References

Agarwal, B (1994). *A Field of One's Own: Gender and Land Rights in South Asia.* Cambridge: Cambridge University Press.

Bhagwati, JN (1982). Directly Unproductive Profit-Seeking (DUP) Activities. *Journal of Political Economy*, 90, 988–1002.

Buchanan, J (1993). *Property as a Guarantor of Liberty.* Brookfield, VT: Edward Elgar, pp. 56–57.

Buchanan, J (1980). Rent Seeking and Profit Seeking. In *Toward a Theory of Rent-Seeking Society*, JM Buchanan, RD Tollison and G Tullock (eds.), College Station, Tx: Texas A & M University Press.

Coase, R (1937). The Nature of the Firm. *Econometrica*, 4, 386–405.

Coase, R (1998). The New Institutional Economics. *American Economic Review*, 88(May), 72–74.

Dixon, RB (1981). Jobs for Women in Rural Industry and Services. In *Invisible Farmers: Women and the Crisis in Agriculture*, B Lewis (ed.), USAID, Office of Women in Development, Washington, DC: ICRW.

Grabowski, R (2005). Economic Growth and Institutional Change. *International Journal of Development Issues*, 4(2), 39–70.

Kandiyoti, D (1990). Women and Rural Development Policies: The Changing Agenda. *Development and Change*, 21, 5–22.

Lal, D. (1983). *The Poverty of "Developmental Economics".* London: Institute of Economic Affairs.

Nee, V (1998). Norms and Networks in Economic and Organizational Performance. *American Economic Review*, 88(May), 85–89.

North, D (1981). *Structure and Change in Economic History.* New York: W.W. Norton.

North, D (1987). Institutions, Transactions and Economic Growth. *Economic Enquiry*, 25, 419–425.

North, D (1990). *Institutions, Institutional Change and Economic Performance.* Cambridge: Cambridge University Press.

Olson, M (1982). *The Rise and Decline of Nations.* New Haven, CT: Yale University Press.

Olson, M (1996). Big Bills Left on the Sidewalk: Why Some Nations are Rich and Others Poor. *Journal of Economic Perspectives*, 10(2), 3–24.

Roy, KC (1994). Landless and Landpoor Women in India Under Technological Change: A Case for Technological Transfer. In *Tecnological Change and Rural Development in Poor Countires: Neglected Issues.* KC Roy and C Clark (eds.), Calcutta: Oxford University Press.

Roy, KC and Tisdell, CA (1993). Poverty Amongst Females in Rural India: Gender-Based Deprivation and Technological Change. *Economic Studies,* 31(4), 257–279.

Roy, KC and Tisdell, CA (1996). Women in South Asia with Particular Reference to India. In *Economic Development and Women in the World Community,* KC Roy, CA Tisdell, and HC Blomqvist (eds.), pp. 97–124. London: Praeger.

Roy, KC (1997). Informal Community Management of Resources, Environmental Preservation and Sustainable Development of the Poor: India's Experience, Myths and Realities. In *Development that Lasts*, Roy, KC, HC Blomqvist and I Hossain (eds.), New Delhi: New Age International Publishers, pp. 151–161.

Roy, KC and Sidenko, AV (2007). Democracy, Governance and Growth: Theoretical Perspective and Russian Experience. In *Governance and Development*, Roy, KC and Prasad, B (eds.), New York: Nova Science.

Roy, KC and Tisdell, CA (1992). Technological Change, Environment and Sustainability of Rural Communities. In *Economic Development and Environment — A Case Study of India*, Roy, KC, Tisdell, CA and Sen, RK (eds.), pp. 71–95. Calcutta: Oxford University Press.

Roy, KC and Tisdell, CA (2002). Property Rights in Women's Empowerment in Rural India: A Review. *International Journal of Social Economics*, 29(4), 315–334.

Smith, A (1776/1976). *An Enquiry into the Nature and Causes of Wealth of Nations*. Chicago: Chicago University Press.

UNDPs (2005), Human Development Report 2005, New Delhi: Oxford University Press.

Van den berg, H (2001). *Economic Growth and Development*. New York: McGraw-Hill, pp. 418–419.

Weingast, B (1995). The Economic Role of Political Institutions: Market Preserving Federalism and Economic Development. *Journal of Law, Economics and Organisation*, pp. 1–31.

World Bank (2001). *World Development Report 2000–2001*. New York: Oxford University Press.

Chapter 4

Institutions and Gender Empowerment in India

Kartik C. Roy

1. Introduction

In the first three chapters we have discussed in detail the major issues involved in women's empowerment and the need for appropriate institutions for facilitating their empowerment. Theoretical arguments have been supplemented by empirical references drawn from India and South Asia. Hence in this chapter we will keep our discussion on women's empowerment in India brief.

2. Property Rights, Economic Freedom, and Empowerment

Many economists[1] and the World Bank (see Chapters 1 and 2) have consistently advocated that women's economic independence facilitates their empowerment. Income is, undoubtedly, expected to make women economically independent as it enables them to acquire the necessary goods and services for the sustenance of themselves and their families. Those who have acquired some skills, can exchange their skill-based entitlements for goods and services. Others who do not possess any skill but have physical strength or property rights, can also use these entitlements

[1] A. K. Sen in his book 'Poverty and Famines' (1981) placed strong emphasis on income as the crucial factor which eliminates poverty, provides a person with economic independence, and consequently the power to take control of one's one life. See Sen, (1981) *Poverty and Famines: An Essay on Entitlement and Deprivation*, Oxford: Clarendon Press.

to obtain the necessary goods and services (Chapter 1).[2] Women who own land can cultivate the land to earn income and become more economically independent. Does the economic independence of a woman in India enable her to be genuinely empowered so that she can take control of her own life?

To answer this question let us examine the status of women in India since the Vedic period.

2.1. *Women's socio-economic status and land rights: Historical perspective*

During the period of the Rig Veda (the third to the second millennium BC), women were not independent in the eyes of the law and had to look to their husbands or other male relations for aid and support. During the later Vedic period (second to first millennium BC) women's status did not improve. Daughters were regarded as a source of misery and women could not go to tribal council, nor could they take an inheritance. Polygamy was also widely prevalent. Hence, there is a clear indication that in the Vedic period, women did not possess land rights.

In the later Vedic period (first millennium BC), there was no improvement in women's socio-economic status; and women's right to inherit property was still not accepted by the state and the society. Polygamy was widely practiced. The rules of marriage became more rigid and child marriage began to be accepted by the society. During the reign of Ashoka (273–232, BC), the practice of seclusion of women was prevalent and superintendents were appointed to look after women in his royal court. The King's personal needs were taken care of by women who were purchased from their parents specifically for this purpose.

The widows had to lead a life of self-control, restraint, abstinence, and penance imposed on them by the priests. Hence, the overall picture that emerges during these three millennia BC is that, by and large, women led a secluded life under the control of men, had no inheritance rights, had no independent existence, and accordingly were treated as properties or as sealed deposits and placed in the same group as minors.

[2] Bina Agarwal placed a great deal of emphasis on the granting of land rights to landless poor women as the principal means of poverty alleviation and empowerment of women. See Bina Agarwal, 'A field of one's own' op.cit. The World Bank included property rights among a number of measures needed to empower women. See, World Bank, World Development Report, 2001, op.cit.

Despite this general picture, there is also the evidence to suggest that under different laws relating to women during different periods of time, women's social status was better. Many of them received education in different fields and became renowned scholars, came out of seclusion and led free lives.

Under the Islamic rule which began in earnest from 1192 AD, the status of women did not improve, as all social practices embodying gender-based discrimination against women including Sati,[3] child-marriage, dowry, polygamy, and polyandry continued unabated among different sections of communities in the country right up to the early part of the 20th century, although there are ample evidence of marriage by choice, informal marriage and widow-remarriage taking place as well as of women taking part in political affairs.[4]

2.2. *Issue of land rights in post-independence India*

Land right has assumed considerable importance in women's empowerment because it enables a women to earn an income which makes her economically independent. This in turn enables her to acquire the bundles of goods that she requires for her poverty alleviation, to take control of her own life and be empowered.

According to Panda and Agarwal (2005), there are several problems with using employment as an indicator of the economic status of women. First, those who work in their family farm do not earn any income and hence their status in the family does not improve. Also those who work on a casual basis do not have the regular income required to make a difference to their economic and consequently to empowerment status. They further argue that those who have regular employment may not improve their

[3] The term "sati" refers to women who accept self-immolation at the funeral pyre of their dead husbands even against their wishes. By accepting this practice, a women provided the society with the proof of her unflinching devotion to her husband even after his death. The society bestows on her the title "Sati" (meaning 'pure women') by which she will be remembered after her death. Lord William Bentinck who became the Governor-General of India in 1829, abolished this pernicious social institution in 1829.

[4] A detailed account of social and economic status of women in India during a period of 5,000 years is virtually impossible to obtain. Hence, we have used the following source to obtain some information: See, R.C. Majumdar, H.C. Raychauduri and K. Dalta, *An Advanced History of India*, MacMillan & Co, Madras, India, 1991.

status within the family if their levels of income are higher than those of their husbands or brothers.

The implications of these arguments are that those women who are employed, and without any income, and those who are employed with income levels higher than those of their husbands and other male members in their families seem to suffer from more discrimination in their families. We can also further infer from Panda and Agarwal's argument that women who earn some income but their levels are below the levels of their husbands or other male members in the family seem to experience less gender-based discrimination than other women. But those women who own land and/or a house tend to find their status within their families greatly improved. Hence there arises the need for land rights.

2.3. *Women and the current state of inheritance rights*

Even if a person buys or inherits land or a property through legal means, that person will still have to secure customary rights to those properties. It is more difficult for women to secure such rights than for men because the vast majority of poor women in rural India are illiterate and have no knowledge of their inheritance rights. Furthermore, the society to which their households belong has to recognise their inheritance rights to the parents' property. If a poor woman is one of several other claimants to a share of the ancestral property, then that woman also has to seek the support of other claimants to her demand for a share of her ancestral property. Apart from these difficulties, a poor woman may not get the same fair treatment as provided for a male claimant to a property's share by the government officials and legal institutions (Agarwal, 1989, 1994).

Let us now look at the current process of establishing one's inheritance rights to his or her parent's property. Traditionally land titles are in the father's name. Assume that the father of a family of five persons has passed away. For the inheritance rights to the house and the property to pass on to the mother and the three children under Indian succession law, succession certificates which will legitimize the legal rights of the four persons will have to be procured through the law court. In this case the mother has to agree that the three children will be legal owners of the property. If one of the three children is a daughter and the other three do not want her to be a part owner of the property, then the dispute can only be resolved through a lengthy legal battle.

Since India's independence, the following attempts were made to provide legal recognition to women's rights to property ownership including land (Basu, 2004):

(i) The Hindu Women's Right to Property Bill;
(ii) The Hindu Women's Right to Property (Amendment) Bill; and
(iii) The Hindu Women's Estate Bill.

The only effective Acts which remain valid today are the Indian Succession (Amendment) Act 2002 and the Hindu Succession Act, 1956, both of which recognize the right of women to inherit property of an intestate equally with men and the abolition of life estate of female heirs (Government of India, 2005).

The main reasons for land and other properties including houses receiving primacy in Agarwal's writings (1994a,b) over income as the most important factor facilitating women's empowerment are the following:

(i) Land creates a permanent source of income for women whereas income in the form of wages, in the case of a poor and unskilled woman, is mostly casual (non-permanent) and considerably lower than the income that can be obtained after cultivating a block of land per year.
(ii) Since the supply of cultivable land within the geographical boundaries of each province is limited, the increase in demand resulting from higher economic growth and rising population greatly increases the monetary value of the land, thereby enhancing the value of the women in her marital home as well as in her natal home, if she lives there.
(iii) The ownership of land and other assets considerably reduces a woman's vulnerability to shocks such as the death of her husband or sickness of her husband, son, or daughter and to risk such as expenses for weddings (Vehhicio and Roy, 1997).

The same arguments are valid in the case of ownership of other properties such as a house and of assets such as jewellery.

However, even if we assume that a poor woman in rural India possesses both legal and customary rights to her ancestral land, she may not be able to cultivate the land due to lack of finances to ensure first an

adequate supply of food at home and secondly, to purchase the necessary inputs including labor.

Furthermore, a woman with sufficient finances may not be able to procure labor and other inputs because of the enforcement on women of the rule of patriarchy in the rural sector in India. India's female-headed households which account for 10 percent of total households in the country have been badly affected by this social institution (custom) which accords women a social status inferior to that accorded to men (Agarwal, 1989, 1994; Roy, 2006; Chen, 1989). It should also be noted that female-headed households in India are mostly landless and land-poor and accordingly, relative to men, a higher percentage of female heads depend on wage labor. Hence these women are more poverty prone than male heads of households.

2.4. *Women in the total population in need of land rights*

Land rights can become a crucial factor in women's empowerment in India, if the proportion of total women who require land rights to alleviate poverty and gain control over their own lives is large. Hence let us examine this issue.

On the basis of the castes to which they belong, the total Hindu population of India can be broadly classified into the following four categories:

 (i) upper caste
 (ii) other backward caste
 (iii) scheduled caste
 (iv) scheduled tribes

Women in the landholder upper caste families, as well in many other backward caste (OBC) families, do not work in the agricultural field. Hence the need for land rights may not be so important to the women of these two groups of families, which together account for the vast majority of the total population in the country. Many scheduled caste families are landholders but women of these families usually do not work in the agricultural land because these families tend to settle in villages where upper caste landholder families live and because the rules of "patriarchy" also apply to women belonging to scheduled caste families just as they apply to women of upper caste families. Some women from the landless scheduled caste families do go out of their homes to collect non-market

goods from the village commons and to work in agricultural lands of land-holder families where such work by women is socially accepted.

However, the overwhelming majority of tribal families does have homesteads but does not possess cultivable land. In tribal communities, social customs allow women to go out of their home to work in agricultural field. Customary inheritance rights in different tribal communities may prevent women from inheriting a part of their ancestral land. Hence, both legal and customary land rights are important for helping tribal women to gain control over their own lives and to enjoy substantive freedom.

So what is the size of this tribal female population in India? On the basis of 2004 data (World Bank, 2005), we have estimated that out of a total Indian population of 1,112 million, the number of females stood at 536.14 million which accounted for about 48.2 percent of the total population. The total tribal female population which stood at 44.39 million accounted for 8.27 percent of the total female population in the country, but they accounted for only 4 percent of India's total population (male and female) in 2004. Hence, only a very small proportion of India's population genuinely do require land.

2.5. *Granting land ownership to landless women: Ground realities*

Economists and scholars from other disciplines who have consistently argued for the granting of land rights to poor landless women in rural India have failed to consider the institutional environment relating to land transfer in rural India.

Poor rural women can acquire land ownership in three ways:

(i) They can purchase land from other landholders.
(ii) The state can distribute land to landless women from unused state property.
(iii) The state can determine the maximum size of land holdings per family on the basis of the number of members living in each family, confiscate the surplus land from any family holding excess land and distribute that land to landless women.

However, poor landless women do not have enough money to buy land. In the Indian Constitution, land was placed under the jurisdiction of respective provinces (Basu, 1991). Out of all provinces only in West Bengal and

Kerala, the communist-led governments implemented some land reform measures and transferred land titles to landless families and not to women during the 60 years since India's independence. According to the village tradition, male heads of families became the legal and customary owners of these newly acquired lands. Since the early 1990s, three new tribal provinces were carved out of India's three largest provinces to satisfy the demands for homeland by tribes in these states. The governments of these provinces which are run by tribals, have done nothing to empower land-less tribal women by granting them land ownership. Even in provinces where the rules of matriarchy prevail, the issue of women's land rights did not receive any serious attention.

Within this institutional scenario, since it is difficult to establish property rights for landless women, the state can at least try to secure the tenancy rights of these women who are working on land of other land owners and their ability to sell the ownership rights where they own a property jointly with other members of their families.

However, the number of women working as tenant farmers is small in the country. Hence, ultimately, creating opportunities for women to earn outside agriculture, an income on a regular basis is most essential for helping women to alleviate poverty and take control of their own lives.

In urban areas, women's right to ancestral property (land and house) is not that an important issue. With the spread of education among members of urban families, daughters tend to inherit their share of their parents' property. In the rural sector also, educated sons tend generally not to object to the transfer of the rightful share of the parents' property to the daughters. It seems therefore that too much importance has been given to woman's land rights for their empowerment.

3. Women's Employment and Income

As part of the annual series in the 60th round of the National Sample Survey Organization (NSSO), an all-India survey on the situation of employment and unemployment was conducted during January to June, 2004 with a reasonably large sample of households. The survey results reveal the presence of large rural-urban and male/female divide in employment and wages as well as in literacy. Between the rural and urban segments, there are differentials among the usual principal status, current weekly status and current daily status of unemployment. The principal usual

Table 4.1: Employment and wage status of male and female populations, 2004.

	Total usual status					
	Rural			**Urban**		
	Total	**Male**	**Female**	**Total**	**Male**	**Female**
1. Percentage of total population in labor force	44	55	32	37	56	16
2. Percentage of usually employed as self-employed	—	57	62	—	44	45
3. Percentage of usually employed who are in agriculture	—	66	84	—	—	—
4. Percentage of usually employed in urban areas working in:						
(a) tertiary sector					59	53
(b) secondary sector					35	31
5. Average wage per day of casual labor (Rs)		56.53	36.15		75.51	44.28
6. Share of female casual wage in male casual wage per day (percent)			63.94			58.64

Source: Government of India (2006) Economic Survey 2005–06, New Delhi, Government of India.

status refers to the unemployment on an average in the reference year. The main features of the results of the survey are presented in Table 4.1 (Government of India, 2006).

It can be seen from the table that while 44 percent of the total population in the country were in the labor force, only 32 percent and 16 percent of all rural and urban female population were in the labor force. Alternatively, 68 percent of all female population in rural India and 84 percent of all urban female populations were not in the labor force. Also the labor

force participation rate for female labor stood at 45.2 percent in 2003 (World Bank, 2005).

In other words 54.8 percent of women in the labor force were not actively employed as labor. This figure compares very unfavorably with 20.8 and 16.1 percent for China and Cambodia in the same year. What are the reasons for this trend?

The reasons for this trend may be found in the following:

(i) If a large population of women suffer from acute economic poverty, the labor force participation rate of women in a country would tend to be high. This argument can very well apply to women in Cambodia, but certainly not to women in China. The low labor force participation rate of women in India can be the result of better economic conditions of women in India.

(ii) Although a vast proportion of women in the labor force do suffer from acute economic poverty and want to participate in socially visible and socially recognized economic activity, they cannot do so because of the enforcement on them of rules of "patriarchy". These rules are more comprehensively applied on women in the upper caste and other backward caste families than in the scheduled caste and tribal families.

(iii) Women cannot increase their participation rate in the labor force due to lack of employment opportunities.

(iv) Many women in their natal, as well as in the marital home, want to be economically independent to earn a greater freedom and accordingly register their names to be counted in the labor force but do not seek to actively participate in the labor force because of the cultural conditioning which instills in their mind a kind of fear or apprehension about what society would say about them and their families if they go out of their home and work for employment. So, they become subservient to their masters, the patriarch or matriarch; and in their later life they also enforce the same rules on their own children that they had to abide by. This situation is prevalent in villages and rural towns.

Of the four reasons, the second, third, and fourth reason explain why the proportion of women in the labor force, and the proportion of women in the labor force who are active participants in economic activities, are so low in India compared to China.

Table 4.1 also illustrates all other aspects of employment where women have fared worse than men. Rows 3 and 4 show that 84 percent of rural women who are usually employed are in agriculture compared with 66 percent of rural men. This implies that for women, the opportunities for employment in non-agricultural activities are very limited. Among the usually employed in urban areas, 53 percent are employed in the tertiary sector compared with 59 percent of men and 31 percent are employed in the secondary sector, compared with 35 per cent of men.

The reasons for this trend are that urban women are more educated than rural women and there are more jobs for them in the teaching profession, public service, banking, nursing, etc. in urban areas than in rural areas. Accordingly, the difference between the urban male and female employment rate among the usually employed in the urban sector is small.

Row 5 relates to the differences in the casual wage rates of female and male laborers in rural and urban areas. The gap between the female and male labor wage rate is wider in urban areas than in rural areas. Row 6 shows that the ratio of the female casual labor wage rate to the male casual labor wage rate declined from 68.94 percent in rural areas to 58.64 percent in the urban areas. Another study (UNDP, 2005), after estimating the average annual income of male and female laborers on the basis of purchasing power parity (PPP), estimated the ratio of female to male earned income.

3.1. *Other aspects of women's employment status*

(i) *Nature of women's employment*

While in rural India the overwhelming majority of employed women are in the agricultural sector, in the urban India, poor illiterate women mostly are employed in the informal sector. Between 1995 and 2002, 41 percent of the total urban informal sector employment was taken up by women. These informal sector jobs are very insecure and wages are low. Although women, in general, spend about 35 percent of their total daily time on market activities reflecting the lower work force participation rate for women relative to that of men, women spent about 65 percent of their total time on non-market activities for which they receive no monetary reward. Men on the other hand spend only about 8 percent of their time on

non-market activities. Thus, men earn more income than women, and enjoy the fruits of free labor provided by women members of their families. Women are also adversely affected by lack of opportunities for them to acquire new skills to obtain better employment and income. The level of unemployment of men and women tends to vary sharply across states. In several states where wage rates have been pushed up due to the fixation of minimum wage rates for labor, in both the agricultural and industrial sectors, there also had been a high incidence of unemployment in general.

In the organized industrial sector, the trade unions could force the employers not to reduce the level of employment. This benefited male laborers favorably, but in the agricultural sector where the vast majority of poor women were employed, the minimum wage rule which was informal, was enforced on landholder families by informal agents of the state. Since the agricultural wage in India is paid in cash and also in kind (a breakfast during the morning tea time and a late afternoon lunch), the increase in cash wage also increased the total cost of rural labor. Hence, the overall cost of the minimum wage to the landholder's family was considerably higher than the cash component of the wage.

Furthermore, the informal agents of the state also imposed restrictions on the movement of labor from one village to another, thereby, forcing the landholder's families to hire labor (mostly male labor) from the same village to which the cultivators belonged. Previously, under a competitive labor market, the village labor had to compete with laborers from their nearby villages (both males and females) and from tribal villages. The result was that the productivity of the village labor fell and thousands of tribal female and other non-tribal female laborers lost their jobs.

Leaving aside the 7 percent of workers in organized industries and in services who earn regular salaries and wages, work under a formal contract with their employer and who are mostly unionised, the other 93 percent of the country's work force, including the vast majority of poor women, are employed in unorganized informal sectors. These women work on informal casual contracts at wages boarding on starvation (Harris-White, 2004).

It is virtually impossible to obtain an accurate estimate of the number of women employed in the informal sector, their wage level, and working conditions. The information (Government of India, 2005) available to us suggests that the majority of women workers are employed in rural areas, 87 percent of them are employed in agriculture as laborers and

cultivators. In the urban sector, 80 percent of women workers are employed in informal (unorganized) sectors such as household industries, petty trades and services, and building and construction.

In 1993, out of a total employment of 27 million people in both the organized public and private sectors, women's share was roughly 5 million (GOP, 2006) (Government of India, 2005). This accounted for only 18.5 percent of total organized sector employment. Of these 5 million women, 2.9 million were employed in organized public sector and 2.1 million were in organized private sector.[5]

(ii) *India's labor market institutions*

Although Indian labor laws, which are highly protective of labor and make the Indian labor market relatively inflexible, apply only to the formal labor market (organized sector). They have greatly restricted labor's mobility and have promoted capital-intensive methods of production which in turn have adversely affected the long run capability of the organized sector to maintain a healthy growth in demand for both male and female labor. The laws which made the labor market flexible are The Minimum Wages Act, 1948; Payment of Wages Act, 1936; Payment of Bonus Act, 1965 and the Boards and Contract Labor Act, 1970 (Government of India, 2005b). Furthermore, since the Indian Constitution placed labor in the concurrent list of subjects, the labor force within the geographical boundaries of each province is subject to the labor laws of the central government.

Furthermore, in an enterprise the organized labor supply may be controlled by more than one trade union because in democratic India there are innumerable political parties, and there are innumerable trade unions affiliated with these parties. Moreover, there are enterprise-based unions and employment type based unions.

All such controls over the labor force further weaken the capacity of enterprises to create greater job opportunities. Also, unless there are separate unions for women, women's chances of receiving fair treatment from union leaders and from employers are marginal.

[5] In India any organization employing 10 or more persons is placed under the organized sector. Once an organization is included under the organized sector, the possibility of forming a labor union in that organization rises greatly.

The actions of these unions co-opted by political parties have led to the overstaffing of public sector enterprises, thereby significantly undermining the efficiency of these enterprises (World Bank, 2005a,b,c; Basu, 1991; Government of India, 2006a,b; UNDP, 2005; Harris-White, 2004).

China, which had a history of extreme employment security, has drastically reformed its labor relations and created a country whereby workers became highly mobile. This high labor mobility also facilitated the sustainability of high rates of economic growth which in turn enabled millions of semi-skilled women and those previously laid off by the liquidation by the Chinese government of many inefficient state enterprises to be newly employed as well as re-employed.

(iii) Caste-based stratification of women

Hindu women in India are not a monolithic group. They are stratified by the castes to which they and their families belong. Consequently, their extra-household mobility to look for employment or for other social interactions is still conditioned by the customs pertaining to their respective castes, despite the fact that the force of caste-based customs on women's extra-household mobility in economic and social sphere has diminished considerably due, among other things, to the expansion of education.

In Fig. 4.1 we present the broad stratification of women into various castes.

Women and their families belonging to the lowest castes (untouchables), scheduled castes, tribes, and other backward castes are by and large poor; and consequently, caste-based customs allow these women extra-household freedom to engage in economic and social transactions independently of their husbands or other male members of their families. Caste-based customs do not allow a vast proportion of women belonging to upper caste families, which are mostly well-off both economically and socially, the same extra-household freedom as enjoyed by lower caste families.

The other reason for these women to be looking for employment or engaged in employment could be that these women are happy and contented to be traditional housewives bringing up children and devoted wives subservient to their husbands and other superior members of their families. These women, it would appear, are not too concerned about the absence of income and of extra-household freedom.

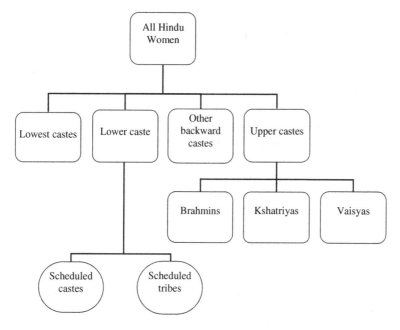

Figure 4.1: Stratification of Indian Hindu women in various castes.

From the discussion above one can reasonably argue that while for millions of poor women, property ownership and/or income are crucial to their empowerment, for many other millions, these may not be so important.

3.2. *Income and assets in household bargaining*

In Chapter 2 we discussed whether women's income and/or asset ownership can increase women's bargaining power in intra-household resource allocation. Much of the discussion referred to the Indian situation. It was argued, on the basis of results of empirical research that women's income and/or assets do not seem to increase women's bargaining power in intra-household decisions. The results of Tisdell and Regmi's (2004) field work in rural Orissa in India reveal that wives who contribute a greater cash income to their family are in fact less empowered than wives who contribute less. It was also found that the education of wives does not necessarily empower them within families and that wives with no education are more likely to be involved in family decision-making than those

who have an education. Their study further suggests that women who are involved in family decision-making tend to have some control over family resources.

The results of an extensive field survey in Tamil Nadu, India by Lakshmanasamy and Roy (2006) reveal that in India the human capital (education) and dowry (assets) which a women brings with her to her marital home does not tend to increase her bargaining power in household decision-making regarding resource allocation.

Nandal's (2006) study of women workers in a construction industry in the unorganized sector in Haryana province in India found that although generally within the family, the husband's status is superior to that of his wife and the major decision-making role is played by the husband, the situation appears to be different in families where women earn income and contribute that to the families' income pool. Out of 528 female respondents in the field survey, Nandal found that for 38.64 percent of women, the majority of household decisions were taken by their husbands. In case of the 34.28 percent women, the decision was taken jointly by the husband and wife and only 16.10 percent of women reported that they had to take all the decisions. These women were heads of their families. Hence, what this study suggests is that even if the wife in a family is earning income, the decision-making power is mainly exercised by the husband.

The present author's observation[6] of women's status in rural and urban Bengal in India suggests that caste-based customs greatly influence women's status in most families. In poor families belonging to lower castes, the need for income enables women to successfully bargain for extra-household freedom to engage in socially visible income earning activities while bargaining away at least a considerable proportion of their intra-household freedom in allocation of household resources. As incomes of these families rise, due to the larger income earned by male members, the need for women's income is lessened and women are forced to bargain away their extra-household freedom while not necessarily gaining intra-household decision-making power. On the other hand, in economically well-off families mostly belonging to upper castes and to some other backward castes (OBC), women, including many of those who are educated, bargain away their extra-household freedom after they enter their

[6] Information obtained through private conversation with women from lower caste and upper caste families in Salboni (tribal territory), Midnapore town, and in Calcutta (Capital of West Bengal Province) in India during my field work in 1999; 2000; 2001 and 2006.

marital home in exchange for some intra-household decision-making power in the intra-household resource allocation. Since these families do not require financial support from these women to maintain their current living standards, they tend to treat those women well who stay inside their homes. Of course, in the intra-household decision-making power sharing, if a woman's view is directly in conflict with that of her husband or of the family head, then that woman's view is not accepted by the male decision maker.

In nuclear families, where both the husband and wife are working for economic need and are educated, women tend to enjoy considerable extra-household and intra-household freedom and decision-making power. Nevertheless these women are also subordinate in status to their husbands or their family heads. Hence income alone cannot facilitate women's empowerment because it is the social institutions (customs, traditions) which determine how much extra-household and intra-household freedom can be granted to a women (Kantor, 2003). In other words, as women in India's "patriarchy" are treated as caretakers of and subordinates to male members, and as they are perceived as the property of their husbands and fathers, they cannot decide what is good for them. It is also found that as household wealth increases, the survival chances of women drop (Harris-White, 2005). Wealth creation and property accumulation tend to benefit men disproportionately.

4. Dowry, Assets, and Violence against Women

In Chapter 2, various reasons have been put forward to explain why the "Dowry" as an institution still persists in the Indian subcontinent. It is also suggested that the main reason for the payment of the "dowry" by a bride's family is to deprive the girl of a share in the family's immovable property (land, house, etc.). Also the dowry is a means by which the family of the bride aims to enhance its social status — by establishing a relationship with the family of the groom which may possess greater wealth and may belong to a higher caste compared with the bride's family (Srinivasan, 2005).

In the informal marriage market in India, the groom's price is determined by the socio-economic status of the family, his academic qualification and income earning capacity. Hence, the conventional economic principle applies also in the marriage market, in the sense that the dowry, which contains utility functions of all members of the groom's family, must

belong to that family. Srinivasan (2005) found a linear causal relationship between the post-1991 economic reform which facilitated India's high growth outcomes and the rise in dowry amounts in both cash and kind. One can, therefore, see that the reasons for the dowry are varied; and one or several of them can apply to individual cases in India.

4.1. *Dowry-related torture and murder*

If the dowry is considered as an asset owned by the bride's marital family, then the women cannot exercise any bargaining power in her dealings with her husband and other members of her marital family. Consequently, the failure of the bride's parents to meet the rising demand for the dowry, even after the original dowry amount had been paid, has led to the torture and murder of the bride by the groom's family members including, in many cases, the groom himself.

No correct official estimate of dowry-related deaths is available as many deaths are not reported. A conservative estimate by Stowe and James (1995) placed such deaths at around 2,000 per year. Although the majority of such deaths occur in North West India, these are well spread throughout the country. However, in many cases such deaths are the culmination of domestic violence against women in their marital home due to the failure of their parents to fulfil their dowry requirements.

Generally, women are subjected to physical and sexual abuse in greater proportion in rural areas than in urban areas. The latest statistics available from the National Family Health Survey (The Statesman Weekly, March 10, 2007) reveal that 62.2 percent of women in urban areas and 58.5 percent of women in villages experienced trauma due to physical violence committed against them in Bihar. The all India average rate of domestic violence against women is 40.2 percent in rural India.

The primary reasons provided by these women for such suffering are lack of education and non-compliance by their parents with ever increasing dowry demands by their marital families. Thus one can justifiably argue that as long as these women are valued in their marital homes only as the medium of property transfer from natal to marital homes, women would continue to be subjected to harassment and physical abuse leading eventually to their death in many cases.

4.2. *Infanticide, abortion, and missing women*

The population pressure, greater earning power of men, strong desire to have a male child to carry forward the family name and to act as a social safety net for parents appear to have combined together to contribute to the deliberate death of female babies. Worldwide estimates suggest that for each 100 men there should be 102 women. Although this pattern is widely prevalent in developed countries, it appears to be not so in developing countries where the female to male ratio has been consistently declining. It is possible that many women may not have been counted and others may have died due to complications during childbirth or inadequate supply of food and health care in the family which can be a direct result of lack of intra-household bargaining power. Millions of girls are missing through more frequent abortions of female foetuses, infanticide, and neglect of female babies.

A study (Derze and Sen, 1989) placed the total number of women missing in the world and in India in the early 1990s to be 95 million. The availability of medical facilities to pre-determine the sex of a child before birth is enabling thousands of couples to seek an abortion of female foetuses, which in most cases is performed illegally by providers not using proper medical procedures. In rural India in the late 1980s, about 69 percent of all abortions were performed illegally (Duggal, 2004). These abortions are tantamount to physical violence committed against women and they expose women's vulnerability to such violence, as women, by and large, do not willingly tend to accept such a course of action. The sex ratio of females per thousand males in India continued to decline from 972 according to the 1901 census to 926 according to the 1991 census (Government of India, 2005c). Although the ratio increased to 933 in the 2001 census, the level of infanticide and abortion seem to have been rising rapidly again.

4.3. *Vulnerability to other risks*

Single women (unmarried or widowed) are more vulnerable than married women to various types of harassment by male relatives. This may take the form of very costly litigation which could force them to mortgage their land to pay for legal expenses and eventually to lose their rights to land (Agarwal, 1989).

Poor women are also vulnerable to the risk of being beaten or murdered by men to prevent them (tribal women) from exercising their customary rights particularly in Bihar Province (Kishwar, 1987).

While poor low class caste families are generally subjected to economic and social oppression because of their low social status and weak economic power, the women of these families because of their gender are more vulnerable to harassment and rape by upper class landlords to suppress expected female militancy and the militancy of men dishonoured by the violation of women in their families. This trend is particularly pronounced in Bihar. Women are also vulnerable to risks of the sudden death of their husbands or 'keepers', sudden sickness of themselves or children or their keepers; the inability to pay for loan repayment to money lenders; the inability to secure loans for meeting sons' and daughters' wedding expenses and of systematically being beaten or slapped in their face by their husbands or keepers. There are, however, no correct estimates of the total number of such instances. In its assessment of vulnerability of the poor, the World Bank (2001) has used the following indicators:

 (i) Urban informal sector unemployment;
 (ii) youth unemployment;
 (iii) children in the labor force;
 (iv) female headed households;
 (v) pension contribution; and
 (vi) private health expenditure.

India's performance in each of these indicators is presented in Table 4.2. As the table shows, between 1995 and 2002, out of the total employment in the urban informal sector, female laborers accounted for 41 percent compared with 54 percent for male laborers. The proportion of total children between the 10–14 age group in the labor force declined from 17 percent in 1990 to 11 percent in 2003.

The share of female headed households in the total households hovered around 10 percent and did not decline at the end of 1998–99. In the early 1990s, only about 8 percent of the working age population contributed to pension schemes. Hence the proportion of working age female population who contributed to the pension scheme would have been very marginal indeed. On the other hand, private health care expenditure which causes greater hardship for women than men reached almost 79 percent of the total private health care expenditure in 2002.

Table 4.2: Indicators of vulnerability of India's poor.

Country	Urban informal sector employment % of urban empowerment		Youth unemployment		Children labour force (% in ages 10 to 44)		Female headed households		Pension contributions			Private health expenditure
	Male 1995–2002	Female 1995–2002	% of male labor force	% of female labor force	1990	2003	Year	% of total	Year	% of labor force	% of working age population	% of total 2002
India	54	41	NA	NA	17	11	1998–1999	10	1992	10.6	7.9	78.7

Source: World Bank (2005), World Development Indicators 05, Washington DC: World Bank.

5. Gender-related Development Indicators and Deprivation Scores for Women

In Table 4.3 we present selected gender empowerment indicators for women in India and China.

It can be seen from the table that in India except for "Life expectancy at birth", the scores for women in all other indicators are considerably lower than those for men. Also the other interesting point that emerges from the table is that in all indicators, China's scores are far superior to those of India.

Table 4.3: Selected gender empowerment indicators: India and China.

Value	India	China
1. Gender-related Development Index (GDI)		
(a) Rank	98	64
(b) Value	0.586	0.754
2. Life expectancy at birth (2003)		
(Years)		
(a) Female	65	73.5
(b) Male	62	69.9
3. Adult literacy rate (2003)		
(% ages 15 and above)		
(a) Female	47.8	86.5
(b) Male	73.4	95.1
(c) Female rate as % of male rate	65	91
4. Net primary enrolment (2002/03)		
(a) Female ratio (%)	85	N/A
(b) Ratio of female to male rate	0.94	N/A
5. Gross tertiary enrolment (2002/03)		
(a) Female ratio (%)	10	15
(b) Ratio of female to male rate	0.68	1.69
6. Youth literacy (2003)		
(a) Female rate (% ages 15–24)	68	99
(b) Female rate as % of male rate	80	99
7. Ratio of estimated female to male earned income	0.38	0.66
8. Inequality in economic activity.		
Female economic activity as a % of male rate (2003)	50	86
(Ages 15 and above)		

(Continued)

Table 4.3: (*Continued*)

Value	India	China
9. Inequality in time allocation (%)		
(a) Time spent by women		
(i) Market activities	35	N/A
(ii) Non-market activities	65	N/A
(b) Time spent by men		
(i) Market activities	92	N/A
(ii) Non-market activities	8	N/A
10. Women's political participation (% of total) 2005		
Seats in parliament held by women		
(i) Lower House	8.3	20.2
(ii) Upper House	11.6	N/A
(iii) Women at Ministerial level	3.4	6.3

Source: UNDP (2005), *Human Development Report,* New Delhi: Oxford University Press.

Now in Table 4.4 we present the gender-based deprivation scores for Indian women on important indicators. Among the nine indicators that we have used, in one of them, "mean years of schooling", the deprivation level of women is low. In the other indicators, the deprivation levels are medium. Hence, it appears that the deprivation levels of women at large in India is neither very low nor very high and that there is an urgent need to further lower the deprivation level. It can also be seen from the table that in a number of indicators the deprivation levels of men are lower than those of women.

6. The Constitution, Law, and the Indian State

In Part III of the Indian Constitution, Articles 12–35, deal with citizens' fundamental rights which include, among others, the right to equality including equality before the law, prohibition of discrimination on grounds of religion, race, caste, sex or place of birth, and equality of opportunity in matters of employment; the right against exploitation and the right to constitutional remedies for the enforcement of fundamental rights (Government of India, 2005b,c).

Table 4.4: Deprivation scores for women in India.

Year	Indicators	Total	Raw value		Deprivation scores		Deprivation levels for women			Comments
			M	F	M	F	High	Medium	Low	
2003	Adult literacy (% of age 15 & older)		68	45	0.33	0.57	Medium	—	—	Lower score indicates lower deprivation rate
2003	Mean years of schooling		10.1	9.9	0.33	0.31	—	—	Low	Lower score indicates lower deprivation rate
1998–2000	Total educational attainment deprivation		—	—	0.32	0.47	Medium	—	—	Lower score indicates lower deprivation rate
2003	Life expectancy at birth		63	64	0.35	0.43	—	Medium	—	Lower score indicates lower deprivation rate
2000–05	Fertility rate (no. of births per woman)		—	3.1	—	0.68	—	Medium	—	Score very close to 0 indicates very low fertility rate
2000	Maternal mortality rate (per 100,000 live births)		—	5.4	—	0.73	—	Medium	—	Score very close to 1 indicates very low maternal mortality rate

(Continued)

Table 4.4: (*Continued*)

| Year | Indicators | Total | Raw value | | Deprivation scores | | Deprivation levels for women | | | |
			M	F	M	F	High	Medium	Low	Comments
1995–03	Contraceptive prevalence rate		48	—	—	0.46	—	Medium	—	The lower score indicates higher use
2003	Female's share in total labor force		—	32.6	—	0.51	—	Medium	—	Higher score indicates lower participation rate
2003	Labor force participation rate for women (between the ages of 15 & 64)		—	45.2	—	0.62	—	Medium	—	The lower score is better

Source: World Bank (2005a), World Bank (2005b), UNDP (2005).

Upholding women's right to prohibition of discrimination on the ground of sex and caste requires the state to formulate appropriate laws, the judiciary to uphold these laws and the state's administrative apparatus to apply measures to give effect to these laws.

6.1. *Laws affecting women's property rights*

After India's independence from the British Rule in 1947, the task of reforming the Hindu Law by the Congress Party led government became very difficult because many leading members of the Congress Party did not want this law changed. Hence, there were some cosmetic changes to the law which did not genuinely strengthen women's rights relative to those of men. Therefore, while under provision of 5.15 of the Hindu Succession Act 1956, sons and daughters were given equal rights, the state also maintained the coparcenary system which resulted in the denial of rights to women in their ancestral home and property. As a result, compared with the brother's share in the ancestral home and property, the sister's share was miniscule. The property inherited by a son becomes a separate property and daughters can have equal rights only in a separate and self-acquired property of their father.

Although the Hindu Marriage Act of 1955 was based on a formal concept of equality where the spouses were deemed equal and had equal rights and obligations toward each other, it required Hindu women to maintain their husbands and denied them the right to divorce their husbands by mutual consent. The court also, in interpreting this Act, continued to undermine a women's right to engage in income earning employment against their husband's wishes under the ancient notion of a husband being the lord or master of the house. Hence, it would appear that the State and the judiciary acted in unison to deprive women of their right to the ancestral property, to freedom of movement, and to engage in gainful employment in whatever location it is available. However, the Supreme Court in a recent judgement (Hasan, 2004) on gender equality within personal laws, held that the personal laws conferring inferior status on women are anathema to equality. Personal laws have been derived not from the constitution but from a sense of equality and from the religious scriptures. The laws thus derived must be consistent with the constitution lest they become void under Article 13 if they violate fundamental rights.

6.2. *Laws relating to the prohibition of dowry*

Although the anti-dowry movement began in earnest in India since the early 1950s, the Dowry Prohibition Act (Act XXXVIII of 1961) was passed in the Parliament in 1961 and began to be enforced from July 1961. It failed to realize its objective because Section 3 of the Act penalised both the persons offering and receiving a dowry; and Section 7 made the offence non-cognizable, thereby preventing a magistrate to act suo moto. In making the law effective one had to make a complaint, the groom who received the dowry would not file a complaint against himself. On the other hand, the bride's parents also could not file a complaint, knowing fully well that if they file a complaint, their daughter for the rest of her life in her marital home would suffer from physical and psychological torture which ultimately could force her to commit suicide.

The Dowry Prohibition (Amendment) Act, 1984 made the "dowry taking" a cognizable offence and anyone, including parents, relatives of the bride, welfare organizations, or police, could report such an offence to the court. However, since this amendment was also not enough to stop the ever increasing dowry-related deaths, further amendment was made to the Act in 1986 which, besides increasing the punishment for a groom for receiving dowry, redefined the connotation of the term "dowry death" by making it an offence under the Indian Penal Code (Basu, 1991).

Although this law is being enforced now in a few cases, the practice of "dowry giving" and dowry deaths continue unabated. How can the practice of "dowry giving and taking" be stopped if those who enact the law and those who uphold and enforce the law also commit the same crime of offering and receiving a dowry?

7. Recent State Actions for Women's Empowerment

The Planning Commission (Government of India, 2006) in its midterm review of the Tenth Plan (2002–07) identified such areas of concern as adverse child sex ratio, high infant mortality, wide gender gaps in literacy and wage rates, escalating violence against women, and child trafficking. Although 42 Acts of the central government concerning the welfare of women have been operating, a number of these acts contain gender discriminatory provisions. Hence, the National Commission for

Women (NCW) is currently in the process of removing these discriminatory provisions. Furthermore, to provide immediate and emergent relief to women who are victims of domestic violence, the protection of women from The Domestic Violence Act 2005 came into force in September 2005. Another bill to protect women from sexual harassment is currently in the process of being drafted. However, making laws for women's empowerment is one thing and implementing those laws effectively is an entirely different matter. It is in the area of implementation, that the effectiveness of India's political institutions appears to be weak.

The Indian State has also not been able to raise women's participation in political decision making to any measurable extent as evidenced in row 10 of Table 4.3. The table shows that in 2005, in the lower house and the upper house of parliament, women held only 8.3 and 11.6 percent of total seats. In the same year, only 3.5 percent of the total ministerial positions were held by women. On the other hand in China, in the same year, 20.2 percent of seats in the lower house were held by women; and 6.3 percent of the total ministerial positions were held by women.

In India's decentralized democracy, the centres of political power include the federal government, provincial governments, and local governments consisting of corporations, municipal councils, and village panchayats, the total number of which run into thousands. At the provincial and municipal government levels, women's participation in decision making is visible but at the village level where the discrimination against women on the basis of gender is considerably higher than in towns, women's participation in socially visible and socially recognized decision making is very marginal.

Historically, the state has held the view that women cannot attain empowerment unless they earn income through self-employment activities or by working as employees in other people's organizations. As a result, programs such as "Swabalamban" (self-reliance), and "Support to Training-Cum-Employment" programs (STEP) which have been in operation have helped women's self-help groups (SHGs) to utilize credit with the help of women's organizations for income generating activities. Also provisions were made for women to get trained in such crafts as poultry, bee-keeping, weaving, IT, skill upgrading, and capacity building. The state also has, in recent years, facilitated women to take up employment away from their homes.

8. Population Policy and Women's Health

The improvement in the health conditions of women and children requires an integrated approach which aims on the one hand to substantially lower the rate of population growth and on the other to improve the health status of women.

In pursuance of this approach the Indian State's National Population Policy of 2000 endeavours to achieve net replacement levels of total fertility rate by 2010 through vigorous implementation of intersectoral strategies. If success is achieved in this area, then the state's target of lowering the infant mortality rate to 28 per 1000 live births and that of lowering the maternal mortality rate to 1 per 1000 live births can be achieved. The state currently has adopted a decentralized approach to the implementation of family planning program by allowing the provinces and Union Territories to devise their own programs to suit their individual requirements.

A large proportion of the health care services are currently delivered by NGOs. The state also has made remarkable progress in the implementation of its immunization program for infants and pregnant women for controlling vaccine-preventable diseases such as childhood tuberculosis (BCG), diptheria, pertussis, neo-natal tetanus, measles, poliomyelitis, and wild polio.

Nevertheless, in 2003, India's population growth rate stood at 1.68 percent. The average annual growth rate during 2000–04 reached 1.5 percent. To bring it down to 1 percent, the fertility rate which in 2001 stood at 3 per women will have to be brought down close to 1 percent. The Indian State has relied on voluntary efforts on part of couples to reduce fertility, but social customs and family pressures weakened the effectiveness of this effort as evidenced in the moderate couple protection rate which stood at only 48.2 percent in 1998–99.

One study (Dowling and Valenzuela, 2004) found that among the four major components of family planning: (i) contraceptive supplies, (ii) training of staff, (iii) information, education, and communication (IEC), and (iv) incentive payments, particularly for sterilization, Indonesia allocated more than 60 percent to contraceptive supplies and India less than 30 percent. India spent only 12 percent on IEC and Indonesia spent 38 percent of its budget in all items in this category. Accordingly, Indonesia achieved greater success in reduction in the fertility rate and population growth rate than India.

9. Piecemeal Approach to Women's Empowerment

The Indian State has historically viewed the issues of dealing with women's empowerment as one of creating socially visible employment opportunities for women to earn income. The programs for income generation have helped a small proportion of the total female population who are extremely poor. However, programs for training for self-employment of women cannot succeed unless these women possess adequate capital, low-cost input supply, and marketing facilities for their products.

However, there are millions of women who require wage employment but cannot secure such employment due to gender bias against them in all employment processing and creating institutions. But there are millions of others who do not require employment to procure food and other basic necessities but have very little freedom and decision making power in intra-household and extra-household matters and live under "classic patriarchy". They also need state action to enable them to attain empowerment.

9.1. *Important variables in women's empowerment*

Among all the following variables relevant to married women's empowerment, one can see the overriding dominance of non-economic variables (Mishra and Singh, 2002–03):

(i) Literacy level of married women;
(ii) Married women's involvement in decision making;
(iii) Regular exposure of married women to media;
(iv) Married women not ever beaten or physically mistreated since the age of 15;
(v) Married women with access to money;
(vi) Married women suffering from anaemia; and
(vii) Married women receiving all recommended types of ante-natal care.

Education can empower women by enhancing their level of awareness and perception of their status, by raising the average age at marriage and by encouraging them to make greater use of contraceptives to limit family size. Exposure to the media (such as reading newspaper, watching television, etc.) increases a woman's knowledge about the condition of other women in their own country and in the outside world. A married woman regularly beaten and sexually assaulted becomes powerless, voiceless, and

loses control over her own life. On the other hand, a married woman's access to money without any condition attached to the way it has to be spent, strengthens her empowerment status by enhancing self-confidence and her power in her family's decision making.

These variables cannot be favorable to women in the absence of change in the social perception of women, i.e., in social institutions. The major determinants of the power and position of women in the Indian society are governed by economic variables such as ownership of land and other property, employment or income, control over one's own and one's husband's income, as well as by social variables such as women's access to health care, information, knowledge, education and skills, and most importantly by the degree of freedom enjoyed in decision-making in all economic, social, and political aspects of their lives including the extra-household freedom of movement and interaction with others. A recent study (Kishor and Gupta, 2004) examining women's freedom outside their homes found that out of 84,682 married female respondents, 70.6 percent needed permission from their husbands or family heads to go to market and 78 percent needed permission to meet with friends and relatives outside the confines of their homes. Out of 5,621 unmarried female respondents, only 36.3 percent needed permission to go to market, and 39.7 percent needed permission to meet with their friends and relatives. Among the total 90,303 women interviewed, only 31.6 and 24.2 percent respectively, did not require permission to go to market and to meet with friends and relatives outside the confines of their home.

This important study confirms our view that the Indian State's attempt to empower women has not met with great success because Indian women, by and large, do not seem to enjoy the substantative freedom which is the most fundamental condition for women's empowerment.

10. The Failure of the State in Empowering Women

Chai and Roy (2006) argue that the primary reason for the failure of the State to empower women stems from its failure to change the social perception of a girl being a burden to her natal family because (i) any investment in her education, health care, food, clothing will not bring any return to her natal family as she will eventually be wedded to a suitable groom, (ii) the cost of a wedding of an educated girl is considerably higher than that of an uneducated girl, (iii) her presence as an unmarried young

woman in her natal home tends to bring shame to her family, and (iv) like Chinese parents, Indian parents, by and large, also have a strong preference for sons who will carry forward their family names and look after their parents in their old age.

From this discussion, one can legitimately infer that the root cause of this social attitude to women is the informal or customary rule that a women ought to get married and live in her marital home. Here one can see Victor Nee's (1998) absence of close coupling of this informal rule and the formal constitutional directive granting women the same freedom as the one enjoyed by men. Consequently, the outcome regarding women's empowerment is suboptimal.

The capability of the Indian State to change the social perception of women and to change social rules governing women's behavior with a view to restoring to women their entitlement to substantative freedom is substantially less than that of the Chinese State because of the following factors.

The Indian State which is a federal democratic state, consists of 31 provinces and accordingly the centres of power include one federal government, 31 provincial governments, and hundreds of local governments within each province. The leaders and other members of the governance structure at the vast majority of the centres of power are men and are an integral part of the same society which imposes rules of patriarchy on women. Under both Hindu and Islamic culture in India, customary rules governing women's behavior tend to win over formal rules in case of conflict between the two, particularly in the vast rural hinterland. On the other hand, the governance structure is centralized in China's autocratic state, and the Confucian culture is less rigid than its Indian counterparts, and hence, more adaptive to changes.

In India's decentralized governance structure, the leaders are more interested to stay in power than to pay adequate attention to women's empowerment issues because women have not yet been able to form a powerful lobby group to demand action to eliminate social and economic hindrance to their attaining empowerment. However, following the 73rd and 74th Amendments to the Indian Constitution in 1993 which reserved for women one-third of positions in Panchayat institutions at the village level (Swaminathan, 1999), women's representation in the three-tier structure of elected local bodies is rising.

Nevertheless, women's socio-economic status in general in India has been improving, albeit slowly. Women's control over their own lives is perceptibly better in 2007 than it was in 1950.

11. Recommendations and Conclusion

Social customs imposing gender-based discrimination on women existed in India during the Aryan rule from three millennium BC. Therefore, it is not going to disappear from the Indian society soon. The important factors which have so far acted as a catalyst for women's empowerment are improvements in education, health care, and employment opportunities, all of which are directly dependent on higher economic growth which in turn is dependent on the state according primacy to economic freedom over political freedom in the society and on the capacity of the state to implement policies to promote growth. The state also has to reform its institutions to ensure that the benefits of growth are passed on to women. Robert Barro's study (Roy and Sideras, 2006) found some indication that political freedom is positively correlated with economic growth for lower levels of political freedom but is negatively correlated as a nations approach full democracy. Hence, in a country that has achieved a moderate amount of democracy, a further increase in political rights impairs growth and investment because the dominant effect of the political democracy comes from the intensified concern with income distribution where individual political freedom which is at its highest level seems to impair growth and investment.

The penetration of free-market forces and the growth of economic freedom of individuals genuinely began in 1991 although the country gained political freedom in 1947. At the same time, the forces of globalization have forced the Indian State to lower its barriers to free flow of trade in goods and services. The increased interaction of India with the rest of the world in trade and commerce has also accelerated the country's cultural interaction with the rest of the world and, thereby, has been weakening the power of India's social institutions (Roy and Sideras, 2006). This is a favorable externality stemming from the increased globalization of the Indian economy.

Thus our recommendations are that the Indian State should take measures to:

(i) Remove the most important barriers to the operation of free-market forces in economic affairs, with a view to accelerating economic growth;

(ii) Accord the expansion of education for girls and women, and of community education for family and of society's elders, the priority status within the state's planned objectives;

(iii) Accord also to the improvement in all major indicators of women's health status, the priority status within the state's planned objectives;

(iv) Improve the performance of the governance regime of the state to facilitate women's empowerment; and

(v) Embrace the forces of globalization and further remove the restrictions on the operation of free market rules in the product and labor markets as well as in international trade.

If actions are taken to achieve these goals, then women would be genuinely endowed with the power to take control over their own lives and be empowered. This goal can, in the end, be reached only if women themselves want to be fully empowered. The most important question that needs to be answered then is: Do all women really want substantative freedom from all kinds of subservience to their husbands and other male members in their families? The answer, even in the most industrialized developed economies, would probably be in the negative.

References

Agarwal, B (1989). Rural women, Poverty and Natural Resources: Sustenance Sustainability and Struggle for Change. *Economic and Political Weekly,* 24(43).

Agarwal, B (1994). *A Field of One's Own: Gender and Land Rights in South Asia.* New Delhi: Oxford University Press.

Agarwal, B (1994). Gender and Command over Property: A Critical Gap in Economic Analysis and Policy in South Asia. *World Development*, 22(10) 10, 46–62.

Agarwal, *op.cit.*

Basu, D (1991). *Commentary on the Constitution of India.* Calcutta: R.N. Sarkar.

Basu, M (2004). *Women and Law in India.* New Delhi: Oxford University Press.

Basu, M. *op.cit.*

Chai, JCH and Roy, KC (2006). *Economic Reform in China and India: Development in a Comparative Perspective*, Cheltenham, UK: Edward Elgar.

Chen, M (1989). Women's Work in Indian Agriculture by Agro-processing Zones; Meeting Needs of Landless and Land poor Women. *Economic and Political Weekly*, (24)43.

Dowling, JM and Valenzuela, MR (2004). *Economic Development in Asia.* Singapore: Thompson Learning.

Dreze, J and Sen, A (1989). *Hunger and Public Action.* Oxford: Clarenden Press.

Duggal, R (2004). The Political Economy of Abortion in India: Cost and Expenditure Patterns. *Reproductive Health Matters*, 12(24), 130–137.

Government of India (2005a). *India 2005*. New Delhi: Government of India.

Government of India (2005b). *India 2005*. New Delhi: Government of India.

Government of India (2005c). *ibid.*

Government of India (2005d). *op.cit.*

Government of India (2006a) *Economic Survey 2005–06*. New Delhi, Government of India.

Government of India (2006b). *Economic Survey 2005–06*. New Delhi: Government of India.

Government of India (2006c). *Economic Survey 2005–06*. New Delhi: Government of India.

Harris-White, B (2004). India's Informal Economy: Facing the 21st Century. In *India's Emerging Economy; Performance, and Prospects in 1990s and Beyond*, Basu, K (ed.), New Delhi: Oxford University Press.

Harris-White, B (2005). India's Socially Regulated Economy. *The Indian Journal of Labor Economics,* 47, 50–68.

Hasan, Z (ed.). (2004). *Forging Identities: Gender, Communities and the State.* New Delhi: Kali for Women.

Kantor, P (2003). Women's Empowerment through home-based work: Evidence from India. *Development and Change,* 34, 425–445.

Kishor, S and Gupta, K (2004). Women's Empowerment in India and its States: Evidence from the NFHS. *Economic and Political Weekly*, 39(7), 694–712.

Kishwar, M (1987). Toiling without Rights: Ho Women of Singhbhum. *Economic and Political Weekly,* 24(31).

Lakshmanasamy, T and Roy, KC (2006). Human Capital and Dowry in Household Bargaining and their implications for women's empowerment. Mimeographed, School of Economics, The University of Queensland, Brisbane, Australia.

Mishra, SK and Singh, RP (2002–03). Determinants of Female Empowerment and Reproductive Behaviour in India. *Indian Economic Journal,* 50(3 and 4), 87–98.

Nandal, S (2006). Women workers in unorganised sector: A study on Construction Industry in Haryana. *International Journal of Development Issues,* 5(2), 119–132.

Nee, V (1998). Norms and Networks in Economic and Organizational Performance. *American Economic Review*, 88, 85–89.

Panda, P and Agarwal, B (2005). Marital Violence, Human Development and Women's Property Status in India, *World Development*, 33, 823–850.

Roy, KC (2006). Institutional Deterrents to Women's Empowerment in Rural India. In *Institution, Globalization and Empowerment*, Roy, KC and Sideras J (eds.), Cheltenham, UK: Edward Elgar.

Roy, KC and Sideras, J (eds.) (2006). *Institutions, Globalization and Empowerment*, Cheltenham, UK: Edward Elgar.

Srinivasan, S (2005). Daughters or Dowries? The changing name of Dowry Practices in South India. *World Development*, 33, 593–615.

Stone, L and James, C (1995). Dowry Bride-Burning and Female Powers in India. *Women's Studies International Forum*, 18, 125–134.

Swaminathan, M (1999). Economic History, India, In *The Elgar Companion of Feminist Economics,* Peterson, J and Lewis, M (eds.), Cheltenham, UK: Edward Elgar.

The Statesman Weekly, Calcutta, India, March 10, 2007.

Tisdell, CA and Regmi, G (2004). Economic, Social and Cultural Influences in the Status and well being of Indian Rural Wives, Social Economics, Policy and Development. *Working Paper Series,* No. 40, School of Economics, The University of Queensland, Brisbane, Australia.

UNDP (2005). *Human Development Report 2005*. New Delhi: Oxford University Press.

Vehhicio, N and Roy, KC (1997). *Poverty, Female-Headed Households and Sustainable Development*. CT: Praeger.

World Bank (2001). *World Development Report 2000–01*. New York: Oxford University Press.

World Bank (2005a). *World Development Report 2006*. New York: Oxford University Press.

World Bank (2005b). *World Development Indicators 2005*. New Delhi: Oxford University Press.

World Bank (2005c). *op.cit.*

Chapter 5

Gender, Institutions, and Empowerment: Lessons from China

Jude Howell

1. Introduction

This chapter examines the role of state and non-state institutions in shaping the position of women in Chinese society. It argues that though state institutions have played a crucial role in enabling women's economic and political participation, the essentially top-down approach to women's empowerment has key limitations. The contradictions and weaknesses of such an approach have become accentuated in the reform period as the rise of market forces undermines the capacity of the state to allocate and regulate resources. The chapter begins by providing an overview of women's current economic, social, and political status in China. It then proceeds to examine the role of state institutions in advancing the economic, social, and political position of women. The third section explores the rise of more independent women's organizations in China and their contribution to new perspectives and approaches that query established practices and policies. In the conclusion we reflect upon the lessons from the Chinese case, underlining the salience of both state and non-state institutions in the effective empowerment of women.

2. Overview of Women's Status in China

In this section we examine the economic, political, and social status of women in China. We begin by outlining the situation of women in pre-liberation China, and then move on to introduce the changes brought

about after the coming to power of the Chinese Communist Party in 1949, and then focus our attention on the changes in women's status during the reform period.

Women's position in pre-liberation China was strongly influenced by Confucian norms and values. Within this value framework, women were expected to be obedient first to their fathers, then to their husbands, and later in life to their sons (Curtin, 1975; Davin, 1976). Their position in the family, whether in urban or rural areas, was thus a key determinant of their status in society. In a predominantly rural China, women's lives revolved around their immediate farming household, where they took prime responsibility for child-care, care of the elderly, and particular agricultural tasks. Their lives were oriented inwards, whilst men were focused outwards, as captured in the phrase *"nanren wai, nuren nei"* (men go out and women stay in). In the industrializing parts of China in the 1920s and 1930s, women's insertion into the waged manufacturing workforce, and particularly the textile sector, gave them greater material independence compared to their rural sisters (Hershatter, 1986; Honig, 1986). Nevertheless, they were still subject to a strong gender ideology that positioned women as inferior and less valuable to men.

In pre-liberation rural China, practices such as child marriage, bigamy, and virilocal marriage reinforced the low social status of girls and women. As women in many parts of China moved to their future husbands' household upon marriage, they lacked the social networks built up through childhood that their husbands enjoyed, leaving them more isolated in the village community, without strong allies or friendships. Furthermore, this marriage practice led rural families to lament the birth of a girl, who was seen as a burden on the family, and to prize the arrival of a son, who would labor in the fields and, in the case of the eldest, take care of his parents in old age (Croll, 1983). In this perspective, families were reluctant to invest in the educational or other development of girls as any such investment would be lost to the husband's family. As a result, the educational, social, health, and political status of girls and women was considerably lower to that of boys and men. Sons' healthcare and education was prioritized over that of daughters'. Few girls in rural areas gained basic literacy, let alone had opportunities for secondary education. As women, their health suffered through multiple and often difficult child births and a general lack of basic health care provision. Women rarely enjoyed formal positions of leadership in their local communities, even in urban areas.

This account of pre-liberation China caricatures the situation of girls and women. In reality, the manifestations of gender oppression, the specific forms of gender divisions of labor, and the status of girls and women varied across regions, between rural and urban areas, between ethnic groups, and according to particular historical periods. Nevertheless, this diversity and complexity remained strongly shaped by a Confucian ideology and enduring social practices that treated girls and women as subordinate and inferior to males.

The rise of communist power in 1949 marked a watershed in gender relations in China. Within the first year of power the Chinese Communist Party introduced the first Marriage Law, which prohibited child marriage, betrothal gifts and bigamy, and made it easier for women to divorce.[1] Indeed many of these initiatives reflected the changes the Communists had introduced in the areas they occupied during the 1930s (Davin, 1976). For example, in the Jiangxi Soviet both the Marriage Regulations of December 1931 and the Marriage Law of 1934 defined marriage of free association between a man and a woman and permitted divorce by mutual agreement (Davin, 1976). Also, the Labor Law of the Chinese Soviet Republic gave women the right to maternity leave, equal pay for equal work, and required employers to provide crèches and kindergartens[2] (Davin, 1976). The first women's organizations, namely, the Committee to Improve Women's Lives and the Representative Congress of Women Workers and Peasants, were set up in the Jiangxi Soviet in the 1930s.[3] Through these and other measures, the Chinese Communist Party began

[1] The 1950 Marriage Law included freedom of divorce. Though initially women and men took this opportunity to file divorce cases, the number of divorce cases coming before the courts declined from the mid-1950s. Now that men and women have the freedom to choose their partners, it was officially assumed that there would be little need for divorce (Croll, 1994). Reported divorce figures remained low up till the late 1970s.

[2] However, Davin notes that the Labor Law applied to industry and handicraft workers, who were but a small minority in the occupied areas and so the law probably had little practical significance.

[3] The Committees to Improve Women's Lives were set up from above to propagate Party policies and to gauge the views of women. Though much of their work was devoted to the war effort, they also organized literacy classes for women (Davin, 1976). The Women's Congresses were supposed to be held in every village or district every 3 or 6 months. Each member was elected by 15 to 20 women. These were the most important women's organizations but there is little available material on what they actually did or on their impact (Davin, 1976).

to institute a gender ideology that recognized the structural subordination of women. It was in the occupied areas that the seeds of Chinese Communist gender ideology and practice were first sown.

Faced with the formidable tasks of reconstruction after almost 30 years of violence and social upheaval, the Chinese Communist Party embarked upon a program of comprehensive social and economic transformation. By the end of the 1950s, the new leadership had instituted a range of rural and industrial reforms that sought to collectivize land ownership and nationalize the bulk of industry. The Party mobilized women into these processes, thus drawing them out of the confines of the household into the wider public space. Women rapidly entered the waged workforce and began to assume leadership positions in reform campaigns and in political structures. This was facilitated in part by the establishment of kindergartens, which accelerated at break-neck speed during the Great Leap Forward.[4] The opportunities for schooling for girls increased as the Communist Party built schools in rural areas and promoted an ideology of gender equality. In 1951, for example, the female primary school enrolment rate was 28 per cent. Within 5 years this had risen to 35.2 percent and by 1973 it had reached 40.7 percent (Research Institute of All-China Women's Federation and Research Office of Shanxi Provincial Women's Federation, 1989). However, the pace of change was also constrained by enduring gender attitudes, norms and values, the availability of material resources, and the process of consolidating power and institutionalizing change.

This dramatic shift in gender relations was taken even further during the tumultuous years of the Cultural Revolution from 1966–1976. It was during this period that Mao and his followers harnessed most stridently their version of an emancipatory gender ideology. In line with Mao's adage that "women hold up half the sky", women were pushed even more rapidly into the labor force and political life. Now there were no barriers to women carrying out any kind of work that had previously been done by men. Images

[4] In 1946 there were 1,301 kindergartens in China. By 1952 this had increased to 6,531. However, it was during the period of accelerated collectivization during the Great Leap Forward that kindergartens enjoyed phenomenal growth. By 1960 there were 784,905 kindergartens in China. In the subsequent years of hardship, the number of kindergartens fell back to 16,577 by 1963 (Research Institute of All-China Women's Federation and Research Office of Shaanxi Provincial Women's Federation, 1989). The figures picked up again from the mid-1970s and have remained at around 172,000 from 1985 onwards (as of 1992, there were 172,506 kindergartens in China) (Research Institute of All China Women's Federation, Department of Social, Science and Technology Statistics, State Statistical Bureau, 1998).

of women steel workers, of women laboring in the fields, working in factories, digging roads and dams, driving trains, buses, and cranes abound. There appeared to be no limits to what women could achieve. Like their male peers in the heady days of the Cultural Revolution, young schoolgirls too were mobilized as Red Guards, traveled around the country, and went down (*xiafang*) to "learn from the peasants".

By the late 1970s, women's economic, social, and political position was radically different to that of their pre-liberation sisters. Most women up till the age of 60 years participated full-time or part-time in production[5] (Croll, 1983). Women could now choose their own husbands. With a gender ideology that condemned the idea of female inferiority, rural girls had opportunities to attend primary and secondary schools. In urban areas, however, those young people required to go to the country-side during the Cultural Revolution forfeited their secondary schooling and university education. Due to the lack of systematic gender disaggregated figures, it is impossible to trace accurately the participation rates of women in the economy, but newspaper reports, personal accounts, and secondary information all testify to the radical change in the lives of girls and women in both rural and urban areas compared to pre-Liberation China. The Cultural Revolution also opened up spaces for women in political life. Accounts of this period report women taking on positions as team leaders, participating in the revolutionary committees, and even reaching the higher echelons of power. In fact Mao's second wife, Jiang Qing was the first of two women to enter the Politbureau at the Party Congress of 1969 (Howell, 2006).

However, whilst women's economic, social, and political status had risen considerably over 3 decades of communist rule, there were still considerable barriers to and constraints upon change, despite the euphoric declarations abounding during the Cultural Revolution. Though the participation of women in the workforce was high by global standards, there was still a marked gender division of labor, whereby women continued to dominate in sectors perceived as appropriate to their "natural" skills, such as textiles and light industry[6] (Andors, 1975; Croll, 1983). In the rural

[5] The participation rate of women in employment was as high as 90 percent in 1979 (Croll, 1983).

[6] According to official figures published by *Women of China* in 1982 and quoted by Croll (1983), women accounted for 60 percent of workers in cotton textile, finance, and trade, 50 percent in light industry but only 18 percent in coal-mining, 14 percent in metallurgy. Moreover, in Beijing in 1981 90 percent of workers allocated to the textile industries and 80 percent of those allocated to medical departments were women (Croll, 1983).

areas, women tended to receive fewer workpoints than their male coun-
terparts, and to be assigned to less skilled and mechanized work in the
communes (Croll, 1983). Though there were greater opportunities for
girls to go to school, in rural areas illiteracy amongst women remained
high, standing at 42 percent in 1980[7] (Croll, 1983). Practices such as child
marriage, "wife-beating", and betrothal gift continued in the rural areas,
even though the Party and Women's Federation stringently denied their
persistence. At all levels of the Party and government there was still a sig-
nificant imbalance in the levels of female and male political participation.
At the Fourth Congress of the National People's Congress held in 1975,
the participation of women actually reached its numerical peak, with
women accounting for 22.6 percent of all delegates (China Statistical
Yearbook, 2005, p. 775).

With the gradual introduction of market reform from 1978 onwards,
women's economic, social, and political status began to change again. The
decollectivization of agriculture, the diversification of ownership systems,
the gradual growth of a private sector, and the greater opening up of the
economy to foreign trade and investment brought about significant struc-
tural changes in the economy, rebounding in turn upon the nature of soci-
ety. For girls and women, these new developments proved double-edged.
On the one hand they created new opportunities but on the other hand they
marked a step backwards in terms of some aspects of their social, eco-
nomic, and political status.

With the development of the household contract system, the rapid
growth of rural industry, and the expansion of domestic sideline produc-
tion such as pig- or poultry-raising, the avenues of employment for rural
women increased (Croll, 1983; Davis and Harrell, 1993; Xiaoxian, 1994).
However, with the collapse of the commune system, women in rural areas
were also propelled back into the relative isolation of their rural compounds.
Individual effort now replaced the collective activity of the production
teams and compound. For some women, the relaxation of controls over
rural-to-urban migration from 1984 onwards along with the expanding
private sector, domestic services and new sites of industrialisation created
new employment openings and an escape route from the drudge of rural
labour (Summerfield, 1994; White *et al.*, 1996). Young female migrant

[7] According to this survey of 707 peasant women of child-bearing age carried out in 1980
and reported in *Jingji Yanjiu* in 1982, only 3.5 percent of women had attended senior
middle school and only 45 percent had attended primary school (Croll, 1983).

workers began to pour into the coastal cities of Guangdong, Fujian, and Jiangsu in search of employment in the newly established foreign-invested enterprises or as domestic workers in urban households. By 2006 migrant workers formed the bulk of the manufacturing labor force, with women dominating in certain sectors such as textiles and electronics.

Whilst the reforms opened up new economic opportunities for some women, they also dramatically changed the fortunes of others. In particular, women who had worked for many years in state or collective enterprises began to lose their jobs as such companies no longer proved competitive in an increasingly fierce and global marketplace. Though accurate data is not available, scholarly field work and newspaper reports suggest that women have been the first to lose their jobs when state enterprises were streamlined or closed down, with women accounting for approximately 60 percent of all redundancies[8] (Howell, 2003). This pattern was not peculiar to the reform era; as Curtin (1975, p. 56) notes, when communes were being reduced in scale during 1959–1960, women were the first to be released from work. Furthermore, when seeking further employment, women face not only gender but also age discrimination. Whilst men in their 40s have some chance to become re-employed, women as young as 30 are rejected by employers as being too old (Howell, 2003). Advertisements for positions reflect a preference for young, attractive women, particularly for positions in the public eye such as receptionists and hotel staff, discriminating further against unemployed women (Lizhen and Xiaocun, 1990; Yunjie, 1994).

Sexual discrimination has not been confined to laid-off state enterprise workers. Female graduates in the reform era have frequently encountered difficulties in seeking employment, with employers indicating their reluctance to employ women on the grounds that they will bear children.[9] Whilst 9 percent of employed women are white-collar workers and 91 percent blue-collar workers, 12 percent of employed men work as white-collar employees and 88 percent as blue-collar workers

[8] Official unemployment statistics between 1983 and 1994 suggest a continuing trend where unemployment rates for women consistently exceed those of men. For example, in 1983 the unemployment rate for men aged 15–24 was 0.7 compared to 1.1 for women; in 1988 the rates were 0.7 and 1.0; and in 1994 they were 0.8 and 1.1 (ILO Bureau of Statistics, 2005).
[9] This discriminatory attitude has surfaced in different periods of post-liberation China. For example, Curtin[6] reports how in the mid-1950s women were discriminated against in various kinds of jobs, because the employers would have then had to set up nurseries and provide maternity leave.

(China Human Development Report, 2005, p. 4). With the pressure to become more profit-conscious, employers have begun to renege on their obligations to provide maternity leave (Woo, 1994). Wage differentials between men and women have worsened. According to the *China Human Development Report 2005*, the ratio of female-to-male earnings decreased from 0.84 in 1988 to 0.82 in 1995 and a similar pattern emerged in the wage differences between male and female urban workers.[10] The sexual division of labor has continued into the reform period, with women in the manufacturing force predominating in light industries such as textiles and electronics, where women have an apparent predisposition for dexterous work. The expansion of the low-paid domestic services sector has drawn women further into areas that rely upon their supposed natural skills for nurturing, caring, and maintaining the home. At the same time women are under-represented in high-paying industries, where only five percent, as compared to ten percent of men are located (China Human Development Report, 2005, p. 4). Even though migrant women workers have gained in terms of employment opportunities, they often have to labor in arduous conditions, working very long hours in unsafe and unhealthy environments. Moreover, the problem of sexual harassment, especially in private factories, has also cast a shadow over the apparent fortunes of migrant women workers (Howell, 1997).

With regard to women's political participation, the record in the reform period is also mixed. At the national level, women's numerical representation in the National People's Congress has not increased significantly over the past 30 years. Women accounted for 20.2 percent of all deputies to the Tenth National People's Congress in 2002, that is 604 out of 2,985 deputies (China Statistical Yearbook, p. 775), ranking 37th out of a total of 136 countries in terms of female numerical representation in parliamentary institutions (www.ipu.org). Indeed, the participation rate dipped by 1.6 percent compared to the previous congress. Furthermore, after 50 years of Communist rule, there has never been a female President or General Party Secretary. Wu Qi was the only female member of the Politburo in 2005 (www.china.org.cn). Of the 198 Central Committee members elected at the 16th Party Congress in 2002, only five were women, accounting for a mere 2.5 percent (Du, 2004). Women continue to form a minority of Party members. In 2005 there were 12.96 million

[10] According to the China Human Development Report (2005, p. 4), the wage function of women was 1.8 percent lower than for men in 1988 and this increased to 16 percent in 1995.

female Party members, making up only 18.6 percent of the total (Xinhua News Agency, 23 May 2005). These patterns are reproduced at lower levels of the Party/state hierarchy. The first woman ever to become provincial governor was Gu Xiulian in 1983 in Jiangsu province and the first woman to become Provincial Party Secretary was Wang Shaofen in 1985. The only woman since to serve as a provincial governor is Song Xiuyan, who came to office in 2004 as acting governor of Qinghai province.

At all levels women tend to be placed in deputy rather than leading positions (Howell, 2006). So women are to be found as deputy governors, deputy mayors, deputy Party secretaries, deputy village committee chairs but rarely as provincial, county or township governors, mayors, or Party secretaries. In 2005 only 6.3 percent of ministerial positions were occupied by women (Human Development Report 2005:317). Women account for only two out of 24 vice-chairs on the 10th Chinese People's Political Consultative Committee, a mere 8 percent, or only one out of five State Councillors and one out of four vice-premiers (www.china.org.cn). This pattern of under-representation is repeated at the provincial, county, and township levels as well as in village committees and village Party branches. In the capital city of Hunan province in 2003, for example, women accounted for only one out of six mayors (17 percent), one out of 13 Party committee members (8 percent), and 68 out of 400 People's Congress delegates (17 percent).[11] Following the introduction of village elections women's representation in village committees has declined compared to the pre-reform era. Women make up only 1 percent of all chairs of village committees (Fan, 2000) and it is unusual to have more than one female member of such a committee. Moreover, when women are represented on village committees, they are nearly always assigned responsibility for family planning and women's affairs, issues that are seen as appropriate to women, a pattern that is echoed at higher levels of the Party and government system[12] (Howell, 2006).

In terms of women's social status, the picture during the reform period is again mixed. Compared to pre-Liberation China, girls have far

[11] Interview, provincial Women's Federation, Hunan Province, 2003. It should be noted that the provincial Women's Federation in Hunan province has been playing a pioneering role in attempting to improve the political status of women in the province.

[12] Even in the first decade after liberation, female veterans of the Long March such as Cai Chang, Kang Keqing, and Deng Ying Chao were assigned to work with women and children, rather than in defence, trade, or transport.

greater opportunities to enter primary, secondary, and tertiary education. However, there continue to be disparities in educational opportunities for boys and girls, particularly at institutions of higher learning (China Human Development Report, 2005, p. 9) and in rural areas. As of 2004, women accounted for 41.6 percent of all postgraduates, 46 percent of all senior secondary school graduates, 47 percent of all junior secondary school graduates, and 47 percent of all primary school graduates (China Statistical Yearbook, 2005, p. 690). In rural areas preference for boys in education continues to prevail. The figures for drop-outs in primary school are higher for girls than for boys. Moreover, fewer girls than boys in rural areas complete secondary schooling. As a result women account for 72 percent of the illiterate and semi-literate population in China (China Statistical Yearbook, 2005, p. 107) and 86.5 percent of women as compared to 95 percent of men count as literate (Human Development Report, 2005, p. 300). The sex ratio imbalance has increased during the reform period, particularly in rural areas, as governmental family-planning policy to reduce population growth has reinforced preference for male infants.[13]

From this account it is evident that the economic, political, and social status of women has risen considerably over the last 50 years in China. In 2005 China ranked 64th in the gender-related development index compiled by the Human Development Report. However, changes in gender relations require sustained efforts by government and social activists, as well as fundamental shifts in social norms, attitudes, and values. In the next section, we look more closely at the role of state and non-state institutions in shaping the destiny of women in China.

3. State Institutions and Women's Empowerment

The Chinese Party/state has played a key role in advancing the position of women in China. It has drawn upon ideological, legislative, and institutional means to shift societal gender norms and values. At the ideological level it has manipulated images and language through its propaganda machinery and deployed mobilizing techniques such as mass campaigns to both condemn practices considered oppressive to women and to promote

[13] According to China's Fifth National Census compiled in 2004, the ratio of female to male babies was 100 to 117.

new ideals of femininity and womanhood. Drawing upon a Marxist-Engelsian analysis of female subordination, it framed oppressive practices such as child-marriage, wife-beating, foot-binding, and bigamy as part of a feudalist, Confucian ideology. In order to increase the participation of women in the waged labor force, it mobilized women into reconstruction work and associated their new participation with processes of economic, social, and socialist modernization.

During the heady days of the Cultural Revolution, the idea of gender equality and female emancipation was taken to new heights. Images abounded of androgynous females clad in plain, blue uniforms, donning steel safety helmets, or laboring in the fields, gazing steel eyed toward an imagined, communist future. Such depictions of women challenged "feudal" notions of femininity and womanhood, which emphasized beauty, physical appearance, weakness, and frailty. In the new China of the Cultural Revolution, where women "held up half the sky", there were no barriers to what women could achieve. Posters of women melting steel, driving tractors, and mining coal reinforced an ideological imagery of gender equality that sought to break down gender divisions of labor based on notions of physical strength.

In the reform period, the terrain of gender ideology has become increasingly contested as state-propagated images of the "modern woman" compete with notions of femininity and womanhood introduced by market forces (Croll, 1994; Howell, 1997). With the declining emphasis on mass mobilization in the reform period, it became, in any case, harder for the Party/state to rely on the use of crude propaganda techniques to manipulate ideas and attitudes. Adverts using images of women to sell household products such as fridges and washing-machines reinforced the ideas of women as housewives and as chief guardians of domestic tasks. The rise of the fashion industry, the sale of beauty products, and the import of foreign films and music nurtured a gender culture emphasizing the values of physical appearance, youth and sexuality, and of women as consumers rather than as producers. As the older images of androgynous women laboring in factories and fields became increasingly ineffective as a device to inspire women, the Party/state through the agency of the All-China Women's Federation began to deploy in its popular magazines pictures of women wearing make-up and clad in fashionable clothes bearing designer labels. Furthermore, female Party and government cadres and officials soon cast away their baggy blue jackets and trousers. Instead, they

donned brightly-colored clothes, business suits, make-up and wore fashionable hair-styles, projecting images of the modern woman, efficient, enterprising, working but also attentive to her appearance.

These competing images of women have not gone uncontested. At times of economic hardship, some Party and government leaders have encouraged the idea that women should stay at home, as occurred at different times in the 1950s[14] (Hershatter, 1986). In the reform period, some economists, newly trained in the principles of the market, have argued that women should return to the hearth so as to allow men the opportunity to work. As state enterprise reforms accelerated from the mid-1990s onwards such ideas have become more current. Images of women that emphasize their domesticity, their physical appearance, and sexuality compound such argumentation and render attractive the idea of remaining at home as mothers and wives.

As well as using ideological means to reshape societal attitudes toward women, the Party/state has also introduced a raft of legislative, regulatory, and policy measures to advance women's position. One of the first pieces of legislation was the 1950 Marriage Law, which not only prohibited practices deemed oppressive to women such as foot-binding, child marriage, wife-beating, and bigamy but also enabled women to divorce for the first time. This was a landmark piece of legislation which promised to radically reshape the nature of family life, particularly in rural areas. Aware of the practical challenges of implementation, the Party/state sought to propagate the key messages of the new law and reinforce its tenets through, inter alia, campaigns against wife-beating and foot-binding. Over the decades the Marriage Law has been revised on several occasions. In April 2001, it was amended again to include a clause on domestic violence, thereby recognizing officially that the problem of "wife-beating" had not disappeared in the process of socialist modernization. It also clarified

[14] Davin argues how policies toward women's participation in the waged economy fluctuated according to the performance of the economy. For example, in 1955 the Party declared the "five good things for a housewife to do" movement, but when the industrial and construction sectors improved in 1956, articles extolling the virtues of women participating in industrial production increased (Davin, 1976). Again Davin (1976) points out how in early 1958 pressure on women to retire increased as the Second Five Year Plan aimed to reduce the number of cadres, but this trend was then subdued by the start of the Great Leap Forward later in the year, which mobilized a nationwide effort to accelerate industrial production.

the prohibition on bigamy so as to address the growing phenomenon in some provinces during the reform period of husbands co-habiting with a third party.[15]

Apart from legislation relating to family life, the Party/state has also introduced a range of legislative and regulatory measures governing the workplace. These have granted women maternity rights and the right to breast-feed during work hours. However, these rights have come under challenge during the reform period as enterprises have become more aware of costs and the importance of competitiveness. Enterprise managers have tried to resist these legal requirements by avoiding to pay maternity leave, terminating contracts if women become pregnant, or by refusing to employ women on the grounds that they will bear children and become a burden to the company (Woo, 1994). At the same time with the rapid development of the foreign and domestic private sector, particularly from the late 1980s onwards, conditions of employment have worsened for many unskilled and semi-skilled workers. Excessively long hours, compulsory overtime, the use of hazardous chemicals, and unsafe working environments has led to numerous accidents, ill-health, and often protests. As women make up a significant portion of migrant workers in the manufacturing and services industries, the Party/state introduced specific legislation to protect the interests of female workers. The Law for the Protection of Women's Rights and Interests passed in 1992 sought to safeguard women's rights and interests and promote equality between men and women.[16] In September 2005, the law was revised again to clarify certain elements and to add new provisions that responded to gender issues emerging in the reform period. For example, the amended law introduced new measures to counter all forms of discrimination against women, and especially in the workplace. It also made sexual harassment unlawful for the first time. The amended law clarified

[15] Other amendments included clarification of Article 7 which prohibited marriage where one of the partners suffered from a disease; the stipulation in Article 34 of new provisions for granting divorce; the protection in Article 39 of women's rights and interests in the operation of land under a household contract; and the clarification in Article 17 of jointly owned and individually owned property.

[16] Other laws and regulations aimed at protecting female employees include the Labor Insurance Regulations of the P.R. China, 1953; Announcement on Female Workers' Production Leave by the State Council, 1955; Female Employees' Labor Protection Regulations, 1988; Regulations of Prohibited Types of Occupational Posts for Female Employees, 1990 (Cooke, 2005).

the concept of "equal pay for equal work" by stating that this included also equal treatment to housing, material benefits, and remuneration.[17]

Along with a legislative framework that sought to advance and protect women's interests, the Party/state also encouraged women's participation in the labor force by collectivizing activities that had previously been the prime responsibility of women in the household, in particular, the provision of food and childcare. The experience with collective food provision proved unpopular and only fleeting. During the Great Leap Forward in 1958, some villages established public canteens where all families ate together, thereby freeing women in principle from the tasks of feeding. However, as most of the staff working in the collective kitchens were women, the institution was not as emancipatory as appeared. The idea was abandoned fairly quickly as families preferred private arrangements for the provision of food. The state's attempts at providing child-care arrangements have proved more enduring, though have come under challenge during the reform period. From the early 1950s, the Party/state began to require state units to provide access for its employees to child-care facilities such as crèches and kindergartens. Whilst large state units could provide their own such facilities, employees in small-sized factories or less well-endowed enterprises relied more on crèches and kindergartens run at neighbourhood level or informal arrangements such as family relations, friends, and neighbours. In the reform period, the employer provision of kindergartens and crèches has declined as enterprises have become more cost-conscious and newly established enterprises have not set up such facilities. In this context families have relied increasingly on relatives and neighbours to assist and on privately-run crèches and kindergartens.

A key institutional element of the Chinese Communist Party's endeavor to enhance the position of women is the All-China Women's Federation (ACWF). Compared to many countries in the world, China has one of the longest standing national policy machineries for women. It thus provides an interesting case for exemplifying the benefits and challenges of state institutions in promoting changes in gender relations. The ACWF grew out of the experiences and institutions that developed in the areas occupied by

[17] Also in November 2004 the state council promulgated the "Employment Protection Supervision Regulations", which included provisions on the mistreatment of women and minors. Under these regulations, employers would be fined for failing to grant pregnant employees maternity leave or requiring nursing mothers to do night-shifts or requiring female employees to work at high altitudes (TransAsia Lawyers, 2004).

the Communists in the 1930s. It was established in 1949 as a mass organization to mediate between the Party and specific groups in society. Like other mass organizations it served to communicate and propagate Party policy downwards and relay the views of women upwards according to the principles of democratic socialism. During the Cultural Revolution, the ACWF became dormant, as it came under attack from radicals, as with many other Party and government organs. Some branches resumed their activities in the mid-1970s (Davin, 1976; Johnson, 1983) but it was only after the consolidation of the reformers' power in 1978 that the work of the ACWF was revitalized. The ACWF has branches across the country with representatives down to township level. By 2000, it had an establishment of over 80,000 employees. Staff were allocated to their positions according to state plans at least up till the mid-1980s, after which posts were open to application from competing candidates.

The ACWF is the key organ through which the Chinese Communist Party has propagated gender policies and mobilized women in urban and rural areas. It is regularly consulted by the Party on any new legislation, regulations, or policies deemed relevant to women such as revisions to the Marriage Law, employment law, or family planning. In the reform period it has begun to alter its structures and ways of operating so as to respond more effectively to the changing structural situation of women and the diversification of women's interests (Howell, 1996, 1997; Howell, 2005). For example, it has established legal sections to deal with the violation of women's rights and interests and the amendment of legislation. Similarly, it has set up structures to promote income-generation activities by women in rural areas, encouraging women to engage more fully in the market economy. It has also reworked its imagery so as to promote new images of the "modern woman" in an increasingly consumerist and market-oriented society.

Whilst changes in the socio-economic structure of reformist China required the ACWF to find new ways of engaging with an increasingly diverse and complex mass group, the decision by the Party to host the UN Fourth World Conference on Women had a pivotal influence on the trajectory of the ACWF. The preparations for this event introduced national and provincial ACWF leaders to an array of new international women's organizations and issues. When leaders traveled to international meetings, they encountered first-hand the enthusiasm and committed engagement of many female activists and non-governmental women's organizations. Through this event, female scholars in China and ACWF officials were

introduced to the concept of gender and hence a new way of analyzing and potentially addressing female oppression. Furthermore, they encountered discussion around issues such as domestic violence, lesbianism, and sexual harassment in the workplace, which were barely acknowledged or conceptualized in China, or, as in the case of domestic violence, vehemently denied. The preparatory processes as well as the event itself thus opened up new ways of thinking about and organizing around gender issues in China. As will be discussed in greater detail in the next section, it also precipitated the rapid growth of new non-governmental women's organizations. Indeed, the very concept of "non-governmental" provoked senior leaders in the organization to reflect more closely upon the identity of the ACWF. In order to facilitate international exchange but also echoing this emerging discussion about its own identity, the ACWF began to refer to itself in its publicity and in dialogues with international agencies as a non-governmental organization, and often in the same breath as both a non-governmental organization and a mass organization.

The structural identity of the ACWF was not, however, a new issue. As part of the institutional structure of the Chinese Communist Party, the ACWF has on the one hand gained symbolic and institutional prominence but on the other hand has had to address certain dilemmas of representation. Its proximity to power has been double-edged. Like all mass organizations, the ACWF has to manage a double set of interests, namely, those of the Party and those of the social group it purportedly represents. In some circumstances these two sets of interests can clash. For example, the closure of state enterprises from the 1990s onwards, has often led to women becoming the first to be made redundant. In such a situation, the ACWF has to consider whether to prioritize the overall national economic policy of state enterprise restructuring or to protect the interests of women losing their jobs. Similarly, the gradual introduction of labor markets has given employers' choice over the size and nature of their work force, a choice that is in tune with the market-oriented reforms of the Party. However, employers have sometimes exercised this choice to the detriment of women by refusing to appoint female candidates on the grounds that they may become pregnant.

These tensions underline the dual role of the ACWF as an intermediary agency for both the Party and for women and have stimulated considerable debate within the organization about the nature of its relationship to the Party. Such debates surfaced prominently at the 6th Annual Congress

of the ACWF held in September 1988 when delegates put forward diverse views about the appropriate organizational nature of the ACWF. For example, some delegates proposed that the ACWF should become autonomous of the Party whilst others suggested that the ACWF should become a ministry, with higher powers and authority, or should become a department. The political unrest in 1989 and the subsequent clamp-down inhibited further open debate on these issues. However, the pre-paratory events leading up to the UN Fourth World Conference on Women in Beijing, and in particular, the ACWF's encounter with women's non-governmental groups from all over the world re-opened these debates. Though the identity of the ACWF has not been discussed at recent national congresses, it remains an issue that concerns many senior lead-ers. Since Women's Federation cadres often use the terms mass organi-zation and non-governmental organization interchangeably to describe the Federation, it illustrates the lack of resolution around this issue.

This lack of resolution does, however, create problems for the effec-tiveness of the institution. On the one hand, its relationship to the Party endows it with authority, symbolic power, and some resources. However, as it does not enjoy ministerial status, its powers are limited. In particular, it does not have the authority to coordinate other ministries, thereby con-straining its influence and its ability to address gender issues that do not appear to fall within its institutional scope. On the other hand, its prox-imity to the Party also creates dilemmas of representation, as discussed above. Furthermore, its proximity to the Party makes its future potentially vulnerable. In the former Soviet Union where the various Women's Unions were similarly part of the Communist Party's infrastructure, the demise of the Communist Party also heralded the breakdown of their respective women's organizations. If the Chinese Communist Party were to undergo a similar fate, then the ACWF would also risk collapse, unless it had secured sufficient public confidence in its work as distinct from that of the Party. Such a scenario remains unlikely at the moment. A more imminent concern is how the ACWF can continue to resource its activities and staff and adapt its ways of working so as to respond effectively to an increas-ingly complex and diverse range of gender issues. Part of this challenge relates to how it negotiates its relationships with the new wave of inde-pendent women's organizations that have emerged over the past 2 decades. It is to these new organizations that we turn our attention in the next section.

4. Women Organizing Independently

The emergence of more independent forms of organizing around gender issues in China has to be set against the broader context of civil society-state relations in China.

In post-liberation China the spaces for organizing independently of the Party/state were sharply constrained. In order to restore social order after years of conflict, the Chinese Communist Party banned organizations deemed threatening, co-opted others, and instituted its own architecture of intermediary organizations[18] (White et al., 1996). Most prominent here were the mass organizations such as the All-China Women's Federation, the All-China Federation of Trade Unions, the Communist Youth League, which served as the primary arteries linking the Communist Party to the defined constituencies of women and children, workers, and youth respectively. These mass organizations served as key channels for the Chinese Communist Party to communicate downwards Party policy and for grassroots' views and perceptions to be reflected upwards, according to the principle of democratic socialism. Following a period of dormancy during the heady days of the Cultural Revolution, the mass organizations were gradually resurrected in the late 1970s.

With the onset of market reforms in 1978, under the leadership of Deng Xiaoping, the state began to loosen its hold over the economy, allowing market forces increasingly to determine resource allocation. The decollectivization of agriculture, the gradual development of rural markets and self-employed traders, the emergence of private domestic industry, and the opening up of China's economy to global trade all began to reshape not only the way economy was organized but also the structure of society. With the increasing diversification of interests and growing recognition by the government of the need for new structures of interest mediation, new forms of association such as trade and business associations,[19] chambers of commerce, and professional organizations began to develop during the 1980s. Trading, business, and professional associations snowballed during the 1980s and formed the bulk of more independent forms of association during this period (White et al., 1996; Unger, 1996;

[18] For further details about pre-revolutionary and pre-reform civil society see White et al. (1996), Yun (1994), Huang (1993) and Rowe (1993).

[19] The idea of trades and business organizations was promoted by the well-known economist Xue Muqiao, who argued that social organizations could "serve as a bridge between the state and the enterprises" and thereby a way of indirectly regulating the economy.

Wank, 1995; Pei, 1998). Specific business, professional, and trading groups for women such as women entrepreneurs' associations, women's business associations or women journalist associations, academic associations began to emerge during this period.

The growth of social organizations reached a peak during the tumultuous year of the democracy movement in 1989. Independent student organizations, autonomous trade union groups, and democracy groups sprouted across the country, leading many China observers to interpret this wave of spontaneous associating as the rise of civil society. The tragic events of June 4th and the subsequent clampdown on independent organizing halted the pace of growth of independent associations and led to disillusion amongst many China watchers about the prospects for civil society (Sullivan, 1990; Madsen, 1993; Huang, 1993; Liang, 1994). In the autumn of 1989, the State Council introduced new regulations governing the registration of social organizations. All social organizations were required to re-register under these regulations.[20] This allowed the Party/ state to close organizations it was suspicious of, whilst at the same time encourage the development of associations it deemed safe, reflecting a recognition that certain kinds of independent associations were more beneficial to the economic reform process. Over the next few years, there was little growth in the number of registered social organizations as state officials proceeded cautiously and social organizations struggled to find government departments which would act as their supervisory unit (*guakao danwei*). China scholars became more cautious in their analyses, drawing back from the notion of civil society and highlighting the corporatist nature of many social organizations (White *et al.*, 1996; Chan and Unger, 1996; Unger, 1996).

As Deng Xiaoping regained hold of the political reins following his tour of the South in 1992, market reforms deepened and the political tension began to ease. In its efforts to counter international condemnation following the June 4th tragedy, the Chinese Communist Party was keen to host the 1995 Fourth World Conference on Women. This event catalyzed the development of more independent women's organizations in China and indirectly fostered a more positive climate for autonomous associations

[20] These were the new Management Regulations on the Registration of Social Organisations, which replaced the 1950 regulations. Under this, social organizations were required to affiliate to a supervisory body (*guakao danwei*), which was responsible for overseeing the day-to-day affairs of the association, and to register with the Division of the Supervision of Social Organizations in the Ministry of Civil Affairs.

(Howell, 1997). As international women's organizations planned also to hold a parallel NGO Forum to the World Conference, the Chinese government came under pressure to produce its own contingent of women's NGOs. With the opening of political space around gender matters coupled with financial support from both the government and international donor and cultural agencies, women began to organize around issues such as single motherhood, marriage law, professional and business interests, rural development, and domestic violence. Women's professional, academic, business, and trade associations became more dynamic, whilst more independent women's groups with a wider reach than successful professional women's associations developed rapidly.[21] For example, a new journal for rural women, entitled *Rural Women Knowing All* (*nunong jia*) was established in 1993. Some women set up a single parents' club whilst others started a group for divorced women. A cross-cultural discussion group on gender issues called East Meets West provided a lively and open forum for comparing different analytic approaches to gender oppression.[22] A network on women's health emerged that initiated, amongst other things, the translation of the celebrated publication *Our Bodies Ourselves*. The Jinglun Family Centre and the Maple Women's Psychological Counselling Centre introduced the idea of hotlines and counselling, and encouraged younger women to reflect on gender issues and volunteer their time and energy. Apart from more formal types of organization, salons sprung up across China to discuss not only women's issues but the concept of gender itself, sometimes encountering interference from public security agencies.[23] Though women's research groups, hotlines, and salons had already begun to emerge in the late 1980s, the clampdown after 1989 had inhibited their further growth.

The preparations for the Conference and, in particular, the need for China to be able to engage with international players on gender issues stimulated the development of women's studies courses and centers across China. The first women studies center to be set up in China was in

[21] For example, the Capital Women Journalists' Association, which was set up in 1986, became much more vigorous in extending its reach, organising activities, and setting up less formal groups such as the Media Watch Group, which analysed the coverage of women in national newspapers (Howell, 2005).

[22] For an excellent discussion about the formation and impact of this grups, see Ge and Jolly (2001).

[23] For example, salons held at the Beijing Languages Institute and Beijing Institute of Geology came under the scrutiny of the public security department.

Zhengzhou University in 1987. By 2001 there were over 40 such centers in various universities and colleges (Du, 2001). Women involved in these centers translated American and European feminist theory, researched international feminist movements, and highlighted the limitations of orthodox Marxist approaches to sexual oppression. In this way the concept of gender was gradually introduced into China and the field of gender and women's studies began to blossom.

The Fourth World Conference on Women thus catalyzed not only changes in the approach of the long-standing All-China Women's Federation to women's issues but also in the landscape of independent organizing around gender issues (Hsiung *et al.*, 2001). The ACWF began to refer to itself in its publicity and in encounters with women from other countries as a non-governmental organization so as to enhance its legitimacy internationally, to facilitate fund-raising from international bodies, and to create the appearance of having some distance from government organs. However, it has never been wholly comfortable with this designation, nor with the concept of gender or feminism, which it views as a Western import at odds with Marxist analyses of women's emancipation. International agencies such as the Ford Foundation, British Council, UNDP, and Asia Foundation played a key role in catalyzing and facilitating the development of these more independent groups. By the mid-1990s there was a significant layer of more independent women's organizations covering a range of issues. Some of these registered as social organizations such as the professional and business associations whilst others such as salons, clubs, and networks were able to operate in the interstices of government regulation and illegality. Women's organizations thus varied considerably in their size, formality, proximity to government, sources of funding, and the issues they addressed.

Although there was a lull in activity after the 1995 conference as some groups dried up, some could not register formally,[24] organization around women and gender has continued to thrive into the new millennium. Since 1995, new groups have emerged, such as new women's legal counselling centres in Shanghai, Xian, Wuhan, and Xishuangbanna, drawing on the resources and support of international agencies such as Ford Foundation, Oxfam Hong Kong, and the Asia Foundation. In the autumn of 1996, new

[24] For example, the Women's Teahouse, which was set up after the 1995 Conference to bring together divorced, single parents, halted its activities after 1 year because it could not find a supervisory department and lacked sufficient funds to register (interview, October 1997).

124 *J. Howell*

directives issued by the Ministry of Civil Affairs and the Ministry of Public Security sought to rectify financially irregular social organizations and take stock of existing social organizations. This culminated in a new set of revised regulations on social organisations, issued by the Ministry of Civil Affairs in November 1998, which increased the requirements for registration. Though this affected the ability and desire of some women's groups to register, some got around this by registering as enterprises under the Industrial and Commercial Bureau, the Maple Leaf Psychological Counselling Centre being a case in point, by affiliating as second- or third-level organizations to other registered associations, or by continuing to operate as unregistered groups.

Despite the introduction of a more restrictive regulatory environment in 1998, women's organizations have grown and remained active, not least because of government concern about sharpening socio-economic inequalities, rising social tensions, and the need to restructure welfare provision. From the mid-1990s onwards, there has been a rapid growth of organizations concerned with the social impact of economic reforms and the interests of marginalized groups, which has provided a fertile context in which women's organizations can extend their activities (Howell, 2004). Illustrative of this is the development of legal counselling centres focusing on women workers' rights, such as in Fudan University, of organizations concerned with the rights of migrant women workers, such as the China Working Women's Network in Shenzhen or the Female Migrant Workers' Club in Beijing, and the growth of hotlines for gay and lesbian groups[25] (He, 2001). Nevertheless, such groups remain at risk of surveillance and closure. In 2005 Chinese government leaders, affected by Vladimir Putin's clampdown on NGOs because of their purported roles in the Color Revolutions of Georgia and Kyrgyzstan, became increasingly concerned about the activities of non-governmental organizations and their potential political threat. Surveillance of groups providing services to workers and other social groups deemed sensitive has increased and some organizations have not been able to re-register under the Industrial and Commercial Bureau.[26]

[25] For a detailed account of the Lesbian and Gay Beeper Hotline see He (2001).
[26] In 2005 organizations registered under the Industrial and Commercial Bureau were required to re-register. This provided an opportunity for government authorities to scrutizise and close any groups that it considered politically risky. For example a migrant workers' center in Panyu district in Guangdong was closed in the spring of 2006. Similarly, the activities of the female migrant workers' centre in Shenzhen also came to a halt in 2006 as local authorities began to scrutinize their work (personal communication, 2006).

The rise of more independent women's organizations in China has thus played a crucial role in developing new analytic frameworks for understanding gender subordination, in drawing attention to the increasingly diverse and complex needs of women in the context of rapid socioeconomic change, and in introducing new approaches to women's issues. Relationships between the ACWF and the new women's groups have not always been smooth. To the extent that these groups have raised sensitive issues and have reached out to women that the ACWF has not been able to or wanted to reach, they have proved to be a challenge to the capacity and legitimacy of the ACWF. The ACWF has encouraged the formation of some associations, especially female business, trades, and professional associations, supported their activities and involved them in their own activities (Howell, 2000). It has consulted different women's groups about specific issues and processes of regulatory and legislative change, and invited them to meetings and events. However, at times, these relationships have been fraught with tension. On the one hand more independent groups have expressed concern about interference from the ACWF;[27] on the other hand the ACWF has perceived more independent women's groups to be treading on their territory, especially when their activities have attracted national and international attention. The relations are rendered further complex and blurred in that some of the activists in new women's organizations are also cadres in the ACWF, as has been the case with *Rural Women Knowing All*, the Gender and Development Network, and the Women's Health Network.

Compared with the ACWF, new women's organizations remain small in scale and do not wield the same influence on policy, legislative, or regulatory processes. This is in part because many of these new organizations focus on providing services and do not aim to advocate on issues. Even if they do seek to change policy and influence local and national leaders, their capacity to do so is constrained by the regulatory environment governing social organizations, which prohibits the formation of branch organizations. Though the Internet and informal opportunities for horizontal coordination such as networking meetings and conferences go some way

[26] For example, when a new women's organization in southern China began to run training courses in gender issues for government and Party officials, the local Women's Federation intervened on the grounds of them treading on their ground. In another instance a women intellectuals' association perceived the increasing involvement of ACWF cadres in their activities as stultifying (see Howell [2000] for further details).

to circumventing these regulations, women's organizations, like non-governmental organizations, in general, lack legitimacy in the eyes of government. At the most their influence is indirect, when compared with the ACWF. To influence policy they are strategically compelled to ally with the ACWF, which has the authority, resources, institutional and personal networks to mobilize opinion, and to participate in gender-specific policy and legislative processes. Despite the constraints of size, sustainable funding, and relatively closed political processes, new women's organizations in China have made a vital contribution to enhancing the status of women in China.

5. Conclusion

Women's economic, social, and political status has improved substantially over the past 60 years. The Chinese Communist Party has played a key role in enhancing women's position, deploying ideological and legislative means to change societal attitudes toward the position of women in society. By establishing a specialized national machinery for women, namely, the All-China Women's Federation, the Party created the institutional means to propagate new gender values and norms, to implement policy changes, and to mobilize women into political and economic life.

However, such a top-down, statist approach to gender oppression also has its limitations. The increasing diversification of social interests in the reform period rendered the category of "women" far more complex than a simple division between rural and urban women. The task of addressing the increasingly diverse and complex needs of women has proved challenging for the ACWF. The hosting by China of the Fourth World Conference on Women in 1995 was an opportunity that the ACWF seized to strengthen its capacity and to rethink its understanding of women's needs and interests. This event also catalyzed the development of new women's organizations which drew attention to issues such as domestic violence, divorce, and the contradictions between the government's gender ideology and women's lived experiences. By opening up debates and conceptual thinking around women's issues, they developed the field of women's studies in China and experimented with new ways of addressing women's needs. Though the ACWF remains as the key agency for the promotion of policy and legislative changes relating to women, the new women's organizations play a key role in developing alternative

perspectives on the understanding of and approach to gender issues. The enhancement of women's position in China in the future will thus hinge upon the initiatives of both state and non-state institutions.

References

Andors, P (1975). Social Revolution and Women's Emancipation in China During the Great Leap Forward. *Bulletin of Concerned Asian Scholars*, 7(1).

Chan, A and Unger, J (1996). Corporatism in China. A developmental state in an East-Asian context. In *China after Socialism. In the Footsteps of Eastern Europe or East Asia*, McCormick B and Unger, J (ed.). London. M.E. Sharpe.

Cooke, FL (2005). *HRM, Work and Employment in China*. Routledge: London and New York.

Croll, E (1983). *Chinese Women Since Mao*. Zed Press: London.

Croll, E (1994). *From Heaven to Earth*. Routledge: London.

Curtin, K (1975). *Women in China*, Pathfinder Press: New York and Toronto.

Davin, D (1976). *Woman-Work: Women and the Party in Revolutionary China*. Oxford: Clarendon Press.

Davis, D and Harrell, S (eds.) (1993). *Chinese families in the post-Mao era*. Berkeley: University of California Press.

Du, J (2001). Gender and civil society in China: Women's organisations in the context of increasing globalisation. *Paper given at the Forum on Governance in China*, Institute of Development Studies, University of Sussex, September.

Du, J (2004) Gender and Governance: The Rise of New Women's Organisations. In *Governance in China*, Howell, J (ed.), Rowman and Littlefield Publishers, Inc., Boulder, pp. 172–192

Fan, Y (2000). Cunweihui xuanju: Nongcun Funu Fazhan de Jiyu yu Tiaozhan (Village Committee Elections: opportunities and Challenges for Rural Women's Development). In *1995 Shijie Funu Dahui Wu Zhou Nian Yanjiuhui (Beijing Plus Five Conference*, China Women's Research Conference and UNIFEM (eds.), pp. 273–275. Beijing.

Gao, X (1994). China's Modernisation and Changes in the Social Status of Rural Women. In *Engendering China. Women, culture and the state*, C. Gilmartin, Hershatter, G, Rofel, L and White, T (eds.) pp. 80–100, Harvard University Press, Harvard.

He, X (2001). Chinese queer (tongzhi) women organising in the 1990s. In *Chinese Women Organising: Cadres, Feminists, Muslims and Queers,* Hsiung, Ping-Chun, Jaschok, M and Milwertz, C with Chan, R (eds.). Oxford and New York, Berg.

Hershatter, G (1986). *The Workers of Tianjin 1900–1949*. Stanford University Press, Stanford, California.

Honig, E (1986). *Sisters and Strangers: Women in the Shanghai Cotton Mills, 1919–1949*. Stanford University Press, Stanford, California.

Howell, J (1996). The struggle for survival: Prospects for the Women's Federation in post-Mao China. *World Development*, 24(1), 129–144.

Howell, J (1997). Post-Beijing Reflections: creating ripples, but not waves in China. *Women's Studies International Forum*, 20(2), 235–252.

Howell, J (2000). Organizing around women and labor in China: Uneasy shadows, uncomfortable alliances. *Communist and Post-Communist Studies*, 33, 355–377.

Howell, J (2002). Women's Political Participation in China: Struggling to Hold Up Half the Sky. *Parliamentary Affairs*, 55(1), 43–56.

Howell, J (2003). State Enterprise Reform and Gender: One Step Backwards for Women?. In *Asian Politics in Development*, Benewick, RJ, Blecher, M and Cook, S pp. 83–108. Frank Cass Publishers, London.

Howell, J (2004). New Directions in Civil Society: Organizing around marginalized interests. In *Governance in China*, Howell, J (ed.), pp. 143–171. Rowman and Littlefield Publishers, Inc.

Howell, J (2005). Women's organizations and civil society in China: making a difference. In *Gender and Civil Society. Transcending Boundaries*, Howell, J and Mulligan, D (eds.), pp. 54–77. Routledge, London and New York.

Howell, J (2006). Women's Political Participation in China: In Whose Interests Elections?. *Journal of Contemporary China*, issue 15, number 49, November 2006, pp. 603–619.

Hsiung, P-C, Maria, J and C, Milwertz with Chan, R (eds.) (2001). *Chinese Women Organising: Cadres, Feminists, Muslims and Queers*, Oxford and New York, Berg.

Huang, PC (1993). Public Sphere/"Civil Society" in China. The third realm between state and society. *Modern China*, 19, 2 April, 216–240.

ILO Bureau of Statistics (2005). *China: Unemployment Statistics*, downloaded via Laborsta Internet operated by the ILO Bureau of Statistics, May 2005.

Johnson, KA (1983). *Women, the Family and Peasant Revolution in China*, Chicago, IL: University of Chicago Press.

Liang, DX (1994). Institutional amphibiousness and the transition from communism: The case of China. *The British Journal of Political Science*, 293–318.

Ma, L and Ji, X (1990). Female Sex and Power. *Zhongguo Funu*, March, pp. 4–6 (in Chinese).

Ma, S (1994). The Chinese discourse on civil society. *China Quarterly*, 137, March, 180–193.

Madsen, R (1993). The public sphere, civil society and moral community: A research agenda for contemporary China studies. *Modern China*, 19(2), April, 183–198.

Pei, M (1998). Chinese civic associations: An empirical analysis. *Modern China*, 24(3), July, 285–318.

Research Institute of All China Women's Federation, Department of Social, Science and Technology Statistics, State Statistical Bureau, (eds.) (1998). *Gender Statistics in China (1990–1995)*. China Statistical Publishing House, Beijing.

Research Institute of All-China Women's Federation and Research Office of Shaanxi Provincial Women's Federation (eds.) (1989). *Statistics on Chinese Women 1949–1989*. China Statistical Publishing House.

Rowe, W (1993). The problem of "civil society" in late imperial China. *Modern China*, 19(2), April, 139–157.

Sullivan, LR (1990). The emergence of civil society in China, Spring 1989. In *The Chinese People's Movement. Perspective on Spring 1989*, Saich A (ed.) East Gate Books, Armonk, pp. 126–145.

Summerfield, G (1994). Effects of the changing employment situation on urban Chinese women. *Review of Social Economy*, spring, 40–59.

TransAsia Lawyers (2004). State Council Issues Rules for the Supervision of Employment Protection. *PRC Employment Law Newsletter*, November/ December Special Issue, 5(10), 1–8.

Unger, J (1996). Bridges: Private Business, the Chinese Government and the Rise of New Associations. *The China Quarterly*, 147, September, 795–819

Wank, D (1995). Private business, bureaucracy and political alliance in a Chinese city. *Journal of Australian Affairs,* 33, January, 55–71.

White, G., Howell, J and Xiaoyuan, S (1996). *In Search of Civil Society. Market Reform and Social Change in Contemporary China*, Clarendon Press, Oxford.

Woo, MYK (1994). Chinese Women Workers: The Delicate Balance between Protection and Equality. In *Engendering China: Women, Culture and the State*, CK. Gilmartin, Hershatter, G, Rofel, L and White, T (eds.), pp. 279–298 Cambridge, Mass: Harvard University Press.

Xinhua News Agency. "Chinese Communist Party says membership reaches 69.6 million". in Xinhua News Agency, Beijing, [23 May 2005] reprinted in BBC Summary of World Broadcasts, Asia/Pacific, [23 May 2005].

Zhang, Y (1994). The Value of Women: On the Topic of 'Young Spring Chickens'. *Zhongguo Funu*, 2, 7–9 (in Chinese).

Chapter 6

Institutions and Gender Empowerment in Taiwan

Cal Clark* and Janet Clark

1. Introduction

Taiwan has experienced very rapid industrialization and economic trans-
formation during the postwar era. From the 1950s through the 1980s, it
averaged 9 percent growth per year. Moreover, unlike many developing
countries, industrialization brought decreasing income inequality, giving
Taiwan a record for "growth with equity". By the 1990s, it had basically
achieved the status of an industrialized nation (Chan and Clark, 1992;
Kuo *et al.*, 1981; Ranis, 1992). For example, its GDP per capita of
$15,000 in 2003 was three times higher than that of any other developing
country included in this book (Republic of China, 2006; World Bank,
2006). In contrast, democratization and political reform were delayed for
a considerable length of time as the country was ruled by the authoritar-
ian Kuomintang (KMT) party that had evacuated to Taiwan in 1949 at the
end of the Chinese Civil War. Although there was gradual political reform
during the 1980s, a democratic government was not really established until
the early 1990s (Copper, 2005; Rigger, 1999; Tien, 1996).

As discussed in much more detail in the theoretical introduction in
Chapters 1 through 3, women's empowerment or "substantive freedom" to
pursue their own goals crucially depends upon the social, economic, polit-
ical, and legal institutions that structure life in a particular society. This sit-
uation is particularly complex in developing countries because development
itself is usually associated with momentous changes in a nation's eco-
nomic, social, and political institutions. Taiwan represents a case where
these institutional changes generally promoted women's empowerment.

* Corresponding author.

Indeed, institutions in several areas interacted quite positively to improve women's status. While much of this institutional change was undoubtedly fortuitous, it is clear that women made very impressive gains in Taiwan in the half century following World War II.

This chapter has four substantive sections. The first provides the theoretical framework by outlining the very different impacts that industrialization and democratization might have upon the status of women. The second presents summary data on the status of women relative to men in Taiwan over the postwar era to justify the conclusion that significant progress toward women's empowerment has occurred on the island. The third and fourth then seek to explain women's growing empowerment by the country's institutional configuration and change: one on social and cultural institutions and one on political institutions.

2. The Conflicting Dynamics of Development for the Empowerment of Women

Many developing nations are passing through revolutionary economic, social, and political transformations. Development is usually associated with the transitions from agricultural to industrial economies and from authoritarian to democratic political systems. Initially, both these transformations were expected to lead to the greater empowerment of women in developing societies, but unfortunately the dynamics of development in many countries turned out to be much more problematic concerning the status of women.

During the 1950s and 1960s, there was widespread optimism that socioeconomic and political development would lead to equality for women who had long been suppressed in patriarchal societies nearly everywhere in the world. According to this perspective, industrialization should both bring much greater affluence, thus permitting and indeed requiring mass education, and rearranging production relationships and lifestyles. These economic transformations, in turn, would stimulate changes in traditional cultures that would make them more open to women's empowerment (Black, 1996; Eisenstadt, 1973). Cultural change and modernization, it was argued, should directly undermine traditional patriarchal norms and, by stimulating industrialization, should indirectly set off a series of socioeconomic changes favorable to women: (i) women's greater participation in the formal labor market, (ii) growing prosperity and

opportunities for education, and (iii) a more urbanized society in which the repressive power of extended kinship systems is diminished. Together, these changes should give women more autonomy, resources, and a sense of self-efficacy, thereby promoting women's empowerment and a marked improvement in the status of women.

Historical reality, unfortunately, did not live up to this theoretical potential. Instead, a much more perverse scenario unfolded in many developing nations. The processes by which modernization actually worked to the detriment of women in many cases had both concrete economic and more abstract ideological components. At the more concrete level, the economic changes accompanying industrialization proved to be far less favorable for women than anticipated by early modernization theory, as argued fairly early in the path-breaking work of Ester Boserup (1970). Thus, many women face marginalization, rather than empowerment, from such disparate facets of modernization as the mechanization of agriculture, the breakdown of strong kinship ties and the extended family, and the evolving division of labor in industrial urban centers. For example, new agricultural techniques (e.g., the Green Revolution in South Asia) were dominated by men, thereby marginalizing women in agricultural production (Boserup, 1970; Roy, 1994), and women's contribution to the industrial work force was largely limited to the least skilled and most tenuous positions (Scott, 1995; Truong, 1999). Consequently, while women in some social groups and classes have clearly benefitted from industrialization, the accompanying economic and social transformations have reproduced and reinforced patriarchy in many societies.

The failure of industrialization and modernization to revolutionize the status of women, moreover, was exacerbated by a change in scholarly and political perspectives on the relationship between modernization and the status of women. At the philosophical or theoretical level, the prime target of modernization came to be regarded as subordinating traditional economies and social relations — what Goran Hyden has called an "economy of affection" (Hyden, 1987) — to the supposedly much more efficient and transformative norms of, depending upon one's ideological predilections, the market or national planning (Scott, 1995). This philosophical stance, which is certainly consistent with the central thrust of modernization theory, however, turned modernization theory "on its head" regarding the role and status of women. In the initial formulation, women were expected to benefit from "the passing of

traditional society" (Lerner, 1958) with its highly patriarchal norms. In direct contrast, the "economy of affection" came to be seen as embodying the world of "irrational backward-looking women." Rather than liberating women, therefore, modernization came to represent the domination of masculinist role definitions in both the economy and the new emerging public sector.

Democratization and political reforms were likewise seen as possessing a strong potential for promoting the empowerment of women. Since democracy provides broader avenues for influencing public policy, previously excluded and marginalized groups, such as women, might gain some impact on governmental activities through two distinct mechanisms. First, women could become public officials themselves with the power to enact reforms lessening discrimination against their sex. Second, greater political and civic freedom could provide a conducive context for the emergence of independent women's groups pushing a government to enact desirable reforms. In either case, the end result is that government policy can be used to loosen and remove the restrictions on women erected by patriarchal cultures. However, the strength of the existing patriarchal culture will almost inevitably influence both the extent of women's autonomous participation in the public sector and the efficacy of government policy. Indeed, women seemingly made few gains from the democratic transformations in Latin America and the former Soviet bloc during the 1980s and 1990s (Waylen, 1994).

While both industrialization and democratization have the theoretical potential to promote the empowerment of women, these positive effects are far from assured. The institutional context under which development occurs, therefore, may make a very major difference in how much "substantive freedom" women are able to gain. After presenting data suggesting that the status of women improved quite appreciably during the postwar era in Taiwan, we then seek to explain this progress via the country's specific cultural, economic, political, and legal institutions.

3. Women and Development in Taiwan: Fairly Good General Outcomes

Taiwan's rapid development has seemingly had fairly good outcomes for women, at least at the aggregate level. Table 6.1, for instance, presents

Table 6.1: Indicators of women's socio-economic status in Taiwan.

	Women's average school years	Fertility rate	Women's percentage of labor force
Taiwan, Actual	9.5	1.7	42
Taiwan Dep Ratio	39.4	10.0	35.7

Source: Republic of China, 2006.

data on women's average schooling, the fertility rate, and women's share of the labor force. Taiwan's scores on the Gender Deprivation Index (see Chapter 3 for a discussion of this index) are fairly low on all three social indicators, especially considering that this index compares conditions in Taiwan with those in the wealthiest nations in the world. Taiwan's fertility rate of 1.7 per woman is low by even the standards of the developed world, creating a Gender Deprivation Index value of 10.0. Ironically, perhaps, Taiwan's fertility rate is virtually the same as China's, even though it is the result of the normal "demographic shift" associated with industrialization and urbanization rather than of draconian government intervention. Women's relative status is not so good in terms of their 9.5 average years of schooling and 42 percent proportion of the labor force, as the Gender Deprivation scores for these two variables are 39.4 and 35.7 respectively. Still, as the comparative data in Table 6.3 indicate, this record appears to be quite good for developing nations, such as the ones included in this book.

Sen's theory of entitlement exchanges put strong emphasis upon the resource endowment available to women. Consequently, educational policy in a country is crucial for women's empowerment because, as discussed in the theoretical introduction in Chapters 1 to 3, educational opportunities are vital if women are to develop their skills and resources. At the beginning of Taiwan's industrialization, educational opportunities were quite limited; and very substantial gender inequality existed in the education system. For example, in 1951 the average man had attended school for 4 years, while the average woman had only a year and a half of education (Chiang and Ku, 1985). The government instituted compulsory primary school (Grades 1–6) at the beginning of the country's development drive; and compulsory schooling was expanded to 9 years or junior high in 1968 (Hsieh, 1996).

Table 6.2: Percentages of age groups attending school.

	1969 (%)	1988 (%)
Age 6–11		
Male	98	99
Female	97	99
Age 12–14		
Male	70	91
Female	54	90
Age 15–17		
Male	43	73
Female	31	80
Age 18–21		
Male	20	29
Female	15	33
Age 22–24		
Male	7	8
Female	3	8

Source: Clark *et al.* (1996), p. 47.

Table 6.3: Percentages of all employed men or women in specific industries.

	Men, 1966 (%)	Women, 1966 (%)	Men, 1986 (%)	Women, 1986 (%)
Agriculture	43	47	19	14
Manufacturing	18	19	30	40
Commerce and Services	25	32	30	39

Source: Chou *et al.* (1990), p. 61.

Universal education paid for by the government is obviously very advantageous for girls because it prevents cultural prejudices from preventing girls from going to school. The data on the percentages of girls and boys in various age cohorts who attended school in 1969 and 1988 demonstrate the importance of Taiwan's educational policy (Clark *et al.*, 1996). In 1969, just after the increase in compulsory schooling, there was nearly universal schooling for both girls and boys through to the age of 11. For older children, however, the proportion of those in school dropped

considerably; and serious gender inequality existed for those who continued their schooling. For example, only little more than half (54 percent) of the girls aged 12–14 were in school compared to nearly three-quarters (70 percent) of the boys.

Clearly, the patriarchal traditional culture was acting in a biased manner to limit the resource endowments of many girls and women in Taiwan. Two decades later, as Taiwan emerged as an industrialized society, the picture was much more positive. School attendance for both girls and boys had increased substantially. Furthermore, the decided gender inequality that existed in the educational system had been overcome as well. Indeed, by 1988 women had become a little more likely than men to have continued their education beyond 15 years of age. Despite this aggregate equality in educational opportunities for girls and boys, more subtle but serious gender biases continue in the educational system. For example, lower levels of schools seem to be more oriented to educating and encouraging boys than girls; and substantial gender segregation by subject matter exists at the level of colleges and vocational schools (Hsieh, 1996).

The movement of women into the formal labor market is widely seen as a major factor promoting their empowerment. In Taiwan, women played a central role in the country's industrialization. As Table 6.1 above showed, they now comprise 42 percent of the labor force compared to only 27 percent in 1966. Thus, women have clearly become much more participative in the formal economy over the last 4 decades. The data on the sectoral distribution of women's and men's employment indicates that both sexes responded to the changing economy fairly similarly during Taiwan's spurt of rapid industrialization between 1966 and 1986, leaving agriculture and moving into manufacturing and, to a lesser extent, commerce and services at about the same rates. In terms of horizontal gender segregation, therefore, these data suggest that industrialization brought an impressive improvement in women's integration into Taiwan's economy.

This tells us nothing, of course, about women's vertical segregation within particular industries. Even here, though, Table 6.4 shows a surprising similarity between women and men with the very glaring exception of the very top occupational stratum of managerial and administrative jobs from which they were generally excluded. In contrast, women gained "equal representation" in professional occupations throughout this period. In the middle of the occupational hierarchy, women did

Table 6.4: Percentage of all employed men or women at specific levels of occupational hierarchy.

	Men, 1966 (%)	Women, 1966 (%)	Men, 1986 (%)	Women, 1986 (%)
Managerial	4.4	1.4	1.2	0.2
Professional	4.6	5.8	6.0	6.7
Clerical	7.3	6.1	11.2	18.0
Sales	10.4	12.4	13.3	13.7
Production	20.2	16.6	42.6	36.2
Agriculture	42.4	46.6	18.5	14.2

Source: Chou *et al.* (1990), p. 61.

extremely well in gaining the rapidly expanding number of clerical positions between the mid-1960s and mid-1980s, becoming well over-represented in this job class, while the proportion of both men and women working in sales remained about the same throughout this period. Women were not disproportionately concentrated at the bottom of the occupational ladder either. Throughout these 2 decades they were slightly underrepresented among production workers; and they went from being slightly overrepresented to slightly underrepresented in agriculture (Chou, 1990).

Despite Taiwan's relatively good record in terms of aggregate statistics, more detailed and qualitative studies point to continuing and substantial biases that women face in labor markets. Most importantly, women's role in the industrial labor force has always been subject to very considerable discrimination. For example, women have formed a highly disproportionate number of the "part-time proletariat" who work in factories before marriage, rank at the bottom of pay and status among manufacturing employees, have almost no opportunity for advancement, and continue to be subordinated within traditional family structures. In agriculture and small-scale commerce, moreover, women are far more likely than men to occupy the marginalized status of "unpaid family help" (Greenhalgn, 1985; Hsieh, 1996; Kung, 1983).

Turning to the political realm, women have gained very significant representation in many areas of government. As illustrated by the data in Table 6.5, the question of how well women are represented in Taiwan's politics is one of whether one sees a glass "half full or half empty".

Table 6.5: **Women's political representation in Taiwan, 1998–2001.**

Legislative representation	Number of women	Percentage of women members
Legislative Yuan	43	19
National Assembly	61	18
Provincial Councils	16	20
District Councils	151	17
Town Councils	620	17
Executive representation		
National Govt's Cabinet	9	23
County/City Executives	3	13
Town Mayors	18	6
Judicial representation		
Grand Justices	1	6
Supreme Court Justices	10	13
Administrative Court Justices	5	21
High Court Justices	39	13
District Court Justices	261	32
Civil service representation		
Political Appointees	23	7
Grades 10–14	775	11
Grades 6–9	28,754	39
Grades 1–5	39,826	54
Employees	7,871	62

Source: Clark and Clark (2002), pp. 21, 23 and 24.

On the one hand, women are grossly under-represented in almost all categories of political offices and jobs; on the other, they now have very significant representation that is fairly high for a developing country. At the turn of the century, for example, women held about one-fifth of the seats in legislative bodies at all levels of government, although they did not achieve this level of representation in the most important Legislative Yuan until the 1990s.

Likewise, women now generally hold at least one-fifth of the cabinet posts, although a woman was not appointed as a minister until 1988; and women are even less well represented among the mayors and chief executives of cities and counties and at the top levels of the judiciary. Finally, women hold only approximately 10 percent of the high-level positions in

the civil service, but do have much better representation (nearly 40 percent) at the middle levels (Chou, 1990; Clark and Clark, 2002).

4. The Impact of Social and Cultural Institutions on Women's Empowerment in Taiwan

As discussed in much more detail in Chapters 1 through 3, a nation's social and cultural institutions are a central determinant of the opportunities that women have for empowerment in a particular society. In many developing nations, these institutions, in turn, may change considerably due to the effects of either new government policies or the momentous social change associated with industrialization and urbanization. However, official institutions and policies do not necessarily change more informal social institutions which may still work to prevent women's empowerment. Taiwan presents a good case, illustrating both the potential and limits for such change in social and cultural institutions to shape women's resource endowments and ability to use their endowments.

The stereotype of Taiwan is that it is a Chinese Confucian society with a highly patriarchal culture. Yet, this stereotype of the unmitigated suppression of women has been challenged by several scholarly traditions. First and most broadly, historical research has demonstrated that the status of women in Chinese societies has varied widely both among classes and in different historical eras. This certainly indicates that there is no "iron law of patriarchy" inherent in Chinese culture that can be easily adduced from the norms of Confucian philosophy. Rather, Confucian culture (like any other major cultural tradition for that matter) is consistent with a variety of social formations. Consequently, women's status has varied considerably among different Chinese societies and historical eras (Ropp, 1976; Teng, 1996; Watson and Ebery, 1991).

Second, the major thrust of these historical studies has also been supported by anthropological research in Taiwan itself. Teng (1996) argues that this research tradition is based on Margery Wolf's *Women and the Family in Rural Taiwan* (1972). Wolf's anthropological field work found a variety of social phenomena that were at variance with the prevailing stereotype of women's universal oppression and victimization under Confucian patriarchal culture. Women's status differed considerably over their life cycle; women actively participated in informal social networks

that exercised considerable power; and some of these social networks even constituted "a women's community" (Teng, 1996).

Robert Weller's work on civil society and democracy in China and Taiwan represents a somewhat broader application of this approach (Weller, 1991). Weller is primarily concerned with the extent to which groups independent and autonomous from the state and official organizations have developed in Chinese societies and with the contribution that such manifestations of a "civil society" can make to the development of democratic politics. His analysis of civil society in Taiwan and China, though, is distinctive because of the strong emphasis that he places on the role of women in developing informal social organizations in Chinese societies. Weller argues that historically, women have played a leading role in a wide array of "horizontal" social organizations (e.g., religious groups, poetry societies, clothes-washing groups, and revolving credit associations) at every level or class in society. While these organizations, unlike those dominated by men, were almost exclusively communal and local in nature, the ties were often more intense and more trustworthy than in male organizations. In contemporary society, Weller sees women as taking a leading role in small business and revolving credit associations, charitable groups, and even more conventional political interest groups.

Thus, Taiwan's Confucian culture, while strongly patriarchal, seemingly provided women with some opportunities to gain and use resources. Two major policy changes associated with Taiwan's industrialization program, universal education and a radical land reform, created opportunities for many but certainly not all women on the island. Traditionally, most families in Taiwan had been reluctant to invest in education for their girls who were regarded as "spilled water" because they left the family upon marriage. However, this severe barrier to women's empowerment was at least partially overcome in the 1950s because the government made primary and later middle-school education compulsory and paid for it with public funds. The importance of the government's educational program for women is strongly indicated, for example, by the much higher continuation rate of boys than girls beyond the compulsory level that lasted through the mid-1970s (see Table 6.2), implying very significant cultural biases against girls and women (Hsieh, 1996). Even with these limitations, though, the tremendous expansion of educational opportunities for women during the postwar

era is widely seen as making a major contribution to women's empowerment in Taiwan (Chiang and Ku, 1985; Chou *et al.*, 1990; Farris, 2000).

The implications of land reform were quite significant, too. During the 1950s and 1960s, these effects were clearly positive. Because of the small agricultural plots that were institutionalized by the "Land to the Tiller" program, large-scale mechanization was limited, thereby curbing the pressures for a gender-based division of labor in which men would monopolize the new, much more productive technologies. Consequently, women shared the benefits of vastly increased ownership and somewhat increased productivity with men without facing the negative spin-offs that the Green Revolution can produce for the status of women. Furthermore, the growth of nearby factories minimized the disruption of traditional ties and support systems that industrialization inevitably generates. The manner in which this system affected women changed drastically in the 1970s and 1980s, however, when low-educated rural women became increasingly trapped in increasingly marginalized small-scale agricultural production (Clark *et al.*, 1996).

Rapid industrialization and urbanization set off other important social changes in the status of women in Taiwan. First, the urbanization accompanying rapid industrial growth helped to undercut the extended kinship groups which are normally considered to be at the core of Confucian patriarchy, as well as stimulating the "demographic transition" from high fertility to low fertility rates. Second, industrialization increasingly brought women out of the home into the paid workforce. Initially, the implications of this transition were decidedly mixed for women, as the major opportunity for work was in semi-skilled labor-intensive industries with low wages and poor working conditions. Even here, where women workers could certainly be considered exploited in economic terms, employment brought increased independence for many women workers, though (Farris, 2000).

These major social changes brought significant pressures, undercutting traditional family relations. Several traditional norms continued to hold sway even as what has been termed the "new nuclear family" has increasingly replaced the extended rural kinship system in urbanized Taiwan. For example, daughters are still viewed as "marrying out" of their natal families. However, women, especially those who are educated and employed, have become much more independent. For example:

> Highly educated urban women after marriage use their greater economic independence to help their natal families financially. Thus, various tensions within the family are evident as women assume new roles in the

larger society. Many men resent challenges to their traditional preroga-
tives of domination in the public domain and also resent challenges to a
sexual double standard. This contributes to domestic discord and a slowly
rising divorce rate (Farris, 2000, p. 158).

Women in Taiwan have made important strides toward obtaining legal
equality, but some of these legal victories have been quite recent. For exam-
ple, family law was grossly discriminatory until the mid-1990s. Husbands
had the right to manage the joint property of married couples and were auto-
matically awarded custody of the children after divorces. That such legal dis-
crimination could exist in what was an essentially industrialized society
certainly underlines the lasting power of informal patriarchal institutions in
Taiwan. Similarly, abortion was legalized in 1984, but a woman had to obtain
the consent of her husband or legal guardian before she could have an abor-
tion, again indicating a continuation of patriarchal norms. Violence against
women also remains a problem, which may even be exacerbated by the
growing strains that result from women's ongoing empowerment in
Taiwanese society. A tragic incident cruelly underlined this problem in 1996
when feminist activist Peng Wan-ru was murdered by a taxi driver on her
way home from a debate in the Democratic Progressive Party (DPP) on her
proposal requiring the party to slate at least 25 percent of women candidates
in national elections, symbolizing the problems that exist in protecting the
security and rights of women (Hsieh, 1996; Farris, 2000; Yang, 1999).

In sum, social and cultural institutions have changed very significantly
in postwar Taiwan. Some of these changes were the result of explicit gov-
ernment policy, while others were shaped by government policy. In general,
these institutional changes worked to expand the empowerment of women
by allowing them to gain more personal resources and by relaxing the con-
straints on how they could "exchange" these resources and "entitlements" in
the pursuit of their own goals. Still, a very important caveat to this overall
conclusion should be noted. These institutional factors work very differently
for various classes or groups of women, benefitting some and hurting others.
Thus, while the number of "winners" has expanded greatly, the number of
"losers," though declining, remains quite significant.

5. The Impact of Political Institutions on Women's Empowerment in Taiwan

The preceding discussion implies that Taiwan's political institutions might
be important in explaining the growing empowerment of women there for

two distinct reasons. First, the comparatively good representation of women in government suggests that we should search for factors that promoted political careers for women; and, second, the importance of government policies for improving women's status also should focus attention upon the public sector. This section, hence, describes two political institutions that are essential for understanding the position of women in Taiwan's politics. One is the formal election system that constitutionally mandates a minimum number of legislative seats for women; and the other is the informal expansion of interest groups, including women's groups, that occurred after the country democratized.

Article 136 of the 1946 Constitution mandates that women be guaranteed a minimum representation in legislative assemblies at all levels of government. In practice, this has meant that one or more seats are "reserved" for women in Taiwan's multi-member electoral districts, with the number of "reserved seats" being determined by the size of the district. When a sufficient number of women candidates get enough votes to be elected, they are considered to have met this quota. However, when no or not enough female candidates get enough votes to be elected, those with the most votes are awarded the seat or seats reserved for them. Overall, about 10 percent of legislative seats were reserved for women by this system (Chou *et al.*, 1990).

This reserved-seats system, in turn, became important because the strategy of the Kuomintang party for ruling Taiwan utilized competitive local elections, even though the national government remained quite authoritarian. Rather than destroying the pre-existing social and political groups when it evacuated to Taiwan in 1949, the regime attempted to co-opt and manipulate them when possible. In the political realm (government bodies, farmers associations, etc.), this resulted in the Mainlander (i.e., those who had come with Chiang Kai-shek) "national" elite playing "local" Islander (i.e., long-time residents of Taiwan who were almost all Han Chinese as well) factions off against each other and retaining power by acting as an arbitrator among them. Whether intended or not, the introduction of local elections based on the Japanese system of one nontransferable vote in a multi-member district proved perfect for this strategy since it forces factions of the dominant party to compete against each other directly (Rigger, 1999).

This combination of electoral system and KMT strategy for incorporating competing Islander groups into the regime then shaped the application of a traditional Confucian norm in an unexpected manner.

In Chinese society, social, economic, and political life is organized around informal networks based on kinship and other types of personal relations or *guanxi* (Pye, 1988). Such networks have been and still are extremely important in Taiwan. For example, they are credited with undergirding the complex network of small firms which has contributed so much to the nation's economic success (Greenhalgh, 1988) and are viewed, often in a far less positive light, as being a key element in Taiwan's electoral and patronage politics (Rigger, 1999). Normally, such informal *guanxi* networks would probably discriminate against women because of their linkage to the traditional patriarchal culture. However, the "reserved seats" system turned this normal patriarchal bias on its head!

Some women had to be recruited to run, or else a seat would go by default to a woman from an opposing faction or, more recently, party. Moreover, the KMT's more indirect strategy of "divide-and-rule" was based on maintaining real competition at the lower levels in order to prevent Islander challenges to the Mainlander top elite. Real competition, in turn, meant that gradually women who were first elected as tokens would almost be forced to develop their own political skills and become viable political leaders in their own right. Thus, the growing success of women over time can be explained by this unintended interaction of electoral institutions and traditional Chinese networks. This process was also stimulated by the rapid growth in the number of women with advanced education and professional employment, which greatly expanded the "eligibility pool" for women candidates (Chou *et al.*, 1990; Clark and Clark, 2000; Yang, 1999).

Unfortunately, not all these changes were positive or necessarily implied that women would make steady progress toward equal representation. The very kinship nature of Taiwan's political factions generated several important constraints on women politicians. First, there was an understandable tendency for leaders to recruit relatives or other extremely loyal women to run for "women's seats" which undoubtedly undercut their subsequent ability to gain true independence and political stature. Second, revulsion against kinship-based factions at times hindered the careers of women who were married to political leaders. Third, the patronage orientation of most local networks and factions (as well as limited revenue capabilities) gravely limited their abilities to attack the social problems of special interest to women (Chou *et al.*, 1990; Clark and Clark, 2000).

Another important role played by women in Taiwan's politics was as activists in feminist and women's groups which pushed for an aggressive agenda of democratization, social reform, and the granting of equal rights to women. During the authoritarian era from the late 1940s through the 1970s, a variety of women's groups existed. However, they either were officially organized by the regime, such as the Kuomintang Party's Office of Women's Activities, or were fairly conservative social and professional organizations that were closely tied to the Office of Women's Activities. Consequently, these organizations were highly supportive of the political status quo and refrained from challenging Taiwan's patriarchal culture. In addition, Taiwan's feminist movement in the 1970s and early 1980s was something of a "one-woman whirlwind", in large part because of the open hostility from the regime toward its leader Hsiu-lien Annette Lu, who was very active in the political opposition (Chiang and Ku, 1985; Clark and Clark, 2000; Farris, 1994). For example, when Lu was arrested for participating in a major demonstration, her interrogators specifically berated her for her activities on behalf of the Feminist Movement, even though they had nothing to do with the alleged reason for her arrest:

> "Your motivation to launch such a movement is to destabilize the society, especially to arouse dispute between the husbands and wives of our high ranking officials so that their marriages may be broken" (Farris, 1994, p. 311).

Certainly, patriarchy was alive and well in the regime at that time; and repression from the KMT sharply limited support for Lu and her Women's New Awakenings Foundation.

The beginning of Taiwan's democratic transition in the mid-1980s, however, opened up more "space" for both feminist activities and the formation of new, independent women's groups. Many new women's organizations were formed. In 1986, for instance, Chen Hsiu-hui established the Homemakers Union which was concerned with the protection of the environment and a wide range of social issues. The growth in the number and kind of women's organizations demonstrated concern not only for the traditional women's issues of child care and hospital services but also for broader social goals. Women displayed an increased willingness to focus on shared substantive issues such as prostitution, pornography, and discrimination in the workplace. They also participated in protests related to nuclear development, pollution, police-protected prostitution, and aborigines' land struggles. Somewhat later in the 1990s, the Feminist

Movement in Taiwan began to expand as well. In particular, the diversity (as well as the number) of feminist groups increased to meet the needs of particular groups of women. For example, the Feminist Studies Association became quite active in academic life; the Warm Life association was formed by divorced women; and the Taipei Association for the Promotion of Women's Rights and Pink Collar Solidarity supported working women against the still prevalent patriarchal norms in Taiwan's economy and society (Farris, 1994, 2000a; Ku, 1998; Weller, 1999).

Not all women's groups were particularly feminist, though. In fact, several seemingly derived their success from appealing to traditional values. For example, the Homemakers Union Environmental Protection Foundation primarily appealed to middle-class housewives who "root their environmentalism in issues of household and motherhood". Moreover, probably the most successful women's group through the 1990s, the Compassionate Relief Merit Society, appeared distinctly unfeminist. Compassionate Relief had been founded by a Buddhist nun in the 1960s and grown to a membership of 4 million (80 percent are women) 25 years later, making it the largest civic organization in Taiwan, with a charitable budget of over $20 million annually. This organization, in addition to its traditional religious orientation, ignores normal feminist concerns in its support for the traditional family structure and in its appeal to wealthy housewives (Weller, 1999).

6. Institutions and Women's Empowerment in Taiwan

Taiwan's rapid industrialization has clearly been accompanied by a remarkable improvement in the status and "substantive freedom" of women in that society. Just as clearly, however, significant barriers and limitations remain as well. The nation's social, economic, and political institutions have shaped this process to a considerable extent. The central role that universal primary education and land reform played in the expansion of women's resource and endowments and ability to exchange these endowments validates Sen's theory of development. This also raises the ironic point that the policies that have almost certainly been the most effective in increasing women's substantive freedom were not really implemented with women in mind but were, instead, part of a general development program that focused on human capital. In contrast, many laws that were explicitly aimed at promoting equality were only passed in the last decade or so after the advent of

democratization in Taiwan; and, as noted in the previous section, strong indications of continuing patriarchal policies were easy to find until quite recently. The timing of the legal reforms, probably not coincidentally, followed the explosion of women's interest groups in the late 1980s and early 1990s, in line with the finding that the activities of independent women's groups are the key to enacting policies that promote women's rights (Bystydzlenski and Sekhon, 1999; Lee and Clark, 2000). In short, women now have considerable resources at their disposal in Taiwan, but future progress depends upon their ability to use these resources to attack the remaining patriarchal aspects of social and political institutions in Taiwan.

References

Black, CE (1966). *The Dynamics of Modernization: Essays in Comparative History.* New York: Harper & Row.

Boserup, E (1970). *Women's Role in Economic Development.* Allen & Unwin: London.

Bystydzienski, J and Sekhon, J (eds.) (1999). *Democratization and Women's Grassroots Movements.* Bloomington: Indiana University Press.

Chan, S and Clark, C (1992). *Flexibility, Foresight, and Fortuna in Taiwan's Development: Navigation between Scylla and Charybdis.* Routledge: London.

Chiang, LHN and Ku, YL (1985). *Past and Current Status of Women in Taiwan.* National Taiwan University's Women's Research Program: Taipei.

Chou, BE, Clark, C and Clark, J (1990). *Women in Taiwan Politics: Overcoming Barriers to Women's Participation in a Modernizing Society.* Boulder, CO: Lynne Rienner.

Clark, C and J Clark, (2002). *The Social and Political Bases for Women's Growing Political Power in Taiwan.* Baltimore: University of Maryland Series in Contemporary Asian Studies.

Clark, C, Clark, J and Chou, BE (1996). In *Economic Development and Women in the World Community.* Roy, KC, Tisdell, CA and Blomqvist, HC (eds.), pp. 37–48. Westport, CT: Praeger.

Copper, JF (2005). *Consolidating Taiwan's Democracy.* Lanham, MD: University Press of America.

Eisenstadt, SN (1973). *Tradition, Change, and Modernity.* Wiley: New York.

Farris, CS (1994). In *The Other Taiwan: 1945 to Present.* Rubinstein, MA (ed.), pp. 305–329. Armonk, New York: M.E. Sharpe.

Farris, CSP (2000). In *Democracy and the Status of Women in East Asia*. Lee, RJ and Clark, C (eds.) pp. 143–167. Boulder, CO: Lynne Rienner.

Greenhalgh, S (1988). In *Contending Approaches to the Political Economy of Taiwan*. Winckler, EA and Greenhalgh, S (eds.), pp. 224–245. Armonk, New York: M.E. Sharpe.

Hsieh, HC (1996). In *Women, Education, and Development in Asia: Cross-National Perspectives*. Mak, GCL (ed.), pp. 65–91. New York: Garland.

Hyden, G (1987). In *The Political Economy of Kenya*. Schatzberg, MG (ed.), New York: Praeger.

Ku, YL (1998). In *Guide to Women's Studies in China*. Hershatter, G Honig, E, Mann, S and Rofel, L (eds.), pp. 115–134. California Institute of East Asian Studies, University of California, Berkeley.

Kung, L (1983). *Factory Women in Taiwan*. Ann Arbor, MI: UMI.

Kuo, SWY, Ranis, G and Fei, JCH (1981). *The Taiwan Success Story: Rapid Growth with Improved Income Distribution in the Republic of China*. Boulder, CO: Westview.

Lee, RJ and Clark, C (eds.), (2000). *Democracy and the Status of Women in East Asia*. Boulder, CO: Lynne Rienner.

Lerner, D (1958). *The Passing of Traditional Society: Modernizing the Middle East*. New York: Free Press.

Pye, LW (1988). *The Mandarin and the Cadre*. Ann Arbor: University of Michigan Press.

Ranis, G (ed.) (1992). *Taiwan: From Developing to Mature Economy*. Boulder, CO: Westview.

Republic of China, National Statistics (2006). Taipei: Government of Taiwan. www.gov.tw.

Rigger, S (1999). *Politics in Taiwan: Voting for Democracy*. Routledge: London.

Ropp, P (1976). The seeds of change: Reflections on the condition of women in the early and mid Ch'ing. *Signs*, 2, 5–23.

Roy, KC (1994). In *Technological Change and Rural Development in Poor Countries*. Roy, KC and Clark, C (eds.), pp. 65–79. Oxford University Press, New Delhi.

Scott, CV (1995). *Gender and Development: Rethinking Modernization and Dependency Theory*. Boulder, CO: Lynne Rienner.

Teng, JE (1996). The construction of the 'traditional Chinese woman' in the Western academy: A critical review. *Signs*, 22, 115–151.

Tien, HM (ed.), (1996). *Taiwan's Electoral Politics and Democratic Transition: Riding the Third Wave*. Armonk, NY: M.E. Sharpe.

Truong, TD (1999). The underbelly of the tiger: Gender and the demystification of the Asian Miracle. *Review of International Political Economy*, 6, 133–165.

Watson, RS and Ebrey, PS (eds.) (1991). *Marriage and Inequality in Chinese Societies*. Berkeley: University of California Press.

Waylen, G (1994). *World Pols.*, 327–354.

Weller, RP (1999). *Alternate Civilities: Democracy and Culture in China and Taiwan*. Boulder, CO: Westview.

Wolf, M (1972). *Women and the Family in Rural Taiwan*. Stanford: Stanford University Press.

World Bank (2006). *World Development Report*, 2006. New York: Oxford University Press.

Yang, WY (1999). *Politics of Gender Differences in Taiwan's Legislative Yuan*. Unpublished PhD Dissertation, Michigan State University.

Chapter 7

Institutions and Women's Empowerment in Kenya

Tabitha W. Kiriti-Nganga

1. Introduction

Despite worldwide progress in promoting women's rights, in no country are women free from discrimination. This discrimination feeds and is reinforced by violence against women (Amnesty International, 2002). This has led to marginalization of women and the lack of political and economic empowerment.

Empowerment implies the creation of an enabling environment for individuals to fully use their capabilities to take charge of their lives. Empowerment also implies the building or acquiring of capacity to accomplish certain tasks and attain specific goals. In the case of women, empowerment involves creating an enabling environment so that women can use their competencies to address the fundamental problems of society at par with their male counterparts. Therefore, true empowerment should show that women are increasingly breaking the traditional boundaries and stereotypes in Kenya and the world at large.

Kenya has a geographical area of 583,000 square kilometres and is bordered by Somalia to the northeast, Indian Ocean to the east, Ethiopia to the north, Uganda to the west and Tanzania to the South. Kenya gained independence in 1963 from the British government. Politically, the country is divided into 210 parliamentary constituencies, which are represented by duly elected members.

Currently, the population is estimated at 32 million, the last census having been carried out in 1999. The Gross National Income per capita in 2004 was $460 while in terms of purchasing power parity, it was $1,050 during the same year. Agriculture is the mainstay of the economy although its

performance has been going down over the years. In 2004, the share of agriculture in total Gross Domestic Product was 16 percent. Since 66 percent of the population lives in rural areas, rural poverty has been quite high and in the late 1990s, rural poverty was 53 percent while urban poverty was 49 percent. The total population that lived below the poverty line during the same period was 52 percent.

2. Women's Contribution to Kenya's Economic and Social Development

Over 75 percent of women in Kenya live in rural areas where they dominate the agricultural sector. The contribution of women to economic and social development is, therefore, most dominant in agriculture and most of the food consumed by Kenyans are produced by women. And in business they are more involved in the informal sector while men dominate the formal sector. This setting means that since much of the country practices subsistence agriculture, women's earnings are minimal.

The World Bank (2006a) shows that Kenyan women are "time-poor" due to their dual roles in the household economy and in the labor market. On average, it shows, women work longer hours (12.9) compared to men (8.2) yet they earn less since more of these hours are not remunerated. They cook, clean, reproduce, and do other household chores which release time for the men to do other things.

In the business sector, women make up nearly half of all micro-, small, and medium enterprises (MSMEs), but their businesses tend to be smaller and are less likely to grow. They also suffer from lack of sufficient capital investment than male-owned firms. Despite their potential, women-owned businesses in Kenya are less likely to grow, are smaller, and are twice as likely to be operating from home as male-owned businesses.

The contribution that women make to economic, social, and political lives of their nations, communities, families, and the next generation, makes them key actors in effective development. The basic objective of development is enlarging people's choices. The essential components of enlarging people's choices is the equality of opportunity for all people in society, sustainability of such opportunities from one generation to the next, and the empowerment of people so that they participate in and benefit from the development process. This entails equal access to basic social services, including education and health, equal opportunities for participation

in political and economic decision-making, equal reward for equal work, equal protection before the law, elimination of discrimination by gender, and equal rights of citizens at the workplace and at home at all times (United Nations Development Programme, 1995).

Women face discrimination not only at the household level where resources are unequally allocated but also at the national level where the systems (laws, culture, taboos, and so on) are anti-women. More than 800 million women are economically active worldwide, whether in agriculture, small and micro-enterprise, or in export processing industries. However, women's unemployment rates remain high relative to those of men and when employed, they are paid less than men for the same work. Women also constitute 60 percent of the rural poor (Jazairy, *et al.*, 1992).

Limitations on women's legal rights and participation in civil society are widespread. Political leadership positions are still mainly occupied by men. Although women have increasingly provided dynamic leadership in Non-governmental Organizations (NGO's) and small enterprise sectors, legal restrictions on women's land and property ownership continue to hamper women's ability to acquire productive assets to reduce their vulnerability to poverty.

Girls' education has been shown to have a dramatic impact on women's economic power and on families' welfare but progress toward gender equality in education still lags behind, both in absolute terms and relative to those of boys. However, violence impedes women's ability to live full and productive lives. It restricts their contributions to family, societal and economic development.

3. To Cope with Vulnerability

Vulnerability generally refers to the potential to be adversely affected by an event or change (Kelly and Adyer, 2000). Social characteristics such as gender, age, wealth status, and education are associated with vulnerability. Adger and Kelly (1999) argue that the architecture of entitlements, or the pattern of access to resources, is determined both by material sources of entitlement and the context within which they are distributed, including formal structures and more diffused rules of the game and social and cultural norms. In addition to formal entitlements, many responses are based on informal rights based not on law but on locally accepted notions of legitimacy (Gore, 1993).

The Kenya government has done too little to combat the entrenched, chronic abuses of women's and girls' human rights that expose them to so many risks, including HIV/AIDS. By failing to enact and effectively enforce laws on domestic violence, marital rape, women's equal property rights, female genital mutilation, and sexual abuse of girls, and by tolerating customs and traditions that subordinate women, the Kenya government is enabling HIV/AIDS to continue claiming the lives of women and girls.

Generally, women in Kenya are vulnerable to risks such as: domestic violence, including marital rape; violations of property and inheritance rights; the harmful traditional practices of bride price, widow inheritance, and ritual sexual cleansing; female genital mutilation and sexual abuse of girls. These abuses are perpetrated by families and tolerated by governments. They are among the most pervasive and dangerous forms of abuses of women and girls. Domestic violence limits women's capacity to resist sex and to insist on their spouse's fidelity or condom use. Yet, Kenya has failed to prevent domestic violence, prosecute or otherwise punish perpetrators, or provide health or legal services to survivors except for a few NGOs. Marital rape is not treated as a crime and the male members of Parliament do not even believe that marital rape can exist. Domestic violence and spousal rape has caused or contributed to most women's HIV infection.

Most Kenyan women are also vulnerable to abuses of their property rights and rights of inheritance. Many widows are barred by law and custom from inheriting property, evicted from their lands and homes by in-laws, and stripped of their possessions. Divorced women are often expelled from their homes with only the clothes on their backs. A woman's access to property usually hinges on her relationship with a man. When the relationship ends, the woman stands a good chance of losing her home, land, livestock, household goods, and other property. While this discrimination stems from customs that favor men for inheritance and property ownership, it is also supported by government policies and laws that discriminate women in inheritance and divorce matters.

In countries like Kenya, where twice as many women are HIV-positive as men, the AIDS epidemic magnifies the devastation of women's property violations. AIDS deaths result in many women becoming widows at a younger age than would otherwise be the case. These women and their children are likely to face not only stigma against people affected by HIV/AIDS, but also deprivations caused by property rights violations. Children orphaned and affected by HIV/AIDS, especially girls are also at

risk of property-grabbing when their parents are sick or die. Divorced and separated women fare no better. Most women in Kenya remain in violent relationships because leaving would mean losing their homes and other material belongings.

Kenyan women are also vulnerable to harmful traditional practices. While traditional practices and customs are important to community identities this should not be at the expense of women's and girls' rights and health. Just as discriminatory statutes must be amended to protect women's and girls' rights, harmful traditional practices must be transformed to eliminate abusive aspects. Such practices as payment of bride price or dowry, widow inheritance, female genital mutilation, and ritual sexual cleansing are especially harmful to women.

The payment of dowry by a man's family to his future wife's family acts as an obstacle for women attempting to leave abusive relationships. Though the intent is meant to show appreciation to the bride's parents and reinforce relations between families, dowry is an outright purchase of a wife. A woman in such a relationship cannot say no to sex when her husband desires it. It is also a major cause of domestic violence as most men beat their wives to measure up and some women even appreciate beating as a sign that their husbands love them.

Other harmful traditional practices are practices where widows are coerced into engaging in risky sexual practices upon the death of their husband. These practices include widow inheritance also known as wife inheritance and ritual sexual cleansing. Wife inheritance is where a male relative of the dead husband takes over the widow as a wife, sometimes in a polygamous family. Cleansing usually involves sex with a social outcast who is paid by the dead husband's family, supposedly to cleanse the woman of her dead husband's evil spirits. In both of these practices, safe sex is seldom practiced and sex is often coerced. While some women consent to these practices, others are coerced into them in order to stay in their homes and keep their property. Rejecting these practices can result in social exclusion or rape. Succumbing to them can contribute to HIV infection.

Female genital mutilation (FGM) is practiced by no less than 26 tribes in Kenya. It is most prevalent in the rural areas and in the slums in urban areas. The communities that do not practice FGM are considered unclean or immature. Some girls are stigmatised and shunned by their schoolmates that they decide to undergo the operation, even when their parents would have decided otherwise. In early June 2006, it was reported on Kenyan TV that a girl had died in Meru district when trying to circumcise herself

after her mother had refused to give her permission. This practice is meant to curtail a woman's sexual urges. It undermines the educational and economical opportunities of Kenyan girls since most girls drop out of school after the operation in order to get married. Although banned, FGM continues unabated since the local administration turns a blind eye in exchange for bribes. However, FGM is not actually outlawed in the Constitution which sanctions it as a customary practice, nor has it been addressed in the traditional structures of customary laws. Even when cases of forcible circumcision are brought to court, they are not taken seriously by the magistrates and are taken as ordinary assault. Until meaningful measures are introduced, women whose communities practice FGM will still have to suffer the consequences. Unless the risks outlined above are removed, women's freedom will always be curtailed and we cannot talk of gender empowerment.

4. Gender Empowerment: Discrimination against Women in Kenya

Women constitute 52 percent of Kenya's population, but the majority of them are among the illiterate and poor in the country (Republic of Kenya, 2003, 2004, 2005). Majority of the women are still affected by customary laws and practices, which for so long have perpetuated their oppression and enhanced sex-based discrimination.

Kenya, being a patriarchal state, fears the illegalization of sex discrimination because it may lead to countless court suits by women. This fear has, therefore, meant that women, who are most likely to be affected by such provisions, are denied constitutional protection from sex-based discrimination.

Even where the *dejure* process has been made in achieving equality, women continue to be discriminated against as a result of conflict between laws in Kenya and customary practises and the economic situation. Women experience a wide range of discriminatory practices, limiting their political and economic rights. They are *de facto*, second-class citizens. Customary law disadvantages women, particularly in property rights and inheritance. Under the customary law of most ethnic groups in Kenya, a woman cannot inherit land and most live on the land as a guest of male relatives by blood or marriage. Customarily, women do not own property, or the land they work on, which causes them economic hardship and places them in a position of dependence.

The traditional inferior status of women is reinforced by the predominance of marriages under some form of customary law that limits women's rights. There are several laws governing marriage and divorce based on the different religions in the country; namely customary, Christian, Hindu, and Muslim laws. The Marriage Bill has to date not gone into force that is expected to harmonize these laws. The constitutional legitimization of sex discrimination has far-reaching consequences for women in Kenya as will be noted in this chapter. This has meant that in the area where women are most affected, the constitution offers them no protection.

The majority of the poor in Kenya are women and it means that legal services are in most cases out of reach for a majority of them. This means that special legal aid arrangements are necessary to enable them to challenge discriminatory practices inherent in personal law. For example, there is a general principle under customary law that the husband should manage the wife's property, except for movables such as personal effects. There are also divergent practices on the position of the woman, with regard to her property rights and dissolution of marriage.

The responsibility to care for a child born out of wedlock is placed squarely on the mother, who has to provide for its education and other necessities of life. This is discriminatory. An unwed mother has no remedy, save for pregnancy compensation, which is recoverable by parents under customary law. The compensation of Ksh. 1,000 (US$13.7) sanctioned by the law, is contemptuous and would not even go halfway to defray medical expenses related to the child's birth. In any case, it is recoverable by parents for the lost honour of their daughter and not necessarily for the maintenance of the child.

In the Law of Succession Act, there is a distinction between rights of married and unmarried daughters. It has been argued and held that married daughters are not entitled to inherit. This means that an unnecessarily high number of female-headed households in urban centres that are exposed to extreme poverty, overcrowding, unemployment, and health hazards are the victims of this Act. Women have rarely inherited land and other property in their rural homes. This may be the reason why more female household heads move to urban areas in search of employment as they seek other means of production and survival.

Poverty and traditionalism remain two serious obstacles to women's equal rights in Kenya. The UN Economic and Social Council (1998) noted that poverty in general, inhibited the full implementation of

women's rights and that the situation meant that women have unequal access to resources, ensuring continued discrimination.

The draft constitution, rejected on 21 November 2005, had provided for the equal treatment of women with men, including the right to equal opportunities in political, economic, and social activities and the equal right to inherit, have access to land, and control property. The draft had prohibited any law, culture, custom, or tradition that undermined the dignity, welfare interest, or status of women.

4.1. *Second-class citizens*

Although Kenya's various ethnic groups have different cultures and traditions, some of which contribute to promoting women's rights, in general, the status of women in Kenya is that of second-class citizens. Section 82 (3) of the Kenya Constitution, denies women protection outside their homes (e.g., in the workplace) whilst Section 82 (4) (6) further denies them protection in their homes. The effect is that at no time are women guaranteed protection from sex-based discrimination. Section 82 (4) (b) legitimises the traditional position, which accorded women fewer privileges than men in matters concerning their families, marriage, divorce, and succession. Other than this, The Marriage Bill of 1985 gives equal rights to spouses in a marriage in matters concerning custody of children, divorce, or division of matrimonial property. But this bill has failed to pass through parliament because it objects to a man's right to chastise his wife, to make adultery a reason for divorce proceedings, and objects to a wife having a right to object to her husband marrying a second wife.

Forced marriage is customary in some communities in Kenya. In other communities in Kenya, on the death of her husband, a woman is "inherited" by his brother or close male relatives. The woman's consent to this new marriage or to sexual relations with her new "husband" is not sought.

4.2. *Citizenship*

The world organization against torture (OMCT) raised the issue of gender discrimination regarding citizenship in its alternative report to the

committee on the rights of the child. As the OMCT report pointed out, the constitution of Kenya and the Kenya Citizenship Act (Chapter 70, Laws of Kenya) discriminate against children born to Kenyan mothers abroad but do not discriminate against children born to Kenyan fathers abroad. Children born to Kenyan mothers abroad have to apply for citizenship and are given entry permits for a limited duration upon entry into Kenya, while similar treatment is not accorded to children of Kenyan fathers born to non-Kenyan mothers.

The law of domicile, The Domicile Act (Republic of Kenya, 1998, Chapter 37, Laws of Kenya) gives credence to and perpetuates the practice of discrimination against children born out of wedlock. In Kenya, residence is different from domicile and domicile or origin refers to the home of the parents at the time of birth. In Kenya, this is often equated with the ancestral home that every person born within lawful wedlock is presumed to have. Children born out of wedlock are accorded the domicile of their mothers whereas those born within lawful wedlock acquire that of their fathers. Domicile determines other rights such as voting rights. In many cultures, children born out of wedlock do not belong in the mother's home (domicile) and have no rights to inherit property. As a result, many are often rendered without domicile.

According to the Kenyan constitution, a Kenyan woman marrying a foreigner does not pass on her citizenship to her husband, though it applies if a Kenyan man married a foreign woman. These laws are discriminatory and since Kenya is a signatory to the convention on the eradication of discrimination against women, it should live up to its obligation under the convention by repealing such provisions, which promote discrimination against women.

5. Women's Bargaining Power in the Household Economy

Access to critical resources provides an alternative way of conceptualizing determinants of women's second-class position. In Kenya, besides satisfying the family's need for food, clean clothes, and a nice and tidy home, women's activities include participating in cash crop production and other income-generating activities and tending livestock. Men's responsibility for taking care of the family is primarily fulfilled through provision of cash, mainly through wage labor, production and sale of cash crops such as tea, coffee, and of livestock. This pattern of resource control heavily

favors men. They control the major means of production, income, and surpluses. To the extent that women control the resources and surpluses generated through their own production or family production, these are usually quite small and economically insignificant. Further, the few resources most rural women control (typically a vegetable garden, small amounts of maize, beans, finger millet, chicken, and evening milk from goats) are almost entirely oriented towards providing for the home and family, or providing women with the means (i.e., cash) to acquire necessary family consumption goods on the market (Kiriti, 2003).

In Kenya, although land now belongs to individuals, it can be bought and sold or used for purposes over which women have no control. Under certain circumstances, women can thus be denied access to land, and traditional rights of female kin give way to men's legally confirmed rights. The introduction of cash crops in Kenya increased gender inequality in the provision of credit since cash crops are male-controlled. Credit schemes and extension services are geared toward male farmers, ignoring women and undermining their position as primary producers of agricultural products.

As revenue-generating cash cropping rises in importance, the proportion of resources controlled by women tends to diminish. This is largely due to the fact that household resources, such as land and inputs, are transferred away from women's crops in order to promote the production of cash crops. An increase in family income arising from cash crop production usually results in a new loss to women as in some Kenyan societies men take possession of any cash income earned by women, or most of it, and use it for their own ends (Kiriti, 2003). Just as Sen (1981) demonstrated that famine could occur in the midst of an increase in aggregate food availability, poverty amongst women and children can increase with rising aggregate family income (Tisdell, 1999).

Agricultural inputs and training are rarely provided to female farmers. Even efforts to reduce poverty through land reform have been found to reduce women's income and economic status because the state distributes land titles only to male heads of households. Cultural and social barriers to women's integration into agricultural programs remain strong because, women's income is perceived as a threat to men's authority. While men are taught new agricultural techniques to increase their productivity, women, if involved at all, are trained to perform low-productivity tasks that are considered compatible with their traditional roles, such as sewing, cooking, or basic hygiene. Women's components of development projects are frequently little more than welfare programs that fail to improve

economic well-being. Furthermore, these projects tend to depend on the unpaid work of women, while men are remunerated for their efforts (Todaro, 1997).

Men's control over labor as a factor of production can translate into claims on women's labor for cultivation of the husbands' fields. In effect, the culturally determined rules of access to and control over resources may constrain women as much as external biases in providing access to farm support services (Palmer, 1997). The cultural norms actually may predetermine unequal access to agricultural inputs, marketing services, and farmers' organizations because of the link between farm support services and land title, for which women are rarely eligible (Jiggins, 1989).

Unequal access to resources means unequal barter or bargaining capabilities and suboptimal resource allocations in the household. Domination of women by men, perceived as embedded in cultural norms and institutions, characterises intra-household power relations and resource allocation patterns (Kiriti *et al.*, 2004). Kenyan women's agriculture is carried out within the confines of powerful and limiting constraints. For example, inputs such as fertiliser and insecticides, seeds, and credit facilities are channelled to men. Women do not qualify for loans unless a spouse or male relative represents them. After all, they do not have the collateral needed for a loan. Through land adjudication and registration, land previously held by custom and over which simple user rights prevailed became the object of property rights. Land rights go to the male heirs while the daughters are almost entirely excluded. If a daughter is married, she cannot inherit land from her parents. If she is not married, she is treated like a pariah and can only be given a small portion of land in which to cultivate vegetables and other simple food crops but no cash crops since these crops mean permanence. The land can never be registered in her name and she is at the mercy of her brothers or other male relatives (Kiriti *et al.*, 2004).

Situations where wives head households due to the continued absence of husbands (*de facto*) output may be low because women are not decision-makers. Men though absent want to make all the decisions concerning the household and the allocation of resources (Kiriti *et al.*, 2003). They control the output, which they sell but do not buy the inputs. Women rely on remittances which come from their husbands and when it comes, it is either too little or too late to be used to buy inputs.

The diversity of needs and interests among family members and the allocation of the scarce resources are determined by the degree of

decision-making power possessed by each negotiating party. Furthermore, not all household members have equal bargaining power to enforce their own definition of utility and, therefore, not all members benefit equally from the way resources are actually allocated. This view interprets observed inequalities in the distribution of household resources not as the most efficient reaction to the prevailing wage/price situation or as evidence of the household's maximizing behavior, but as evidence of structural asymmetries in the economic, social, and legal position of men and women, which give the two unequal bargaining power (Bennet, 1983).

Bargaining power or a household member's ability to realize personal allocational priorities, can be influenced by the individual's contribution to the household income and some studies have shown that increases in women's income have given women more decision-making power and control over the distribution of resources within the household. Acharya and Bennet (1983) found that women's involvement in market activities gives them greater power within the household in terms of their input in all aspects of household and resource allocation decisions. At the same time, confining women's work to the domestic and subsistence sectors reduces their power vis-à-vis men in the household.

The greater a woman's net control of income, the greater her leverage in other household economic and domestic decisions, and the greater her overall "voice and vote" (leadership) in the relationship. Tisdell (1999) identifies five factors that may increase the threat power of a married woman in relation to her husband or partner: (i) her capability of finding independent employment and the level of income earned by her; (ii) her ownership of property and ability to transfer, inherit, and bequeath property; (iii) her rights to collective family assets in the event of dissolution of marriage; (iv) her ability to institute divorce proceedings, especially if the legal hurdles to divorce are minimal; and (v) contacts with influential networks in a community.

However, legal, institutional, and social factors also affect bargaining power. For example, property rights could easily have a much bigger impact than changes in relative earnings of men and women (Folbre, 1992). The World Bank (1996) says that women and children are more vulnerable because tradition gives them less decision-making power and less control over assets than men, while their opportunities to engage in remunerative activities and, therefore, to acquire their own assets, are more limited.

Compared to men, women in Kenya are disadvantaged in their access to and control of a wide range of assets. With fewer assets and more precarious claims to assets, women are more risk-averse, more vulnerable, have a weaker bargaining position within the household, and consequently are less in a position to respond to economic opportunities. Access to land is not an end in itself. Access to land and other productive resources are critical in creating wealth and generating growth. The right mix of assets, including land, labor, and financial services, is critical to ensure that women are economically empowered.

6. The Institution of Marriage and Dowry

A very well-known characteristic of African marriage is the payment of bride-price or dowry. Unlike in other cultures where dowry is paid by the parents of the girl, in non-Muslim Black Africa it is always the parents of the boy or man who pay dowry to the parents of the girl. Among the Kikuyu, for example, to marry a wife is rendered by *kugura mutimia* (to buy a wife), and to give your daughter in marriage is *kwendia mwariguo* (to sell your daughter). There is no end to paying dowry. Though at first it may be fixed at so many goats or cows, the parents of the girl always had (and still have) a right to demand a gift from the family of the boy at any time during their lifetime.

With few exceptions, Kenyans still believe in and demand the paying of dowry. Due to modernity, however, the mode of discharging this duty has changed. Today, almost always, dowry is paid in cash, not in the form of livestock.

Due to the individualism and selfishness which have accompanied modern life, some parents ask for too much money as dowry and it has degenerated into a commodity-exchange, a wife-buying activity (Wanjohi, 1999). This modern life has distorted the real meaning of dowry. The huge amounts of money parents ask for these days play a role in the domestic abuses and violence. Parents are using this as an opportunity to get rich and make up for money that they couldn't make elsewhere. Dowry has turned women from human beings into property. Some men abuse their wives physically and emotionally, because they feel that they (wives) are purchased commodities, like cows or cars. They expect their wives to be submissive and powerless. Just like FGM, bride price demeans a woman.

It makes her the property of her father to be sold to another man. She then becomes a servant of the buyer; bearing children, providing sex, and performing household chores.

7. Women's Reproductive Decision

The rate of population growth in Kenya was until recently, among the highest in the world. 3.7 percent in 1980, 3.1 percent in 1990, and 2.0 percent in 2003. Despite some decline in fertility, 7.7 children in 1980, 5.9 in 1990, and 4.4 in 2003, there is still need for sustained promotion of family planning services (Kiriti and Tisdell, 2005a). Women have a right to contraceptive information and services for them to be able to determine the number of children they would like to have. Certain laws restrict women in the exercise of these rights. No specific law governs family planning and dissemination of information relating to it. Also, in most cases in Kenya a married woman is expected to show her spouse's consent before she can have tubal ligation. This requirement is constraining in that a woman who has made an independent and informed choice may be prevented from exercising her right by the spouse if he wants more children.

Abortion is illegal in Kenya, whether the woman herself or someone else performs it. Under the Kenyan Law, abortion is only allowed where the operation is performed to save the physical or mental health of a pregnant woman. In this instance, at least two medical opinions have to confirm the necessity of the operation. The woman's consent and that of her spouse (if she is married) are a prerequisite to such an operation. This law is restrictive and interferes with a woman's right in so far as making decisions as to how to regulate her fertility. By making abortion illegal, the law makes the service unavailable to women who might find themselves unable to cope with the child they are expecting. Consequently, the law imposes compulsory motherhood on expectant women with all the attendant consequences.

Currently, 24 percent of married women in Kenya would like to limit or space their pregnancies, but are not using any method of contraception. Women in Kenya have on average of 4.4 children, and for every 100,000 live births there are 1,300 maternal deaths — a staggering figure. Nearly half of all the births are reported to be unwanted or unplanned and almost

half of Kenyan women give birth before the age of 20. An estimated one-third of maternal deaths can be attributed to unsafe abortion (Republic of Kenya, 2005).

According to UNAIDS (2004) there were an estimated 890,000 AIDS orphans in Kenya as of 2001 as shown in Table 7.1, a number expected to increase to 1.5 million by 2010. Due to the socio-economic and cultural status of women in Kenya, they are twice as likely as men to become infected by HIV/AIDS; currently 60 percent of those living with HIV/AIDS are women.

By the end of 2001, 2.5 million people in Kenya were estimated to be living with HIV/AIDS. About 1.4 million women in the age bracket 15–49 years were HIV-positive compared to 0.9 million men in the same category by the end of 2001. The HIV infection rate of all pregnant women aged 15–24 years was 9.8% in 2003 (Republic of Kenya, 2004).

Women and girls are more vulnerable to HIV than men and boys because of their limited access to economic and educational opportunities, and the multiple household and community roles they are responsible for. Also, women and girls are subject to social norms that deny them sexual health knowledge and practices that prevent them from controlling their bodies. The gender division of labor and male urban migration keep men away from their wives for long periods, leading to promiscuity and the spread of HIV. Women in the rural areas may also find themselves discriminated against when trying to access care and support when they are HIV-positive. In Kenya, women who are HIV-infected are divorced even when it is their husbands who have infected them. Family resources are more likely to be devoted to buying medication and arranging care for ill males than females. Because of lack of hospital facilities in rural areas and lack of income, those in rural areas affected by AIDS may find it difficult if not impossible, to obtain hospital care. Therefore, they mostly have to be cared for at home. Generally, this is the burden of females (Kiriti and Tisdell, 2005b).

As the country loses young productive people to AIDS, the effects have an influence over all sectors of the economy. The loss of income of the breadwinner, increased medical expenses, and increased time taking care of the sick persons may lead to reduced agricultural output. Households in most cases fall into deeper poverty as women are left bearing even larger burdens: as workers, educators, and mothers and,

Table 7.1: People living with HIV/AIDS in Kenya.

Year	Total adults and children (millions)	Adults (millions)	Adult rate (%)	Women 15–49 yrs (millions)	Men 15–49 yrs (millions)	Children <15 yrs yrs (millions)	Orphaned due to AIDS <15 yrs (millions)
End 1999	2.1	2.0	NA	1.1	0.9	0.078	NA
End 2001	2.5	2.3	NA	1.4	0.9	0.22	0.89
End 2003	1.2	1.1	6.7	0.72	0.38	0.100	0.65

Source: UNAIDS (2004).

ultimately as caregivers, as the burden of caring for the ill family members rests mostly with women and girls.

8. Education, Health, and Employment

8.1. *Education*

Education is an important component of human capital development and takes the largest share of the national budget. The Kenya government offers free primary education. However, the primary school completion rate is only 73 percent while the average number of years of schooling is 7.4 (World Bank, 2006b). Education is treated as a basic need by the government, and as such the government is committed to the position of equal education opportunities for all persons in Kenya. However, inequalities still persist in enrolments of girls and boys starting from pre-primary to the university level as shown in Table 7.2.

Levels of education and literacy for women and men differ widely. Although the number of boys and girls is roughly equal at the primary level, men substantially outnumber women in higher education. In rural areas, families are more reluctant to invest in education for girls than in educating boys. Adult literacy in Kenya is 84 percent while 70 percent of the illiterate persons in Kenya are female.

The enrolment of girls in secondary schools is considerably lower than in primary schools. This is mainly due to early marriages, pre-marital pregnancies and poverty where parents would rather educate boys than girls. This means that the girls may eventually slip back to illiteracy. This trend continues in tertiary institutions where there are more boys than girls and translates to lack of empowerment for women in employment, decision-making, and control of resources (Kiriti, 2005). In 2004, female students in all universities in Kenya comprised only 33.6 percent of the total number of students enrolled.

The Education Act does not make education a right for all Kenyans although current policy-makers make it compulsory. Women's education is often curtailed by factors such as early pregnancies, discrimination and cultural practices. The education materials used in various institutions fail to depict women as role models whom school girls can naturally identify with. In various schoolbooks, there are continuous use of masculine words, illustrations, and content. Women portrayed in schoolbooks are often

Table 7.2: Enrolment in pre-primary, primary and secondary schools in Kenya (1999–2004) (thousands).

Year	Pre-primary		Primary		Secondary		University	
	Male	Female	Male	Female	Male	Female	Male	Female
2000	636.8	609.8	3,064.5	3,013.6	402.5	356.5	37.4	21.8
2001	671.1	645.1	3,079.6	3,002.2	421.2	376.4	43.7	27.6
2002	738.9	708.6	3,143.1	2,988.0	431.3	387.9	51.1	29.9
2003	809.5	783.4	3,653.5	3,463.8	460.6	419.4	51.5	30.6
2004	815.8	788.8	3,815.5	3,579.3	481.6	431.0	57.9	33.6

Source: Economic Surveys, Various Issues.

known as mothers, cooks, nurses, or teachers. Most books fail to show them in technical positions.

8.2. *Health*

The WHO and UNICEF estimate that more than half a million women in developing countries die from complications of pregnancy and childbirth, leading causes of death and disability among women of reproductive age. In 1995, more than half of all maternal deaths occurred in Africa. The number of births attended to by skilled health personnel remain very low in Sub-Saharan Africa. In 2003, the maternal mortality rate was 640 per 100,000 live births in Africa as compared with 470 per 100,000 for the developing countries as a whole. The estimated number of maternal deaths in 2000 in Kenya was 11,000. However, in terms of maternal mortality ratio, which reflects the obstetric risk associated with each pregnancy, Kenya had 1,000 deaths per 100,000 live births and 1 woman in 19 faces the risk of maternal death in the course of her lifetime in Kenya. In health care, the incidence of malnutrition tends to be higher among children than adults, and in emergency situations, children also suffer more than adults. Hence, child and infant mortality rates in Kenya are 20 and 76 respectively (World Bank, 2006b).

The major cause of the high Maternal Mortality Ratio (MMR) in Kenya is the burden of unsafe motherhood. Most deliveries take place at home due to lack of skilled health personnel in health facilities and the long distances to the nearest health facilities, lack of family planning facilities, ante-natal care, safe delivery, and essential obstetric care. Cost is another factor that prevents pregnant women from delivering in a health facility. There is a direct decline in utilization of maternity services linked to the introduction of user fees and this has mainly affected the poor.

Basic education, which equips recipients with essential literacy and numeracy skills, yields high rates on investment, thereby enhancing labor productivity. Similarly, health care, sanitation, and nutrition improve people's standard of living and productivity by reducing sickness and mortality rates and by increasing life expectancy. However, diseases such as tuberculosis and malaria hamper human capital formation in Kenya.

Poverty, lack of basic health services, poor nutrition, and inadequate living conditions all contribute to the spread of tuberculosis (TB). There were only 227 cases of TB per 100,000 in 1990 in Kenya but by the end

of 2003, this had risen to 821 per 100,000 (World Health Organisation, 2005). The disease is spreading rapidly because of the emergence of drug-resistant strains of tuberculosis and the spread of HIV/AIDS, which reduces resistance to TB. Poorly managed TB programs also allow drug-resistant strains to spread. TB is a leading cause of death among women of reproductive age and is estimated to cause more deaths among this group than all causes of maternal mortality.

Malaria, one of the world's most common and serious tropical diseases, is a protozoal infection transmitted to humans by mosquitoes. More than 41 percent of the world's population is at risk of acquiring malaria, and the proportion increases yearly due to deteriorating health systems, growing drug and insecticide resistance, climate change, and war. High-risk groups include children, pregnant women, travellers, refugees, displaced persons, and laborers entering endemic areas. Malaria causes low birth weight. Mortality in these infants is 4 times higher than in normal birth infants. In Kenya, 545 cases per 100,000 people were diagnosed with malaria in 2000 (United Nations Development Programme, 2005). The impact of malaria is more severe on children under 5 years of age and pregnant women. Majority of these live in absolute poverty and the impact of malaria on them is devastating since the cost of malaria control and treatment is quite high. Prompt and effective treatment of malaria, which can reduce death rates by 50 percent, should be included in routine child and maternal health care. Insecticide spraying, bed nets, and other cost-effective measures can help prevent malaria.

8.3. *Employment*

Women make up about 75 percent of the agricultural workforce, and have become active in small urban businesses. However, the average monthly income of women is about two-thirds that of men and women hold about 1 percent of land titles (Republic of Kenya, 2003). This marginalization of women in the workforce means that most women are financially dependent upon husbands, thereby making it extremely difficult for them to leave situations of domestic violence.

The participation of women in formal employment is quite low. In 2002, female participation accounted for only 29.6 percent of the total wage employment in the modern sector. The education sector remained the major female employer in 2002, engaging 136.3 thousand females

with a share of 27.1 percent of total female employment. Of the total wage employees, 1,381.1 thousand were on regular terms of employment of which 29.1 percent were females (Republic of Kenya, 2004). There are also differences in amounts earned by males and females in Kenya. For example, male earnings in terms of purchasing power parity were $1,067 compared to women's $962 (United Nations Development Programme, 2005).

A number of reasons can be given for women's low participation in formal employment, such as lack of equal education and skills compared to men, cultural attitudes about women working, or family obligations. Kenya's employment law is provided by the Employment Act (Cap. 226), which does not specifically provide for employment as a right. However there is an underlying implication that it is gender-neutral, but bearing in mind that the constitution condones sex discrimination, one can see that the gender neutrality of the employment law can be undermined by such a provision.

In the Export Processing Zones (EPZs), women are often preferred due to the nature of work. They are often underpaid and overworked. No trade unions are permitted in such zones, which makes labor very cheap and working conditions fairly poor. Women employees are guaranteed maternity leave for 2 months, though they are supposed to forfeit their annual leave the year they take up maternity leave. Maternity has often been used as an excuse to deny women's appointment to certain posts for the simple reason that it would be uneconomical to employ them.

Although Kenya's employment laws are gender-neutral, in practice women have not been sufficiently catered for. Deliberate measures are, therefore, important to ensure that practices, which tend to promote sex discrimination, are eliminated. If women are to fully participate in policy-making and implementation, it is important that impediments that prevent their participation are eliminated. A number of these arise from societal attitudes on the role and place of women and other roles, which place barriers to the advancement of women.

9. Ownership of Property

Land and the division of household property are prime areas where gender-based disparities marginalize and disenfranchise women of Eastern Africa. In Kenya, the Constitution permits the application of customary

law to personal matters and to the devolution of property. The Constitution contains no provision for gender as a basis for non-discrimination and as a result, even gender-biased practices are held as valid and constitutional. Women's access to economic resources in Kenya is largely defined by customary laws. Inheritance is usually along the male lineage; hence, women do not inherit family property. There is a need to re-examine the impact of the formalization of customary laws relating to land. The customary right of the male head of the household or the clan leader being the allocator of land has been mistakenly misunderstood to be a right of ownership. This has resulted in a reduction of access to land for women in the customary arena. An additional complication in the Kenyan situation is the growing number of cohabiting couples who found families outside of both the formal or customary legal regimes. When such unions end, the woman is usually left with no access to any household property. They are also left with no entitlement to maintenance from her partner or his family.

In Kenya, the issue of property in marriage is contentious as wives have often been treated as part of the husband's property. But Christianity seems to have worsened the already bad situation. In a Christian marriage, the existence of a woman is incorporated into that of the husband. They are no longer two but one flesh. Unfortunately, this single flesh is usually the husband, not the wife. As such, all property, including that jointly acquired or even that acquired by the wife alone, is registered in the name of the husband. In Kenya, the type of marriage entered into determines the kind of property rights a woman will have. The English law (Married Women Property Act), which governs civil and Christian marriages in Kenya, allows a wife to acquire, hold, and dispose of any property. But African customs and traditions usually do not allow women to own property such as land. This view is very strong in Kenya today despite the overwhelming Christian and Western influence in the country. Among the Luo, daughters are not supposed to inherit land from their parents since they are considered foreigners in their ancestral land. This is how strong culture is against property ownership by women. In Kenya, customs and social norms often seem to override legislation. Unless lawmakers base their decisions on cultural practices, they cannot go far.

According to Kenya's Law of Succession, if a husband dies without having written a will, the widow is entitled only to his personal and household effects and not his estate, for the rest of her life until she remarries. Among most Kenyan ethnic groups, Luhya, Luo, Kalenjin, Maasai, and

so on, tradition stipulates that men own property while women have user rights to the same. To reverse this mentality is likely to take time.

In Kenya, tussles over ownership of property usually come up only when divorce or death has occurred. In all four kinds of marriages, Statutory (Christian and civil), Hindu, Islamic, and customary, a wife may acquire, control, and own property during the subsistence of the marriage. However, under the customary law wives do not enjoy substantial protection in matrimonial property questions. The woman's role remains largely confined to maintaining, tending, and improving the various forms of property. The man's unchallengeable position as head of the family militates against the woman's freedom in property matters.

By tradition and social sanctions irrespective of the law, women in Kenya are not autonomous individuals but need a male guardian to act for them in all legal transactions to acquire and transfer property, to apply for loans and credit and sometimes even to seek employment or to open bank accounts. However, there is no law in Kenya stipulating that married couples register their property jointly. But the fear of most wives is that, if the husband dies intestate, the property will be contested for by all interested parties (dependants) and that personal/religious/customary law will apply.

10. Technological Development, Transfer, and Adoption

The Kenyan agricultural sector has been the mainstay of the economy, accounting for 24 percent of GDP, over 50 percent of total export revenues, and 62 percent of overall employment. Women are a major force in the agricultural sector. They constitute over 70 percent of all agricultural workers, but in most cases operate on an unpaid family basis (Republic of Kenya, 2000). They provide over 80 percent of the labor in food production and 50 percent in cash crop production. Yet women only hold about 1 percent of registered titles in Kenya. Without titles, women are often unable to access cooperative membership, markets, and credit (World Bank, 2006a).

Although the Kenya government aims at increasing agricultural production and improve farming methods, men control most of the resources for and the proceeds from the sector. Therefore, while women in Kenya have the potential to become more efficient, they lack the complementary inputs that would increase their productivity. On average, female-headed farms in Kenya own less than half of the capital equipment owned by

male-headed farms (World Bank, 2001). In particular lack of appropriate small-scale technology for the processing and storage is a major limitation for female farmers in Kenya.

In the agricultural sector, training and extension services, and the use of female field extension workers are important factors in raising female productivity. However, only 7 percent of agricultural extension services are directed toward female farmers and only about 11 percent of all extension personnel are women. In Kenya, women typically receive less than 10 percent of the credit awarded to smallholders and only 1 percent of the total amount of credit directed to agriculture (FAO, 1989). It is not only in agriculture that women face discrimination in accessing information on new technology, especially on new farming methods.

Women's access to technology development, for example, Information and Communication Technology (ICT), is constrained by factors that go beyond issues of technological infrastructure and socioeconomic environment. Socially and culturally constructed gender roles and relationships play a critical role in shaping and limiting the capacity of women to participate on equal terms in the information society.

One may often assume that technology is a tool that society can use and not something that can influence society. This ignores the differential influences of technology on various sections of the society and also assumes that technology is gender-neutral. Technology is not gender-neutral and neither is the policy environment in which it is developed.

The array of new information and communication technologies ranges from mobile phones, fixed-line telephones, radio, television, print media, satellite technology, and the Internet. This is a complex set of goods, applications, and services used to produce, process, distribute, and transform information. These new ICTs bring a major shift in the vastness, depth, and ease of use. Mobile communication, built upon wireless and digital platforms, is portable, has much more coverage and is cheaper. Internet communication is set to make communication extremely economical all over the world, and Internet radio provides much greater variety and reach than ever before. Computer monitors now act as TVs of the Internet.

Women's access to and control over ICTs is not equal to that of men. Access refers to the ability to make use of the technology as well as the information and knowledge it provides, while control refers to the ability to decide how ICTs are used and who can use them. Effective use refers to the ability of women and girls to use ICTs strategically to advance multiple

development goals. There is a huge gap between women and men's access to telecommunications infrastructure in Kenya. Info-communication infrastructure is largely concentrated in urban areas, whilst the majority of women in Kenya, are located in remote and rural areas. Simply stated, if the technology is not there, where women are to be found, then women cannot have access to it, use it, or much less, control it.

Illiteracy is a serious problem in Kenya. The majority of illiterate people in Kenya are women, and of the total out-of-school children, majority of them are girls. The inability to read and write is a major barrier to women's access to ICTs because the use of ICT requires various kinds of literacy. The language of the Internet excludes many from it. Language is not the only basis for exclusion. Content is often not relevant to the situation or lives of Kenyan women. Women's viewpoints, knowledge, experiences, and concerns are also inadequately reflected on the Internet, particularly perspectives from women in developing nations. Gender stereotypes predominate and perpetuate those reflected in the print media.

Apart from that, most married men do not like their wives using the Internet or mobile phones because they believe that their wives will engage in extra-marital affairs and some women in Kenya have found themselves in trouble when they refuse to give their husbands or boyfriends their passwords for mobiles and emails. Without these, most women who might be interested in business lose out on contracts as they would not like their mobiles to ring when their husbands are around or even check their emails because the husbands will want to know what is contained in those emails. Hence, most wives rely on their husband's mobile phones who in most cases will sieve the messages that they would like the wife to have. Some will even confiscate their wife's mobile to make her incommunicado.

One of the more pervasive but intractable problems is "technophobia," the fear of technology. Most Kenyan women often have complex relationships with technology and machines as a result of being socialized over time to believe that machines and technology are a man's domain and not for women and girls, thus generating a gender bias in attitudes toward studying or using information technology. The social factors that produce these gender differences operate in both institutional and informal settings. In some societies, cultural norms discourage interaction between women and men outside the family, and women may be uncomfortable in situations where men are present either as trainers or as peers.

Women tend to be concentrated in end-user, lower skilled ICT jobs and make up a very tiny minority of managerial maintenance and design personnel. Stereotypical views of women's skills and abilities have made them preferred employees for certain kinds of work even in the IT industry, particularly work related to word-processing or data-entry. Men are more likely to be found in the high-paying, creative work of software development and design.

When new technology is introduced and implemented, it generally means some jobs are made redundant and majority of the layoffs are women. This means replacing women with machines.

11. Violence Against Women

The experiences of women in Kenya show how the failure of the authorities to combat discrimination and, in particular, to prohibit, investigate, and punish violence against women perpetuates suffering. Despite the moral and legal obligations, the government has not reformed Kenya's laws, to make all acts of violence against women criminal offences, nor has it addressed the discriminatory practices of the police force, prison services, and court system. Some courts view any form of domestic violence as a private affair, which should be settled only by village elders.

Unequal power relations between men and women have led to the domination of and discrimination against women, which in turn leads to violence against women. Women in Kenya are specifically vulnerable. Violence against women is widespread and persists in all layers of society. In 1999 the attorney general of Kenya acknowledged that violence against women pervades all social and ethnic groups. It is a societal crisis that requires concerted action to stop its scourge (Statement by the Hon. S. Amos Wako, 1999).

Culture influences the relationship between the various groups in society and some cultural practices, beliefs, and traditions have had the tendency to relegate women to the second status in society, thereby not only violating their rights as human beings but also leading to the discrimination against women. Some customs and cultural practices have found their way not only into law but are also used as justification for violence against women (Kenya, Combined Third and Fourth Periodic Reports).

The Committee on the Elimination of Discrimination Against Women defines discrimination as including gender-based violence, that is, violence that is directed at a woman because she is a woman or that which affects women disproportionately. It includes acts that inflict physical, mental, or sexual harm or suffering, threats of such acts, coercion, and other deprivations of liberty. The committee stated that laws against domestic violence and abuse, rape, sexual assault, and gender-based violence should give adequate protection to all women, while promoting respect for their dignity and integrity. However, cases of gender violence still persist as shown in Table 7.3.

Kenya's combined third and fourth reports submitted under the convention on the elimination of all forms of discrimination against women leaves the issues of violence in the family, violence in the community and violence at the hands of state agents untouched. Violence against women has been a problem in Kenya. This is mainly manifested in the number of rape or attempted rape cases, assaults, and battering. In Kenya, women are physically and sexually abused every day. Rape occurs in all social and ethnic groups. It is a crime that shocks and traumatises the victim, but it is largely suffered in silence. Victims of rape in Kenya often face huge obstacles in trying to bring the perpetrators to justice. Many rape victims are too intimated by cultural attitudes and state inaction to seek redress. To do so can lead to hostility from family, the community, and police, with little hope of success. Those who seek justice are confronted by a system that ignores, demeans, and even condones violence against women and protects perpetrators, whether they are state officials or private individuals. Table 7.3 shows the reported cases of rape, attempted rape, assault, and battering on women between 2000 and 2005.

Table 7.3: Reported cases of rape, attempted rape, assault and battering on women, 2000–2005.

Offence	Year					
	2000	**2001**	**2002**	**2003**	**2004**	**2005***
Rape and attempted rape	883	933	984	1,126	1,419	1,451
Defilement/incest	752	1,094	1,021	1,182	1,489	1,416
Assaults and battering	6,255	6,648	7,896	8,544	8,950	9,169
Total	7,890	8,635	9,901	10,852	11,867	12,036

Source: Economic Survey 2006. * Figures are estimates.

Table 7.3 provides the number of reported cases of violence against women and girls for 5 years. Violence is a major factor in the subordination of women and it occurs in different arenas, including economic, political, social, and private spheres of human life. Cases of rape, including attempted rape, have been on the increase over the 6-year period. Between 2003 and 2004, the total number of reported cases of violence against women and girls increased by 9.4 percent, and by 1.4 percent between 2004 and 2005. Cases of defilement and incest increased from 1,182 in 2003 to 1,489 in 2004. Battering and assault of women had the highest prevalence in 2005 constituting over three quarters of all reported cases of violence against women. Currently, there is a pending Bill in Parliament on Sexual Violence and Assault which, if passed, will pass harsh sentences on men who sexually assault women or girls. However, it has met with a lot of resistance from the predominantly male parliament. If passed without amendments, it would be one way of empowering women where they can work and realize their potential without fear. The government of Kenya should reform both its laws and practices to end impunity for violence against women.

12. Women's Participation in Political Governance

The Kenyan society is a patriarchal society with widespread discrimination against women and a virtual absence of women in positions of power in the socio-economic and political spheres. Although women in Kenya are the majority of the voter population, they turn out to be underrepresented. Women in Kenya have achieved little progress since the Beijing Platform for Action was adopted. Women account for 52 percent of the country's adult population and 60 percent of the voting population. Their participation in the political and elective office is at a low level. Although some women have attempted to enter the political field, the number of women members of parliament are still very few. Table 7.4 shows the distribution of parliamentary seats between 1969 and 2002.

As Table 7.4 shows, women represent only 7.7 percent of the total members of the current parliament. Other than this, there has been no significant appointment of women into top-level ministerial posts in the government and in parastatals. Participation of women in political and public decision-making is viewed as critical to the actualization of gender equality because women must command real political power if their concerns are to be prioritized and meaningfully included in the national agenda.

Table 7.4: Distribution of national assembly members by gender, 1969–2002.

Year	Elected members			Nominated members			National assembly members		
	Men	Women	% Women	Men	Women	% Women	Men	Women	% Women
1969	154	1	0.7	11	1	8.3	165	2	1.2
1974	152	5	3.2	10	2	16.7	162	7	4.1
1979	155	3	1.9	11	1	8.3	166	4	2.4
1983	157	1	0.6	10	2	16.7	167	3	1.8
1988	186	2	1.1	11	1	8.3	197	3	1.5
1992	182	6	3.2	11	1	8.3	193	7	3.5
1997	206	4	1.9	7	5	41.7	213	9	4.1
2002	201	9	4.3	4	8	66.7	205	17	7.7

Source: Economic Survey 2004.

Representation of women should also be effective at the district and locational levels, as well as in the county, town, and municipal councils. Unfortunately, participation of women is low and ineffective at the local and national levels. In the political process where women are significantly ignored in policies, policy-making, and implementation, policies adopted to improve their lot will not be easily practised.

As a result of poor representation, women in Kenya feel they lack a sufficient voice to push the enactment of laws that could enhance respect for women's rights and fight against their economic marginalization. The rejected draft constitution had provided affirmative action that required political parties to ensure that at least one-third of their candidates for direct elections were women.

Poverty, intimidation, and harassment of those women who would like to enter politics prevent many a woman from making attempts to join politics. There is a widespread belief in Kenya that women should be guided by men and those who are in politics or political activists are rebels, consequently they are branded as divorcees and trouble-makers. A former president of Kenya apparently commented that "women are *unworthy* of any political education" as they would cause too many political troubles if they knew more about their rights. As such a respectable woman is supposed to give way to men to take leadership positions.

13. The Demise of Neoclassical State and Women's Empowerment

When it comes to matters to do with discrimination against women in Kenya, customary law takes precedence in most cases. Even when a law has been passed against such discrimination, this is usually undermined by traditional practices. For example, in theory, women in Kenya now have the right to inherit property (since the mid-1990s). Married women had already gained the right to inherit their deceased husband's property since 1981 with the introduction of the law of Succession Act (Cap. 160 Laws of Kenya). In practice, however, the rights of women (married or not) to inherit anything have been continuously undermined by traditional practices, sexist interpretations of the law, and politically motivated violence. As a result, despite women representing over 50 percent of the population, they own only 1 percent of the land in Kenya. Although there are no legal obstacles to the law, daughters are much less likely to inherit their father's land. Occasionally, a father will give his

daughter a plot of land, though he is reluctant to do so because it means there will be less land for his sons in the future (Davison, 1988). There are currently no positive laws that would systematically confer women the same inheritance rights as their male siblings whilst African culture that denies daughters the right to inherit their father's property takes precedence (*Daily Nation*, 12–14 November 1996).

Wife's inheritance has become a major source of conflict between customary and statutory laws in Kenya. Tradition and customary practice provided protection to a widow who might otherwise have had no means of subsistence, and whose own birth family might not have wanted her back. However, it clashes with the rights of women to inherit property, which is enshrined in statutory laws adopted in the mid 1990s. A woman may receive threats of rape and threats to her life from in-laws when she refuses to abide by customary laws to be married to one of her husband's brothers. This is mainly to reclaim back the land that their brother may have acquired when he was alive. Thus, due to a clash between customary and statutory laws, the women is inherited against her will. Hence, customary laws can affect women's rights to equality. A woman can be disinherited even when she is married under statutory law when it comes to matters of inheriting land. In-laws can even claim that the woman is not married under customary law (that dowry was not paid, or other rituals were not performed) and, therefore, has no right of inheritance. She is then thrown out of her home.

In some cases, judges will deliberately misdirect themselves and give judgements against females. For example, a woman in Kenya was only granted 30 percent of the family business because the judge felt that since the woman had given birth by caesarean, her contribution to the family income must have been reduced. This shows the Kenya government's ineffectiveness as an institution due to weaknesses in its executive branch and its agents.

The judiciary in Kenya is also not independent of the executive. The present system is that of lack of separation of the executive and judicial powers and a domination of the judiciary by the executive branch. Court orders may be given by the trial judge but the executive arm of the government may refuse to honour it. Other times, when a case is entered in favor of a woman, especially in matters of land inheritance, the police may refuse to serve the order because the family (in-laws) may fight back or even when it is served it means putting the life of the woman in danger.

Corruption is also deeply entrenched in the judicial system. Accused persons find it cheaper to deal directly with the trial judge or magistrate instead of defence lawyers because at a fee, magistrates and trial judges can guarantee results, unlike the lawyer. A woman who believes that she can get justice from the courts of law may be surprised when the case is ruled against her if she has not given a bribe to the magistrate or trial judge. If not, the case may go on for ever without judgement being entered, leading to huge costs in terms of lawyers, fees, transport costs to attend court, and so on until the woman gives up.

The cost of justice in Kenya is too high for the common person. About 52% of the population lives below the poverty line, majority of whom are women. They cannot even afford to pay the fee to open a file. Case and court fees are each about 20 times as much as the filing fee. Hence, women are victims of both economic and social institutional failures and when caught on the wrong side of the law, for example, for brewing liquor illicitly, they face stiff jail sentences (in most cases with their infants) as they are usually unable to pay the fines.

13.1. *The new institutional economics and gender empowerment*

Kenya is now trying to codify its legal structures. How it goes about it in terms of inheritance, divorce, and other laws can make a big difference for gender concerns. Attaining a level playing field in legal matters is complicated by often competing systems of customary and statutory law. If too large a gap exists, a set of complications arise. For example, Kenya has embarked on land adjudication and registration with a view to giving land titles, in many cases, as a means of collateralization and getting better credit markets. Credit markets are important for getting the kinds of inputs that improve economic efficiency. Land titling has unintended consequences. Sometimes, customary law dictates that women have user rights to land. Land titling places land ownership in the formal market, often resulting in giving title of that land to men. In the process of giving land titles, Kenya may have increased efficiency, but will have also greatly changed the distribution of income between men and women and on expenditures on children, health, and education.

Another area receiving increasing attention is the issue of violence, particularly against women. Domestic violence and rape are all forms of violence that in part result from as well as exacerbate inequities. Women

remain in these relationships because they often do not have any outside economic opportunities. Increased economic opportunities for women may go against certain customs that require a woman to stay at home and look after the husband and children. Violence is one area where the government of Kenya needs to think about the interactions of legal structures and economic behavior.

In some way, the gender gap in Kenya has narrowed. Wage differentials are down. Differences in education for men and women are reduced. At the same time, large gaps remain, particularly in some regions, for example, large gaps exist in higher education, female mortality and morbidity rates exceed those of men, women are still employed in lower-paying jobs, female wages in Kenya are lower than male wages, and women work longer hours and have poorer access to a range of productive resources, such as credit, labor, and extension services.

The World Bank (2006a) found that gender inequality leads to inefficiency and reduced productivity and, hence, low growth rates. In Kenya, for example, the bank found that it doesn't matter whether a farm is managed by a man or a woman, but it does matter how much education a farm manager has. If you increase education for women, the productivity of farms managed by women increases. There would be a year-on-year increase in GDP growth of 3.5 percent if female secondary education enrolment was brought up to the level of male secondary enrolment. Also, increasing rates of education appears to reduce fertility rates, which helps increase per capita income. Finally, eliminating gender inequalities in education and access to agricultural inputs could result in a one-off increase in output by as much as 4.3 percent of GDP followed by a sustained year-on-year increase of 2.0 to 3.5 percent in GDP growth. To achieve its target of 7 percent real GDP growth, the government, therefore, must address gender-based barriers. The government of Kenya needs to think more about this kind of relationship in allocating education and other resources.

In a bid to increase women's income, the Kenya government and various NGOs have been encouraging women to borrow credit from various micro-finance institutions. However, this novel idea has led to the impoverishment of many women since, after borrowing the loan, they are no longer in control of the management of loans. They usually hand over the money to their husbands who divert the money from its original intention while the women continue paying the loan and interest (Kiriti and Nganga, 2006).

Commercialization of agriculture has also adversely affected women in the sense that men control the income from cash crops although women provide the labor which is usually unpaid. Increased acreage of cash crops has also led to reduced food for subsistence leading to food insecurity in various households (Kiriti, 2003).

All these disadvantages are a result of the position of the women in the household where they have to adhere to customary rules that recognize the man as the head of the household and the controller of finances in the household. This curtails Kenyan women's bid for economic empowerment. On the other hand, lack of resources and political harassment of women who aspire for political positions prevent women from engaging in politics.

The Kenyan government needs to realize that how it allocates resources, that is, how it transfers income has enormous impacts on the distribution of income in the household, not only between men and women, but between adults and children. It has got to think explicitly about these factors in terms of specific policies and interventions as well as unintended side effects of policies set for other purposes. It also needs to identify interventions that will change the bargaining structure, improve equity, and increase efficiency. In addition, there is also the need to think about the unintended consequences of policies and projects on the bargaining relationship, on the distribution of income between men and women and on gender equality and empowerment.

14. Institutional Non-Compliance and Women's Deprivation Scores

We now come to the Gender Deprivation Scores for Kenya. The indicators used are Gross National Product per capita, life expectancy at birth, educational attainment (comprising mean years of schooling and adult literacy), fertility rate, maternal mortality rate, contraceptive prevalence rate, and finally, females' share in total labor force. The deprivation scores are calculated by subtracting Kenya's indicator of, say, life expectancy from the highest rate in the world and dividing this by the difference between the highest rate and the lowest in the world. Table 7.5 below shows the deprivation scores for Kenya.

As Table 7.5 shows, the deprivation score for women in life expectancy at 84.1 percent, compared with 78.6 percent for males in Kenya, is very high. In terms of education, the educational attainment

Table 7.5: Gender deprivation scores for Kenya.

Indicator	Deprivation scores		
	National	Male	Female
GNP per capita	0.990		
Estimated earnings		0.990	0.982
Life expectancy		0.786	0.841
Educational attainment		0.265	0.356
Primary school completion rate	0.360		
Fertility rate	0.571		
Maternal mortality rate	0.445		
Infant mortality rate	0.560		
Child mortality rate	0.627		
Contraceptive prevalence rate	0.554		
Female share in total labor force	0.214		
Gender-related Development Index (GDI)	0.693		

Source: Author's Calculations.

deprivation for Kenyan women is 35.6 percent compared with 26.5 percent for Kenyan males. The respective scores in terms of estimated earnings are 98.2 percent for females and 99 percent for males.

15. Policies and Programs for Women Empowerment in Kenya

Since the NARC (National Rainbow Coalition) government came to power in 2003, it has strengthened the national machinery for promoting gender equality with the establishment of the Ministry of Gender, Sports and Culture, and the National Gender Commission. However, the legal framework for promotion of gender equality remains weak and inadequate, despite Kenya's ratification of the Convention on the Elimination of Discrimination against Women.

Kenya does not have a comprehensive gender and development policy that can guide the legislative reforms. There are a number of bills that have been pending for the last 6 years, which seek to protect women's human rights. These include the Affirmative Action Bill, Criminal Law Amendment Bill, National Gender and Development Bill, Equity Bill, Domestic Violence (Family Protection) Bill, and the Gender and Development Policy Bill and Session Paper.

The National Commission on Gender and Development Act 2003 was passed and is expected to coordinate, implement, and facilitate gender mainstreaming in national development. The Gender Department has also been established in the Ministry of Gender, Sports, Culture, and Social Services to oversee policy issues affecting women in Kenya. However, its commissioners are not full-time and the commission is under-funded. So far, it has not been very effective in enhancing women's empowerment in Kenya. The Kenya National commission on Human Rights has been established through an act of parliament with the task, among other things, of observing the principle of impartiality and gender equity.

The Domestic Violence (Family Protection) Bill 2000 was published, but not introduced in parliament. It is intended to provide for the intervention of court cases of domestic violence, including physical, sexual, and psychological harassment, intimidation, and destruction of property and so on. This is an important bill for women of this country and efforts should be made to re-introduce it to parliament. The government, civil society, and NGOs have been working very closely to provide women, who are subjected to violence, with access to the mechanism of justice and informing women of their rights in seeking redress.

The Central Bureau of Statistics has also embarked on measures for including data on women's contribution to GDP into the national account data. Most of the data on employment is currently collected and analyzed in a disaggregated manner to reflect gender contributions.

The government, through the Ministry of Labor and Manpower Development, has for the first time in the country's history formulated a comprehensive draft employment policy mainstreaming women in employment planning and discouraging child labor.

Despite these initiatives, women are under-represented in decision-making levels in public employment, judiciary, and private employment and in statutory bodies. Women are still highly marginalized largely due to their relatively low levels of skills and weak empowerment, which are in turn due to disparities in access of men and women to educational, training, and other opportunities caused by culture and institutional bottlenecks, gaps in laws and in socio-cultural attitudes and practices.

The Economic Recovery Strategy process attempts to link district priorities with government resource allocations and recognizes the increasing awareness and acceptance of the role of the community-based organizations, community empowerment, and partnerships between the government and civil society in providing rural services. However,

community empowerment does not necessarily reflect gender empowerment, nor women's activities indicate gender equality. There is, therefore, the need for special policies and programs to address these challenges to uplift women from their second-class status.

16. Summary, Conclusions, and Policy Recommendations

This chapter has shown that, social, economic, and even judicial institutions have actually enhanced women's discrimination and lack of empowerment. Culture and state laws have not provided safety nets for women. Women in Kenya are actually second-class citizens because they do not enjoy the same status as men. They have high illiteracy rates, are among the poorest, are vulnerable to harmful cultural practices, face discrimination in both formal and informal institutions, earn lower than their male counter parts for equal work, and they face domestic and other types of violence. Their participation in politics is low due to customary practices that frown upon women politicians and political activists. The society does not allow them to own property and they only own 1 percent of all registered land. Women in Kenya have not managed to adopt new technology due to various forms of discrimination and institutional biases and the technology, especially ICT, has also not been friendly to them due to pressure from their spouses. In a bid to reduce these imbalances, the government in most cases is faced with a dilemma due to contradictions and clashes between the written law and the unwritten law. The gender deprivation scores show that women in Kenya are not only disadvantaged at home but compared to other women in the world, they are also still lagging behind. The government, through various programs and legislations, has been trying to remedy the situation but without success. Community-based organizations have not helped either because they do not necessarily reflect gender empowerment. We state below policy recommendations which, if implemented, would reduce the power of these institutions and lead to women's empowerment.

Affirmative action should be taken to ensure that women are well represented in the government by appointing women to top leadership posts. Legislation may facilitate this by deliberately reserving a certain number of seats in parliament or the party for women. The same should be provided for in the local councils.

Policy interventions and legislative measures are necessary to ensure that women are empowered to have access to matrimonial property. More training and employment are some examples of the necessary interventions. Moreover, legislation is necessary to address rights of women involved in situations of cohabitation for a considerable number of years without going through a ceremony of marriage under any law. Parliament should enact a uniform law of matrimonial property, and a provision be made that household duties performed by a wife in any system of marriage in lieu of monetary contribution toward the acquisition of property entitle her to a share of the property acquired by the husband during the existence of the marriage. The law should have clear guidelines on the status of property acquired by a spouse before marriage.

The government should amend the Kenya Citizenship Act to ensure that every child born to either parent of Kenya citizenship is granted automatic citizenship. It should also amend the Domicile Act to ensure an end to discrimination against illegitimate children.

The principle of non-discrimination is not adequately implemented with respect to certain vulnerable groups of children, especially girls. Also, the constitutional guarantee of equal treatment does not cover various tribal, traditional customs, and practices associated with, for example, fostering, marriage, and divorce that constitute major challenges for the full realization of children's rights in the state. The government should adopt an official policy to end the practice of early marriages, and include a minimum age that is the same for boys and girls. It should also enact specific legislation ensuring the rights of girls to inherit property, particularly in those cultures that have traditionally denied this right to girls.

The Kenya government should fervently pursue the goal of achieving gender balance and create a mass of women leaders in strategic positions, especially in managerial positions. It should also protect and promote women's equal rights with men and remove all discriminatory practises and prejudices in education, the electoral systems, and at work and also sensitize men on the importance of involving women in decision-making. It should also encourage NGOs, the private sector, and trade unions to achieve equality of men and women in their ranks, including decision-making bodies and all negotiations.

Political parties should try to integrate women into elective and non-elective positions. They should take measures to ensure that party structures do not discriminate against women directly or indirectly. They

should also incorporate gender issues in their political agenda and ensure that women participate in leadership on equal basis with men.

Measures should also be adopted to improve women's economic status. Affirmative action and other actions should be taken to redress gender imbalances. There should also be changes in the oppressive traditional and cultural practices. The government should reform its law and practices to end impunity for violence against women.

The government must demonstrate commitment to remove legal impediments and socio-cultural obstacles against women, especially in rural areas where the majority of women live and are economically active. The constraints on women's access to land, credit and extension services, inputs, and new technologies must be removed, and opportunities should be created for their enterprise. Measures to improve women's access through institutional reforms must be pursued and monitored for effectiveness.

Gender biases in the educational system, training, and employment must be consistently attacked to give women new opportunities for achievement, while school curricula must incorporate concepts of gender equality so that students will incorporate them throughout their lives. Young women need role models to motivate them and must be given usable education and skills to play meaningful roles in society.

Reform laws to protect women's equal rights, especially in the areas of inheritance, sexual violence, domestic violence and spousal rape, marriage, division of property upon divorce, land use and ownership, access to housing and social services should be pursued. There is also the need for implementation of programs designed to address women's rights violations and improve enforcement of women's rights. These include ensuring that national HIV/AIDS programs include concrete measures to combat discrimination and violence against women, providing training for judges, police, and other officials on women's rights, improving data collection relating to domestic violence, women's property rights, and sexual abuse of girls.

A focus on the gender dimensions of ICT is essential not only for preventing an adverse impact of the digital revolution on gender equality or the perpetuation of existing inequalities and discrimination, but also for enhancing women's equitable access to the benefits of ICT and to ensure that they can become a central tool for the empowerment of women and the promotion of gender equality. Policies, programs, and projects need to

ensure that gender differences and inequalities in the access to and use of technology are identified and fully addressed so that such technological development actively promotes gender equality and ensure that gender-based disadvantages are not created or perpetuated, which would eventually lead to women's empowerment.

References

Acharya, M and Bennet, L (1983). Women and the subsistence sector: Economic participation and household decision-making in Nepal. *World Bank Staff Working Paper* No. 526. Washington. DC: World Bank.

Adger, WN and Kelly, PM (1999). Social Vulnerability to Climate Change and the Architecture of Entitlements. *Mitigation and Adaptation Strategies for Global Change*, 4, 253–266.

Amnesty International (2002). Kenya: Rape — the Invisible Crime. http://web. amnesty.org/ai.nsf/index [8 March 2002].

Bennet, L (1983). *Dangerous Wives and Sacred Sisters: Social and Symbolic Roles of High Caste Women in Nepal*. New York: Columbia University Press.

Davison, J (1988). Cited by Lastarria-Cornhiel, *Impact of Privatisation on Gender and Property Rights in Africa*. Paper presented at the International Conference on Land, Tenure and Administration, Orlando, Florida, 12–14 November 1996.

FAO (1989). *Food Supply Situation and Crop Prospects in Sub-Saharan Africa*. Rome: FAO.

Folbre, N (1992). Introduction: The Feminist Sphinx. In *Issues in Contemporary Economics, Vol. 4: Women's Work in the World Economy*, Folbre, N Bergmann, B, Agarwal, B and Maria, F (eds.), pp. 23–30. Hong Kong: Macmillan Academic and Professional Ltd.

Gore, C (1993). Entitlement Relations and Unruly Social Practices: A Comment on the Work of Amartya Sen. *The Journal of Development Studies*, 29, 429–460.

Jazairy, Alamgir and Panuccio (1992). *The State of World Rural Poverty: An Inquiry into its Causes and Consequences*, Rome: IFAD.

Jiggins, J (1989). How Poor Women earn Income in sub-Saharan Africa and What Works Against Them. *World Development*, 17(7), 953–963.

Kelly, PM and Adger, WN (2000). Theory and Practice in Assessing Vulnerability to Climate and Facilitating Adaptation. *Climate Change*, 47, 325–352.

Kenya, Combined Third and Fourth Periodic Reports submitted under the Convention on the Elimination of All forms of Discrimination Against Women, UN Doc CEDAW/C/KEN/3-4.

Kiriti, T (2003). *Gender Inequality in Agricultural Households in Kenya: An Economic Analysis.* Unpublished PhD Thesis, The University of Queensland.

Kiriti, T (2003). *Gender Inequality in Agricultural Households in Kenya: An Economic Analysis.* Unpublished PhD Thesis. The University of Queensland.

Kiriti, T (2005). Evaluating Public Policies for Poverty Reduction: Tools, Techniques and Process. *A Concept Paper Presented at a UNCRD Workshop at United Nations Gigiri*, 28–30 June, 2005.

Kiriti, T and Tisdell, C (2005a). Family Size, Economics and Child Gender Preference: A Case Study in the Nyeri District of Kenya. *International Journal of Social Economics*, 32(5), 492–509.

Kiriti, T, and Tisdell, C (2005b). Gender Inequality, Poverty and Human Development in Kenya: Main Indicators, Trends and Limitations. *Indian Journal of Social and Economic Policy*, 1(2) (2005).

Kiriti, T, Tisdell, C and Roy, K (2003). Female Participation in Decision-making in Agricultural Households in Kenya: Empirical Findings. *International Journal of Agricultural Resources, Governance and Ecology*, 2(2), 103–124.

Kiriti, T, Tisdell, C and Roy, K (2004). Institutional Deterrents to the Empowerment of Women: Kenya's Experience. In *Twentieth Century Development: Some Relevant Issues*, Roy, KC (ed.), pp. 27–48. New York: Nova Science.

Kiriti-Nganga, T (2006). Micro-Financing and Gender-based Poverty: The Case of Women's Groups in Nairobi. To be published in *Gender Development and Policies*.

Outlaw Practice, MP says (2 November 1998). *Daily Nation*, p. 5.

Palmer, I (1991). *Gender and Population in the Adjustment of African Economies: Planning for Change*, Geneva: International Labor Office.

Republic of Kenya (1998). *Laws of Kenya: The Constitution of Kenya* Revised Edition, Government Printer.

Republic of Kenya (2000). *Economic Survey*, Nairobi: Government Printers

Republic of Kenya (2003). *Economic Survey*, Nairobi: Government Printers.

Republic of Kenya (2004). *Economic Survey*, Nairobi: Government Printers

Republic of Kenya (2005). *Economic Survey*, Nairobi: Government Printers

Sen, AK (1981). *Poverty and Famines: An Essay on Entitlement and Deprivation.* Oxford: Clarendon Press.

Statement by the Hon. S. Amos Wako, the Attorney General, during the 16 days of activism against violence against women, 10 December 1999.

Tisdell, CA (1999). Sen's theory of entitlement and deprivation of females: An assessment with indian illustrations. *Social Economics, Policy and Development*, Working Paper No. 2, University of Queensland.

Tisdell, CA (1999). Sen's theory of entitlement and deprivation of females: An assessment with indian illustrations. *Social Economics, Policy and Development*, Working Paper No. 2, University of Queensland.

Todaro, MP (1997). *Economic Development*. 6th Ed. London and New York: Addison Wesley Longman Limited.

UNAIDS (2004). *Report on the Global HIV/AIDS Epidemic* (July 2004).

United Nations Development Programme (1995). *Human Development Report*. New York: Oxford University Press.

United Nations Development Programme (2005). *Human Development Report*, New York: Oxford University Press.

United Nations Economic Commission for Africa (1998). *African Women and Economic Development*. Addis Ababa: African Centre for Women.

Wanjohi, S (1999). Traditional African Wisdom & Modern Life: African Marriage, Past And Present. *A Journal of Social & Religious Concern*, 14(1).

World Bank (1996). *The World Bank Annual Report*. Washington, D. C.: The World Bank.

World Bank (2001). *Attacking Poverty*. Washington, DC.: The World Bank.

World Bank (2006a). *Kenya: Gender and Economic Growth Assessment*, Washington, D.C.: International Finance Corporation and the World Bank.

World Bank (2006b). World Development Report 2006. www.worldbank.org/wdr2006.

World Health Organisation (2005). The *World Health Report 2005 — Make Every Mother and Child Count*. Geneva, WHO.

Chapter 8

Institutions and Gender Empowerment in the Global Economy: The Peruvian Case, 1990–2005

Patricia Fuertes Medina

Development orientations changed radically in Peru from 1990 to 2005 and institutional changes took place to move it toward a market-led economy. Do liberal institutions facilitate or hamper the empowerment of marginalized groups, such as the majority of women in Peru? Trends in the participation of Peruvian women in the economy and labor markets show ambivalent outcomes for women's empowerment. While the struggle for setting a market-led economy is producing an increasing pressure for women's labor, it does not necessarily translate into women's empowerment in all aspects and among all Peruvian women. In highly unequal societies like the Peruvian, women's empowerment seems differentiated as far as the institutional changes of the 1990's did not take into account the general unfavorable starting conditions for women's human capital formation and the particular exclusion of indigenous women. So far, liberal institutions in labor markets seem to have brought about the feminization of flexible, informal, lowly qualified, and hidden labor, tending to make working Peruvian women a "mass" of unorganized, low-wage, temporary workers without labor rights and with little choice and voice in labor markets.

1. Introduction

Peru is a small economy at the global level. However, in recent years it has stood out as a stabilized economy in the Andean Region, showing sustained and increasing rates of economic growth. Democratic institutions were restored in Peru in 2001 after 2 decades of internal war, economic

debacle, and authoritarian and corrupted regimes.[1] In 2006 a World Bank report highlighted the Peruvian situation "as the opportunity" to become a new Latin American "miracle" if attention is placed on firmly addressing poverty, inequality, and gender gaps (World Bank, 2006).

Beyond growth and good macroeconomic performance, deep-rooted poverty and inequality are major challenges for the Peruvian society.[2] Almost one-half of Peruvians are poor and 17 percent are extremely poor. Rural women, children, and the indigenous population are amongst the deprived.[3] So far, the formal and democratic institutions have yet to prove effective for the empowerment of these groups and for a meaningful reduction of poverty.

Development orientations changed radically in Peru from 1990 to 2005. Peru went through a structural adjustment program and reforms aimed at stabilizing and liberalizing the economy. External debt repayment, macroeconomic equilibrium, state reduction, and the construction of an "enabling institutional environment" for foreign investments were prioritized while social investments in human capital formation (education, health, infrastructure) experienced constraints and decreased over the period.

The radical shift in the orientation of the Peruvian economy was led by an authoritarian and corrupt regime (Alberto Fujimori, 1990–2000) and later on it was enforced by a democratic regime (Alejandro Toledo, 2001–2005). After the dissolution of the National Parliament by Alberto Fujimori in 1992, a liberal constitution was proclaimed in 1993, which established the free market as the guiding force in the Peruvian economy and society.

Do the liberal institutions in the economic, legal and/or political spheres established in the 1990's — to move toward a market-led economy — facilitate or hamper the empowerment of impoverished and marginalized groups, such as the great majority of women in Peru?

This chapter reflects on women's empowerment by discussing trends in the participation of Peruvian women in labor markets and the economy from 1990 to 2005. It focuses on some effects of liberal institutions regulating labor markets and discusses the likely implications in terms of the status, access to decent work and empowerment for Peruvian women.

[1]The internal war claimed 60,000 victims, especially among the rural poor and indigenous population.
[2]According to official figures, poverty reduction from 2001–2004 accounted for less than 2 percent (INEI, 2006).
[3]At least 46 percent of Peruvian children ranging from 6 to 13 years were exposed to child labor in 2003; and illiteracy was concentrated in rural indigenous women (Fuertes, 2005).

The analysis found that the struggle for setting a market-led economy in Peru — aimed at the integration into global markets — is producing an increasing pressure on women to enter the labor market, but that this is not necessarily translating into women's empowerment at all levels and among all Peruvian women.

Given the general unfavorable starting conditions of women (compared to those of men) for human capital formation and the particularly poor educational position of indigenous women, the majority of working Peruvian women has become a "mass" of lowly qualified, low-wage, unorganized, temporary, and informal workers with little choice and voice in labor markets. For example, two-thirds have no access to social security and labor rights. Moreover, a third of working Peruvian women work for domestic and global factories as hidden, low-wage or unpaid family workers. Yet, the extent of home-based work is not captured by official surveys and census in Peru and is not covered either by labor legislation.

The first part of this chapter discusses the analytical framework and the second part describes some key aspects of the status of women in Peru. Using secondary data from official census and national surveys, parts three and four analyze some implications for women's empowerment of the institutional changes that occurred in Peru's labor markets.

2. Analytical Framework: Empowerment and Institutions in the Global Economy

2.1. *Empowerment and institutions in development*

Empowerment is about people taking control over their destiny. This is the core question of development. Gutierrez and Sen refer to development as a process of liberation and/or empowerment, meaning the increasing capacities of individuals and societies to act and to decide with effective freedom (with voice and choice) in the economic, social, political, and individual spheres (Iguíñiz, 2005).

Institutions play a crucial role for people's empowerment as they influence their general status. Institutions — the rules "of the game" — regulate people's access to factors of production, assets (whether social or physical), and the goods and services essential for people's survival. Thus, institutions may represent barriers or may facilitate people's empowerment.

North emphasizes the importance of setting enabling institutional environments in successful development cases (European and Southeast Asian countries). Development strategies define and redefine "rules for the game" to establish such environments with different impacts on people's survival and empowerment (North, 1991). In fact, the rules for the game could be "enabling" or may exclude individuals, depending on the starting conditions of individuals or social groups. Gender gaps and deeply rooted inequalities represent unfavorable starting conditions for individuals affected by them (women or other excluded groups).

What is an enabling institutional environment to empower deprived groups in unequal societies? Gender gaps and inequalities rely on traditional, patriarchal, and "gender-blind" institutions in the economic, social, legal, and political spheres (whether formal or informal) which historically have prevented women from equal opportunities as those available for men.

The removal of gender inequality would require the creation of an alternative institutional environment. The central concern of this chapter is to discover how far the institutional changes associated with globalization in domestic economies and worldwide contribute to women liberation and/or empowerment.

2.2. *Global economy, gender, and labor markets*

The global economy — the integration of domestic markets into international markets — is part of the ongoing globalization process. It is a further stage of capitalist expansion (Sander, 2005) to consolidate as the predominant system for the organization and distribution of production, labor, wealth, and power worldwide.

The creation of "hot spot areas" is central to the globalization process and part of building "conducive environments" for foreign direct investments. To benefit from globalization, developing countries are forced to attract foreign investments and to compete among themselves by means of ever better conditions for capital entrance,[4] many times with detrimental consequences for labor and the environment.

[4]"Capital flows to developing countries quadrupled in early 90's ... developing countries share of World foreign direct investment stood at 40 percent" (Mehara and Gammage, 1999).

The major criteria for hot spot areas include: (i) they should have cheap labor (whether qualified or unqualified); (ii) they should be close to centers of production with adequate infrastructure, transport, financial services, reliable communications, supportive industries, and services (Sander, 2005); and (iii) they should also be legally stable, sometimes meaning weak legislation for labor and natural resource management. Institutional changes take place in land, labor, goods, and services markets to develop "hot spot" areas, with inevitable consequences for women's status, labor conditions and empowerment.

In fact, the market-led globalization and its institutions are not gender-neutral. Major trends — global trade, internationalization of production and finance — show it is effective in controlling and reallocating labor, specifically, women's, youth's and children's labor, the generally unskilled and unorganized labor force in developing countries (Salama, 1999). Flexibility and/or deregulation of labor markets is central to globalization and has been accompanied by the feminization of labor in certain productive sectors, certain labor categories and the deterioration of labor conditions worldwide.

Institutional changes accompanying flexibility in labor markets have generally implied the absence of basic labor and social rights. Moreover, in low productivity economies, where technological improvements and innovations are scarce — as is the case of many developing countries — the search for competitiveness has largely relied on lowering labor costs.

2.3. *Regional trends and patterns of the feminization of labor*

Feminization of labor refers to the increase of women's participation in formal and/or informal economies, in certain productive sectors, and in certain labor categories under capitalist relations. As an effect of current globalization, some authors have emphasized: (i) the feminization of flexible and informal labor in developing countries; and (ii) the increase of wage labor for women (Mehara and Gammage, 1999; Sook and Gills, 2002).

Table 8.1 shows the likely ways in which the current liberal and market-led globalization has had an impact on labor in general and on women's labor in particular. Patterns of the feminization of labor are different among regions depending on how each economy is inserted into global markets. While concentration of women's labor by sector may

Table 8.1: Liberal globalization and women's labor.

Policy orientation	Strategies	Consequences for labor conditions	Consequences for women's labor
• Emphasis on export production and sector • Substantial increase in foreign direct investment	• Competition by lowering costs in export sector: search for "ever cheaper labor" • Creation of "hot spot areas"	• Concentration of labor in export sectors • Tendency to increase labor exploitation via lower wages, longer working hours, no or very little job security • Mass of workers consisting of part-time, temporary, casual, or subcontracted labor • Mass of invisible, unorganized low-wage or unpaid workers for domestic and global markets	• Feminization of labor force; increasing pressure over women labor • Women working for global factories (special category of women labor) • Proletarization of women (they come from rural areas, family-farm sector) • In developed economies, feminization of labor is concentrated in the service sector • In Asia, feminization of labor occurs in manufacturing and export agriculture • Women as a marginalized group of workers, consisting of part-time, temporary, casual, or subcontracted labor (precarious work)

Source: Based on D Sook and S Gill (2002).

differ among regions (i.e., the Asian countries concentrate women's labor in the manufacturing and export agriculture sectors; Latin America, Africa, and Europe concentrate women's labor in the service sector), what seems common in the process is the intense withdrawal of women's labor from subsistence sectors to the informal and/or formal sectors.

2.3.1. *Precarious and exploitative versus decent work*

Special categories of women's labor under capitalist relations have intensified with globalization, such as women's home-based work for export sectors (jewellery, textiles, informatics) or women working for export agriculture. In the global labor market, migrant women from developing countries (Mexico, Dominican Republic, Philippines, Peru) to developed economies (US, Spain, Italy, Japan) have become crucial actors in globalization due to the increasing and significant amount of remissions they generate working as nurses and/or as domestic workers (Levaggi, 2007).

Do any of these working categories imply women's empowerment or women with effective freedom to decide, with voice and choice? Do any imply access to a decent work?

Decent work includes at least four concepts which in turn allow levels of empowerment: (i) labor rights; (ii) employment opportunities; (iii) access to social security; (Levaggi, 2007) and (iv) social dialogue, or the right to be organized in order to reach social dialogue. Therefore, decent work is part of major development goals, such as social inclusion, poverty reduction, the strengthening of democracy, and personal realization. The ILO states that the creation of decent work requires an adequate institutional environment so as to guarantee that men and women have access to employment in "egalitarian conditions, security, and dignity" (Levaggi, 2007).

2.3.2. *Feminization of flexible and informal labor*

There is a consensus among researchers about the increase of the informal sector as a consequence of trade liberalization in economies with a former high incidence of informality. The most vulnerable groups (the less qualified) have found "a place" in informality, as has been the particular case of women. The informal sector is quite diverse and might include dynamic sectors linked to exports, but it also includes people in quite precarious

jobs with almost no qualification requirements such as garbage collectors, recyclers of sanitary garbage, street vendors, or deliverers of messages (Mehara and Gammage, 1999). These informal jobs are not captured by national surveys and census, nor included in labor legislation. What has been the case for Peruvian women once the liberalization of the economy and deregulation of labor markets took place?

3. The Status of Women in Peru

3.1. *Country profile*

Peru is one of the five countries in the Andean Region, together with Colombia, Ecuador, Bolivia, Venezuela, and Chile. They all share the Andean Cordillera and take part of the Community of Andean Nations (CAN). Among CAN members, Peru's GDP is third in size, while it ranks second in terms of population, as shown in Table 8.2.

Peru is rich in terms of natural resources. It possesses an important proportion of the region's natural gas reserves (located in the Peruvian forest). For decades it also had the second most important industrial fishery of the world. Mining represents 50 percent of annual exports, but agriculture employs 37 percent of the active labor population in Peru.

Economic concentration is also high in Peru. Half of the nation's GDP is generated in Lima, the capital, which contains one-third of the total population, financial services, industry, public infrastructure, and services.

Table 8.2: Peru in the community of Andean nations, 2005.

	GDP (million US dollars)	Population (million people)	Exports (US million dollars)	Human development index and ranking (2004)
Bolivia	8,932	9.6	2,791	115
Colombia	113,403	46.0	20,885	70
Ecuador	20,285	13.2	9,869	83
Peru	73,850	28.0	16,830	82
Venezuela	132,848	26.6	50,491	72

Sources: CAN "Principales indicadores de la CAN 1994–2005" Cuadros estadísticos Table 1, p. 11. UN "Human development 2006", Table 2, pp. 290–291.

3.1.1. *Diverse and unequal*

Peru is quite diverse and differentiated in social, economic, and cultural terms. Income and social differentiation among Peruvians relate to their ethnic, formal/informal, and urban/rural backgrounds.

3.1.1.1. Formal and informal Peru

As with many other Latin American countries, informal economies in Peru are crucial for poor people's survival. Small and informal enterprises in Latin America employ 50 percent of the active population in the region.[5] However, the informal sector seems even more far-reaching in Peru since at least two-thirds of its GDP is generated by small enterprises working outside the formal system (World Bank, 2006).

3.1.1.2. Urban and rural differentiation

More than two-thirds of Peruvians live in urban areas. Lima, the capital, contains 30 percent of the economically active population. Rural areas have the poorest population, as well as the majority of the economically active population employed in agriculture. According to the 1995 National Survey of Households, 71 percent of the extremely poor in Peru are employed in the subsistence agriculture sector (Fuertes, 2005).

3.1.1.3. Indigenous and non-indigenous Peruvians

In 2001, indigenous[6] households made up 42 percent of households in Peru.[7] One third of the inhabitants in Lima, identified themselves as indigenous,

[5]Development and Training Services Inc. "Scope of work for GATE/Peru Sub Task 3.1: Gender opportunities and constrains to integrating information and communications technologies (ICT) in micro- and small enterprises (MSES)" (2006).
[6]The term refers to the descendants of former inhabitants of the Peruvian territory before the Spanish Conquest in 1535.
[7]The National Survey of Households of 2001 defined indigenous households as those where the head of household acknowledges indigenous backgrounds, identifies him or herself as indigenous and speaks at least one indigenous language.

while half indigenous households are rural (Trivelli, 2005). The most important indigenous groups are the Quechuas and the Aymaras (in the Southern Andes). There are almost 60 indigenous groups in the Peruvian Amazon. The non-indigenous population is composed of ethnic groups such as the "mestizos"[8], blacks, and a reduced number of whites (less than 10 percent of Peruvian population).

Social and economic gaps between indigenous and non-indigenous Peruvians are significant. As shown in Table 8.9 later in this chapter, indigenous people have fewer years of school and earn less than non-indigenous Peruvians (Hernández *et al.*, 2006). Indigenous children attend poor schools and have less schooling (indigenous males average 6 years of school while non-indigenous males average 9). Differences for rural indigenous girls are even worse (see Table 8.5).

3.2. *Institutional changes in Peru, 1990–2005*

The shift in development orientations in Peru — to move toward a market-led economy — took place in 1990, in a context of hyperinflation,[9] internal war, and strong state repression to combat subversive groups.[10] Structural reforms operated on the bases of institutional changes in different sectors and markets. They changed the conditions for people's access to means of production (land, water, forests, financial resources), goods, and public services dramatically. These changes had differentiated impact on men and women (Chacaltana *et al.*, 1999; Fuertes and Villanueva, 2003; Lopez, 2002).

As summarized in Table 8.3, the most crucial reforms to "deregulate" the economy were implemented from July 1990 to October 1991, with no gradual strategy (Pinzas, 1996). Peruvians were confronted with "adjustments" affecting their personal, social, economic, and political lives in less than 1 year. This was known as "the shock" that Peruvians had to deal with in the early 1990s.

[8]Descendants of the mixing of indigenous population and the Spanish conquers.
[9]By the end of 1989 annual inflation was 7,000 percent.
[10]The Movimiento Revolucionario Tupac Amaru MRTA and Shining Path, declared war on the Peruvian State in May 1980. About 60,000 Peruvians died from 1980–1995, and 10,000 remained as "missing" (CVR, 2004).

Table 8.3: Structural reforms and institutional changes in Peru, 1990–1991.

		New institutions
July 1990	Removal of price and exchange rate controls and the first phase of trade liberalization	
March 1991	Second phase of trade liberalization, removal of barriers to mobility of international capitals	
October 1991	New labor legislation, legislation to promote foreign investments, and the beginning of privatization of public services and enterprises	Flexible labor, free contracting, no restrictions to fire workers. Facilitation of individual negotiation of wages and labor conditions

Source: Based on Pinzas (1996), pp. 9 and 19.

The social and political costs of implementing liberal institutions were high in terms of democracy and human rights.[11] The national parliament was dissolved by Alberto Fujimori's regime with the support of the military in 1992 to proclaim a liberal constitution in 1993. State repression extended to social leaders and trade unionists to "prevent" social and political opposition to the dramatic effects of institutional changes — especially those affecting Peruvians' purchasing power and employment levels, such as changes in labor markets and trade liberalization.

While institutional changes focused on building a "conducive environment" for capital flow and foreign investments, nothing was defined in terms of human capital formation. Social investments in human capital formation (education, health, social provision) experienced constrains and decreased over the period to lower levels than those of the 1970s (Francke, 2001).

In fact, rates of social investment in Peru are amongst the lowest in the region.[12] This has had negative effects on labor qualifications and

[11]Investigations on human rights violations from 1990–1995 concluded in 2004 that Alberto Fujimori's regime assassinated trade unionists after the dissolution of the national parliament. Between 1991 and 1993 at least two prominent trade unionists were assassinated (Pedro Huillca Tecse and Adrian Medina).

[12]In 2006 Latin America invested US$610 per capita in education, health, and social prevision, while Peru invested just US$170 in that year (Chevarría, 2006).

productivity, particularly for historically excluded groups. Peru is not very competitive. For example, it ranks 68th out of 116 countries (Giugale, 2006). Institutional changes in labor markets, consequently, brought about the so-called "flexible labor" which had adverse connotations for vulnerable groups in the Peruvian society.

3.3. *Women in Peru*

15 years after the radical changes in the orientation of the economy, what has happened to Peruvian women? Women were 53 percent of Peruvian population in 2005. Urban women constituted 71 percent of the women in Peru, while rural women were 29 percent (INEI, 2006).

3.3.1. *Status of Peruvian women*

To analyze the general status of Peruvian women, we focus on the evolution of women's participation in the economy and labor markets over the past 3 decades. Although methodologies differ from year to year and despite the fact that a rigorous comparison is not possible, official data from National Surveys of Households and National Census illustrate how women's participation in the economy almost doubled over the past decades. Women in Peru accounted for 45.7 percent of the economically active population in 2005, while they were only 20 percent in 1981 (INEI, 1984; MTPE-PEEL, 2006).

Trends in women's and men's rates of economic activity in Peru over the last 30 years show women's labor operated as an adjusting variable in both times of economic stress and growth. For example, from 1970 to 2005 the rates of economic activity for women were much more volatile than for men. As a result, the gender gap has been reduced considerably in the past decade.

The increase in women's rates of economic activity intensified steadily from the mid-1980s onwards. The economic debacle in the mid-1980s[13] caused the first wave of the feminization of labor in Peru. Women entered the informal sector to cope with the recession and hyperinflation which

[13]The 1980's were marked by hyperinflation, macroeconomic disequilibrium, and an external debt crisis in the region; it is known as "the lost decade". In the Peruvian case, it was also marked by internal war and political unrest.

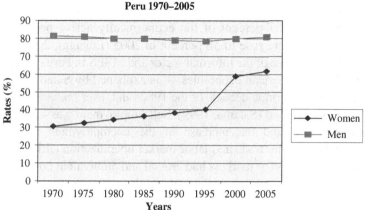

Graphic 1 : Evolution of economic activity rates by sex,
Peru 1970–2005

Figure 8.1: Labor force participation by gender.
Sources: INEI 1995 "Proyecciones de la PEA 1970–2015", based on ANNEX 1,
Table 8 and INEI (2006) "Compendio Estadístico 2006", based on Table 7.5.

had reduced their purchasing power to less than a third of the 1975 level. Later on, liberalization intensified the feminization of labor as women continued to enter in the labor market to cope with the increasing under-employment among men in the early 1990s (Chacaltana *et al.*, 1999; Fuertes and Villanueva, 2003).

Contradicting theories which predict that women's economic activity should have an inverse relation with economic cycles (i.e., it grows in times of crises and remains the same or decreases as there is economic growth (MTPE-PEEL, 2006)), rates of economic activity for Peruvian women continued to increase during 1995–2005 even as economic growth took place and as the deregulation of labor markets increased women's access to either formal and informal markets through "flexible labor".

3.3.2. *Gender and market liberalization*

Women's participation in labor markets increased in Peru by means of informality, self-employment, and informal home-based work as survival strategies. After the implementation of liberal reforms, the increase of

the informal sector as well as the increase of micro- and small enterprises (MSES) was considerable. According to the ILO, in 1990 the informal sector employed 52.7 percent of the economically active population in Peru, while this figure rose to 58 percent in 2005 (Levaggi, 2007).

The rapid increase of the informal sector and MSES in Peru — and other "adjusted" Latin American economies — is explained by Salama as a consequence of the economic debacle of the 1980s and, later on, as a side-effect of market liberalization (Salama, 1999). Self-employment was a response to de-industralization and the increase of the unemployment and under-employment rates after trade and labor market liberalization (ILD, 2005).

The liberalization of markets had crucial and ambivalent consequences for women. Some authors stress the fact that the gender system was eroded as market liberalization increased pressure on women's labor, withdrawing them from home and subsistence sectors to public spheres and pressing for a reallocation of labor at the household level between reproduction and markets (Fuertes and Villanueva, 2003; Lopez, 2002). But it also made men's employment unstable and diminished the role of men's wage labor as the most important contribution to total household incomes. In fact, the number of income contributors at the household level increased in Lima from 1.94 in 1990 to 2.02 by 1995 (Chacaltana *et al.*, 1999). The reallocation of women's time and labor to the market economy — in the case of urban women — increased by 4 hours per week between 1995 and 2005.[14]

Women were forced to enter markets in precarious conditions. In general, they were less educated than men, had very little access to financial services, and had almost no access to technical training. Moreover, they have the burden of reproductive tasks and roles.

The reallocation of women's labor in favor of markets might have in turn increased the level of gender conflicts within the household. What conditions allowed the changes observed in women's rates of economic activity?

3.3.3. *A differentiated process of women's empowerment*

Table 8.4 shows the evolution of key aspects to analyze women's increasing participation in the Peruvian economy. This increase was facilitated by positive trends in the evolution of some underlying conditions for women such as the increase in schooling years, lowering fertility rates, delay of

[14]MTPE-PEEL, "Distribución de la PEA segun rama de actividad 2000–2003–2005", available in www.mintra.gob.pe/peel/estadisticas/ind_RAM_ACT_INIEI.pdf.

Table 8.4: Status of women and gender gaps in Peru, 1990–2005.

	1981	1990	2000	2005
Intrafamily violence against women (physical)	—	—	41%	40.8%
Fertility rate	4.3	4.0	2.9	2.5
Rate of contraceptive use (% fertile women)	—	32.8	50.4	68.2
Access to education				
School enrolment (% children from 6 to 11 years)				
Women				97.4
Men				97.9
Years of school				
Women		7.1	8.5	
Men		8.3	9.0	
Economic participation and labor markets				
Economic activity rates				
Women			57.0	61.6
Men				

Sources: INEI (1984) "Censo de población 1981"; INEI (2006) "Compendio Estadístico 2006" based on Tables 5.21 and 5.22; INEI (2001) "Perú: Encuesta Demográfica y de Salud Familiar 2000"; and INEI (2006) "Perú: Encuesta Demográfica y de Salud Familiar Continua 2004–2005".

maternity (by means of increasing contraceptive use) and the increasing access to financial services by the mid-1990s (Chacaltana *et al.*, 1999; Barrig, 2005; Blondet, 1994).[14]

The trends in these underlying conditions show that there is an ongoing process of empowerment for women in Peru as a combined effect of both public policies and women's individual choices. Nevertheless, it is a differentiated process of empowerment since women from historically excluded groups (such as indigenous and rural women) still lag behind urban and non-indigenous women, as well as men. On the other hand, gaps between rural and urban women have evolved differently over the past decade. For some crucial aspects such as fertility rates and the use of contraceptives, the gaps had diminished (see Figs. 8.2 and 8.3).

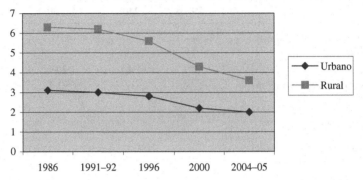

Figure 8.2: Fertility rates, urban versus rural.
Source: Based on INEI ENDES 1986, 1991–92, 1996, 2000 and 2004–05. INEI "Compendio Estadístico 2006".

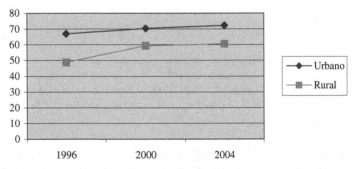

Figure 8.3: Contraceptive use, urban versus rural.
Source: INEI 2006, "Fecundidad y pobreza en el Peru: 1996, 2000–04". From Table 2.20 p. 46 and Table 2.27, p. 50.

However, as shown in Tables 8.4 and 8.5, significant gaps remain in empowering aspects such as education. Overall, the gap between men and women in education has been reduced as a general trend in terms of education. For example, among boys and girls from the ages of 6 to 11, the rates of school enrollment had become almost similar by 2005.

Table 8.5: Years of school by gender and area of residence in Peru, 1993 and 1999.

	Total	Men	Women
1993			
Total	7.7	8.3	7.1
Urban	9.0	9.6	8.5
Rural	4.1	5.0	3.1
1999			
Total	8.4	9.0	7.8
Urban	9.7	10.2	9.3
Rural	5.2	6.1	4.4

Sources: INEI, ENAHO 1993 and 1999, IV Quarterly.

Nevertheless, educational gender gaps are significant when it comes to rural areas and the indigenous population.

3.3.4. *Decision-making at the household level*

The fact that Peruvian women increased their participation in labor markets generated a new process of decision-making at the household level, resulting in gains for women's empowerment. Available data from National Surveys on Demography and Socio-economic Conditions (INEI, ENAHO, 2006, 2004, 2005) indicate that, as a general trend, Peruvian women have gained more power over time to decide how to use the incomes they generate (see Table 8.6). This positive trend is most

Table 8.6: Women's decision-making in Peru, 1996–2005.

	Decides on her own over incomes (% of women)		
	1996	2000	2005
Total	62.9	78.2	80.5
Urban	N/A	82.2	82.4
Rural	N/A	60.8	70.5

Sources: INEI (2001) ENDES 2000 Table 3.9 p. 39 and INEI (2006) ENDES 2004–2005, Tables 3.11 and 3.12, pp. 40–41.

pronounced among women under 25 years old, non-married women, college women, and women living in urban areas.

3.3.5. *Countertrends*

Despite the fact that important progress has been made in lowering fertility rates and raising school enrollment for women over the past decades, Peruvian women are still subject to male control at different levels in both public and domestic spheres. The degree of violence against women reveals that the process of women's empowerment in Peru is far from being conflict-free as it challenges the gender system. Intra-family violence against women was declared a national concern in Peru in 1997.[15] Before 1997, it was considered a private affair. However, as reported in Table 8.4 earlier, National Surveys in 2000 and 2005 reveal high levels of violence against women.[16] At least 41 percent of Peruvian women are victims of physical violence — in some cases leading to injury — but just 14 percent denounce violence (INEI, ENAHO, 2000, 2004, 2005). No more than 1 percent of demands are favorable to women in the Peruvian judiciary system (Detensoría del Pueblo Peru, 2006a,b).

Sexual harassment is still common in public schools and in some labor spheres. Sexual violation was a systematic practice of the military during the internal war from 1980 to 1995. The Peruvian Commission for Truth, Justice, and Reconciliation (CVR) reported in 2004 that 98 percent of sexual violations in the war period were perpetrated against peasant and indigenous women (CVR, 2004). These crimes are yet to be judged.

Male-headed institutions, such as the Catholic Church and conservative right-wing parties, exert permanent pressures on state institutions to remove the progress made in the implementation of women's reproductive rights. Barrig describes how these pressures are applied and how civil society and women's movements have been effective in confronting such countertrends (Barrig, 2005).

[15]The Peruvian State subscribed in 1997 to the "Belem do Para" International Convention, by which it is committed to prevent, eradicate, and sanction violence against women, as well as to support National Plans to eliminate violence against women.
[16]In 2000 and 2004–2005, national surveys (INEI, ENAHO, 2000, 2004 2005) included modules on violence against women, aimed at establishing the magnitude of the problem at the national level.

4. Labor Markets and Peruvian Women

Women represented 43 percent of the active labor force in Peru in 2005. More than one-third worked in rural areas, while nearly two-thirds worked in urban areas.[17] Figure 8.4 shows that almost two-thirds of working women in Peru are employed in the service sector, while agriculture also contains an important portion. Just one in 10 Peruvian women works in the manufacturing and industrial sector. Trends over the past 25 years show this structure has remained fairly stable with some gains for agriculture.

The increased participation of Peruvian women in agriculture over the past 25 years could be explained by several different factors. First, estimates of women's contribution to the economy have improved. New methodologies were introduced in official surveys and census to capture gender issues in economic variables (decision-making at household level, income generation, etc.). Second, the increased participation of women in agriculture could be explained as an effect of internal war in the 1980s and early 1990s. War withdrew men from agriculture and reallocated women's labor in the sector.

Third, it could have resulted from the liberalization of agriculture. Modern export agriculture developed in the 1990s in the richest valleys of the Peruvian Coast and is showing sustained and increasing rates of

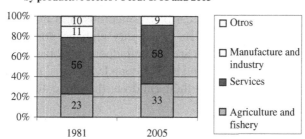

Graphic 3: Distribution of female active labour force
by productive sector / Peru: 1981 and 2005

Figure 8.4: Women workers by economic sector.
Source: Based on INEI (1984) Census 1981, INEI ENAHO 2005; in: MTPE-PEEL, "Distribución de la PEA segun rama de actividad 2000–03–05".

[17]28% work in Lima and 37% in the rest of urban Peru (MTPE-PEEL, 2006).

growth. The production of paprika, asparagus, sweet peppers, olives, artichokes, grapes, and mangos has created a more intensive demand on woman's labor in agriculture as these are labor-intensive crops which require of some gender-differentiated abilities beyond physical force. Young rural women migrate from the poorest areas in the highlands of Peru to the coast as temporary agricultural laborers. The magnitude of these flows has not been yet captured by official surveys since they are mostly focused on urban areas.

4.1. *MSES and the service sector*

Like the rest of Latin America, the micro- and small enterprise sector (MSES) and the service sector continue to be crucial for women's employment in Peru and little has changed in this regard in the past 25 years (see Fig. 8.4). As far as they are a response of vulnerable groups to structural poverty, MSES in Latin American are frequently low-productivity and low-income-generating enterprises, concentrated on subsistence activities (petty trading, personal, and/or domestic services) in the informal sector. Informal MSES have lower labor qualifications compared to those of the formal sector. That is why vulnerable groups — the lowly qualified labor force — such as women, youth and children are concentrated in them.

As shown in Fig. 8.5, the majority of Peruvian women employed in the service sector are involved in petty trading (as street vendors, retailers), wholesaling, MSES, personal, and non-personal services. But they are also involved in quite precarious, dangerous, and informal activities (as garbage collectors, recyclers of sanitary garbage, street vendors, and deliverers of messages) which are not included in national surveys and the census and are not even covered by Peruvian labor legislation. These risky activities include women and their children, thereby extending the range of vulnerable workers.

4.2. *Qualifications, education and working categories*

More than two-thirds of the economically active population in Peru (71 percent) has a basic education (primary and secondary levels), while 21 percent has technical and/or university education (INEI, 2005). Francke has stressed the fact that in the "adjustment decade", important

Graphic 4: Women in the service sector / Peru 2005

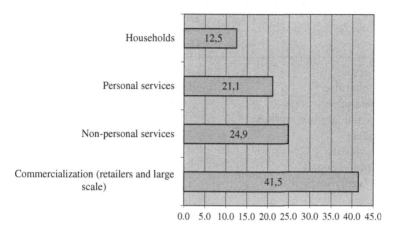

Figure 8.5: Women in the service sector.
Source: PEEL-MTPE (2006), "Informe sobre la mujer en el Mercado laboral", Table 2.

investments were made to enlarge the outreach of school enrollment (especially for primary and secondary levels). However, the major problem of the Peruvian educational system is the quality of schooling which has been affected by the lowering of funding for teacher training and salaries, as well as by the reduced provision of school texts (Francke, 2001).

Despite the fact that the educational profile of Peruvian women has improved in terms of school enrollment, they still go to school for fewer years than men and school attendance continue to be lower for women than for men. Women, consequently, still constitute an important part of the non-qualified laborers in Peru (MTPE-PEEL, 2000, 2004, 2005). Blondet (1994) referred to the educational profile of Peruvian women as quite unequal. Right now, while 21 percent of women reach the university level, especially among the coastal, urban, and non-indigenous populations, 11 percent of women are illiterates, mostly rural and indigenous women.

So far, the majority of independent working women in Peru is non-professional (see Table 8.7) — meaning no university and/or technical studies. This in turn reveals that conditions for universal access to education and job training for women is yet to be achieved and points out major concerns about women's human capital formation.

Table 8.7 shows that the majority of Peruvian women (36 percent) work as independent workers, while a third (29 percent) still work as

Table 8.7: Female active labor force by labor category in Peru, 2005.

	Distribution of employed women (%)		
	Urban	Rural	Total
Public sector	9.0	2.3	6.5
Micro-enterprise	14.2	7.1	11.6
Small enterprise	6.4	1.8	6.7
Medium and large enterprises	7.8	0.7	5.2
Independent	39.4	29.6	35.8
Professionals	1.4	0.1	0.9
Non-professionals	38.0	29.5	36.9
Unpaid family worker	12.9	56.4	29.0
Others	10.2	2.1	7.2
Total	100	100	100

Source: MTPE-PEEL (2006) Table 2, p. 10.

unpaid family workers. Although women's unpaid work seems to be a rural problem, it would be hiding a major phenomenon in the case of urban women and their families who work for domestic or global factories under the invisible and officially unrecognized category of home-based work.[18]

Home-based work is not new among Peruvian women, but some recent qualitative studies on key sectors, such as jewellery and textiles (Massila, *et al.*, 2004), show it is increasing and is crucial among urban women over 30 years old and among unemployed youth and children in the shantytowns of the periphery of coastal cities like Lima, Trujillo, Chiclayo, and Ica.

As economic growth spreads across the country, domestic enterprises are relying on home-based work as part of a low-cost strategy because it is the home-based worker who assumes all operating costs and has no labor rights. According to labor specialists, home-based work for domestic and global factories could be largely hidden under different labor categories: micro-enterprises, independent and non-qualified workers, unpaid family

[18]"The term refers to two types of workers who carry out remunerative work within their homes — dependant, subcontracted workers and independent own account workers ... but here the term refers to the first category only ... the under-remuneration of home-based workers is particularly acute because their remunerative home-based work is often seen as simply an extension of their unpaid housework (Chen *et al.*, 1999)."

workers, and as household work (MTPE-PEEL, 2005). Official surveys and the census do not capture it.

4.3. Gender and labor status: How decent is work?

Table 8.8 provides an overview on the labor status of Peruvian women before and after the liberalization of labor markets. 13 years later, adequate work for women has increased very little, while adequate work for men decreased. Nevertheless, men still have much more presence among those with adequate jobs compared to women and women have a major presence among informal workers, which translates into an absence of basic labor rights (a formal contract observing vacations, 8 hours of work, pregnancy considerations for women, and social provision).

Table 8.8: Labor markets and gender gaps in Peru, 1990–2005.

	1981	1990	2000	2005
Economic participation and labor markets				
Activity rates (%)				
Women		—	57.0	61.6
Men				
Adequate employment (%)				
Women	—	37.7	—	40.0
Men	—	58.6	—	53.6
Informal employment (%)		52.7		58.0
Women	—	62.9		65.1
Men	—	46.3		53.0
Incomes (US$)				
Women	65.3	136.0	—	151.4
Men	131.0	208.0	—	
Access to social security (% of employed men/women)				
Women	—	24.3	—	16.5
Men	—	20.3	—	13.0

Source: INEI, "Compendio Estadístico Peru" (2006), p. 299. ILO "Panorama Laboral 2005, Table 6-A, p. 100, Structure of non-agricultural work; Table 7-A, p. 104 "Wage labor with social security.

Formal work does not necessarily provide social benefits and labor rights in Peru, but just a private contract of "personal services" with no labor compromise (i.e., more than 50 percent of public employees work under these labor categories). Labor contracts are different from service contracts. The latter are predominant in both the private and public sectors in Peru. While social security was not extended in Peru before the liberal reforms, women lost more than men in terms of access to social security (see Table 8.8). In particular, the loss of employment because of the reduction in the size of the government and the effects of liberalization on industrial sectors (e.g., chemical and textiles) affected the major adequate employment sources for women quite adversely.

4.4. *Labor, Gender, and Ethnic Gaps*

The labor status of Peruvian women is not only influenced by gender factors but also by ethnic ones. The labor status of indigenous women is much more precarious than those of non-indigenous Peruvian women. In 2001, for example, the income gap between indigenous men and women was 49.5 percent while it was only 37.1 percent between non-indigenous men and women, as reported in Table 8.9. Informal work was also more significant for indigenous women than for non-indigenous women, while unpaid work was more acute in the case of indigenous women than for non-indigenous women, as indicated in Table 8.10.

5. Conclusions and Outlook

This chapter focused on discussing some likely implications of institutional changes in labor markets on women's status and empowerment in Peru from 1990 to 2005. The process of women's empowerment in Peru looks differentiated. It does not affect all aspects of women's lives and all Peruvian women in the same manner.

The traditional gender system eroded as market liberalization and its effects increased pressure on women's labor, withdrawing them from home to public spheres and pressing for the reallocation of women's labor at the household level between reproduction and markets. This has had ambivalent outcomes for women's empowerment in Peru.

Table 8.9: Indigenous and non-indigenous in labor markets in Peru, 2001.

	Men	Women	Gaps
Indigenous			
Wage Income (US$)			
Total	1,248	630	49.5
Formal sector	2,745	1,694	38.3
Informal sector	1,089	545	50.0
Labor status (%)			
Self-employed	41.3	33.2	—
Unpaid family worker	15.8	43.4	—
Non-indigenous			
Wage Income (US$)			
Total	2,278	1,433	37
Formal sector	4,194	2,826	32.6
Informal sector	1,923	1,172	39.1
Labor status (%)			
Self-employed	33.9	35.2	—
Employers	21.3	22.4	—
Factory workers	27.5	6.9	—

Source: Based on Trivelli (2005) "Indigenous Households and Poverty in Peru", Table 24 non-indigenous women, as indicated in Table 8.10.

Table 8.10: Indigenous and non-indigenous Peruvian women.

	Indigenous women	Non-indigenous women	Gaps
Wage Incomes (US$)			
Total	630	1,433	56.0
Formal sector	1,694	2,826	40.1
Informal sector	545	1,172	53.5
Labor status (%)			
Self-employed	33.2	35.2	
Unpaid family worker	43.4	22.4	
Factory workers	7.9	6.9	

Source: Based on Trivelli (2005), "Indigenous Households and Poverty in Peru", Table 24.

Favorable trends in some underlying conditions for Peruvian women (lower fertility rates, increased school enrollment, and increasing use of contraceptives) have run parallel to and allowed a major rise in women's rates of economic activity. There is an ongoing process of empowerment for women in Peru as a combined effect of both public policies and women's individual choices. In addition, as a consequence of a greater exposure of Peruvian women to markets and public spheres, a new process of decision-making at household and individual levels has developed in favor of women.

However, while decision-making over incomes has improved for women in Peru — as they entered into formal and informal markets — the level of gender conflict remains high and seemingly permanent in Peru. Moreover, reported rates of violence against women at both the household and public levels remain high.

The liberal institutions of the 1990s in labor markets have brought about a considerable increase in women's participation in the labor force, but they have not yet been effective in generating "decent work" for women. This has to do with the nature and orientation of the institutional environment built in Peru during the 1990s.

The Peruvian case also illustrates how an enabling institutional environment to empower vulnerable groups — in quite unequal societies like the Peruvian — is different from an enabling institutional environment to just move toward a market-led economy. Institutional change operated in Peru to create a "conducive environment" to attract capital flows and foreign investments, but the generally unfavorable conditions for women's human capital formation in Peru and particularly the exclusion of indigenous women, were ignored.

Despite the fact that women's enrollment in primary and secondary schools has improved in Peru, women still are predominant among the unqualified workers. Universal access to education implies more than just high school enrollment for women; it also requires quality schooling and job training.

Without making the social investments to allow the removal of gender and ethnic inequalities, the liberal institutions of the 1990s in labor markets have tended to make working Peruvian women a "mass" of lowly qualified, low-wage, temporary, unorganized, and informal workers without any labor rights.

Moreover, a third of working Peruvians (both rural and urban) are in the informal sector, including even hidden and unpaid family workers and

home-based workers, not only in subsistence agriculture but also in the dynamic export sectors. Furthermore, indigenous Peruvian women are very over-represented among the less educated, the unpaid, and the informally and self-employed working women in Peru. Gender and ethnic gaps, therefore, must be addressed before decent work and empowerment for all Peruvians can be attained.

References

Barrig, M (2005). De quién es la mano que mece la cuna?: los derechos de las peruanas en el año 2004. In *Pobreza y desarrollo: Informe anual 2004–2005*. Lima: Oxfam GB. Oficina del Programa en Perú.

Blondet, C (1994). *La situación de la mujer en el Perú 1980–1994*. Documento de Trabajo 68, Serie Estudios de Género 1. Lima: Instituto de Estudios Peruanos (IEP).

CVR (2004). *Informe Final de la Comisión de Verdad y Reconciliación en el Peru*. Lima: Defensoría del Pueblo. http://www.cverdad.org.pe/final/index.php

Chacaltana, J, García, NE and Burga, C (1999). *Mujer, empleo y pobreza: La experiencia reciente de los países Andinos*. Documento de Trabajo 100. Oficina de área y equipo técnico Multidisciplinario para los países andinos. Lima: Oficina Internacional del Trabajo (OIT).

Chen, M, Sebstad, J and O'Connell, L (1999). Counting the invisible workforce: The case of home-based workers. *World Development*, 27(3), 605.

Chevarría, F (2006). En gasto social estamos muy lejos del promedio regional. In *El Comercio 30de Setiembre 2006*, p .b1.

Defensoría del Pueblo Peru (2006). *Violencia Familiar: Un análisis desde el derecho penal*. Informe 110, Serie Informes Defensoriales. Lima: Defensoria del Pueblo. Noviembre. http://www.defensoría.gob.pe/inform-defensoriales.php

Defensoría del Pueblo Peru (2006). Resolución defensorial No. 0053-2006. Lima: Defensoría del Pueblo. Noviembre. http://www.defensoria.gob.pe/resol-defen.php?a=2006

Dong-Sook S. Gills (2002). Globalization of production and Asian women. In Annals of the American Academy of Political and Social Science, Vol. 581, Globalization and Democracy, pp. 106–120.

Francke, P (2001). Políticas sociales: balance y propuestas. Documento de trabajo No. 194. Departamento de Economía, Pontificia Universidad Catolica del Peru. Lima: Centro de Investigaciones Sociales , Económicas, Políticas y Antropológicas (CISEPA).

Fuertes, P (2005). Trabajo infantil y adolescente en la Región de Piura. Boletín de Economía Laboral No. 31. Año 8. Programa de Estudios y Estadísticas laborales

PEELL-Ministerio de Trabajo y promoción del Empleo del Peru (MTPE). Lima: MTPE. http://www.mintra.gob.pe/peel/publicaciones/bel/BEL_31.pdf

Fuertes, P and Villanueva, A (2003). Desarrollo Empresarial: *Éxito = Ser + saber + hacer* Movimiento Manuela Ramos. Lima: MMR.

Giugale, M (2006). *Peru la oportunidad de un país diferente: próspero, equitativo y gobernable*. World Bank. http://www.bancomundial.org.pe

Hernández, M, Patrino, HA, Sakelariou, C and Shapiro, J (2006). Quality of schooling and quality of schools for Indigenous Students in Guatemala, Mexico and Peru. World Bank Policy Research Working Paper 3982.

ILO (2005). Panorama Laboral 2005: América Latina y el Caribe (Avance primer semestre). Oficina Internacional del Trabajo, Oficina Regional para América Latina y el Caribe. Lima: OIT.

INE (1984). Censos Nacionales VIII de Población III de Vivienda 12 de Julio 1981. Resultados Definitivos. Volumen A, Nivel Nacional: Tomos I y II. Lima: Instituto Nacional de Estadística (INE).

INEI (1995). Estimaciones y Proyecciones de la Población Económicamente Activa 1970–2015. Instituto Nacional de Estadística e Informática. http://www.inei.gob.pe/biblioineipub/bancopub/Est/Lib0176/C2-3.htm

INEI (2001). "Perú: Encuesta Demográfica y de Salud Familiar 2000". Lima: Instituto Nacional de Estadística e Informática (INEI).

INEI (2006). Perú: Encuesta Demográfica y de Salud Familiar ENDES Continua 2004–2005. Dirección Técnica de Demografía e Indicadores Sociales. Dirección Nacional de Censos y Encuestas. Lima: Instituto Nacional de Estadística e Informática (INEI). http://www.inei.gob.pe/biblioineipub/bancopub/Est/Lib0732/Libro.pdf

INEI (2006). Fecundidad y Pobreza en el Perú: 1996, 2000 y 2004. Centro de Investigación y Desarrollo (CIDE). Lima: Instituto Nacional de Estadística e Informática (INEI). http://www.inei.gob.pe/biblioineipub/bancopub/Est/Lib0688/Libro.pdf

INEI (2006). Perú: Compendio Estadístico 2006. Instituto Nacional de Estadística e Informática. Lima: INEI. http://www.inei.gob.pe/bib ioineipub/bancopub/Est/Lib0704/Libro.pdf

MTPE-PEEL (2005). Estadísticas laborales – Empleo Perú Total: Distribución de la PEA por sexo según Rama de actividad económica 2002–2003–2005. http://www.mintra.gob.pe/peel/estadisticas/ind_RAM_ACT_INEI.pdf

Iguiñiz, J (2003). *Desarrollo, libertad y liberación en Amartya Sen y Gustavo Gutiérrez*. Lima: PUCP.

Levaggi , V (2007). Qué es el trabajo decente? El Comercio 17 de Enero, p. A4.

López, C (2002). *Género y Cooperación en un nuevo paradigma*. Seminario Género y Cooperación en Colombia. SINERGIA- CORDAID.

MTPE-PEEL (2006). Informe anual 2005 La mujer en el mercado laboral Peruano. Programa de Estudios y Estadísticas laborales (PEEL). Ministerio de Trabajo y

Promoción del Empleo del Peru. Lima: MTPE. http://www.mintra.gob.pe/peel/publicaciones/informes/inf_annual_mujer_2005.pdf

Masilla, JC, Ynoñan, P and Arroyo, R (2004). Una cadena global de explotación: caso de trabajadoras de cadenitas de oro. Instituto de salud y Trabajo. Ica: ISAT.

Mehara, R and Gammage, S (1999). Trends, Countertrends and Gaps in Women's Employment. *World Development*, 27(3), 533–550.

North, D (1991). Institutions. *Journal of Economic Perspective*, 5(1), 97–112.

Pinzas, T (1996). Respuestas empresariales al proceso de reformas en el Perú. Documento de Trabajo 82. Consorcio de Investigación económica. Instituto de Estudios Peruanos. Lima: IEP.

Salama, P (1999). Riqueza y pobreza en América Latina: La fragilidad de las nuevas políticas económicas. Universidad de Guadalajara, Coordinación Editorial. p. 186. México: Fondo de Cultura económica.

Sander, H (November 1999). Global Economic Development: Lecture Handout prepared for SEPIA Programme, Maastricht School of Management.

Trivelli, C (2005). Los Hogares indígenas y la pobreza en el Peru: una mirada a partir de la información cuantitativa. Documento de Trabajo 141. Lima: IEP.

World Bank (2006). Peru — Country Partnership Strategy: Chairman's concluding remarks. Report 38297.PE-Peru Cas — PO95660. Document 2006/12/19.

Chapter 9

Institutions and Gender Empowerment in the Fiji Islands

Biman C. Prasad* and Nalini Lata

1. Introduction

Gender issues in many developing countries are controversial despite various international agreements on the rights and empowerment of women. This is partly due to the lack of committment from developing country governments to develop appropriate institutional mechanisms to support the development and empowerment of women. The Fiji Islands in this respect is no exception. Fiji is a small island nation with a population of about 800,000. It gained independence in 1970 and its development in the first decade of independence was very good but since the beginning of the 1980s, it has not performed well. The military coups of 1987, 2000, and more recently in 2006, have set the country back by about 20 years. Associated with this are increasing levels of poverty, unemployment, and crime. Invariably, the major impact of this slide into declinism has been on women and children in Fiji. The ability of women to navigate through this difficult period in Fiji's history has been hampered by the retarded development of appropriate institutions in certain areas. However, on the positive side Fiji has been moving ahead with some legislation designed to empower women, for example, the Family Law Bill which was passed by the parliament in 2006. The next section provides a discussion of the status of women in Fiji through an assessment of the various indicators for the participation of women in the political and economic life of the country. The third section describes government policy and programs for

* Corresponding author.

the development and empowerment of women in Fiji. The fourth section discusses some of the legislation for empowering women, and the last section provides some concluding comments and policy implications.

2. Political and Economic Status of Women in Fiji

The general status of women was that they were less likely to be educated at the primary and secondary levels and to move on to tertiary education. They were also less likely to obtain well-paid jobs and promotions, to own fewer businesses, and they faced problems in obtaining credit. The rising unemployment and poverty in recent years saw the number of families receiving financial family assistance through the Department of Social Welfare increase from 5,166 in 1987 to 7,972 in 1993 of whom 70 percent were female-headed households (Economic and Social Commission for Asia and the Pacific, 1999). However, over the years, progress has been made in education, and gender equality is now almost achieved, as will be discussed.

The United Nations Development Program (UNDP) introduced a new index in 1995 known as Gender Empowerment Measure (GEM), which quantifies the economic and political position of women relative to men for a given country. Measured on a scale of 0–1, 1 indicates complete gender equality and scores closer to 0 indicate very high gender inequality. As can be seen from Table 9.1, among the selected countries, Australia has the highest level of equality between the genders, while the GEM for Fiji is 0.34 indicating the need for policies to achieve more equality.

The Human Development Index (HDI) measures human development and quality of life on a global level. Countries are ranked according to the level of development as high, medium, or low. From Table 9.1 it can also be seen that Australia and New Zealand have the highest standard of living, while Fiji is ranked at medium standard. The Gender Development Index (GDI) adjusts the average achievements in HDI measurements by taking into account inequalities between the two genders. Here again, Fiji is at the medium level.

Considering the political status of women in Fiji, while women have been active members in politics by voting and supporting male candidates, their own participation as candidates for elections and politicians has been limited. Women's participation has been generally low at national and municipal levels due to a number of factors, including attitudes and cultural

Table 9.1: Gender Empowerment Measure (GEM), Human Development Index (HDI), and Gender-Related Development Index (GDI) for Fiji and selected countries.

Country	GEM in 2003	HDI 2001 rank	HDI 2004 rank	GDI 2001	GDI 2004
Australia	0.81	High	High	2	3
Bangladesh	0.22	Low	Medium	121	110
Fiji	0.34	Medium	Medium	63	69
Indonesia	—	Medium	Medium	92	90
New Zealand	0.77	High	High	17	18
Vanuatu	—	Medium	Medium	—	—

Sources: Food and Agricultural Organization, "Asia and the Pacific Region: Rural Women's Equality Challenges", *Rural Women and food Security in Asia and Pacific: Prospects and Paradoxes* (RAP Publicarions 2005/30, Food and Agricultural Organization, 2005, www.fao.org).
United National Development Report (United Nations, 2001, 2004).
World Resources, Gender and Development (World Resources Institute, 2005, www.earthtends.wri.org).

values. Traditionally, women's primary role has been as a housewife, looking after children, and safeguarding the culture. Politics is seen to belong to men. Apart from cultural obstacles, lower levels of education, lack of leadership training, lack of support from families and the cost of participating in the election present further obstacles. In addition, working women seem more hesitant to give up their employment since their success in elections is not guaranteed (Chandra and Lewai, 2005). Most particularly, funding was recognized by Fiji Women Rights Movement (FWRM) as being one of the greatest obstacles that women faced in entering politics. These obstacles will have to be addressed if more women in Fiji are to be involved in politics.

While the participation of women in civil society has been minimal it showed a rise during 1987–1995 period mainly due to the advocacy by non-government organizations (NGOs). Multi-racial NGOs such as the Fiji Women's Rights Movement and the Women's Crisis Centre have shown more commitment to improving women's legal, political, social, cultural, and economic status. Tables 9.2 and 9.3 show the political status of women for the period 1997–2006.

Table 9.2: Proportion of seats held by women in national parliament, Fiji (%).

	1997	2000	2002	2005	2006
No. of seats	4	11	6	9	9

Source: Asian Development Bank (2003, 2005, 2006), *Key Indicators of Developing Asian and Pacific Countries*. Manila: Asian Development Bank. (www.adb.org).

Table 9.3: Women candidates elected to the parliament, 1992–2001.

Election years	Number of women standing for election	Number of women elected to House of Representatives	Appointed to ministers/ assistant ministers	Total number of elected seats
1992	4	1	—	70
1994	12	3	3	70
1999	27	8	5	71
2001	31	5	4	71

Source: D. Chandra and V. Lewai (2005). *Women and Men of Fiji Islands: Gender Statistics and Trends*. Suva: Population Studies Program. The University of the South Pacific.

The *Pacific Human Development Report*, in looking at the legal status of Fiji women, contended that they were disadvantaged because they lacked access to information about legislation and laws and were less able to afford legal representation and services in comparison to men (United Nations Developments Program, 1999). The issue is not the law itself. Rather, it is how written and unwritten law is interpreted that leads to discrimination. Even though laws and legislation may be gender-neutral in written form, however, direct or indirect discrimination may still result. Hence, the report states that affirmative action and policies are necessary to address the imbalances where the law fails to intervene to correct discrimination against women. There is also a need for changes in social and cultural attitudes. With regards to the legal profession, Jalal raised concerns about the low number of women in the judiciary and magistracy (Jalal, 2006). According to her survey, as the levels of the legal fraternity went higher, the number of women became smaller. Also notable was the fact that there were no women in the Judicial Services

Table 9.4: Women in legal profession.

	Number of women/Total	% of women
Registered lawyers	97/301	32
Lawyers in DDP's Office and Lawyers in Solicitor General's Office	10/23 and 7/16 respectively	43
Partners in private law firms	12/67	17
Judiciary	3/13	23
Magistracy	8/23	34

Source: I. Jalal (2006). *Affirmative Action Can Narrow the Gender Gap in the Legal Sector.* Press Release, Pacific Regional Rights Resource Team (RRRT). (www.rrrt.org).

Commission, only one woman director of a justice agency, and one female human rights commissioner out of three. There had never been a female head of the Solicitor-General's Office nor a female attorney-general (Jalal, 2006).[1,2] Table 9.4 shows the proportion of women in the legal profession in Fiji.

In the labor market, the percentage of women in paid employment has grown over the past 3 decades. Much of the growth came from the expansion of the manufacturing and processing industries in the early 1990s, due to the policies which encouraged tax-free factories. This helped in creating close to 12,000 new jobs between 1987 and 1993. While growth was seen in the labor market with more women participating, a study by the International Labor Office (ILO) found that 44 percent of women who were in paid employment worked in the civil service, mainly in ministries of health and education and mostly in middle management and lower levels of the civil service.[3,4] The report concluded that such factors as general

[1] Fiji Human Rights Commission (www.humanrights.org.fj).
[2] Human Rights Internet (2003). *Fiji Thematic Reports: Mechanisms of the Commission on Human Rights, For The Record.* The UN Human Rights Internet. (www.hri.ca).
[3] International Labor Organization (1998). *Gender Issues in the World of Work, Fiji: Towards Equality and Protection for Women Workers in the Formal Sector.* International Labor Organization. (www.ilo.org).
[4] Ministry of Finance and National Planning (2004). *Millennium Development Goals: Fiji National Report on the Implementation of the Beijing Platform for Action.* National Planning Office, Ministry of Finance and National Planning.

educational disadvantage contributed to women's subordinate position. For example, few women enrolled in training programs that led to appointments to higher positions in the formal sector. However, there is also direct discrimination in hiring and promotion. Women tend to be under-represented in the formal employment sector in both the public and private sectors. The range of occupation also tends to be narrow, with nurses, teachers, garment workers, sales, and service workers as the majority. In the area of business ownership, women again ranked lower than men. According to the Small and Micro-Enterprises (SME) Business Survey, out of 15,456 registered businesses, only 19.2 percent were operated by women (Chandra and Lewal, 2005).[5] Barriers include lack of funding support, limited expertise, and skills in business operations and management, as well as socio-cultural barriers.

Tables 9.5 and 9.6 show the employment status of women in comparison to men over the years. In Table 9.5, it can be seen that women's economic participation increased slightly between 1990 and 2002. As stated earlier, such a rise could have come from the expansion in the manufacturing and processing industries. Table 9.6 provides the number of women employed in various occupations in comparison to men. One area of concern in employment is the nursing profession. The nursing profession, which made up of mostly women, provides general public health care from the nursing stations and health centers. However, due to being

Table 9.5: Economically active population as percentage of working-age population, Fiji.

Year	Male	Female
1980	86.5	70.6
1990	85.0	73.0
2001	85.0	74.0
2002	84.4	73.9
2003	80.5	40.3

Source: Asian Development Bank (2003, 2004, 2005, 2006), *Key Indicators of Developing Asian and Pacific Countries*. Manila: Asian Development Bank. (www.adb.org).

[5] Asian Development Bank (2006). *Country Gender Assessment: Republic of Fiji Islands.* Manila: Asian Development Bank. (www.adb.org).

Table 9.6: Occupation by gender.

Occupation	2000	
	Male	**Female**
Legislators, senior officials and managers	3,497	714
Professionals	7,591	7,988
Technicians and associates	6,606	2,734
Clerks	6,790	8,117
Service workers and shop and market sales workers	9,730	4,945
Skilled agricultural and fishery workers	890	23
Craft and related workers	10,914	1,589
Plant and machinery operators and assemblers	9,942	8,065
Elementary occupations	13,623	4,212
Armed forces	3,131	32

Source: Fiji Statistics (2006). Fiji Bureau of Statistics. (http://www.spc.int/prism/country/fj/stats/index.htm).

underpaid, no night allowances, and no incentives for rural postings, more experienced and qualified nurses tend to migrate to England, Australia, and New Zealand. Emigration, thus, is due to opportunities for better pay and incentives. Additionally, according to an UN report, while women's reproductive health has been well treated, mental health has been neglected.[6,7]

In several ways, women's record in education is considerably better. For example, the female literacy rate is 91 percent compared to 94 percent for males. More broadly, Table 9.7 shows that in terms of education, there is almost equality with regard to girls and boys acquiring and achieving education at all levels.

Still, despite such positive indicators regarding progress toward gender equality, some educational differences do exist that clearly disadvantage women. At the senior secondary and tertiary levels, girls are

[6] Fiji Women's Rights Movement, Fiji Women's Crisis Centre and Ecumenical Centre for Research Education and Advocacy (2002). *NGO Report on the Status of Women in the Republic of the Fiji Islands.* Fiji Women's Rights Movement, Fiji Women's Crisis Centre and Ecumenical Centre for Research Education and Advocacy.

[7] UN (2002). *United Nations Human Rights Committee on the Elimination of Discrimination against Women: Fiji,* Twenty-sixth Session 530th, 531st and 538th meetings. Press Release WOM/1307/1311, CEDAW/C/FJI/1. (www.unhchr.ch/tbs/.nsf).

Table 9.7: Ratio of girls to boys by education level for Fiji.

Level/year	1990	1995	1998	2000	2001	2004
Primary	1.00	0.99	0.99	0.98	1.00	0.98
Secondary	0.95	1.01	0.95	1.09	1.07	1.07
Tertiary	0.80	—	0.62*	1.00	—	—

* Figure is for 1997.
Source: Asian Development Bank (2003, 2005, 2006). *Key Indicators of Developing Asian and Pacific Countries*. Manila: Asian Development Bank. (www.adb.org).

under-represented in subjects such as physical sciences, information technology, and technology. In non-formal education (NFE), which is mainly run by non-governmental and church organizations, there is a significant gender bias. There are usually more places available for males in NFE programs than females and programs for females usually consist of domestic roles such as home economics, cooking, and sewing. Some secondary schools operate technical and vocational education courses for students who generally do not pass external examinations. Out of 1,730 students who enrolled for such courses in 2000, 544 were girls and 1,186 were boys (see Footnote 6). At the tertiary level, while an overall increase in the number of females occurred, they still dominated in the courses traditionally considered for women such as nursing, secretarial studies, and teaching. The male-dominated courses were engineering and marine studies.

While progress toward equality in education has been marked, the same could not be said about the teaching profession. For example, teaching has been traditionally an employment field for women and in 1999, 57 percent of primary school teachers and 48 percent of secondary school teachers were women. However, only 22.5 percent of primary head teachers and 14 percent of secondary school principals were women, strongly indicating a case of institutional discrimination. This seemingly reflects cultural values that undercut women's chances for being promoted to decision-making roles.

3. Institutions, Government Policies, and Programs

Various institutions in Fiji play an important role in raising concerns about the rights of women and working in their interest. Hence, it is significant

to discuss their objectives and their pursuit to supporting women. Since the 1960s, a section existed in the government concerned with looking after the interests of women. In 1998, this was upgraded to become a full-fledged Ministry of Women and Culture, later known as the Ministry for Women, Social Welfare, and Poverty Alleviation (MWSWPA). The primary responsibilities of the ministry are (i) to assess the government policies and their impact on social, economic, and political situation of women and (ii) to encourage the integration of women in national development. The ministry's work is complemented by other government departments and local and international women's civil society organizations (CSOs) working toward improving the status of women in Fiji (see Footnote 7).[8]

The Fiji Women's Crisis Centre (FWCC) was established in 1984 and is an NGO. Some of its activities are to help women and children who have suffered domestic violence, as well as being involved in public advocacy and community education on gender violence. The center addresses all forms of violence against women including rape, beating, harassment, and abuse of children.[9] The center treats all violence against women as a violation of fundamental human rights and as an important development issue.

The Fiji Women's Rights Movement (FWRM) is an NGO which includes a global perspective. FWRM was established in 1986. One of the concerns of FWRM is to redress the imbalances of women's socio-economic and political status through campaigning and lobbying for legislative and attitudinal change in Fiji. A central part of its work emphasized campaigning for anti-discrimination legislation, resulting in sexual discrimination against women being prohibited by the Fiji Constitution in 1990.[10] Other important achievements have resulted from lobbying for Constitutional Changes (1996–1998), the Legislative, Family Law and Legal Literacy Campaign (1993), and the Anti-Rape Campaign (1988–1994) (see Footnote 6).

The Woman's Social and Economic Development Program (WOSED) was established in April 1993 by the then Department of Women and Culture. Apart from being a micro-finance scheme, it supports the national

[8] Ministry of Women, Culture & Social Welfare (2003). *Department of Women.* Ministry of Women, Culture & Social Welfare. (www.fiji.gov.fj).

[9] Wikipedia (2006). *Fiji Women Crisis Centre.* (www.en.wikipedia.org).

[10] Fiji Women's Rights Movement, *Fiji Women's Rights Movement.* (www.fwrm.org.fj).

policy to involve women as equal partners in national political, economic, and social development. It targets one of the five priority areas that the Fiji Government made a commitment to support at the 1995 Fourth World Conference on Women in Beijing: to allocate additional resources to develop women's micro-enterprises and to encourage financial institutions to review lending policies to disadvantaged women who lack traditional sources of collateral.[11]

The National Centre for Small and Micro-Enterprises Development (NCSMED) was established under the Small and Micro-Enterprises Act of 2002. The objective of NCSMED is to develop, promote, and support small and micro-enterprises (SMEs). The focus is upon economically or socially disadvantaged groups, including young people and women. The center advises on how to set up businesses and contact regarding credit and savings schemes. The center also highlights regulations that cause a hindrance to the development of micro-enterprises.[12]

The Women and Fisheries Network is an NGO established in 1993 with the objective to advance women's development in the fisheries sector. Some goals of the organization are to achieve recognition of the importance of Pacific women's fisheries activities in the subsistence communities and domestic food markets, to acquire access for Pacific women to fisheries development resources, and to train and seek representation for women in fisheries decision-making. One of the activities carried out was sea-weed training for women to promote awareness of how sea plants could be used as alternative healthy food source and of their medicinal value, agricultural benefits, and potential to generate income. The success was seen when many women who had taken this training developed and marketed their own sea plant products (Sivoi, 2004).[13]

Fiji is a party to many conventions which aim for the equality of women, including the International Convention of the Suppression of Traffic in Women and Children (1921), the Convention on Political Rights of Women (1954), and the Convention on the Nationality of Married Women

[11] Ministry of Women, Culture & Heritage & Social Welfare (2003). *Women's Social and Economic Development Programme.* Ministry of Women, Culture & Heritage & Social Welfare. (www.women.fiji.gov.fj).

[12] *National Centre for Small and Micro Enterprise Development* (2003). Suva: National Centre for Small and Micro Enterprise Development. (http://www.ncsmed.org.fj).

[13] Women Publishing in the Pacific (1996). *The Women and Fisheries Network.* Australia: Spinifex Press. (http://www.spinifexpress.com.au/fasiapub/fiji/fiji.htm).

(1958). The Convention on the Elimination of All Forms of Discrimination Against Women (Women's Convention) was adopted in 1979 by the UN General Assembly and Fiji became the 139th nation to become a state party to this convention in 1995 (see Footnote 7).

Other important developments include the establishment in 1998 of Government Gender Focal Points at the Deputy Permanent Secretary Level in 17 ministries and departments for ensuring the implementation of Women's Plan of Action and the creation of the Fijian Inter-ministerial Committee on Women in 1998, along with five task forces, one of which is violence against women and children. Furthermore, the Fiji National Women's Advisory Council was established in 1999 to provide a forum where the Minister for Women and Culture can meet women representatives and the Fiji Women's Plan of Action (1998–2008) was adopted in 1998. In the field of criminal law, a no-drop policy on all reported cases of domestic violence was adopted by the police in 1995 and a Sexual Offence Unit was established to be responsible for specific cases of sexual assaults and abuse. The 1997 Constitution also contained provisions prohibiting discrimination on the grounds of gender and the withdrawing previous reservations to articles 5(a) and 9 of the CEDAW Convention in 1999 (see Footnote 7). The government also included a section on "Women in Development" and a commitment "to ensure that gender concerns are addressed in all aspects of our policies and plans" in the Annual Budget Document (see Footnote 3).

A commitment was made by the government to a 10-year Commonwealth Action Plan for Women which was launched at the 7th Meeting of Commonwealth Women Ministers in Nadi in 2004. The plan covers gender equality, the mainstreaming of power structures and decision-making bodies, the eliminating violence against women, and the assisting of disadvantaged women.[14,15]

Jarvenpaa states that public policies for reducing gender inequalities were essential for counteracting market failures and improving the well-being of everyone in the society. It was also seen that public policies and investments that promoted the development of women had proven

[14] Ministry of Finance and National Planning (2006). *Strategic Development Plan 2007–11.* Suva: Ministry of Finance and National Planning. (www.mfnp.gov.fj).

[15] Ministry of Finance and National Planning (2002). *Rebuilding Confidence for Stability and Growth for a Peaceful, Prosperous Fiji, Strategic Development Plan 2003–05.* Republic of Fiji: Ministry of Finance and National Planning.

economic benefits in terms of higher growth rates, improved productivity, reduced health and welfare costs, lower fertility, lower infant and maternal mortality, and increased life expectancy. All of these contributed to building a sound human resource foundation for development. Also, discrimination against women in both households and markets not only brings private costs for the individuals but social and economic costs for the overall society. Other points of importance made by the author concerned the need to address the institutional arrangements for achieving a more efficient promotion of gender policy and to enhance the planning and budgeting for these gender policies (Jarvenpaa, 2006).

According to the Ministry of Finance and National Planning, the government is committed to create an enabling environment for women to participate fully in the socio-economic development of the country, with particular emphasis being placed on enhancing gender equality and, more importantly, on mainstreaming women's concerns in government policies and programs. The government's gender policies are guided by the Women's Plan of Action 1999–2008 which covers five major areas of concern: mainstreaming gender concerns in planning and policy, women and the law, micro-enterprise development, balancing gender in decision-making, and violence against women and children. The government is also committed to implementing relevant millennium development goals (MDG) goals which affect women (see Footnote 14).

3.1. *Legislative development*

According to the Asian Development Bank, Fiji has shown considerable progress with regard to gender issues related to legal and human rights and gender and development (GAD) (see Footnote 5). The key developments include the 1997 review of laws by the Fiji Law Reform Commission which resulted in The Family Law Act 2003. This Act deals with issues relating to maintenance, support, and divorce proceedings. Furthermore, "the enactment of the Social Justice Act of 2001 created a special recognition for the disadvantaged in society which includes increasing the participation of women in socio-economic development" (Caucau, 2005). This Act implements Chapter 5 of the 1997 Constitution which required the Parliament to make provision for a framework for decisions on policy and legislation for affirmative action (see Footnote 7). The establishment of a Human Rights Commission under the Human

Rights Act 1999 was the first in South Pacific region. The Employment Bill which was passed in 2005 contains provisions relating to equal employment opportunities, outlawing discrimination in employment decisions, and providing for equal pay for equal work.[16] There are also provisions in the Act to address "Sexual Harassment" and require employers to ensure measures to be taken to eliminate sexual harassment in the workplace (see Footnote 14). Ratification of CEDAW in 1995 by the Fiji Government and equality in citizenship rights came into effect with Fiji's new Constitution in 1998 (see Footnote 10). The replacement of the 1990 Constitution by the 1997 Constitution recognizes equal rights to citizenship for both women and men and equal status to spouses of Fiji Islands citizens whether female or male (see Footnote 5).

There also has been a large increase in the number of civil society organizations (CSOs) that serve as gender advocacy groups, such as the National Women's Advisory Counsel whose objective is to promote gender equality and to implement the Women's Plan of Action. Also, the increase in government's partnership with NGOs in the provision of legal literacy training for women has been an important aspect of assisting women to understand their human rights and protection in law (Caucau, 2005). The Ministry of Women was in itself a major development for advancing the progress of women in Fiji, with its emphasis on providing gender training services to ministries and departments and conducting seminars on strategic and practical gender needs for the women in the community. The administration of grants and development aid to women's groups complements the government's actions in the implementation of the Women's Plan of Action 1999–2008 (see Footnote 11). The establishment of the Inter-ministerial Committee on Women in 1998 was to oversee and coordinate the implementation of the Women's Plan of Action.[17] Finally, there has been a substantial increase in the number of women accessing micro-credit which was created under the Ministry of Women to help poor women.

Tables 9.8 and 9.9 show the various objectives that the government had set with regard for gender equality and progress for women. The

[16] United Nations Economic and Social Council (2006). *Creation of Employment and Income-Generating Opportunities for Vulnerable Groups in the Pacific.* Jakarta: United Nations Economic and Social Council.

[17] Ministry for Women and Culture (1998). *The Women's Plan of Action 1999–2008.* Ministry for Women and Culture, Suva, Fiji, The Ministry, 1998-2V.ISBN 982-9007-01-4. Population and Family Planning. (www.unescap.org/esid/psis/population/database/poplaws/law_fiji).

**Table 9.8: Strategic development plan for gender mainstreaming:
Policy objective 1: To mainstream gender perspectives,
issues, and concerns in the planning process.**

SDP 2003–2005: Policy Objectives and KPIs	SDP-MTR: Achievements of KPIs	SDP-MTR 2004: Recommendations on revised policy objectives and KPIs
KPI 1: Gender mainstreaming institutions strengthened by 2005.	Ministry of Women's budget increased from F$976,200 in 2001 to F$2,188,700 in 2004.	Retained
KPI 2: National policies, plans, and programs engendered by 2005.	Too broad to be achievable and restated as KPIs 5 and 6.	Deleted
KPI 3: Gender audits conducted in five ministries by 2005.	Conducted in Ministry of Health (HIV/AIDS policy) and Ministry of Agriculture (good security policy).	Retained
KPI 4: Gender sensitization workshops conducted in each division annually.	Partly achieved, but need for feedback and for "way forward" issues to be addressed.	Deleted
KPI 5: Inclusion of gender impact assessments in project appraisals within government by 2003.	Gender impact required in template for project appraisal for submissions for inclusion in the Public Sector Investment Program.	Deleted
KPI 6: WPA reviewed by 2003.	Poor government participation in WPA taskforces has hindered achievement of WPA goals.	Retained. Extend time frame for review to 2005.

SDP = Strategic Development Plan; KPI = key performance indicator; MTR = midterm review; WPA: Women's Plan of Action.
Source: Asian Development Bank (2006). *Country Gender Assessment: Republic of Fiji Islands.* Manila: Asian Development Bank. (www.adb.org). *Report* (Republic of the Fiji Islands, 2004).

Table 9.9. Strategic development plan policy objectives for gender
equality: Policy objective 2: To ensure gender equality
and non-discrimination.

SDP 2003–2005: Policy objectives and KPIs	SDP-MTR: Achievements of KPIs	SDP-MTR 2004: Recommendations on revised policy objectives and KPIs
KPI 7: Review of laws in relation to UN CEDAW by 2004.	Submissions made on domestic violence, the Mental Health Act, the Criminal Procedure Code, and the Penal Code.	Retained, time frame extended.
KPI 8: Gender issues integrated into the legal system by 2005.	Better coordination is needed between MSWSPA and other agencies.	Deleted
KPI 9: Increased collaboration and partnership with NGOs.	Too general to assess progress although MSWSPA works with many NGOs.	Amend KPI to "increased collaboration and partnership with NGOs to conduct legal literacy training and community awareness."

CEDAW = Convention for the Elimination of All Forms of Discrimination Against Women; KPI = key performance indicator; MSWSPA = Ministry for Women, Social Welfare and Poverty Alleviation; MTR = midterm review; NGO = nongovernment organization; SDP = Strategic Development Plan; UN = United Nations; WPS = Women's Plan of Action.
Sources: Asian Development Bank (2006). *Country Gender Assessment: Republic of Fiji Islands.* Manila: Asian Development Bank. (www.adb.org). *Report* (Republic of the Fiji Islands, 2004).

tables also look at the achievements and recommendations based on the achievements.

According to Jaaverpaa (2006), even though the government had adopted Equal Employment Opportunity policies for the civil service, there was still need for it to be appropriately incorporated into the legislation. Only 16 percent of women held senior executive positions in the

Government mainly in the social sectors. The assessment also noted that women in Fiji were more susceptible to a higher risk of poverty and destitution associated with both labor force discrimination and increase in divorce and separation rates and that most Fijian women lacked inheritance rights to land and land rents as well as other major assists. Regarding health issues, twice the number of women, when compared to men, were suffering from nutritional-related diseases associated with poor diets and poverty. Hence, efforts were needed for improvement in these areas for women as well as for the general population. Also of concern is the declining manufacturing sector which is dominated by women workers who are struggling to support their families on low wages as the cost of living increases. In terms of political participation, women's representation remains low despite a government policy that 50 percent of the members of government boards and other public bodies should be women.

Some of the goals that the government has set to achieve gender quality in the future are mentioned in Fiji National Assessment Report (Dumaru, 2006). Based on Fiji Draft SDP 2005–2007, they include:

- Improvement in women's access to micro-finance by 50% by 2007.
- 30 percent of representation by women in government boards, committees, tribunals, commissions and councils by 2007.
- Increased share of women in wage employment in the non-agricultural sector.
- Gender mainstreaming institutions strengthened by 2007.
- Equal training opportunities at all levels in government.
- Increased proportion of seats held by women in national parliament.
- Maintenance of appropriate sentencing penalties, including counselling, for violent crimes, against women and children.
- Awareness training on the Family Law Act.
- Enactment of the Domestic Violence Bill.

4. Concluding Comments and Recommendations

While there has been some development in trying to help women gain equal rights before the law, much work still remains to be done. Of great importance is to change the cultural and traditional mind-sets of the public which tend to create obstacles in the path of progress for women. In terms of political and legal status, the participation of women is needed

not only for gender equality but to lead the country towards growth and development. While composing nearly half of the population, the potential of women is not recognized and utilized by the economy. While gender equality has been achieved in some aspects of education, there is a need to encourage women to pursue studies in fields traditionally viewed as male-dominated. In terms of employment, there are various fields of work that need improvement. While many women work as teachers and nurses and in other female-dominated jobs, a need to break the norm and venture into other fields is important. Women face difficulties in trying to gain access to savings and loans because they face discrimination by the lending institutions. While women's lack of assets or other securities may be one factor, the main reason could be preference for men applying for loans. However, there are micro-finance schemes in place and the government has also included the objective in its Strategic Development Plan to increase access to micro-finance to women by 50 percent, which will greatly help women in setting up and investing in businesses. Another area that needs to be looked into is laws that are biased against women dealing with issues related to prostitution, abortion, and domestic violence which tend to put women at a disadvantage. For instance, married women are pressured to put up with domestic violence due to financial insecurities or welfare of the children. In cases where laws have been passed and implemented, there is additionally a need to monitor the process to ensure that women are actually able to benefit from such laws because it is not usually enough to change the laws only but also how the laws get interpreted since discrimination may still result and suppress the advantages that could benefit the women.

References

Caucau, A (2005). *Fiji dwell on legislation improvement and progress for women at UN*. Press Releases, Ministry of Information, www.fiji.gov.fj.

Chandra, D and Lewai, V (2005). *Women and Men of Fiji Islands: Gender Statistics and Trends.* Suva: The University of the South Pacific, Population Studies Program.

Dumaru, P (2006). *Fiji National Assessment Report.* United Nations Department for Economic and Social Affairs. www.un.org/esa/ssustdev/natinfo/nsds/pacific_sids/fiji_nar.pdf.

Economic and Social Commission for Asia and the Pacific (1999). *Promoting Women's Rights as Human Rights.* New York: United Nations.

Jalal, I (2006). Affirmative Action Can Narrow the Gender Gap in the Legal Sector. Press Release, Pacific Regional Rights Resource Team, www.rrrt.org.

Jarvenpaa, S (2006). *Country Gender Assessment for the Republic of the Fiji Islands* (Opening Address). Suva: Asian Development Bank.

Sivoi, W (2004). Women in Fisheries. Presentation to the FSP Network Training in Community Based Coastal Resource Management, Cagalai Islands, Fiji, 15–19 November 2004.

United Nations Development Program (1999). *Pacific Human Development Report: Creating Opportunities*. Suva: United Nations.

Chapter 10

Gender Empowerment and the Status of Women in Great Britain

Rene P. McEldowney

1. Introduction

During the last 30 years, British women have experienced unprecedented improvements in social, economic, and political status. More women are working outside the home than ever before and are achieving ever higher ranks in both politics and industry (Equal Opportunities Commission, 2006a,b). 70 percent of women under age 65 are now employed in either full-time or part-time work. In terms of education, female students not only outperform their male counterparts on standardized exams, but they also make up the majority of students admitted to law, business, and medical schools (Equal Opportunities Commission, 2006a). These recent gains and the general acceptance of the expanding role of women within British society are neither universal nor uniform. Gender and pay discrimination still exists at a number of levels, and political involvement and representation lags behind many other Western democracies (Equal Opportunities Commission, 2006a,b; Women and Work Commission, 2006).

This chapter will analyze the status of women within Great Britain by addressing four substantive areas. The first reviews the demographic changes that have taken place since the 1970s and the impact of these changes on the lives of women. The second looks at the educational opportunities of women and the social and economic results of these opportunities. The third section considers the economic status of women and their pay structure. Finally, the fourth part focuses on women's political involvement and their representation within the British government.

2. The Conflicting Dynamics of Demographic Change

In the last 30 years, the population of Britain has grown from less than 55 million to over 60 million (Equal Opportunities Commission, 2006a; Central Intelligence Agency, 2007). Women account for 51 percent of the British population and have an average life expectancy of 81, which is 5 years more than their male counterparts (Central Intelligence Agency, 2007). This increase in population has also been accompanied by declines in infant mortality and deaths due to coronary heart and artery disease, the leading cause of death among British women. These demographic changes have helped to fuel one of the most dynamic and robust economies in Europe. The female contribution to this new prosperity has been considerable, as shown in Table 10.1. 74 percent of women of child-bearing age are employed in either full- or part-time jobs, and 36 percent of these same women are mothers with children under the age of 5 (Equal Opportunities Commission, 2006a).

There have also been big changes in the structure of families. One-family households headed by a married couple now represent only 45 percent of all English households; a figure that is down from over 60 percent in the 1970s (Central Intelligence Agency, 2007). Current British census data also indicate that nearly 10 percent of British households are headed by a single parent. Nine out of ten single-parent households are headed by women. In terms of single mothers who work, recent data suggest that, surprisingly, fewer single mothers work (55 percent), than do mothers who are married or are cohabitating (73 percent) (Central Intelligence Agency, 2007). The reasons for this phenomena are multifaceted, but at least some of it is attributed to the nation's social policy which provides a safety net of support for single parents, which includes government

Table 10.1: Women employment by age, 2005.

	(%) Full-time	(%) Part-time	Employment rate
16–24	56	44	42
24–44	60	40	74
45–64	55	45	64
65 or over	18	82	4

Source: Equal Opportunities Commission (2006). *Facts about Women and Men in Great Britain*. London: HMSO and the Queen's Printer for Scotland.

housing, food subsidies, and child benefit payments for parents who stay at home with their young children (Office of Public Sector Information, 2005). Demographically, the age of the youngest dependent child also has an impact on the employment rate of single mothers in Great Britain. Census data indicate that just over a third (35 percent) of single mothers with children under the age of 5 work outside the home; however, this figure increases to 59 percent for single mothers who have school-age children (National Statistics, 2001).

Like many other Western industrialized nations, England's population is growing older. There are currently over 9 million Britons over the age of 65, and this figure is expected to rise to over 14 million by the year 2031 (Equal Opportunities Commission, 2006a; National Statistics, 2001; The Money Programme, 2000). Current studies also project that by the year 2030, there could be over 36 thousand people in Great Britain over the age of 100 (National Statistics, 2001; The Money Programme, 2000). The majority of this new aging population will be women.

This new longevity is also expected to coincide with a continued decrease in fertility rates, as women get married older, have fewer children and postpone childbirth into their 30s and early 40s. These projections are likely to put an ever increasing strain on what is known as the demographic dependency ratio: the number of tax-paying workers to the number of retirees receiving state pensions (Social Security). There are currently 3.5 British workers for every one retiree. But by the year 2050, this figure is expected to decrease to only 2.1 workers for every retiree (Equal Opportunities Commission, 2006a; National Statistics, 2004a). The current British pay-as-you-go pension scheme rests on the concept that funds to retirees are paid out of the contributions of today's workers. This points to a troubling dilemma. What will happen when there are too few workers to support the growing number of retirees? This is especially problematic when the majority of the older population are women who have traditionally earned less money than their male counterparts, are more likely to be poor, and have fewer sources of private funding (National Statistics, 2004a).

3. Women and Education in Great Britain: Exceeding Expectations

National educational policy is a key component for the advancement and empowerment of British women. Since the 1970s, Great Britain has made

considerable progress toward improving the opportunities and quality of female education. In 1975, educational achievement levels for boys and girls were almost identical. One in four of the students who left school at age 16 (school leavers) passed at least five O-level exams, regardless of gender. But opportunities for further education and job prospects differed considerably between the two sexes. Girls were largely funneled into traditional lower paying women's jobs such as cooks, hairdressers, and retail shop attendants. Male school-leavers, on the other hand, were given greater opportunity to enter into higher paying jobs and apprenticeships such as the construction, mechanical, and automotive trades (Equal Opportunities Commission, 2006a,b).

There have been significant improvements in women's education over the last 30 years. Girls are now better educated and have more educational opportunities than in the past. Evidence indicates that the changing attitudes toward female education have resulted in girls outperforming their male counterparts in a number of areas. In Great Britain, graduating high school students take a standardized exam known as the General Certificate of Education Exam (GCSE). National reports of GCSE scores indicate that British girls have been outperforming boys for a number of years. Table 10.2 shows that in 2004, nearly 60 percent of the females who took the exam earned high grades in five or more subjects (Equal Opportunities Commission, 2006a). By contrast, only 49 percent of boys who took the GCSE exam in 2004 achieved the same level of high grades in five or more subject areas.

Higher education in Great Britain has long been a traditional male stronghold. Women's colleges and institutions of higher learning have been in place for centuries, but education at these all-female institutions

Table 10.2: GCSE scores, 2004.

	Girls (%)	Boys (%)
5+ subjects	59.3	49.2
1–4 subjects	22.2	23.1
Non-passing	15	22.4
No grade	3.4	5.3

Source: Department for Education and Skills (2005). *Education and Training Statistics*. London: Department for Education and Skills.

was not considered on par with the traditional male colleges and universities. Oxford University is a case in point. Women were first admitted to the lectures at Oxford in 1880. Demand grew and by 1893, four female colleges were founded: Lady Margaret Hall, Sommerville, St Hugh, and St Hilda's Hall. However, women graduates of these colleges were not allowed to receive Oxford University degrees until 1920, when the governing bodies of the university agreed to confer degree granting status to the institutions of the all-female colleges. Full integration of women into the traditionally male colleges of Oxford would not be achieved until the 1970s, some 50 years later (Bell, 1990). Even today, the student body of England's most prestigious universities, Oxford and Cambridge, are still majority male. But female enrollment at British universities overall has been rising for a number of years (Blair, 2007). Between 1998 and 2007, three times as many women applied to universities as men. This gap between male and female applicants has become so prevalent that Malcolm Grant, Provost of University College London, gave warning that unless the trend slowed, English colleges would soon become "male-free zones" (Blair, 2007). In terms of field of study, female students have branched out into many traditionally male-dominated disciplines. They now make up the majority of medical, law, and business school classes (Equal Opportunities Commission, 2006a).

However, as Table 10.3 indicates, women are still under-represented in the more technical fields such as computer science and engineering. Despite recent efforts to recruit more female students, over 80 percent of those studying computer science or engineering are men. So while there have been real gains for women in a number of areas within higher education, the more technical fields still remain a challenge.

The news is not nearly so good when it comes to women receiving an education in fields which do not require a college degree (i.e., the traditional trades and apprenticeship programs). While strides have been made in a few areas such as accounting, women are still under-represented in a number of other fields. According to a recent report, most of the non-collegiate training placements remain as segregated as they were 30 years ago (Equal Opportunities Commission, 2006a). For example, as shown in Table 10.4 in 2004, 90 percent of hairdressing apprentices were women, whereas, 98 to 99 percent of the training placements in the more lucrative and male-dominated sectors, such as construction, auto mechanics, and plumbing, were held by men (Equal Opportunities Commission, 2006a).

Table 10.3: Higher education, 2003/04.

	Women (%)	Men (%)
Education	82	18
Law	62	38
Social Studies	59	41
Medicine/Dentistry	58	42
Business	51	49
Physical Sciences	40	60
Computer Science	19	81
Engineering	14	86

Source: Department for Education and Skills (2005). *Education and Training Statistics*. London: Department for Education and Skills.

Table 10.4: Apprenticeships, 2003/04.

	Women (%)	Men (%)
Hairdressing	91	9
Health care	87	13
Accountancy	63	37
Hospitality	52	48
Auto mechanics	2	98
Construction	1	99
Plumbing	1	99

Source: Department for Education and Skills (2005). *Education and Training Statistics*. London: Department for Education and Skills.

Research as to why British women are not entering the more male-dominated trades is inconclusive. But what is clear is that there has been little, if no coordinated governmental effort to try and attract more women to these fields. This has led to a largely segregated workforce in which the lower paid jobs are held by women, while the better paying jobs continue to be dominated by men.

4. The Economic Status of British Women: Unrealized Potential

There is little argument that the overall economic status of British women has improved during the last 30 years (Equal Opportunities Commission,

2006a,b; Central Intelligence Agency, 2007). Women are entering the workforce in greater numbers and have more individual income than at any other time in British history. However, the rate and results of this economic improvement have been less than predicted. Numerous studies indicate that there is still a lot more work to be done if women in the UK are going to achieve economic parity with their male counterparts (Equal Opportunities Commission, 2006a,b; Women and Work Commission, 2006; National Statistics, 2001). For example, despite the fact that women now make up the majority of the population and more than half of the college graduates, they still earn less than males do for the same kind of work (Equal Opportunities Commission, 2006a). This is evidenced by the gender pay gap which currently stands at 17.1 percent for full-time employment and 38.4 percent for part-time workers (Equal Opportunities Commission, 2006a). The exceedingly higher pay gap for women in part-time work can be attributed to two major factors. First, is the desire for women to work around their children's school schedules which often times locks them into lower wage jobs in the retail and hospitality sectors (National Statistics, 2004). Second, is the fact that women who were employed in full-time professional or semi-professional jobs prior to starting their families, often find that by the time they return to work, their skills have become obsolete. Consequently, they can be forced into taking less qualified part-time positions in the hopes of being able to update their skills and gain full-time employment in the future (National Statistics, 2001).

In terms of pay scale, Table 10.5 shows that women working full-time jobs in the banking and insurance industry have the greatest gender pay disparity, followed by the health care and business sectors. This is somewhat surprising given that females now comprise the majority of students graduating with business and accounting degrees. However, these new graduates have been in the workforce for a relatively short time and they are just now starting to make their way up the corporate ladder and into the ranks of middle management (National Statistics, 2001). This is evidenced by the fact that over a third of the managers in Great Britain today are women, and this figure is predicted to grow over the next decade as more women continue to graduate from college and enter the workforce. (National Statistics, 2001). Thus, it might be reasonable to conclude that the current gender pay gap will be short-lived. However, some within the government are not entirely convinced of this and point to a 2007 study by the Equalities and Human Rights Commission which found that at the present rate of change, it may take decades for women to achieve equal economic status with men. For example, the study concluded that it

Table 10.5: Gender pay gap, 2005.

	Pay gap %
Banking and Insurance	41.4
Health care	32.2
Business and Real Estate	23.8
Manufacturing	19.5
Transport, storage and communication	8.9
Public Sector	13.3
Private Sector	22.5
All Sectors*	17.1

* Including sectors not shown.
Source: Office for National Statistics (2005). Labor Force Survey, Spring 2005 data set.

will take 20 years for women to achieve equality in top civil service management positions and another 40 years before there are an equal number of men and women serving on the boards of directors of England's top 100 companies (Cabinet Office, 2007).

Other studies also raise similar concerns. A 2006 report by the Women and Work Commission indicates that while the government has made some effort to try and reduce the gender pay gap, most of their initiatives in the private sector have been voluntary, and the results less than forthcoming (Women and Work Commission, 2006). An earlier report by the Women and Equality Unit, also supports this conclusion (National Statistics, 2004b). After surveying nearly 24,000 British households, researchers found that the weekly median income for males in 2003/04 was almost twice as much as it was for females. As Table 10.6 illustrates, married women over the age of 65 have the greatest gap. Individual income for these women is only 37 percent of what it is for married men over the age of 65 (National Statistics, 2004b). Married women with children do only slightly better than the married women of retirement age, making only 39 percent of the average salary for similar males. In contrast, working women without children do fare significantly better as they make just over half (56 percent) of what their male counterparts make. Finally, women who are single, college-educated, and childless do the best, making 93 percent of the average male salary (National Statistics, 2004b).

**Table 10.6: Median income by gender and family type
2003/04 ($ per week).**

	Women	Men	Difference (%)
Couples without children	425	755	56
Couples with children	326	839	39
Single w/o children	403	432	93
Pensioner couple	152	407	37

Source: Office for National Statistics (2005). Labor Force Survey, Spring 2005 data set.

Clearly, therefore, the economic status of women in Great Britain depends on a number of factors. As Tables 10.5 and 10.6 indicate, the movement of women into the formal labor market has had a positive impact on their economic position. But not all women have benefited to the same degree. Young single women have profited the most, making nearly the same salary (93 percent) as their male counterparts do, while married women and women with children are at a distinct disadvantage. For these are the women who experience the greatest levels of pay discrimination and have the most difficulty in finding well paying jobs with the flexibility required to meet the demands of home and family life (National Statistics, 2004b). But it is women over 65 who have the lowest economic status. They came of age during a more traditional time when women were not expected to work outside the home. Women of this era were expected to stay at home and take care of their families. As a result, they have little or no individual retirement income. Moreover, the British governments of the 1960s and 1970s were the traditional old style Labor governments with liberal state benefits and robust social welfare programs. But beginning with Margaret Thatcher in the 1980s, most of these initiatives have either been eliminated or are greatly reduced, leaving older women to live out their days in a social and economic environment which is vastly different from the one they came to expect (National Statistics, 2004b).

Gender inequality endangers Britain's overall economic health and productivity. Women's skills are under-utilized in an economy which combines a growing number of part-time low-paying jobs with a culture of well-paying professional jobs which require considerable sacrifice and

long hours. To keep its place within the global market, Great Britain will need to draw upon its best and brightest, including women. Economic indicators show that women will compose an ever increasing part of Britain's future workforce. But thus far, the workplace has not responded to these changes in any meaningful way. By and large, pay discrimination still exists at all levels, and work hours still follow the ridged norms of a generation ago. To stay ahead of their competitors, British employers will need to be in a position to take advantage of the workforce of the future. And that workforce is likely to be increasingly female.

5. Gender and Power: The Political Status of British Women

The political status of British women has been steadily improving for decades. Women first achieved the right to vote in 1918. Later that same year the first female MP, Constance Markievicz, was elected to the House of Commons. But it would take another 60 years for England to elect its first female Prime Minister, Margret Thatcher. And while Ms Thatcher did make her mark on British politics, the overall pace of female representation within the political structure has been slow and uneven. There are more women in parliament today than ever before, and there has been a marked increase in the number of female voters. But despite these gains, many within the political arena are unsatisfied with both the number of women elected to political office and the focus of the major political parties.

> A healthy democracy is one which represents the interests of all of its people, and that is hard to achieve if sections of the community are relatively excluded... a better balance also makes electoral sense for individual parties. Electoral Commission research showed that in seats where a women MP was elected to Parliament in 2001, higher percentages of both men and women reported having voted compared with seats where a man was elected (Equal Opportunities Commission, 2006b).

Such findings are noteworthy at a time when all the major political parties are battling for women voters, and levels of cynicism are at an all-time high among younger voters of both sexes. That may be why the relatively low number of women within the Conservative party has received urgent attention by party leaders. They have pledged to win back

the thousands of female voters who deserted the party in 1997 and again in 2005 (Fawcett Society, 2005). However, a recent report by the Equal Opportunities Commission noted that merely recognizing the need to address this imbalance within a political party will not be enough to win over women voters. It instead advises political parties to focus additionally on developing and initiating policies that will address the specific needs of women (Equal Opportunities Commission, 2006b).

Balanced representation in parliament is also a concern. The number of women in the British House of Commons has more than quadrupled over the past 30 years (Equal Opportunities Commission, 2006a). This increase still leaves a marked imbalance, for in real numeric terms the number of women in the House of Commons still accounts for only 20 percent of the total number of MPs. To address this issue, the Labour party has initiated women-only shortlists. The adoption of these new shortlists has moved the Labour party ahead of its main rivals in terms of female representation. 27 percent of current Labour MPs are women, which represents 76 percent of the female members of parliament. These numbers have not gone unnoticed by the Conservatives and Liberal Democrats. Both parties have recently developed similar policies in hope of increasing their female parliamentary candidates (Equal Opportunities Commission, 2006a,b).

The figures in Table 10.7 contrast sharply with the newly devolved Welsh and Scottish Parliaments. Both Wales and Scotland have taken deliberate efforts to increase female representation when they formed their new parliaments. Their goal was to achieve a more balanced government, and both countries have succeeded. As shown in Table 10.8, the Scottish Parliament is currently 40 percent women, and the Welsh Parliament went a step further and actually achieved parity with a 50 percent split between male and female MPs (Equal Opportunities Commission, 2006a,b). It should also be noted that, that kind of positive action also works at the international level because none of the countries topping the international list of 30 percent or more female elected officials has been able to achieve this result without concerted and deliberate political effort to target and promote female leaders (Equal Opportunities Commission, 2006a,b).

British political party leaders are not blind to the power that female politicians can evoke in Great Britain. They take great pains to ensure that female party leaders enjoy substantial media coverage and achieve high profiles. Nearly 75 percent of all conservative female MPs are either shadow ministers or are in the shadow cabinet. The Labour Cabinet also has a considerable number of women. Eight of its 23 cabinet ministers are

Table 10.7: Members of Parliament, 2006.

	Number of women	% of party	Number of men	% of party
Conservative	17	9	179	91
Labour	96	27	257	73
Liberal Democrats	9	14	54	86
Other parties	4	12	30	88

Source: Equal Opportunities Commission (2006). *Facts about Women and Men in Great Britain*. HMSO and the Queen's Printer for Scotland.

Table 10.8: Political representation, 2003–2005.

	2003 Women (%)	2004 Women (%)	2005 Women (%)	Average annual change (pp)
Parliament	18.1	18.1	19.7	0.8
Cabinet	23.8	27.3	27.3	1.7
House of Lords	16.5	17.7	18.4	0.9
Scottish Parliament	39.5	39.5	39.5	0.0
Welsh Parliament	50.0	50.0	50.0	0.0

Source: Equal Opportunities Commission (2006). *Sex and Power: Who Runs Great Britain*. HMSO and the Queen's Printer for Scotland.

female, and their areas of responsibility range from party discipline in the capacity of Chief Whip to the more traditionally female posts of culture and community ministers. These recent gains in the political status of women are not enough. The Equal Opportunities Commission Report, *Sex and Power*, notes that at the current pace of change, it may take up to 200 years and another 40 elections before women hold an equal number of seats within the British Parliament (National Statistics, 2001).

6. The Status of Women in Great Britain

Women in Great Britain enjoy higher status and more economic freedom than at any other time in their nation's history. They now account for 51 percent of the British population and have an average life expectancy

of 81 years of age. They are also better educated, and make up the majority of college graduates along with medical and law school classes. In terms of economic gains, women are entering the workforce in increasingly greater numbers and have more individual income than either their mothers or grandmothers had. There are also 126 women MPs in the House of Commons and 8 sitting female cabinet ministers. However, underneath all of this good news is cause for concern. For despite these gains, unacceptable numbers of British women still live in poverty and are poorly educated. The pay gap between men and women is a striking 17 percent for full-time workers and an appalling 38 percent for part-time workers. And the number of female MPs account for only 20 percent of the total number of those elected to parliament. In short, the increase in the status of British women has been slow and uneven. Young, single, college-educated women without children have realized the greatest gains. But older, non-college educated women with families continue to struggle against entrenched inequalities and gender discrimination. And everyone in Great Britain suffers as a result. A healthy democracy and economy requires that each citizen be allowed to reach their full potential. This will be hard to achieve if significant numbers of British women continue to be excluded.

References

Bell, B (1990). *Oxford*. Prentice Hall, Upper Saddle River, New Jersey.

Blair, A (2007). Growing Gender Gap Risks Turning Universities Into "Male Free Zones". *The London Times*, 15 February 2007.

Cabinet Office (2007). *Fairness and Freedom: The Final Report of the Equalities Review*. London: Her Majesty's Government of the United Kingdom.

Central Intelligence Agency (2007). *World Fact Book*. Washington, DC: United States Government. www.cia.gov/cia/publications/factbook.

Equal Opportunities Commission (2006a). *Facts about Women and Men in Great Britain*. London: HMSO and the Queen's Printer for Scotland.

Equal Opportunities Commission (2006b). *Sex and Power: Who Runs Great Britain*. London: HMSO and the Queen's Printer for Scotland.

Fawcett Society (2005). *Women's Representation in British Politics*. London: Fawcett Society.

National Statistics (2001). *The Big Picture Census 2001 — Benchmark for the 21st Century*. London: Her Majesty's Government of the United Kingdom. www.statistics.gov.uk/census2001.

National Statistics (2004a). *Focus on Older People*. London: Her Majesty's Government of the United Kingdom. www.statistics.gov.uk.

National Statistics (2004b). *Individual Income 1996/97–2003/04*. London: Her Majesty's Government of the United Kingdom. www.statistics.gov.uk.

Office of Public Sector Information (2005). *Child Benefit Factsheet*. London: Her Majesty's Government of the United Kingdom. www.direct.gov.uk.

The Money Programme (2000). *The Age Wave*. London: British Broadcasting Corporation. http:news.bbc.co.uk/1/hi/events.

Women and Work Commission (2006). *Shaping a Fairer Future*. London, www. womenandequalityunit.gov.

Chapter 11

Institutions and Women's Empowerment in the United States

Cal Clark* and Janet Clark

1. Introduction

As discussed in much more detail in Chapter 3, women's empowerment or "substantive freedom" to pursue their own goals is generally much higher in the developed world than in developing nations because of the crucial transformations that development brings to a country's economic, social, political, and legal institutions. The rapidly expanding educational systems that accompany industrialization allow women to develop their innate capabilities. Industrialization and especially the post-industrial economy create better jobs for women that allow them to use and augment these capabilities. Democratization allows women to pursue their rights through the political processes and is associated with the development of legal structures that protect women. In addition, the development of social welfare states relieves women from traditional responsibilities and reduces their dependence on the household. These economic and political changes, furthermore, are supported and stimulated by changes in a society's fundamental values from patriarchal to much more equalitarian norms. Ronald Inglehart and Christian Welzel, for example, found that generational change is the primary reason for the growing commitment to gender equality in post-industrial societies. Indeed, the values of the elderly in the developed world concerning gender are surprisingly similar

* Corresponding author.

to those of the average citizenry in developing countries (Inglehart and Welzel, 2005).

Still, considerable discrimination against women remains in all developed societies. This turns our attention to variations in women's status in the developed world. The US possesses several characteristics that should both enhance and retard women's status. On the one hand, there are several favorable conditions that should promote women's empowerment by creating opportunities for women to pursue self-fulfillment and by protecting their rights. It is the world's richest society and a, if not the, leader globally in the transformation from an industrial to an information-age economy, and it pioneered universal primary and secondary education. Moreover, it is a long-standing democracy with a well-developed legal system. Conversely, however, its highly individualistic value system has limited the development of a social welfare state, and the comparatively high degree of religiosity in the country suggests the continuance of traditional values that question the need for gender equality (Kingdon, 1998; Lijphart, 1999; Lipset, 1996).

2. Background Conditions in the United States

Because of the vast chasm between most developed and developing countries, it makes sense to evaluate the status and empowerment of women in the US by comparing America to other advanced industrial democracies. Table 11.1, therefore, provides data on general economic, political, social, and cultural conditions in the US relative to a group of 21 developed nations.[1] With the one glaring exception of education, these data from the onset of the 21st century confirm the more theoretical conclusions about how the US compares to the rest of the developed world, with their contradictory implications for the status of women.

The first five indicators on economic performance are quite consistent with the image of the US as a global leader in development. When measured in "purchasing power parity" which controls for differences in cost of living and exchange rates, the per capita Gross Domestic Product

[1] Australia, Austria, Belgium, Canada, Denmark, Finland, France, Germany, Greece, Ireland, Italy, Japan, Netherlands, New Zealand, Norway, Portugal, Spain, Sweden, Switzerland, the UK, and the US.

Table 11.1: Indicators of America's economic, social, political, and cultural conditions.

	United States	Average of 21 developed nations	US rank among 21 developed nations
Economic performance			
GDP pc 2003	$37,624	$28,970	1
Growth 1980–2004	3.2%	2.5%	4
Unemployment 2006	4.4%	6.3%	18
Intnet Cnts/1,000 2003	556	425	2
HiTc % Mnf Exp 2003	31%	18%	2
Government policy			
Gv Sp % GDP 2003	37.1%	45.8%	19
Mil % GDP 2003	3.8%	1.8%	1
AntiCorr Index 2006	7.3	7.9	15
Social outcomes			
Infant Mort 2003	7.0	4.5	1
Life Expec 2003	77.2	79.0	20
Poverty Rate 2000	17.1%	10.2%	1
Income Ineq* 2000	8.4	5.6	1
SecSchl Enroll 2003	88%	92%	16
Cultural values 1998–2002			
Self-express index	1.5	1.2	6
Secularism index	−0.5	0.4	19

* Ratio of the income of the richest fifth of the population to the poorest fifth.
Sources: *The Economist*, December 2, 2006, p. 100. United Nations, *Human Development Report, 2005* (Oxford U. Press, New York, 2005). World Bank, *World Development Report, 2006* (Oxford U. Press, New York, 2006).

(GDP) of the US is the highest in the world ($37,624 in 2003). Moreover, it has had one of the highest growth rates since 1980 (3.2 percent versus an average for the developed world of 2.5 percent) and one of the lowest unemployment rates since 1990 (4.4 percent in 2006 versus an average of 6.3 percent in the developed world) among the advanced industrial nations. In addition, the leading position of the US in the transformation from an industrial to an information age economy (Friedman, 1999;

Thurow, 1999) is indicated by its very high (but not top) ranking on Internet connections per 1,000 population and the share of high tech products in manufactured exports. In short, America has precisely the type of economy that should be most advantageous for creating opportunities for women to apply their innate capabilities and to pursue their own dreams.

Conversely, several of the major characteristics of the US government are associated with potential barriers to women's empowerment. First, the size of government in America is quite small for a developed nation. In 2003, for example, the spending of all levels of government (national, state, and local) constituted about 37 percent of GDP, placing it 19th among the 21 developed nations, well below the average of about 46 percent in the developed world. Since large welfare states provide services that lessen the burdens of women for their traditional family responsibilities (Inglehart and Welzel, 2005), small governments could add to the problems facing women. Second, the US has the highest defense burden in the developed world, although its military commitment has dropped considerably in the post-Cold War era. For example, in 2003 military spending consumed 3.8 percent of America's GDP, more than double the average of 1.8 percent for the developed world. A high priority on militarism is often considered to undercut women's empowerment because it can both take resources away from the social welfare state and promote masculinist norms (Inglehart and Welzel, 2005). Third, America scores somewhat below average on Transparency International's Index of Perceptions of Corruption (which ranges from 0 to 10 with higher scores indicating less corruption); and, as indicated in Chapter 3, more corrupt governments in general are less responsive to women's rights and needs.

The nature of government in the US and its highly individualistic culture have been linked to comparatively poor social outcomes (Lijphart, 1999; Wilensky, 2002). The data in Table 11.1 certainly confirm this image. Most strikingly, the US has the highest levels of inequality and poverty in the developed world. For example, in 2000 the ratio of the income of the richest fifth to the poorest fifth of the population was 8.4 compared to an average of 5.6 for all developed countries, and the poverty rate in 2003 was 17.1 percent compared to a developed world average of 10.2 percent. Likewise, the US has the highest infant mortality rate (7.0 per 1,000 live births versus an average of 4.5 in 2003) and lowest life expectancy (77.2 years versus an average of 79.0) for the developed world, although the latter difference seems trivial.

Finally, even in the realm of education, once a major American advantage, the current data are far from impressive. For example, America's net high school enrollment rate of 88 percent in 2003 (versus an average of 92 percent) placed it only 15th among the 21 nations in our sample. Given the critical importance of having a highly educated work force in an information age economy, the declining competitiveness of the US's primary and secondary schools, as indicated by lagging scores on standardized international tests, certainly suggests future problems in the global economy (National Commission on Excellence in Education, 1983).

The distinctive culture of the US in the developed world (Brooks, 2004; Lipset, 1996) might also be expected to affect the status of women. Ronald Inglehart and Christian Welzel have developed a typology of cultures based on survey results from approximately 100 nations, both developed and developing (Inglehart and Welzel, 2005). They found two important cultural dimensions: one ranged from a primary concern with survival to a primary concern with self-expression, and the other covered a range from traditional and religious values to secular ones. The data on America's scores on these two cultural dimensions in Table 11.1 indicate that the US rated fairly highly on the self-expressionism dimension (6th in the developed world), but also was one of the most traditionalist nations (ranking 19th out of 21) on secularism. This would seemingly have contradictory implications for women's empowerment. The high score of America on self-expressionism is consistent with support for women's rights, while its comparatively low score on secularism is not.

3. The Status of American Women in Comparative Perspective

The previous section showed that background conditions in the US, relative to other developed nations, had mixed implications for promoting women's empowerment. It is not too surprising, therefore, that American women appear to be fairly average for a developed nation in terms of the indicators of women's status in Table 11.2, although their ranking varies considerably on some of these measures.

This average position of American women can be seen in the area of education, which is increasingly vital for personal advancement in information age societies. For example, the US is very close to the average for the ratio of girls to boys in secondary school (1.01 versus an average of

Table 11.2: Indicators of the status of women in the US.

	United States	Average of 21 developed nations	US rank among 21 developed nations
Education			
Fem/Ml Sec Sch 03	1.01	1.02	11
Workforce			
Wom % in Lab Fr 2003	60%	51%	4
Fem/Ml Lab Part 2003	83%	73%	4
Fem % Prof Wks 2000	55%	50%	1
Fem % Male Inc 2000	62%	59%	10
Social conditions			
Fem/Ml Life Ex 2003	1.07	1.08	11
Maternal Mort 2000	17	9	1
% Brth Yg Wm 1993–1998	13%	4%	1
Fem Suicd Rate 1993–1998	4.4	6.9	16
Div % Marr 1996	49%	40%	5
Rape/1000 Wom 1994	97	20*	3
Government			
Women % Leg 2005	15%	25%	16
Wom % Cab Min 2005	14%	26%	17
Overall indices			
GDI	942	936	7
GEM	793	763	10

* Median used because of highly skewed distribution.
Sources: United Nations, *Human Development Report, 2005* (Oxford U. Press, New York, 2005). United Nations, *Human Development Report, 2000* (Oxford U. Press, New York, 2000). World Bank, *World Development Report, 2006* (Oxford U. Press, New York, 2006).

1.02 for the developed world). This should not be very surprising given the extremely high enrollments of both girls and boys in secondary school in the developed world. However, given the US's significantly below-average position in high school attendance (see Table 11.1 above), its average ranking here does suggest that American women may be slightly disadvantaged compared to women in other advanced industrial societies in their preparation for the emerging "information age".

The second group of variables in Table 11.2 shows that American women are well above the average for the developed world in terms of their participation in the workforce. For example, they rank fourth both in their labor force participation rate (60 percent versus the developed world average of 51 percent) and in the ratio of their labor force participation rate to men's (83 percent versus the developed world average of 73 percent). Even more impressively, the US is tied with Australia and Finland for having the highest proportion of women among professional and technical workers (55 percent versus the developed world average of 50 percent). In sharp contrast, women's salaries compared to men's are only average in the US. In 2000, American women's earnings were only 62 percent of men's (versus the developed world average of 59 percent), placing them tenth among advanced industrial societies. Thus, American women clearly do not fare atypically well in the world of work.

When we turn to the indicators of women's social conditions in Table 11.2, American women clearly trail the rest of the developed nations badly on three of the six measures. America has by far the highest proportion of babies born to mothers younger than 20 (13 percent versus the developed world average of 4 percent) that is almost double the rate in the number two UK (7 percent). Given the growing importance (if not necessity) of a college education for life in an information age society, this implies that higher numbers of women in America as opposed to those in other developed societies may well face a major barrier to developing their capabilities and pursuing their goals. Likewise, it is tied with France for the highest maternal mortality rate of 17 per 100,000 live births that is almost double the average for the developed world. Women in America also suffer from the third highest rate of rape (97 per 1,000 women) which is nearly five times the median for the developed world, indicating a very serious problem of violence against women.

American women rate closer to average on the other three social indicators. They are almost exactly average on the ratio of women's to men's life expectancy (1.07), somewhat above average on divorce rate (49 percent in comparison to new marriages versus an average of 40 percent for the developed world), and well below the average of 6.9 suicides per 100,000 women at 4.4. Overall, therefore, the social conditions of women in the US appear to be somewhat worse than those in the average advanced industrial society.

Women's role in American government clearly is more circumscribed than in much of the rest of the developed world. For example, in 2005

women held 15 percent of the seats in the national legislature or the US Congress, while the average for the 21 advanced industrial democracies was 25 percent. America, then, only ranked 16th among them. The figures are almost exactly the same for holding ministerial posts where the US ranked 17th based on 14 percent of the positions in the President's cabinet (versus an average of 26 percent for the developed world). Given the findings that higher levels of women's office-holding make governments more responsive to women's concerns and issues (Thomas, 1994), women's lagging representation in America's government might well hurt their ability to use public policy to promote women's empowerment and rights.

As discussed in more details in Chapter 3, several general indices of the status of women in a nation have been developed. The two most prominent are the Gender-Related Development Index (GDI) and the Gender Empowerment Measure (GEM) which are included in the UN's annual *Human Development Report*. The former measures women's socio-economic status based on women's versus men's life expectancy, literacy, school enrollment, and earned income. The latter is based on women's role in the government and economy based on their office-holding, economic occupations, and earnings relative to men's (United States, 2005). The data in Table 11.2 indicate that American women rank slightly above average on both. For the GEM index, American women's economic progress obviously counterbalances their very lagging political position.

These slightly above-average rankings for the US might suggest that women are doing fairly well in American society. However, they do not take into account that the US is the wealthiest society in the world. Indeed, even among just the developed nations, GDP per capita is highly correlated with both the GDI and GEM indices: $R^2 = 0.66$ and 0.33 respectively. Table 11.3, therefore, presents the results of a "residuals" analysis in which the expected GDI or GEM score for a nation is predicted based on its GDP per capita. The "residual" is the difference between a nation's actual value on an indicator and the one that was predicted based on its GDP per capita. Nations with positive scores, then, are doing better than would be expected from their level of affluence, while those with negative residuals are doing worse. These results suggest women in the US fare quite poorly in comparative perspective as the US ranked dead last (i.e., had the largest negative residual) on GDI and trailed all the other developed nations except Japan and Italy on GEM. Clearly, therefore, some combination of America's small welfare state, low level of women's

**Table 11.3: America's position on the GDI and GEM
indices controlling for GDP per capita.**

	GDI index	GEM index
Actual score	942	793
Score predicted by regression of index on GDP per capita	958	868
Residual: Actual — predicted score	−16	−75
Rank among 21 developed nations	21	19

political representation, and traditionalist culture has produced a significant obstacle to women's empowerment and rights.

4. Expanding Opportunities for American Women in Education and the Economy

Women need access to education and the economy in order to develop their own capabilities and exercise the substantive freedom of defining and pursuing their own goals. Educational opportunities have expanded tremendously in the US during the last half century and, at least in the aggregate sense, women's access to education differs little from men's. In 1950, only about a third of Americans were high school graduates. Over the next 50 years, this proportion rose steadily to nearly 85 percent as a high school education became nearly universal and as generational replacement substituted more educated for less educated people. Throughout this time, the high school graduation rates of women and men remained almost exactly the same. The opportunity for a college education also expanded greatly, but here the pattern for the two sexes diverged fairly sharply. As the postwar era commenced, only a small social and economic elite had graduated from college with men being only slightly more likely to have done so than women (7 percent to 5 percent). Access to higher education increased greatly over the next 2 decades, but men were the primary beneficiaries of these new opportunities. After 1970, women's graduation

rates began to approach and, by the 1990s, surpass those of men, but because of men's advantage in the 1950s and 1960s, the absolute difference in graduation rates between the sexes has decreased only slightly (American Men and Women: Demographics of the Sexes, 2000). As indicated in Table 11.4, for example, by the late 1990s women were earning just over 60 percent of the Associate (2 year degrees), 55 percent of the bachelor's and master's degrees, and 40 percent of the doctoral and professional (law, medicine, etc.) degrees. Moreover, this represented a considerable gain over just the previous 2 decades (DiNatale and Boraas, 2003). For example, between 1978 and 1998, women's proportion of Associate, Bachelor, and Master's degrees rose by about 10 percentage points; their share of professional degrees jumped from 26 percent to 42 percent; while their percentage of doctoral degrees approximately doubled from 22 percent to 43 percent. Clearly, women achieved much greater educational opportunities during the last quarter of the 20th century, both in an absolute sense and relative to men.

Of course, the fact that women are gaining equal access to higher education in general does not guarantee a substantive equality if, for example, women students are concentrated in less desirable fields. Table 11.5, therefore, examines women's share of the degrees awarded in specific fields in the mid-1970s and the mid-1990s. This table contains generally good news, although there are several less desirable aspects as well. First, women's representation in higher education increased significantly during these 2 decades from 46 percent to 55 percent of all undergraduate degrees, suggesting that women have been putting themselves into a position to take advantage of the expanding information age economy

Table 11.4: **Women's proportion of college degrees.**

Degree	Women, 1977–78 (%)	Women, 1997–98 (%)
Associate	50	61
Bachelor	47	56
Master	48	57
Doctoral	22	43
Professional	26	42

Source: CB Costello, VR Wright and AJ Stone, Eds., *The American Woman, 2003–04* (Palgrave Macmillan, New York, 2003) p. 219.

Table 11.5: Women's share of college degrees.

	1975–76 (%)	1995–96 (%)
All undergraduate	46	55
Health Professions	79	81
Education	73	75
Psychology	55	73
English	62	66
Visual & Performing Arts	61	59
Biological & Life Sciences	35	53
Business	20	49
Social Sciences	38	48
Mathematics	40	46
Physical Sciences	19	36
Computer Sciences	20	28
Engineering	3	16
All professional degrees	—	42
Law	—	44
Medicine	—	41

Sources: *American Men and Women: Demographics of the Sexes* (New Strategist, Ithaca, NY, 2000) p. 103. CB Costello and AJ Stone, Eds., *The American Woman, 2001–2002: Getting to the Top* (WW Norton, New York, 2001) p. 203.

in the US. The data on individual degrees are a little more mixed, though. None of the five fields that women dominate (health professions, education, psychology, English, and the visual and performing arts) are particularly associated with "good jobs" for those with bachelor's degrees. Yet, the figures are also positive for the more desirable fields of the biological sciences, business, and mathematics in which women received approximately half of the degrees in 1996; and, likewise, women received a respectable 40–45 percent of the advanced degrees in law and medicine. Finally, while women remained substantially under-represented in the physical sciences, computer science, and engineering, they had made substantial gains over the 2 decades covered by these data. Thus, even taking the more detailed data on degree fields into account, the conclusion seems inescapable that women have made very considerable progress toward educational equality in postwar America.

We analyzed women's access to education, particularly higher education, in the US because equality in education is assumed to be necessary

for women to benefit from the opportunities available in the new information age economy. Whether women have been able to take advantage of their educational accomplishments is another and an open question, though. That is, equal education is a necessary but not a sufficient condition for women's attainment of economic equality. When we consider the data on women in the workforce, in fact, we find that women have made significant progress over the last few decades toward economic equality, similar to the situation in education. However, the progress has been markedly less than in the sphere of education, leaving open the question of whether "the glass is half full or half empty".

Particularly during the early part of the postwar boom in the US, men were much more likely to hold jobs in the formal economy than women, at least in part because women in many families were able to stay home as housewives. For example, Table 11.6 shows that in 1950, only 34 percent of women, as compared to 81 percent of men, were in the labor force, resulting in a labor force that was 70 percent male and 30 percent female. Over the next 40 years, women's rate of participation in the labor force increased steadily to 43 percent in 1970 and 58 percent in 1990 before leveling off at about 60 percent for the last decade or so. In contrast, men's participation rate fell slightly due to the growing share of retirees in the population. Thus, women constituted approximately 45 percent of the workforce during the 1990s, although this somewhat overstates their role in the economy since a quarter of women but only a tenth of men work part-time (Blau *et al.*, 1998; Costello and Stone, 2001).

Women, then, have greatly increased their role in the formal economy over the postwar era. This says very little about their socio-economic status, however. For example, the unemployed wife of a business executive has high status, while a "shop girl" or a "sales girl" does not. Consequently, it is necessary to examine the occupational distribution of women and men in Table 11.7 to get much sense of how women's broad scale entrance into the workforce over the second half of the 20th century has affected their socio-economic status. The top two occupational categories are clearly managerial and professional. Here, women do surprisingly well. In 1988, about a quarter of both women and men held these types of jobs; and over the next decade, there actually was a slightly greater growth in women's share (25 percent to 31 percent) than in men's (26 percent to 28 percent), suggesting that women may indeed have been benefiting from the economic changes brought on by the information age. The position

Table 11.6: Women's and men's labor participation rates in the US.

	Women's labor participation rate (%)	Men's labor participation rate (%)	Women's share of labor force (%)
1950	34	81	30
1970	43	80	38
1980	52	77	43
1990	58	76	45
2000	62	73	47

Sources: CB Costello and AJ Stone, Eds., *The American Woman, 2001–02: Getting to the Top* (WW Norton, New York, 2001) pp. 184 & 228. CB Costello, VR Wright and AJ Stone, Eds., *The American Woman, 2003–04: Daughters of the Revolution-Young Women Today* (Palgrave Macmillan, New York, 2003) pp. 242 & 244.

Table 11.7: Occupational distribution by gender.

	Women 1988 (%)	Women 1998 (%)	Men 1988 (%)	Men 1998 (%)
Managerial & professional	25	31	26	28
Managerial	11	14	14	15
Professional	14	17	12	13
Technical, sales & adm support	45	41	20	20
Services	18	18	10	10
Skilled labor	2	2	20	19
Blue collar	9	7	21	20
Agriculture	1	1	5	4

Sources: CB Costello and AJ Stone, Eds., *The American Woman, 2001–02: Getting to the Top* (WW Norton, New York, 2001) p. 245. CB Costello, VR Wright and AJ Stone, Eds., *The American Woman, 2003–04: Daughters of the Revolution-Young Women Today* (Palgrave Macmillan, New York, 2003) pp. 242 & 244.

of women *vis-a-vis* men is, as might be expected, slightly better among professionals than among managers. Still, these data certainly indicate that women seem quite competitive in the "knowledge jobs" that are generally thought to be at the top of the occupational hierarchy in the US economy now.

In contrast to managerial and professional jobs, Table 11.7 also shows that there is considerable sex segregation in other parts of the labor force. Women are twice as likely as men to hold technical, sales, and administrative support jobs and to work in service occupations. Men are almost three times as likely to hold "blue collar" manufacturing jobs and compose 90 percent of the skilled labor pool. These data contain both good and bad news for women. In static terms, skilled labor and those manufacturing jobs that are unionized generally command much higher wages than the sectors in which women predominate. However, with manufacturing in America increasingly being forced to move off-shore, the dynamic change brought about by the emerging information age economy appears quite favorable to women.

Women's broad scale entrance into managerial and professional occupations, of course, does not necessarily mean that they have attained equal power to men within these traditionally male occupations. In fact, their low representation in the top positions has generally been taken to indicate a "glass ceiling" that limits their career options and mobility in most businesses. For example, women are represented in management in approximately the same proportion that they constitute of the total business workforce in the US (40 percent). Yet, they hold only slightly over a tenth of the positions of corporate officers or directors in Fortune 500 companies (i.e., the largest businesses in the US) and only 5 percent or less of the very top positions in these companies. There is some evidence, though, that women are beginning to gain a little more access to the top ranks of management, in part because they have better representation in the economic sectors that are expanding in America's new "information age" economy. For example, during just the second half of the 1990s, women's share of corporate officers rose from 9 percent to 12 percent, the number of women among the top five earners at Fortune 500 companies more than doubled, and the number of Fortune 500 companies with at least three women on their Board of Directors also more than doubled from 19 to 45 (Wellington and Giscome, 2001).

Even given these positive developments, however, women still face very severe obstacles to careers at the top of the corporate hierarchy:

> By and large, the glass walls are there because of the myths that women will not take risks, that women go home and stay home after having children, and that customers and clients will not accept women. While women's achievements have dispelled such myths to some extent at corporate headquarters, these views persist in field operations Many women also dispute the view that it is only a matter

of time before they catch up with men. Women point instead to the inhospitable work environment, contending that the major factors hindering their advancement are stereotyping and preconceptions on the part of male colleagues as well as the exclusion of women from informal networks of communication (Wellington and Giscome, 2001, p. 91).

Overall, the lagging but improving position of women in the American economy (Blau *et al.*, 1998) is well illustrated by the data on comparative average wage rates for women and men with full-time jobs in Table 11.8.[2] In 1975, for instance, women workers were clearly at a gross disadvantage compared to their male colleagues since among full-time employees the median income of women was only 59 percent of men. Over the next 25 years, the position of women improved dramatically, but they still remained far short of receiving equal pay as this wage ratio reached

Table 11.8: Wage ratio of women to men full-time workers.

Year	Ratio of median annual earnings of women to men for fulltime workers (%)
1955	64
1960	61
1965	60
1970	59
1975	59
1980	60
1985	65
1990	72
1995	71
2000	74
2001	76
2006	77

Source: "The Gender Wage Ratio: Women's and Men's Earnings" (Institute for Women's Policy Research, Washington, D.C., 2006) pp. 1–2.

[2] These show a significantly lower degree of inequality than the comparative data on the ratio of all women to all men's salaries in Table 11.2 above because, as previously noted, women have been over twice as likely as men to hold lower paid part-time jobs.

74 percent in 2000 (83 percent for those in the 25–34 age category) and 77 percent in 2006, although there have been almost no gains for women after 2001. These gains resulted from two interacting trends. First, women are able to compete much more equally with men in an information age, as opposed to an industrial, economy. Second, changing legal and social norms have made open wage discrimination much harder. Still, the "gender gap" in earnings remains pronounced and the fact that it is little affected by such factors as education and occupation certainly indicates that women face significant discrimination as the 21st century opens (*American Men and Women: Demographics of the Sexes,* 2000).

5. Women's Continuing Problems with Poverty and Inequality

Despite the undoubted progress that women have made in the US during the postwar era, they still face considerable problems of poverty and inequality. In the 1970s, for example, there was a growing perception that the "feminization of poverty" was becoming a significant social problem (Erie and Rein, 1988; Kemp, 1994). When most Americans married fairly young, as they did at the beginning of the postwar era, wealth and poverty were generally shared fairly equally by women and men. Several social trends in the 1960s began to change this situation, though. The marriage age rose significantly, the number of "nontraditional families" rose dramatically, and, probably most importantly, the divorce rate jumped two-and-a-half fold between 1960 and 1980. Since divorce, on average, proves financially beneficial for men and disadvantageous for women, the combined impact of these trends was to make women much more vulnerable in terms of their personal finances (Costello and Stone, 2001).

The data on the official poverty rate in the US[3] that are presented in Table 11.9 confirm that the image of the "feminization of poverty" is true to a significant extent. For the last 3 decades, the poverty rate for women (which has varied between 11 percent and 17 percent depending upon the business cycle) has been nearly 30 percent higher than for men. This difference between the sexes has stayed almost exactly the same with women constituting 57–58 percent of those living in poverty throughout this period. Thus, far more is at work than rising divorce rates

[3] This poverty rate is considerably lower than the one in the UN data in Table 11.1 above where poverty is defined as family income below 50 percent of the national median.

Table 11.9: Poverty rates by sex.

Year	Poverty rate for women (%)	Poverty rate for men (%)	Women's share of poor (%)
1970	14.0	11.1	57
1975	13.8	10.7	58
1980	14.7	11.2	58
1985	15.6	12.3	57
1990	15.2	11.7	58
1993	16.9	13.3	57
1998	14.3	11.1	57
2000	12.6	10.0	57

Sources: American Men and Women: Demographics of the Sexes (New Strategist, Ithaca, NY, 2000) p. 229. CB Costello, VR Wright and AJ Stone, Eds., *The American Woman, 2003–04: Daughters of the Revolution-Young Women Today* (Palgrave Macmillan, New York, 2003) p. 303.

and "deadbeat dads" who refuse to honor their financial responsibilities to their old families since the disparity between women's and men's poverty rates seems to have been unaffected by the peak in the divorce rate in the 1970s and 1980s.

Even so, the social consequences of rising divorce and illegitimacy are stark in Table 11.10 which demonstrates the tremendous financial challenge facing most families that are headed by a single woman. Over the last 2 decades of the 20th century, families headed by single women have on average received incomes of only about one-third of those going to married couples; and, if anything, the gap between the two increased slightly over time as the median incomes of married couples measured in constant or "real" dollars increased by 15 percent between 1977 and 1997, while those of female-headed families only inched up by 3 percent. Since almost a quarter of America's children (23 percent) now live in female-headed families, this huge gap may have profound implications for the future.

The social problems associated with the feminization of poverty are especially pronounced for minority women who have more limited access to education, as demonstrated by the data in Table 11.11. For high school degrees, this gap, while quite significant for Hispanic women, seems to be narrowing with the almost universal access to secondary school that exists in the US. In 1998, for example, 84 percent of all White women

Table 11.10: Median family income by type of family.*

Type of family	1977	1987	1997
Married Couples	$48,090	$52,262	$55,242
Male Headed	$35,298	$33,286	$29,115
Female Headed	$16,769	$16,307	$17,252

* In constant 1998 dollars.
Source: CB Costello and AJ Stone, Eds., *The American Woman, 2001–02: Getting to the Top* (WW Norton, New York, 2001) p. 291.

Table 11.11: Women's educational accomplishments by race.

Race	High school degree (%)	College degree (%)
White		
All	84	23
25–29	90	30
African-American		
All	77	15
25–29	88	17
Hispanic		
All	55	11
25–29	66	11

Source: *American Men and Women: Demographics of the Sexes* (New Strategist, Ithaca, NY, 2000) pp. 66–67.

had graduated from high school compared to 77 percent of African-American and only 55 percent of Hispanic women. For the 25–29 age group, though, there was almost no difference in the graduation rates of whites (90 percent) and African-Americans (88 percent), with Hispanic women lagging but not quite so badly as for all women at 66 percent. Thus, these data might seem fairly optimistic.

The trend is quite different and more worrisome for two reasons in regard to college degrees, which are becoming almost vital for professional advancement in the US information age economy. First, the relative disparity among the races is significantly greater than for high school education, as 23 percent of White women had college degrees, well above the 15 percent for African-Americans and 11 percent for Hispanics.

Second and more alarmingly, the proportion of White women going to college appears to be increasing: for example, 30 percent of White women who are 25–29 have earned college degrees, but any similar increase for minority women is minuscule at best.

Consequently, minority women are not being afforded the educational opportunities necessary for professional employment, which brings with it the most stable, well-paid, and fulfilling jobs. They also almost certainly face more suspicions to overcome in the job market than White women (Wellington and Giscome, 2001). As the data in Table 11.12 show, women of color are much less likely to have managerial and professional jobs and more likely to work in generally low-paying service occupations than White women. For example, 33 percent of White women in the labor force held managerial and professional jobs versus 25 percent of African-Americans and 18 percent of Hispanics. Women in the US, therefore, are divided by class differences which shape their life chances; and, moreover, class is intertwined with substantial racial differences as well.

6. Institutions and Women's Empowerment in the United States

The position of women in American society is decisively shaped by the socio-economic and political institutions that have evolved in the US. As sketched in Figure 11.1 these institutional effects are somewhat contradictory in their implications for women's empowerment, given the US's current fundamental transformation from an industrial to an information age economy (Friedman, 1999; Thurow, 1999). America's political culture,

Table 11.12: Women's occupational distribution by race, 2000.

Occupation	White (%)	African-American (%)	Hispanic (%)
Managerial & Professional	33	25	18
Technical, Sales & Adm Support	41	39	37
Service	16	25	26
Skilled Labor	2	2	3
Blue Collar	6	9	14
Agricultural	1	1	2

Source: CB Costello, VR Wright and AJ Stone, Eds., *The American Woman, 2003–04* (Palgrave Macmillan, New York, 2003) pp. 254–255.

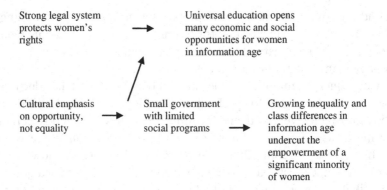

Figure 11.1: Institutions and women's empowerment in the US.

which strongly favors opportunity over equality (Brooks, 2004; Kingdon, 1998; Lipset, 1996), is reflected in the nation's political and economic institutions. In particular, the legal system provides strong support for individual rights which can (but not always do) promote women's empowerment. This ethic is also reflected in the country's commitment to universal education. In combination, these factors have resulted in many economic and social opportunities being opened to women by the emerging post-industrial economy. However, other aspects of America's political culture have created obstacles to the empowerment of a very significant minority of women. In particular, the anti-government philosophy in the US hampers the ability of those women who do not have the requisite education and social status to avoid marginalization in the rapidly changing society. Thus, while gender equality appears to be growing among younger (under 35) Americans, there is also rising inequality between those women who can gain access to good education and professional jobs and those who cannot (Luciano, 2003). The next stage in promoting women's empowerment in the US, hence, should be to ensure that all segments of society receive the education and training necessary to participate in the new knowledge-based economy.

References

American Men and Women: Demographics of the Sexes. (2000), pp. 108 & 190–205. NY: New Strategist, Ithaca.

American Woman, 2001–2002: Getting to the Top. New York: W.W. Norton.

Blau, FD, Ferber, MA and Winkler, AE (1998). *The Economics of Women, Men, and Work.* NJ: Prentice Hall, Upper Saddle River.

Brooks, D (2004). *On Paradise Drive: How We Live Now (And Always Have) in the Future Tense.* New York: Simon & Schuster.

Costello, CB and Stone, AJ (eds.) (2001). *The American Woman, 2001–2002: Getting to the Top*, pp. 180–191. New York: W.W. Norton.

DiNatale, M and Boraas, S (2003). In *The American Woman, 2003–2004 Daughters of the Revolution-Young Women Today*, Costello, CB, Wright, VR and Stone, AJ (eds.), pp. 69–92. New York: Palgrave Macmillan.

Erie, SP and Rein, M (1988). In *The Politics of the Gender Gap: The Social Construction of Political Influence*, Mueller, CM (ed.), pp. 273–291. CA: Sage, Beverly Hills.

Friedman, T (1999). *The Lexus and the Olive Tree.* New York: Farrar, Strauss, Giroux.

Inglehart, R and Welzel, C (2005). *Modernization, Cultural Change, and Democracy: The Human Development Sequence.* New York: Cambridge University Press.

Kemp, AA (1994). *Women's Work: Degraded and Devalued.* NJ: Prentice Hall, Englewood Cliffs.

Kingdon, JW (1998). *America the Unusual.* New York: St. Martin's Press.

Lijphart, A (1999). *Patterns of Democracy: Government Forms and Performance in Thirty-Six Countries.* New Haven: Yale University Press.

Lipset, SM (1996). *American Exceptionalism: A Double-edged Sword.* New York: W.W. Norton.

Luciano, L (2003). In *The American Woman, 2003–2004 Daughters of the Revolution-Young Women Today,* Costello, CB, Wright, VR and Stone, AJ (eds.), pp. 143–163. New York: Palgrave Macmillan.

National Commission on Excellence in Education (1983). *Nation at Risk. Washington,* DC: US Department of Education.

Thomas, S (1994). *How Women Legislate.* New York: Oxford University Press.

Thurow, LC (1999). *Building Wealth: The New Rules for Individuals, Companies, and Nations in a Knowledge-based Economy.* New York: HarperCollins.

United Nations, *Human Development Report, 2005.* New York: Oxford University Press.

Wellington, S and Giscome, K (2001). In *The American Woman, 2001–2002: Getting to the Top,* Costello, CB and Stone, AJ (eds.), pp. 87–106. New York: W.W. Norton.

Wilensky, HL (2002). *Rich Democracies: Political Economy, Public Policy, and Performance.* Berkeley: University of California Press.

Institutions and Gender Empowerment in Greece

Rosita Dellios

1. Introduction

The Hellenic Republic (Greece) is a multi-party parliamentary democracy and a member of the European Union which has influenced standards for women's rights. Greece's 1975 Constitution reflects the principles on equality found in the UN International Convention on eliminating discrimination against women (Act1342/83) and in the European Social Charter (Act1426/84) (Sianou, 2000). Indeed, international regimes are a notable force in favor of Greek women's empowerment. Gaining the right to vote in 1952 — after 3 decades of struggle by women's emancipation groups within Greece — is a case in point. Having become a signatory to the United Nations Convention on Women's Political Rights of 1951, the Greek government introduced a bill to parliament the following year giving full political rights to women. The bill was passed and women first voted in the national election of 1956. Since then, Greece has ratified the Convention on the Elimination of All Forms of Discrimination Against Women as well as other relevant treaties.

2. The Importance of Women in Economic and Social Development in Greece

Greek women have contributed to nation-building efforts in economic and socio-political forms. As early as 1887 through Kallirhoe Parrin's publication of *The Ladies' Journal*, Greek feminists were vocal in the shaping of Greek society. By the 1920s, the National Council of Greek Women, which represented a number of women's groups, published its

views through the *Greek Woman*, a monthly that was joined by *Women's Struggle* — the bulletin of the Greek League of Women's Rights founded by Avra Theodoropoulou and Maria Negraponti. Its cover page in the inaugural issue in 1923 demanded "the same political, civil, and economic rights for men and women" (Petrinioti, 2006). Both the League and the magazine continued into the 21st century, with Xanthi Petrinioti as editor and president since 2003, though disruptions occurred during the 1930s under the Metaxa dictatorship when civil liberties were suspended and later in 1967–1974 during the press censorship imposed by the military junta.

Bold words were matched by heroic deeds during World War II when Greek women fought in the resistance alongside men. After the war, women became wage earners in a new industrializing society with its emerging middle class. Greece's involvement in international governmental organizations, the women's movement, and the demands of industry resulted in a number of fundamental advances for women. By the 1950s, women gained voting rights; in the 1960s and 1970s more and more women joined the paid workforce; and by the 1980s key social legislation in favor of women was passed. In the decade 1977–1987 alone, women's participation rate in the workforce increased from 32 percent to 43 percent (Coutsokis, 2004). By 2004, the participation rate climbed to 54.1 percent, but this was comparatively low in EU terms with most EU countries scoring above 60 percent (Eurostat, 2007). Also, women were now working primarily in the service sector rather than agriculture, a reflection of the Greek economy's changing structure (services constitute almost three-quarters of GDP) and the opportunities available for employment.

3. Socio-economic Status vis-à-vis Men

According to research conducted by the Greek National Centre for Social Research (EKKE) in 2002, the socio-economic status of women in relation to men remains traditional: The breadwinners are predominantly men, and the homemakers, women. Specifically, about twice as many men (88 percent) were employed when surveyed compared to women (45 percent), while women spent on average almost four times as many hours on housework per week (34 hours) compared to men (9 hours), and almost twice as much time on childcare per week (15 hours compared

to 8).[1] The unemployment rate among women (12.9 percent) was three times that of men (4.7 percent).[2]

Women who did find work in paid employment encountered difficulties in integrating because of inflexible work hours, lack of affordable childcare facilities, and a paucity of professional development and vocational programs. The patriarchal family structure prevails to the point that the dowry system is still practised (even though legally abolished), and violence against women remains high for cultural reasons: "To the Greek mentality, a slap in the face is a form of emotional communication for both sexes; and the Mediterranean temperament excuses such gestures as an indication of passion ... The relationships amongst the two sexes are relationships of power and subordination, not of companionship and respect."[3] Moreover, domestic violence is still widely viewed as a private affair, not to be reported or condemned by external parties. Yet, it is singled out as a human rights violation in the US Department of State's 2005 country reports on human rights practices (US Department of State, 2006a).

4. Indicators[4]

Greece's GDP per capita is $23,518. Its total population is 10.6 million, of whom 5.2 million are male and 5.4 million are female. Urban dwellers constitute two-thirds of the population. Greece's high standard of living is reflected in its Human Development Index ranking of 24th in 2006. The exception is Greece's Roma population (estimated 100,000 to 350,000),

[1] Cited in Greek Helsinki Monitor (GHM) and the World Organization Against Torture (OMCT) (2002). Violence Against Women in Greece, Report prepared for the Committee on the Elimination of Discrimination against Women, July, p. 5.

[2] Greek Minister for Labor and Social Security, Dimitris Reppas, cited in Greek Helsinki Monitor (GHM) and the World Organization Against Torture (OMCT) (2002). Violence Against Women in Greece.

[3] Greek Helsinki Monitor (GHM) and the World Organization Against Torture (OMCT) (2002). Violence Against Women in Greece, p. 9.

[4] IMF (2006). *World Economic Outlook*; World Bank (2005), *World Development Report*; CIA (2006), *World Factbook*; UNFPA (2006), *State of the World Population 2006*; BBC News (2006), *Country Profiles*; US Department of State (2006), *Bureau of European and Eurasian Affairs*.

whose living conditions were found in 2005 to be "substandard" and whose children had "inadequate access to schools" (US Department of State, 2006a). Income distribution by household income or consumption is 3 percent for the lowest 10 percent and 28.3 percent for the highest 10 percent. In terms of the overall distribution of family income, the Gini index was 35.1 in 2003. There is free education at all levels, with 9 years compulsory. The adult literacy rate is high at 97.5 percent, as is life expectancy at birth — 79.2 years for the total population (76.7 for males and 81.9 for females). The infant mortality rate is 5.4 deaths for every 1,000 live births (5.9 male and 4.8 female). As with many developed countries, the total fertility rate is low, but Greece's is among the world's lowest — 1.3 children. Abortion and contraception have been legal since the 1980s. Abortion is prevalent, while use of oral contraception is reportedly low — 5 percent compared to 35 percent in other countries in Europe in the 1990s (Praxson, 2004a). Condom use tends to be promoted for prevention of the spread of HIV/AIDS (which has a prevalence in Greece of 0.2 percent), rather than for birth control. The high incidence of abortion — thought to be two or three times the live birthrate but this cannot be verified because few abortions are registered — is attributed to economic considerations (the chief cause identified by women themselves), poor childcare infrastructure for working mothers, and inadequate information on preventative contraceptives (Praxson, 2004b).

5. Decomposition of Exchange Entitlement Theory

The informal institutions, and to some extent formal ones also, may be regarded as hindrances preventing Greek women from attaining the same level of empowerment as men. Even with physical labor as her only endowment, the continued prevalence of "classic patriarchy" means that a woman from an agricultural or fishing community is still expected to fulfill her traditional domestic role and to uphold the honour of the family. Her ambitions are channeled into the domestic sphere and family networks. There has, however, been a greater emphasis in the villages on the education of daughters. This has meant an overcoming of the "ideology of seclusion" so that daughters are allowed to live away from home for tertiary education. Success in higher education and the hoped-for acquisition of professional employment is seen to bring honour to the family and to improve a daughter's marriage prospects. So while a woman attains the

higher stages of Sen's exchange entitlement theory, it is not without social encumbrances. Educated or not, a women is expected to conform to the community standards of the ideal Greek womanhood. The primary component of this is motherhood. Mothers are highly esteemed in Greek society and grandmothers act as matriarchs within the family, while fathers and grandfathers represent the family to the outside world.

The institution of motherhood entails the commonly-held belief that becoming a mother "fulfilled" a woman's "nature", that a "good mother" reared "successful" children, and that this was her duty (an ethical undertaking) (Praxson, 2004c). Love, as commonly understood in the lexicon of Anglo modernity, is subsumed by duty with its devotion to family well-being and honour. This is also true of the institution of marriage: traditionally, "love" is not as highly rated as in modern society; a successful match (which traditionally employed a "matchmaker") would be between class and economic equals, with care taken to investigate the couple's family backgrounds.

By contrast, the consciously modern Greek woman will choose her own marriage partner, if she marries at all (marriage rates have declined while divorce rates are increasing), and then she chooses to restrain her fertility (as the indices, above, show). How may this be reconciled with the cultural value associated with motherhood and family? Such behavior does reflect contemporary trends in the developed world: in 2007, the majority of women in the US were living without a spouse (New York Times report in AFP, 2007).

In the Greek context, however, having few or no children may well be an admission to an inability to fulfill the ideals of being a "good mother", that it is better not to bring a child into the world than to give birth to one who is not given the opportunities to succeed because of inadequate economic resources (Praxson, 2004b). In Greece, a developed country, meeting basic needs is not enough to allow for important life choices such as procreation: there must be the economic and social wherewithal to optimize a child's chances of escaping perceived "poverty".

Ironically, Greek society, in its idealized institution of motherhood, has aligned itself to Sen's exchange entitlement theory by promoting stage 2 "skill-based endowment", then cultivating opportunity through sociopolitical networks. This appropriation of the empowerment of the individual by the institution of motherhood reflects on which values of empowerment are most desirable (family-based or individualized) and the way in which economic circumstances may dictate a woman's choice to

become a mother. As the president of the Federation of Greek Women, Kalliope Boudouroum-Karata, pointed out during International Women's Day in 2000: "Instead of maternity filling a woman with happiness and providing her with a sense of fulfillment free of obstacles to allow her to respond to her biological right, along with her role in society, and the labor market, it fills her with anxiety and guilt which results in a return to a traditional role or the sacrifice of maternity".[5]

Prevailing social attitudes in which women are still closely associated with the traditional roles of marriage and motherhood also mean that they are discriminated against when they seek to enter the upper echelons of their professions. Only five percent of female graduates reach this level.[6] Moreover, like their rural sisters, they shoulder more of the household responsibility than men. Professional urban-based women are more handicapped than village women by often being deprived of assistance in the home from other family members. The extended family with its support system has given way in large measure to nuclear family households in urban environments. This means a professional woman must rely on inadequate government childcare services or employ expensive alternatives (see below) as well as cleaning services if she is to avoid the double burden of maintaining a household and a career. This is not to imply that her country cousin is better off. While rural women do have the family support structure, they lack the opportunities to find employment. A study on the spatial determinants of Greek women's participation in the workforce confirms the known disadvantages of living far from urban centres: "Apart from gender inequalities, Greek women have to deal with spatial inequalities, as well, according to their place of residence" (Kiritikou and Agorastakis, 2006). So geography is also a consideration in exchange entitlement analysis.

Another social institution that negatively impacts on stages 2 and 3 is the media. There remains a significant degree of stereotyping of women which colludes with 'glass ceiling' discrimination. The Greek Consumers Institute (INKA) has identified a number of problematic practices in the media, particularly in advertising: the portrayal of women as objects of

[5] In 'Struggle for Equality in Work Still a Reality for Greek Women' (2006). *Athens News*, 10 March, p. A02, www.athensnews.gr [accessed 30 December 2006].

[6] Maria Kypriotaki, president of the Union of Greek Women (EGE), cited in 'Struggle for Equality in Work Still a Reality for Greek Women' (2006), *Athens News*, 10 March, p. A02, www.athensnews.gr [accessed 30 December 2006].

sexual desire, as housewives, and as the intellectual inferior of men (Tzilivakis, 2003). Violence against women is disguised as a cultural issue (as noted above) and hence often normalized: "Violence against women is not generally portrayed in the media as a social problem that violates human rights ... images in the media reinforce the stereotype of men exulting power by being violent, and women exulting femininity and submission by accepting violence and acknowledging its necessity".[7]

Finally in the sphere of social institutions, the Eastern Orthodox Church of Christ (Greek Orthodoxy), to which 98 percent of native-born Greeks belong, may be viewed as a conservative influence on women's exchange entitlement in the modern world. This institution regards itself as the guardian of Greek identity. Its status is enshrined in the constitution, which proclaims Orthodoxy to be "the prevailing religion". During Ottoman rule, it preserved the Greek language and culture; it also served the cause of national independence by providing "an important rallying point" (US Department of State, 2006b). As Susannah Verney has observed: "[A] powerful element of the nation-building narrative taught in history classes concerns the role of the Orthodox Church in preserving the Greek nation under Ottoman rule, before the late-eighteenth century national awakening" (Verney, 2002).

A Greek woman's identity is, therefore, circumscribed by the church through its emphasis on her roles of wife and mother. Divorce and abortion, though permitted by both church and state, are frowned upon by the church (abortion for economic reasons is considered perverse). As stated by the Rev. Stanley Harakas of the Greek Orthodox Archdiocese of America: "Marriage is holy. The home is sacred. Birth is a miracle. In these we find the very meaning of life itself" (Harakas, 2003).

A woman is expected to maintain the religious life of the family, such as baptisms, fasting before Easter, celebrating the saints days relevant to family members' baptismal names (traditionally, an individual celebrates his or her 'name' day rather than birthday). These are all part of Greek religious culture which women are expected to uphold and transmit to the next generation. In a very real sense, women are the keepers of Greek identity and the Church defines the contents of that identity.

[7] Greek Helsinki Monitor (GHM) and the World Organization Against Torture (OMCT) (2002). 'Violence Against Women in Greece.' Report prepared for the Committee on the Elimination of Discrimination against Women, July, p. 9.

However, just as the Greek Orthodox Church is being sidelined on the issue of identity, as evidenced by the removal in 2001 of religious affiliation on the national identity card,[8] so too women are losing their tradition power domain as cultural custodians. Thus, urbanization has led to an expansion in the economic roles that women undertake, but it has also deprived them of the authority to preserve and transmit national and religious culture. In becoming more 'European' and, therefore, secular (the identity card issue of privacy arose from the need to conform to European standards), Greece is moving away from an historic image of itself as a "backward" Balkan country that languished for centuries under Ottoman occupation only to be kept alive by the Orthodox faith. In a similar vein, women are finding that empowerment comes not from the matriarchal domain of home and hearth but from entry into a European-based economy, society, and political framework.

This Europeanization process, however, did not begin with Greece joining the European Community (now the EU) in 1981. After Greece gained independence from the Ottoman Empire in the early 19th century, Greek society came under greater European influence, with fashion and lifestyles being imitated by the Greek elites. This did not necessarily provide emancipation from the traditional expectations of "modest virginity before marriage and fidelity and demure behavior after marriage" in both elite and peasant classes, but added the burden of turning women into "social objects" (Coutsoukis, 2004). Once again, for Greek women, empowerment is a complex proposition and entails discernment between that which adds and that which subtracts from the ability to enjoy "greater individual freedom and a richer cultural life" (see Chapter 1).

6. Types and Depth of Economic and Social Poverty that Affect Women in Greece

According to Sen, poverty is not only an economic matter but also manifests as socio-cultural and political poverty (see Chapter 1). For Greek

[8] This was the result of constitutional revision. Besides removing religious affiliation, the new Greek identity cards also no longer include "fingerprints, names and surnames of the cardholder's spouse, maiden names, profession, home addresses, or citizenship". 'Privacy and Human Rights 2003: Greece' (2003), www.privacyinternational.org/survey/phr2003/countries/greece.htm [accessed 16 January 2007].

women, all three kinds of poverty are evident. Economic poverty results from unequal pay between men and women. With women earning two-thirds the pay of a man for the same job, they are one-third poorer than their male equivalents. This is a significant degree of disparity which impacts on a woman's life choices, including whether she has "the economic margin to have children" (Correal, 2005). Socio-cultural poverty manifests in the continued power of the patriarchy and depiction of women in the media in stereotypical terms. Politically, they are under-represented in positions of power — whether as bureaucrats or politicians. In 2005, only 7.8 percent of parliamentary seats were held by women (38 women in the 300-seat parliament), among the lowest proportions in the EU. At the local government level, the quota system calls for 30 percent representation, but this has yet to be achieved (Tzilivakis, 2002). At the ministerial level in 2006, only three out of 19 were women, including the Minister of Foreign Affairs, Dora Bakoyannis. In the high courts, women accounted for less than a quarter of the council of state judges, half of the supreme administrative court judges, and as few as a twentieth of supreme court judges (or 3 out of 62) (US Department of State, 2006a). Table 12.1 reports estimates of the deprivation scores for Greek women.

7. Discrimination and the Law

Greek women still spend more time in domestic work than men. After the birth of a child, women tend to reduce the time spent in paid employment. Affordable child care is a key issue. Government daycare centers are

Table 12.1: Estimates of gender deprivation scores for Greek women.

GNP per capita	high
Life expectancy at birth	high
Educational attainment	
a. mean years of schooling	high
b. adult literacy rate	high
Fertility rate	low
Maternal mortality rate	low
Contraceptive prevalence rate	low
Females share in total labor force	medium

unable to cope with demand, and private centres are expensive. The European Union Social Fund will be the source of Greece's funding for more child care centers (Tzilivakis, 2003), but the results are yet to be felt. It should be noted that EU subsidies flowing into the country account for 3.3 percent of Greece's GDP.[9] European standards in a range of sectors are thus not only expressed in terms of rhetoric but also supported by project funding.

As stated above, the 1980s saw major social legislation in favor of women's rights. The Family Law introduced equality of the sexes, adultery was decriminalized, and abortion was legalized. Birth control rights had a positive impact on education and improved living standards. As Silvia Pezzini points out: "Only if birth control rights exist and the woman is willing to use them, can the optimal choice of education for men and women be equal" (Pezzini, 2005).

The results of a quarter of a century of increased rights, however, are best described as suboptimal. As noted, women are still well below EU levels of participation in the workforce. Those who have managed to enter the workforce are found predominantly in lower status, low-skill employment, such as salespersons, service work, and the public sector. Men make up two-thirds of high-income employment.

The greatest inequalities in pay are evident not among the unskilled but in those groups that are older, more educated and earn a higher income.[10] This is despite over half of university graduates being women. The unemployment rate among women is twice that of men[11] and for the long-term unemployed, it is three times. The percentage of unemployed young women (42 percent) is almost twice that of unemployed young men (22.8 percent).[12] Women predominate in temporary employment

[9] Bureau of Democracy, Human Rights and Labor (2003). 'Greece: Country Reports on Human Rights Practices – 2002', 31 March, in US Department of State, www.state.gov/g/drl/rls/hrrpt/2002/18368.htm [accessed 3 January 2007].

[10] Statistical Office of the EU (Eurostar), cited in Tzilivakis, K (2003). 'Equality Still Failing Women in Greece, Hellenic Communication Service, www.helleniccomserve.com/equality.html [accessed 28 December 2006].

[11] Centre for Economic Research (KEPE), cited in Tzilivakis (2003).

[12] Greek Helsinki Monitor (GHM) and the World Organization Against Torture (OMCT) (2002), 'Violence Against Women in Greece', Report prepared for the Committee on the Elimination of Discrimination against Women, July, pp. 5–6.

(two-thirds are women) and 28 percent of women employees work less than 30 hours a week.[13] The Greek government aims to raise women's participation in the workforce to 60 percent by 2010, aligning Greece more closely to participation rates in other EU countries.[14]

The Greek Constitution of 1975 established equal rights for men and women. Article 4, paragraph 2, states: "Greek men and women have equal rights and equal obligations." Article 22, paragraph 1, affirms: "All workers, irrespective of sex or other distinctions, shall be entitled to equal pay for work of equal value". Greece enjoys strong legislative frameworks at both the state and EU levels. Implementation is a problem, as is women's awareness of labor rights. Sexual harassment, for example, is worse in the southern member states of the EU, like Greece, than the northern ones, as there is a tendency not to treat it seriously or to ensure the provision of awareness-raising programs.

In this respect it is instructive to note that Article 116 of the same Constitution allowed — until the new Article 116 para 2 in the 2001 amendment of the Greek Constitutional — for divergence from equality. In practice, these derogations from equality meant affirmative action such as "quotas at decision-making centers" and "conditional preferences for women when employing and promoting employees" was not taken despite Greece having signed international conventions requiring this (Sianou, 2000). Greece's National Commission for Human Rights (NCHR) was active in calling for the implementation by Greece of the International Labor Organization's convention No 111. In its 2002 report, the NCHR called for "particular attention by the Greek state, of affirmative action in favor of women in Greece (following the new Article 116 para 2 of the Greek Constitution) and of the legal and factual equality of sexes in the framework of the relevant, evolving European Community law".[15] The Minister of the Interior, Public Administration, and Decentralization, Prokopis Pavlopoulos, speaking at a gender equality conference in Athens in 2004, said that further constitutional amendment

[13] President of the General Confederation of Workers in Greece (GSEE), Christos Poly-zogppoulos, cited in Tzilivakis (2003).
[14] Greek Helsinki Monitor (GHM) and the World Organization Against Torture (OMCT) (2002), 'Violence Against Women in Greece', p. 6.
[15] Hellenic Republic National Commission for Human Rights (2003). Report 2002, January.

on gender equality was needed, and Greece should aim to exceed the EU goals as they represented only "minimum requirements".[16]

On the whole, however, international treaties have had a positive influence on the rights of women in Greece. A year after Greece joined the European Community (predecessor of the EU), the position of Special Adviser to the Prime Minister on Equality was introduced; while Act 1558.88 established a General Secretariat for Equality, currently under the Ministry of the Interior, Public Administration, and Decentralization, "for the promotion and materialization of the legal and substantive equality in all sectors (political, economic, social, cultural)" (Sianou, 2000). The General Secretariat for Equality has sought to bring Greece in line with the provisions on equality in the European Union Treaty of 1992, and have focused on: gender "mainstreaming", strengthening of equality-promoting mechanisms, attention to employment and better participation in decision-making, combating violence against women, and combating the sexist depiction of women in the mass media (Sianou, 2000).

One area to have escaped the best practices of the General Secretariat for Equality concerns the rights of foreign women, minorities (especially Roma and Turkish women), women in detention, and women suffering from sexual exploitation through trafficking. The US State Department's 2006 'Trafficking in Persons Report' criticized Greece for not fully complying "with minimum standards for the elimination of trafficking", though unlike previous years, "it is making significant efforts to do so" (US Department of State, 2006c). Greece is both a destination and transit corridor for women and children from Eastern Europe, the Balkans, and Africa, who are trafficked for sexual exploitation as well as forced labor. More than 20,000 were reported in 2002 to be "enslaved in forced sex labor".[17] Once categorized as among the worst offenders in trafficking (US Department of State, 2002), Greece entered a memorandum of cooperation with NGOs for closer government cooperation with their activities on the issue. In 2006, there was a national awareness campaign for victims, "clients", and the community. Criticisms still continue with

[16] 'European Conference on Gender Equality in Politics Opens in Athens' (2004), Athens News Agency, http://www.hri.org/news/greek/apeen/2005/05-02-04.apeen.html#03 [accessed 13 January 2007].

[17] Cited in Greek Helsinki Monitor (GHM) and the World Organization Against Torture (OMCT) (2002). Violence Against Women in Greece, Report prepared for the Committee on the Elimination of Discrimination against Women, July, p. 16.

regard to inadequate punishment of traffickers and corrupt government officials who are complicit in the trafficking offences (US Department of State, 2006c).

8. Summary of Findings and Recommendations for Action

While Greece is renowned for bringing the light of democracy to the world, two classes of people were excluded from this early democracy: women and slaves. Today, women are still struggling to gain equality in practice and not only in legislation. As to slavery, trafficking in foreign women and children has been cited as a continuing concern in Greece's human rights record. Genuine democratic development requires gender equality. In light of Greece's continued human rights failings and the unrealized integration within the polity of women's rights in particular, democracy in Greece remains an unfinished project.

Greek identity, which draws heavily on its illustrious classical past, needs to take stock of itself and its prospects. Gender equality is not an isolated issue. Only when it is addressed in a holistic fashion, and viewed as improving everyone's quality of life — not only that of women — will Greece's identity as a modern democracy attain its full stature. The Greek government appears to have recognized this as evidenced by the proceedings of a European conference on gender equality, held in Athens in 2004 within the context of the Long-Term Program of the European Commission on Employment, Social Affairs, and Equal Opportunities. Gender equality was identified as a national priority by the Secretary-General for Equality, Eugenia Tsoumani. She said the Greek government's approach was multi-dimensional in that equality for women was seen as being served on a number of fronts, such as increased participation in the workforce and in addressing the problem of domestic violence.

In the spirit of this quest, a number of recommendations may be made. Government and industry need to provide more family-friendly conditions if motherhood, family life, and career aspirations are to be compatible rather than mutually exclusive. This calls for the provision of flexible work hours, affordable and ample childcare facilities, and delivery of vocational training programs. Government and NGOs need to raise awareness about preventative contraceptives and women's health issues. Male prejudices about a woman's fertility being a reflection of their own virility must also be tackled. The media is an obvious arena for redressing

patriarchal cultural biases, and not only in conveying messages that are specific to contraception. Sexist depictions of women should be more closely monitored and challenged — legally and ethically — if society is to change its underlying view of the role and place of women. Government, NGOs, and the media all have responsibilities to discharge in this area.

The law must prohibit domestic violence and not simply treat it within the general assault category. There is also a requirement for a law against spousal rape. Police need to be trained to respond to domestic violence as a more serious offense and not seek to discourage victims from pursuing charges. The courts, too, have a responsibility to hand down heavier punishments to perpetrators (US Department of State, 2006a). In this regard, there is scope to tap into potential EU assistance for "gender-sensitive policing, with possible exchange programmes for joint training" and to "promote the training of judges in gender and women's rights issues" (EuroMeSco, 2006). Further constitutional amendment on gender equality would underscore the importance of these programs.

As a party to the International Covenant on Economic, Social, and Cultural Rights, Greece is bound to respect the rights of its Roma population to adequate shelter and services. It should ensure that the Roma and other marginalized ethnic groups are afforded educational and employment opportunities without discrimination. Continued effort needs to be expended to combat trafficking, in line with the protocol to prevent, suppress, and punish trafficking in persons, especially women and children (Trafficking Protocol), supplementing the United Nations Convention against Transnational Organized Crime, which Greece signed in December 2000.

In Greece, international law has superiority over domestic law. This is constitutionally recognized. So international treaties to which Greece is a signatory must be upheld. This is the key promoter of women's empowerment in Greece. The traditional patriarchal social structure, on the other hand, may be viewed as the primary inhibitor. Between these two poles, Greek society is attempting to find its balance and to redefine rather than lose its identity. If the forces for progress primarily pertain to formal institutions, and the regressive ones are mainly informal, then greater attention needs to be placed on informal institutional change. This can be done through the assistance of the formal sector in sponsoring programs, such as those recommended above, that encourage a change in attitudes at the community level.

Women themselves are the central players in this change. In this respect the traditional Greek matriarchy of the domestic scene, it would seem, is not so much lost but re-orienting itself. It is facing the challenge of adjusting its role to a world where the European Union has replaced the Ottoman Empire as the arbiter of best international practice in the conduct of culture and society. Successfully negotiating the demands of secular modernity and religious tradition will require cooperation from the Greek Orthodox Church in supporting the empowerment of women. It would thereby reveal the continued relevance of religious belief in shaping modern Greece. Admittedly, the church is socially engaged via such activities as providing shelters for abused women, but it can develop further as an advocate of woman's rights for a more just society. Women, as the traditional custodians of Greek identity, may therefore emerge as co-creators with the religious and secular institutions in redefining what it is to be Greek — and female.

References

Correal, A (2005). Modern Mothers in Greece. *Athens News*, 11 November, p. A35. www.athensnews.gr [accessed 30 December 2006].

Coutsoukis, P (2004). Greece: The Role of Women, www.phtius.com/counties/greece/society/greece_society_the_role_of_women [accessed 28 December 2006].

EuroMeSco (2006). Women as Full Participants in the Euro-Mediterranean Community of Democratic States, Report produced for the European Commission, April, http://ec.europa.eu/comm/external-relations/euromed/women/docs/eurom_report0406_eu.pdf [accessed 15 January 2007].

Eurostat, http://epp.eurostat.cec.eu.int [accessed 15 January 2007].

Harakas, S (2003). The Stand of the Orthodox Church on Controversial Issues. Greek Orthodox Archdiocese of America, www.goarch.org/en/ourfaith/articles/article7101.asp [accessed 7 January 2007].

Kritikou, C and Agorastakis, M (2006). The Participation of Women in the Greek Labour Force: A Spatial Analysis. European Regional Science Association, *ERSA Conference Papers*, http://ideas.repec.org/p/wiw/wiwrsa/ersa06p257.html (accessed 15 January 2007].

New York Times report in AFP (2007). Most US Women Single, *The Australian*, 18 January, p. 6.

Petrinioti, X (2006). Women's Struggle: An Old Fashioned Title for a Modern Feminist Magazine. Feminist Movement Archives, Panteion University, www.genderpanteion.gr/en/arxeia.php [accessed 28 December 2006].

Pezzini, S (2005). The Effect of Women's Rights on Women's Welfare: Evidence from a Natural Experiment, *The Economic Journal*, 115(502), emphasis in the original, published online 2 March 2005, www.blackwell-synergy.com [accessed 28 December 2006].

Praxson, H (2004a). *Making Modern Mothers: Ethics and Family Planning in Modern Greece*, University of California Press.

Praxson, H (2004b). *Making Modern Mothers: Ethics and Family Planning in Modern Greece*, University of California Press.

Praxson (2004c). *Making Modern Mothers* Emphasis in the original.

Sianou, F (2000). Report from Greece by Our Transnational Partner. European Database: Women in Decision-Making, Country Report — Greece, www. fczb.de/projekte/wid_db/CoRe/Greece.htm [accessed 28 December 2006].

Sianou, F. (2000), Report from Greece by Our Transnational Partner, European Database: Women in Decision-Making, Country Report — Greece, www. fczb.de/projekte/wid_db/CoRe/Greece.htm [accessed 28 December 2006].

Tzilivakis (2003). Equality Still Failing Women in Greece.

Tzilivakis, K (2002). Breaking the Barriers, *Athens News*, 3 March, p, A09, www.athensnews.gr [accessed 5 January 2007].

Tzilivakis, K (2003). Equality Still Failing Women in Greece, Hellenic Communication Service, www.helleniccomserve.com/equality.html [accessed 28 December 2006].

US Department of State (2002). Trafficking in Persons Report June, www.state. gov/g/tip/rls/tiprpt/2002/10678.htm [accessed 13 January 2007].

US Department of State (20006a). Greece: Country Reports on Human Rights Practices, 2005, 8 March, www.state.gov/g/drl/rls/hrrpt/2005/61651.htm [accessed 28 December 2006].

US Department of State (2006b). *Bureau of European and Eurasian Affairs*, 'Background Note: Greece', October, www.state.gov/r/pa/ei/bgn/3395.htm [accessed 3 January 2007].

US Department of State (2006c). Trafficking in Persons Report, June, www.state. gov/g/tip/rls/tiprpt/2006/65988.htm [accessed 13 January 2007].

Verney, S (2002). Challenges to Greek Identity. *European Political Science*, 1 (2), www.essex.ac.uk/ecpr/publications/eps/onlineissues/spring2002/features/ve rney.htm [accessed 16 January 2007].

Chapter 13

Institutions and Women's Empowerment in the Contemporary World

Cal Clark, Kartik C. Roy* and Hans C. Blomqvist

This volume has examined the degree of women's empowerment in the contemporary world. It argues that the institutions that exist in a society exercise a powerful and determining influence on the status and rights of women in a particular nation. This conclusion summarizes our major results. The first section provides the theoretical overview that was developed in Chapters 1 to 3, the second tests this model with the case studies in Chapters 4 through 12, and the last tries to draw the implications of these results for the dynamics of women's empowerment in the early 21st century.

1. An Institutional Model of Women's Empowerment

The theoretical introduction to this volume in Chapters 1 to 3 developed an institutional model to explain women's greatly varying levels of empowerment in the contemporary world. This model is based on Amartya Sen's theory of development. To Sen, development is far more than the conventional image of industrial transformation and rising levels of per capita Gross Domestic Product (GDP). Rather, Sen defines development in terms of the enhancement of people's substantive freedom and empowerment. A person's empowerment depends upon two critical stages. First, he or she must be able to develop their innate capabilities through education and the maintenance of health and personal well-being. Second, there must be opportunities for the assets and resources that are so developed to be used or applied. For example, if a person has been trained to be a

* Corresponding author.

software engineer but can only find employment as an unskilled agricultural laborer, there is a tremendous waste in human capital that results in a considerable limitation of that person's substantive freedom (Dreze and Sen, 2002; Sen, 1992, 1999).

The opportunities for empowerment available to individuals and groups, in turn, are strongly conditioned by the institutions that exist in their society. The basic culture of a society creates social values and institutions, such as the family and religion, which strongly shape the lives of people living in a particular society. These social institutions, furthermore, are also substantially influenced by the nature of the national and regional economy. In particular, industrialization produces overwhelming social change and a similar transformation from an industrial to an information-age economy appears to be occurring in the developed world at present. Finally, the nature of government involves two important types of institutions that help determine social outcomes in a nation. The structure of government (i.e., the amount of democracy and corruption) is a political institution that allocates power to influence public policy and the actions of government create laws or legal institutions that promote or retard equality and empowerment in a society.

This institutional model, therefore, would predict that women's empowerment would vary considerably among societies and nations, depending upon their institutional configurations. Women face very substantial discrimination in most traditional cultures due to patriarchal norms that affect family relations, land ownership, access to education, and political power. Conventionally, it was hoped that the radical social and economic changes set off by industrialization would empower women by greatly expanding their access to education and allowing them to participate in jobs outside the home, as well as by promoting more progressive urban alternatives to repressive rural culture. Unfortunately, this proved to be overly optimistic. Men came to control new agricultural technologies, further marginalizing women in rural societies; substantial inequality arose in the education provided to women and men, at least initially; women's industrial employment was generally limited to the least skilled and most exploited positions; and patriarchal norms proved to be very resistant to change (Boserup, 1970; Roy, 1994; Scott, 1995).

This turns our attention to the importance of political institutions and governmental policy. Government inevitably plays a vital role in ensuring

that industrialization and growing GDP really do produce "development" as defined by Sen to mean and require expanding life opportunities and substantive freedom for the bulk of the population. Most centrally, government investment in education is vital for allowing people to develop their innate capabilities. With regard to women, government mandates are necessary in most societies to prevent substantial gender inequalities in access to education. Even if women can develop their capacities equally with men, extensive public policy is almost always necessary to ensure that women can use their assets and resources to attain substantive freedom and empowerment. For example, women must be guaranteed equal property rights, equal opportunity in the labor market, and protection from the violence against women that is pervasive in many societies.

2. Testing the Institutional Model

The nine national case studies included in the book (Chapters 4 to 12) provide strong support for our institutional model of women's empowerment. Women's status and women's rights differ dramatically among these countries and much of this variation clearly derives from the very different social, economic, political, and legal institutions that exist in each. In particular, social values and structures largely shape the opportunities for women to pursue their individual goals. Government policy is crucial for promoting women's empowerment, with China and Kenya or perhaps India representing the extremes of supportive and non-supportive policy environments. Women's empowerment is generally more advanced in the developed than the developing world. Yet, Greece is a good example of the lingering informal institutions that retard women's progress and the US shows the barriers that can be created by the lack of a well-developed welfare state.

2.1. *India*

Kartik C. Roy argues in Chapter 4 that India has only made fairly slow progress in improving the status of women and in creating an institutional environment that promotes women's empowerment. India has had a highly patriarchal culture for several millennia. Consequently, traditional or informal

social institutions still exert strong pressures for women's continued subordination. To some extent, women in India face conventional problems of women's empowerment. For example, their participation in the formal sector of the economy is fairly low, even compared to many other developing nations, like China. There is substantial gender inequality in jobs and salaries, particularly in the informal sector which provides employment to the vast majority of poor women. In addition, many women suffer from a lack of property rights, women's health conditions and fertility rates continue to lag, and women are quite under-represented in government and parliament. Indian women face even graver problems than these considerable challenges, however. The patriarchal culture routinely enforced on women by matriarchs has stimulated substantial violence against women that is linked to the dowry system and sex-specific abortions. Surprisingly, the possession of assets, such as education, has not conferred more power within the household to many women and formal laws mandating gender equality have not been enforced because of the power of traditions and "customary law". Thus, the government needs to adopt policies and laws that will aggressively promote women's empowerment and greatly improve their education, health care and other social conditions. In addition, though, the government should also promote open markets and globalization because they should give women more economic opportunities and expose the nation to ideas that challenge the highly patriarchal culture.

However, the author also argues that the "one size fits all" policy will not facilitate the empowerment of all Indian women as they are not a monotheistic group and accordingly, as empowerment needs of women belonging to different castes, different economic and social classes, and to different religions, are bound to be different.

2.2. *China*

As described in Chapter 5 by Jude Howell, China provides one of the best examples in the world of a government's successful promotion of the empowerment of women. Women had a very secondary status in the Confucian culture of traditional China, in large part because they moved out of their natal families upon marriage, thereby destroying family incentives to invest in women's education and human capital development. With the founding of the People's Republic of China in 1949, the Chinese

Communist Party (CCP) quickly moved to attack centuries of gender inequality. The 1950 Marriage Law mandated equality in household and family relations, women were rapidly integrated into the formal economy as part of China's development program, and educational opportunities for women expanded greatly. The era of economic and market reforms that commenced in 1978 had profound implications for the status of women as well, though the consequences were rather mixed. On the one hand, women gained additional opportunities from the rapidly expanding economy. On the other, they were the first to lose their jobs at state corporations, almost certainly were hurt more than men from the vastly decreased social welfare net provided by the state, and suffered from the rebounding of the patriarchal culture that the waning of authoritarian controls permitted. In sum, women have made tremendous progress in China since the inauguration of the People's Republic. However, significant problems remain. There still is considerable gender inequality in the labor market, women have limited representation in government, especially top decision-making posts, and the authoritarian policy somewhat limits the ability of women's groups, both official and independent, to pursue an autonomous agenda.

2.3. *Taiwan*

Chapter 6 on Taiwan by Cal and Janet Clark documents a similar process to China's dramatic improvement over the last half century in a patriarchal Confucian culture. However, the specific dynamics, especially the role of the state, were significantly different. Taiwan's rapid industrialization that commenced in the early 1950s has clearly been accompanied by a remarkable improvement in the status and "substantive freedom" of women in that society. Just as clearly, however, significant barriers and limitations remain as well. The nation's social, economic, and political institutions have shaped this process to a considerable extent. The central role that universal primary education and land reform played in the expansion of women's resource and endowments and ability to exchange these endowments validates Sen's theory of development. This also raises the ironic point that the policies that have almost certainly been the most effective in increasing women's substantive freedom were not really implemented with women in mind but were, instead, part of a general

development program that focused on human capital. In contrast, many laws that were explicitly aimed at promoting equality were only passed in the last decade or so after the advent of democratization in Taiwan in the early 1990s, and strong indications of continuing patriarchal policies were easy to find until quite recently. The timing of the legal reforms, probably not coincidentally, followed the explosion of women's interest groups in the late 1980s and early 1990s, in line with the finding that the activities of independent women's groups are the key to achieving policies that promote women's rights (Bystydzienski and Sekhon, 1999; Lee and Clark, 2000).

2.4. *Kenya*

In Chapter 7 on Kenya, Tabitha W. Kiriti-Nganga finds a nation with an institutional configuration that is highly discriminatory against women, although very recent political change suggests that some improvement may be on the horizon. The traditional culture was highly patriarchal. For example, dowries are provided by the family of the husband who often believes that it has "bought" the wife. Consequently, power within households is strongly skewed in favor of males, violence against women is quite high, and very substantial gender inequality exists in the control of assets and resources (e.g., women only own 1 percent of the registered land in the country). Moreover, the early stages of economic development in Kenya have, if anything, exacerbated the situation. New agricultural technologies and cash crops have been controlled by men, further marginalizing women in rural Kenya. In the industrial and urban sector, women generally have less education and worse jobs than men. As a result, women, especially rural women, suffer from poverty and poor health. The government has done little to redress the situation of women and even rights that are supposedly guaranteed in law often fall victim to traditional patriarchal values and "customary law". In addition, women lag men considerably overall in literacy and education, although gender equality had been achieved in the lower levels of education by the turn of the century. In large part, this may be caused by women's very low representation in government. Indeed, women pursuing political careers often face open harassment and discrimination. Some more optimistic trends are gradually emerging, though. In particular, the new government that came to power in 2003 has been much more supportive of women.

2.5. *Peru*

Chapter 8 on Peru by Patricia Fuertes Medina highlights the fact that indus-
trialization and the growth of Gross Domestic Product do not necessarily
bring greater empowerment and progress for women. Since 1990, Peru
has pursued market-led growth through integration into the global econ-
omy. This has produced a good record of aggregate growth, but the results
for women have been decidedly mixed. Peru's traditional culture was
highly patriarchal. By the turn of the 21st century, women had made sig-
nificant gains in some areas, as evidenced by the declining fertility and
rising education rates, but the continuing power of the traditional culture
can be seen, for example, in the high level of violence against women. The
changing economic status of Peruvian women is especially problematic.
On the one hand, their level of participation in labor markets doubled
between 1970 and 2000, and this brought some increase in their power in
household decision-making. However, many of the jobs that have been
available for women have been in the informal and home-based sectors,
creating a "feminization" of flexible and low-wage labor and the position
of indigenous women is especially precarious. Thus, substantial institu-
tional change must be promoted to attain "decent work" and empower-
ment for all Peruvian women.

2.6. *Fiji*

Overall, Chapter 9 on Fiji by Biman C. Prasad and Nalini Lata shows that
women's status there as indicated by the Gender-Related Development
Index and the Gender Empowerment Measure appears to be fairly low and
that women's entrance into political office remains quite limited and not
much better than the situation in Kenya. Moreover, women's position has
been especially hampered over the last 20 years by the economic and
political instability resulting from a series of military coups. Yet, women's
empowerment appears to have advanced markedly more in Fiji than in
Kenya because of government support. For example, there is very little
gender inequality in education now and both the female and male literacy
rates exceed 90 percent. Women receive support from a wide array of gov-
ernment politics and programs in the areas of family law, participation in
the labor market, social welfare policy, protection against domestic vio-
lence, and the reduction of gender inequalities in general. A major reason

for this governmental activism, despite the small number of women offi-
cials, undoubtedly is the influence of women's advocacy groups whose
formation, in turn, has been facilitated by the fact that women constitute
one-third of the legal profession. Clearly, therefore, education has played
a central role in promoting women's empowerment in Fiji.

2.7. *United Kingdom*

Chapter 10 by Rene McEldowney concludes that over the last 30 years,
British women have experienced unprecedented improvements in their
social, economic, and political status, similarly to changes in most other
developed nations. There has been a tremendous increase in women's
participation in the work force and traditionally lagging position in edu-
cational achievements compared to men has actually been reversed.
Indeed, there are now significantly more women than men in most uni-
versity curricula, including medicine and law. Consequently, the younger
generation of women appears to be in a good position in Britain's increas-
ingly post-industrial society and economy. Yet, the position of women in
the UK varies tremendously by age, education, and family status. For
example, the gender disparity in pay is more than twice as great among
part-time as opposed to full-time workers and older women are particu-
larly hurt by the cutback in social welfare programs that occurred during
the Thatcher era. In addition, women's office-holding is comparatively
low for a developed country. Women's parliamentary representation of 20
percent in Britain, for instance, is less than half that of Scotland or Wales.
Thus, considerable progress still needs to be made in promoting women's
empowerment.

2.8. *The United States*

In Chapter 11 on the United States, Cal and Janet Clark argue that the
position of women in American society is decisively shaped by the
socio-economic and political institutions that have evolved in that country.
These institutional effects are somewhat contradictory in their implica-
tions for women's empowerment, given the US's current fundamental
transformation from an industrial to an information age economy.

America's political culture, which strongly favors opportunity over equality, is reflected in the nation's political and economic institutions. In particular, the legal system provides strong support for individual rights which can (but not always does) promote women's empowerment. This ethic is also reflected in the country's commitment to universal education. In combination, these factors have resulted in many economic and social opportunities being opened to women by the emerging post-industrial economy. However, some aspects of America's political culture have also created obstacles to the empowerment of a very significant minority of women. In particular, the anti-government philosophy in the US hampers the ability of those women who do not have the requisite education and social status to avoid marginalization in the rapidly changing society. Thus, while gender equality appears to be growing among younger (under 35) Americans, there is also rising inequality between those women who can gain access to good education and professional jobs and those who cannot. Consequently, although the US is the richest nation in the world, its rankings in the developed world on the status of women are only average.

2.9. *Greece*

In Chapter 12, Rosita Dellios finds Greece to be undergoing a very significant transformation in the status and empowerment of women. The nation is one of the poorest in Western Europe, but it is still quite advanced compared to most developing countries with, for example, the literacy and infant mortality rates of the developed world. Still, its traditional and patriarchal culture remains strong, as evidenced by high rates of domestic violence against women and the informal continuation of the dowry system. In particular, the emphasis in women's role remains focused on motherhood and the domestic sphere. Two important change factors are challenging the traditional patriarchy, however, to promote women's empowerment. First, women's participation in the formal economy has increased substantially since the late 1970s and there also has been a movement from agriculture to the service sector in women's employment patterns. Second, Greece has increasingly been affected by a process of "Europeanization" over the last several decades which has resulted in both international agreements and domestic constitutional change mandating the equal treatment of women. Thus, while women still face economic, socio-cultural,

and political poverty and inequality, significant institutional progress appears to be underway.

3. Implications

The individual case studies in Chapters 4 through 12 evidently do validate the institutional explanation for women's empowerment that was developed in the first three chapters. This has both optimistic and pessimistic implications for improving the status of women in the contemporary world. Positively, a facilitating institutional structure can clearly empower women. Thus, developing supportive institutions offers a path to progress. Conversely, however, institutions are notoriously "sticky" or hard to change. Consequently, even if the nature of empowering institutions is known, they may be impossible to construct because of cultural or political factors. For example, political institutions in Kenya seem to reinforce rather than prohibit the customary law that is highly discriminatory against women and, indeed, the very positive institutional change in China (e.g., the Marriage Law of 1950) occurred only after a major political revolution.

More concretely, two sets of institutional changes can improve the status of women in traditional societies. One involves the massive social and economic change set off by industrialization, while new political and legal institutions form the other. Our case studies suggest that economic change by itself is not necessarily very beneficial for women. Indeed, Peru's market-led growth over the last decade and a half has had decidedly mixed benefits for women, especially indigenous women, who remain marginalized in the evolving new economy. Rather government policy is necessary to ensure that new economic institutions do not perpetuate the suppression of women. The polar extremes of China and Kenya certainly support this point. More subtly, Taiwan's strategy of basing industrialization on human capital development benefited women, while America's and Britain's individualistic and *laissez-faire* approach to their transformation to an information age economy has mixed implications for women, empowering some but dis-empowering others. Thus, the battle for women's empowerment in the early 21st century will almost certainly be fought on the political stage. Hopefully, the research reported in this book can serve as the basis for designing successful political strategies.

References

Boserup, E (1970). *Women's Role in Economic Development.* Allen & Unwin, London.

Bystydzienski, J and Sekhon, J (eds.) (1999). *Democratization and Women's Grassroots Movements.* Indiana University Press, Bloomington.

Dreze, J and Sen, AK (2002). *India-Development and Participation.* Oxford University Press, New Delhi.

Lee, RJ and Clark, C (eds.) (2000). *Democracy and the Status of Women in East Asia.* Lynne Rienner, Boulder, Co.

March, JG and Olsen, JP (1989). *Rediscovering Institutions: The Organizational Basis of Politics.* Free Press, New York.

Roy, KC (1994). In *Technological Change and Rural Development in Poor Countries*, KC Roy and C Clark, (eds.), pp. 65–79. Oxford University Press, Delhi.

Scott, CV (1995). *Gender and Development: Rethinking Modernization and Dependency Theory* . Lynne Rienner, Boulder, Co.

Sen, AK (1992). *Inequality Re-examined.* Harvard University Press, Cambridge.

Sen, AK (1999). *Development as Freedom.* Alfred A. Knopf, New York.

Index